A Critical Vision Book An imprint of Headpress

A Critical Vision Book
Published in 2003
by Headpress

Headpress / Critical Vision
PO Box 26
Manchester
M26 1PQ
Great Britain
Fax +44 (0)161 796 1935
Email info.headpress@zen.co.uk
Web www.headpress.com

LAND OF A THOUSAND BALCONIES
Discoveries & Confessions of a
B-movie Archaeologist
Text copyright © Jack Stevenson
This volume copyright © 2003 Headpress
Layout & design: Walt Meaties & David Kerekes
World Rights Reserved

British Library
Cataloguing in Publication Data
A catalogue record for this book is available from the British Library

ISBN 1-900486-23-7

All rights reserved. No part of this book may be reproduced or utilised in any form, by any means, including electronic, mechanical and photocopying, or in any information storage or retrieval system, without prior permission in writing from the publisher.

Images are from the collection of Jack Stevenson. They are reproduced in this book as historical illustrations to the text, and grateful acknowledgement is made to the respective filmmakers, studios and distributors.

FRONT COVER: (main image) unknown; (bottom l–r) Eddy Massey in *Female Trouble*; Ed Wood Jr and Bela Lugsosi in *Glen or Glenda?*; Maria Montez; *Reptilicus*

BACK COVER: "Bat Girl" in a topless Scopitone, circa 1966

The author would like to thank the following people for support, assistance and inspiration in various forms:
Kenneth Anger, Tim Caldwell, Bertrand Grimault, David Naylor, Kip Doto, Joel Shepard, Jim Morton, Silke Mayer, Christina & Pernille Rosendahl, Elizabeth Rozier, DDV & AMVK, Kim Foss, Brandon Kearney, Helen DeWitt, and the folks at the Kinemathek Karlsruhe, the Filmmuseum in Amsterdam and the Olympia Film Society.

In memory of Lisette Arendshorst

CONTENTS

Introduction .. v

TOURS THROUGH GENRE AND HISTORY

It Came From Beyond Belief .. 7
The Incredible B-Movies of Sidney Pink in Denmark

A Million Frightened Teenagers ... 21
In Praise of the Lowly Gimmick and a High Priest named William Castle

3-D Made Easy .. 27

The Jukebox That Ate The Cocktail Lounge .. 31
The Story of Scopitone

A Secret History of Cult Movies ... 47
A Biblical Tale of the Holy Unlikely

The Good The Bad and The Strange .. 58
Christmas Cult Movies

Of Cult Religions and Cars That Fly .. 62
A Look Back at the Future that Never Came

A TRIBUTE TO THIEVES, HAMS AND PROPHETS

Hail, The Conquering Thief! .. 67

The Actor That Wouldn't Die ... 69
A Tribute to Ham

The Cult Of Technicolor .. 73
A Séance

HAUNTED HOUSES AND ILLUMINATED CELLARS

Theatres and Unique Exhibition Spaces .. 76
An Introduction

Market Street .. 77
Movie Theatre Graveyard USA

The Nyback Chronicles (in Two Parts) .. 85
The Pike Street and Lighthouse Cinemas

Europe In The Raw .. 95
Underground Cinemas Show It All!

I, An Arthouse .. 103
The Agony and Ecstasy of Copenhagen's Art Film Scene

The Portable Drive-In-Movie Electric Acid Test .. 111
In Search of the Perfect White Wall

JOURNEY TO THE CENTRE OF CAMP AND TRASH

The Passionate Plastic Pleasure Machine ... 113
Or, Camp Film about to turn Fat and Forty

Trash Ain't Garbage .. 125
Identifying a New Aesthetic in Cinema

Underground Film-Maker, Jon Moritsugu ... 131
Turning Rancid Meat into a Beggar's Banquet

TALES FROM THE CITIES

Personal Encounters from the Portable World .. 136
An Introduction

Boston (in Two Parts) .. 137
Through a Rear Window Darkly and The Lost Picture Show at Chet's Last Call

Guerrilla Cinema In San Francisco ... 142

Fear & Loathing & Good Hash & Dirty Laundry In Europe ... 149

The Jesus Car .. 153
From Here To Hell and Almost Back

From Russia With Confusion .. 155

The Curse Of The One-Armed Garden Gnome .. 158
Report From the First Annual Freak Zone Festival in Lille, France

Of Celluloid and Slime ... 164
A Look Behind the Curtains of The Hamburg Short Film Festival

Kosmorama Nights ... 170
Heating Up a Movie Theatre in the Cold North

Copenhagen (in Two Parts) .. 174
Club Strange and Ballroom Crashing

APPENDIX

Confessions of a Film Collector .. 177

INTRODUCTION

Most books about B-movies are straight-forward genre guides, biographies and encyclopaedias. You will however find this book to be very different, for in addition to carefully researched articles (portraits of Sidney Pink and William Castle, and tributes to gimmicks and cult film) of the kind one would expect to encounter in other genre publications — and which are found here in the section headed GENRE AND HISTORY — it also documents my own first-hand explorations into a different realm of low budget cinema which exists outside the classically defined boundaries of the commercial B-movie.

Most of *these* texts are contained in the section headed TALES FROM THE CITIES, and diverge into territory closer to what could be loosely termed "underground", taking place in both America and Europe. They are film-related incidents and episodes, character studies and reports of unusual one-off film happenings, all of which I have, over the past fifteen years, been privy or party to in my various capacities as show organizer, tour arranger, festival jury member and 16mm projectionist-for-hire. These texts are, appropriately I think, penned in a wholly subjective first-person style that departs from the more orthodox objectivity brought to bear elsewhere in the book.

Articles that comprise the section HAUNTED HOUSES AND ILLUMINATED CELLARS put the focus on movie *theatres* and renegade exhibition spaces. Here the disappearing "sense of place" and atmosphere that is such an integral part of the movie-going experience is stressed. The reader is invited to tour a diversity of venues, from the notorious old grind-houses of San Francisco's Market Street to home-made store-front cinemas that existed in Seattle and New York, to some of the more outré underground film clubs of Europe.

Finally, the section titled JOURNEY TO THE CENTRE OF CAMP AND TRASH seeks to place in historical and theoretical relief "Camp" and "Trash" — two of the concepts which inform so much of the rest of the book and are essential to a basic appreciation of outré cinema in general.

Although many of the people and places chronicled herein are still very much alive and functioning, the book in total resembles something of an archaeological dig, hence the cover image of the movie mummy. The book is a mummy hunt, a trawl through the sands, a drag below cinema's otherwise clean and perfect surface. Things, inventions, technologies, ideas, obsessions and styles from another time are winched up out of the ground… bones and fragments not necessarily all from the same animal but which do more or less fit in some fashion.

But I digress. It is not ancient Egypt we are excavating here. Rather it is a place without fixed borders or a specific location in time or geography; a place that exists more in a spiritual dimension… a place that might be called the Land of a Thousand Balconies.

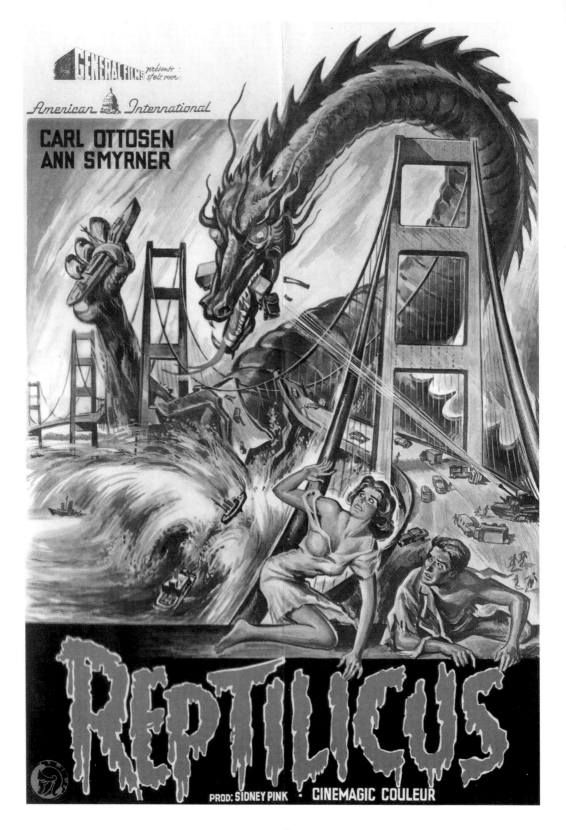

IT CAME FROM BEYOND BELIEF

The Incredible B-Movies of SIDNEY PINK in Denmark

In the fifties and sixties, Los Angeles' sprawling Griffith Park was a virtual haunt of supernatural menace as zombies, perverts and space monsters in exaggerated make-up and baggy costumes staggered after screaming B-queens in torn skirts and heels. To low-budget exploitation directors, the old Hollywood axiom about expensive location shooting usually applied: "A stone is a stone, a tree is a tree — shoot it in Griffith Park."

Ten thousand miles away in Denmark, the good law abiding citizens of Copenhagen felt safe. But it was a false sense of security indeed. On February 20, 1961, the City darkened under the ominous shadow of the giant, prehistoric winged reptile, Reptilicus, and Copenhagen joined other world capitals such as New York, Washington, Tokyo and London in panic as giant stop-motion puppet monsters wrecked terror and destruction on the modern world.

Thanks to the persistence of a stubborn, arrogant and delusional — if occasionally divinely inspired — hustling rogue film producer and science-fiction buff by the name of Sidney Pink, Denmark earned a chapter of its own in the same mouldy history book of cult film lore that contained the now famous Ed Wood.

In their struggles to make frightening science-fiction monster movies, Ed Wood and Sid Pink faced the same disadvantages: lack of money, technical knowledge, and, many would say, talent. Yet they were both possessed by a total belief in what they were doing and were both prone to judge their own films with a wild enthusiasm that left objective observers bewildered — at least at the time. And despite the scorn that film critics have heaped upon them, their films have survived and have undergone cycles of popular revival and critical reassessment.

But unlike Ed Wood, who remained a marginal figure consigned to the fringes of Hollywood, Sidney Pink had a much more varied career that touched on almost every aspect of mid-century media culture.

Employed by both Columbia and Fox studios from the mid thirties until 1941, Pink saved enough money to buy a pair of movie theatres in south Los Angeles, which he operated before enlisting in the army (1941–1946). Upon his discharge he made an attempt to break into the laundry and dry cleaning business, but this failed and he was soon back in the movie game. During the late forties he became a leading west coast distributor of European "art" films and helped to popularise post-war neo-realism cinema which would influence American movie making so profoundly in years to come. Following his stint as a distributor, he became a burlesque theatre producer, and later hosted and promoted experimental live theatre productions like Jean Paul Sartre's *No Exit*.

In 1952 Pink produced the first theatrically released 3-D feature film, *'Bwana Devil*, for director Arch Oboler, beating other gimmick meisters like William Castle to the punch and ushering in the stereoscopic boom. In the mid fifties he involved himself in TV series production and concept development, returning to movie theatre operation in the late fifties with the goal of saving enough money to make another film.

Land of a Thousand Balconies

Sidney Pink's
Journey to the Seventh Planet

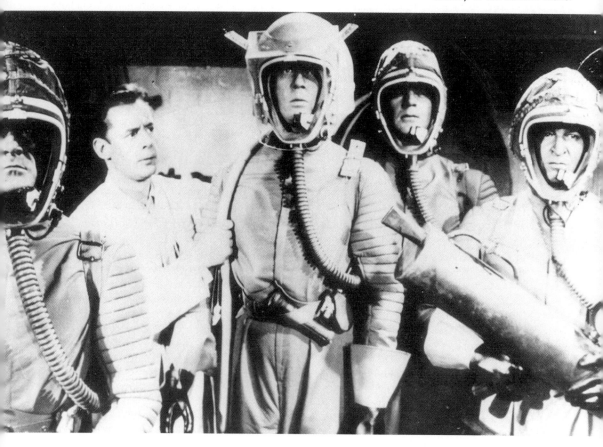

In 1959, still convinced that gimmicks and special effects could make a movie a hit, Pink, a big science-fiction enthusiast, produced the space travel adventure, *Angry Red Planet*. The film boasted a new photographic filter gimmick Pink labelled "Cinemagic", and was populated with the kind of wildly exaggerated monsters that would figure in all his science-fiction films. The movie proved a financial godsend to its American distributor, AIP, and also marked for Pink the beginning of a testy and often contentious lifelong association with Danish-born writer and TV director, Ib Melchior, who directed the film.

Arriving in Paris in 1959 in search of European distribution deals for *The Angry Red Planet*, Pink met Danish movie mogul, Henrik Sandberg, of Merry Films, who invited him to Denmark. After concluding his business in Paris, Pink flew directly to Copenhagen, checked in to The Palace Hotel in Rådhuspladsen (Town Hall Square) and began a love affair with the city and (most of) its people that would last a lifetime. In his autobiography, *So You Want To Make Movies: My Life as an Independent Film Producer*, published in 1989, he lavishes praise on everything Danish from Tivoli to architecture to women and pølse (hot-dogs).

Sandberg inked a deal with Pink for Scandinavian distribution of *The Angry Red Planet*, and also signed the pic's female lead, Nora Hayden — then under exclusive contract to Pink — for his adventure film, *Gateway To Gaza*, slated for shooting in Egypt the following year.

A GREEN-EYED ELEPHANT RUNS AMOK

It was now December, 1959, and Pink began searching for a project to keep Nora and himself busy until production on Sandberg's film started.

Pink sat down and began writing. He ended up with a script for a thirty minute TV pilot entitled *The Green-Eyed Elephant* that he hoped to develop into a sitcom series. The story centred on two gal roommates in Hollywood both trying to make it in the movies. One has looks but no acting talent while the other has talent but lacks beauty. Through the magical meddling of a green-eyed jade elephant that they'd purchased on a vacation to Mexico, the talents of the two were mysteriously merged.

Pink secured a commitment from American ABC-TV to produce thirty-nine episodes dependent on approval of the pilot, and signed English stage actress, Delphi Lawrence, to co-star with Hyden. He then signed Denmark's leading comedy director, Peer Guldbrandsen, to helm the picture. Although *Gengaeld* (*Retribution*, 1955), a post-war revenge drama, was Guldbrandsen's most critically acclaimed film, he was best known in Denmark for his light comedies and charmed Pink as intelligent, likable and more fluent in English than he actually was (according to Pink).

Sid found a cameraman, Aage Wiltrup, he liked so much that he used him for every picture he shot in Denmark. Filming would take place entirely indoors at Saga Studios in Hellerup. Pink rented an apartment nearby and went to work.

Thus began one of the most ill-fated co-productions ever launched, an "insane venture", as Sidney would call it with some understatement. Here was an American TV sitcom pilot filmed in Denmark with American and English leads, a Danish director, crew and cast (all speaking heavily accented English) and a Hungarian production manager whom Pink could only communicate with in pidgin German. And they were supposed to convince American viewers that all this was taking place in Hollywood!

Pink soon found himself at odds with Guldbrandsen's approach to comedy which favoured dialogue and verbal gags — of which few existed in Pink's script — over the kind of goosy body language and mugging that had made Lucille Ball a star and was very popular in America. Arguments on the set were frequent and intense.

Sid was aware of Henrik Sandberg's popular soldier film series (*Soldater kammerater serien*) and loved the comedic acting of Danish box-office champ, Dirch Passer. He quickly wrote a part into the script for Passer and his frequent co-star, Ove Sprogøe, in the hope that they might salvage a film that looked to be a sure loser.

The end result was, in everyone's estimation, so bad as to be unplayable. Pink shipped the rough cut to a friend back in Los Angeles to look at. It was returned with a note attached: "Burn it and don't let anyone know you made it."

The lady editor had walked out during a big fight between Pink and Guldbrandsen and Pink now tried to re-edit the material into some showable form by himself. He ended up dumping everything except the excellent four minute scene with Passer and Sprogøe. Desperate to salvage the project, he rewrote the entire script around this extract, changing the story so that Hayden is smuggled out of America in a steamer trunk to England but lands in Denmark by mistake, thus legitimising the film's Danish locale.

The end result was a seventy-eight minute feature film revolving around Hayden, Passer and Sprogøe. While unsuited to American tastes, *The Green-Eyed Elephant* did play successfully in theatres in Denmark, Norway and Sweden, recouping its costs and turning a modest profit. Almost directly after his unpleasant encounter with Pink, Guldbrandsen went on to make the strangest film of his career, *Baronessen fra benzintaken* (*Baroness From The Gas Station*, 1960). Ninety-sixty would be a good year for "strange".

With a successful film, Pink had salvaged his reputation as a producer in Denmark and given some glory to his Danish backers who were eager to keep the momentum going. He now had a shooting crew in place, solid financial backing and a production deal offer from Saga that would write off studio costs in exchange for Scandinavian distribution rights on another film.

Besieged by new ideas from hopeful scriptwriters — his Danish co-producer, Hans Barfod, among them — Pink began fishing for a script that would satisfy legal and guild requirements for a "Danish production". In the meantime he collaborated with Sandberg on an English language remake of *Gateway To Gaza* — retitled *Operation Camel* — that would go on to receive modest exposure in American theatrical and TV markets.

On a layover in the US, Pink met with AIP distribution bosses, Sam Arkoff and Jim Nicholson, to discuss what kind of picture he should make next. Nicholson suggested a monster movie, and suggested that Pink incorporate the "beauties of the Danish countryside".

In six days Sidney dashed off the script of a movie that would become his best known and most profitable motion picture achievement ever — as well as his greatest embarrassment. That movie would be *Reptilicus*.

Land of a Thousand Balconies

THE MONSTER STIRS!

The story begins in Lapland on an oil drilling rig which winches up out of the frozen earth the preserved tail particle of some prehistoric beast. Brought back to Copenhagen and kept frozen for scientific study at the city aquarium, the specimen begins to thaw and regenerate itself... growing into a hideous, winged reptilian monster which comes to life during an electrical storm and breaks loose to terrorise Denmark.

Seeking to make the film marketable in America, Pink scripted in the role of macho American army general, Mark Greyson, and then proceeded to cast the part with Danish actor, Carl Ottosen, whose English was nearly incomprehensible. Pink's only American player, Nora Hayden, refused to be billed second to Ann Smyrner, a Danish actress actually better known in Germany, and promptly returned to The States. Smyrner, meanwhile, got to cosy up to well known heart-throb, Bent Mejding, who played the hero part with square-jawed woodenness.

The closest thing Pink could find to an American actress was German beauty queen, Marilise Behrens, whose dad was an American GI. Behrens turned out to be an appallingly bad actress and her part was downgraded on an emergency basis.

So much for the "Americanisation" of *Reptilicus*.

Denmark's leading ingénue, Mimi Heinrich, was cast as second female lead but actually got more screen time and sexier outfits than Ann Smyrner who was corseted into a starchy array of baby-doll dresses. Asbjørn Andersen, a star of the Danish Royal Theatre who was known as "The Danish Laurence Olivier", hammed it up as Professor Martens.

At this point, before shooting actually began, Sidney Pink was at his pinnacle as a movie producer in Denmark. The project was the talk of the Danish film industry as a series of teasers in the general press lavished praise and stoked expectations.

A piece in the daily tabloid, *Ekstra Bladet*, (April 7, 1960) hyped the great future of the Hans Barfod-Sid Pink production team, citing the imminent start up of two long planned Barfod projects: *Djaevelen gaar forbi* (*The Devil Walks By*) and an untitled youth problem film. The *Green-Eyed Elephant* debacle was recast as a shining success story, and, the piece went on to report, Pink and Barfod were negotiating to sign top international movie stars like... Lilly Palmer (yes, *the* Lilly Palmer). The upcoming *Reptilicus* was intriguingly presented as Denmark's first science-fiction "trickfilm", an extravaganza loaded with stars. It was not only Reptilicus who would awaken from an ancient slumber: science-fiction film-making in Denmark had been more or less asleep since 1917 when Holler Madison had directed the last stand out fantasy film: *Himmelskibet* (*Sky Ship*).

The optimistic hype would continue throughout shooting. On August 20, 1960, Saga boss, Fleming John Olsen, escorted a writer from the *Politician* newspaper around the set of *Reptilicus*. Olsen claimed it was the film's fantastic story that had hooked him on the project. An article in the September 5 issue of *Berlingske* included a photo of Sid Pink, dressed in shirt sleeves and bowtie, holding the Reptilicus puppet atop a miniaturised model of the Berlingske newspaper building. Pink claimed in the article that associates in the US and England were thrilled with the 1000-metre rough cut footage he had sent them to preview, and that *Reptilicus* was slated to open in Hollywood on Christmas day to qualify it for the Oscar awards, which all involved reckoned it had a good chance to win.

On the set it was quite a different story as chaos reigned supreme, due largely to Pink's admitted arrogance and ineptitude in the director's chair. Sidney claims in his autobiography that he finished the picture "without really knowing what the hell I was doing". To complicate matters, a second (Danish) version was being shot simultaneously on the same sets by Saga director, Poul Bang. With actors memorising dialogue in both Danish and English, Pink would shoot a scene then step out of the way and let Bang do it his way for the domestic version, with crowd and action scenes the same in both cuts. What seemed at first a novel innovation proved a practical disaster.

The casting of Danish actors speaking English in a film aimed at an American public has given rise to a number of colourful if conflicting myths about the picture.

A *Politiken* writer assumed that the Danish accents would be acceptable since the story was obviously taking place in Denmark anyway. Sam Arkoff didn't see it like that. He claims in his autobiography (*Flying Through Hollywood by the Seat of my Pants*) that on a trip to Copenhagen to look at a rough cut — after having dumped $100,000 into the film and listening to Pink's ceaseless ballyhoo — he shut the projector off in horror. The monster didn't horrify him nearly as much as the "sing-song Danish accents" which would have gotten the picture laughed off movie screens in America. (Danes have anything but sing-song accents — small point.)

Over Pink's protestations, Arkoff insisted the film be dubbed with American voices, prompting an exchange of lawsuits and ultimately delaying the release of the film in America. *Reptilicus* was clumsily redubbed at Titra studios in New York, and only Claus Toksvig, a

It Came From Beyond Belief

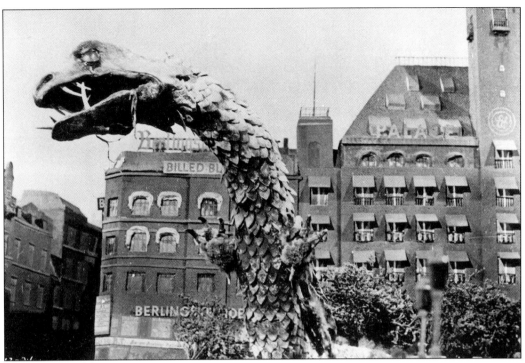

Reptilicus on the rampage.

Danish journalist who already spoke impeccable English, was allowed to keep his own voice. (In the Danish version, American general, Mark Grayson, played by Carl Ottosen, promptly disposes of the need to speak English by claiming in his first line of dialogue that his mother was Danish and they spoke Danish at home.)

Ib Melchior had doctored up the *Reptilicus* script at the instigation of AIP, a contribution that both Pink and Melchior are ever eager to play down. Melchior claims that Pink knew all along that *Reptilicus* would have to be dubbed into "real" English for its American release and pursuant to this instructed his actors to speak with a slow, robotic clarity to make it easier for the sound mixers to lay the dubbing over the actual words. The sum result would have been to further stifle any spontaneity in the performances and to make the actors appear somewhat retarded, but Melchior's assertion is dubious. (Melchior's memories of his collaborations with Pink have undeniably been tainted by an animosity which over the years has culminated in something of a state of war between the two.)

One problem Pink did not encounter was lack of cooperation from the authorities on location shooting. To the contrary, this "successful" American movie maker received the kind of favourable treatment he never would have been afforded in America, and for all its faults, *Reptilicus* would feature locales and production values that would set it apart from much of the low-budget monster movie product that AIP became known for.

Pink was given permission to block off traffic in giant Rådhuspladsen, Copenhagen's majestic main square, whenever he wanted, and he had no problems recruiting multitudes of unpaid extras for the crowd scenes.

The aforementioned owner of Saga studios, Fleming John Olsen, was a prominent member of the political party then in power in Denmark, and secured for Pink the generous cooperation of the army and navy. For a time Saga claimed that Pink had merely been allowed to film troops already on summer manoeuvres, but in fact the film crew was supplied with tanks, cannons and technical advisers by the army, while the navy chipped in with a coastguard cutter and depth charges to shoot scenes that normally would have been rigged with stock footage.

Sidney loved to dine at the famous Divan 1 restaurant in Tivoli, and he shot a nightclub scene there with popular Danish singer, Birthe Wilke, who crooned *Tivoli Nights* — one of two original songs written for the film by Victor Skaarup and Sven Gyldmark. Pink had no idea what "playback" (lip-syncing) was and shot the scene in one take with an ancient 800 pound

Land of a Thousand Balconies

Pathé camera to record the sync sound, and three small ariflexes for long, close-up and crowd shots. It was a highly unorthodox shooting strategy borne out of Pink's ignorance of proper set-up, but it worked nicely and was one of Pink's favourite scenes. It was also a scene commonly cut out of the American prints, and easily so since the implausible side trip to Tivoli — while the monster approached the city no less — was extraneous to the plot.

The other original song was 'Tillicus, sung by Dirch Passer as he cavorts with a troop of children in a field while the monster was supposedly closing in! Although one of the most enjoyable scenes in the film, this sprightly song number did little to enhance the aspect of terror in a film that was trying to be genuinely scary, and these unlikely scenes with Wilke and Passer come across as being both bizarre and expendable.

TERROR IN MINIATURE

The central quarter of Copenhagen was painstakingly recreated in miniature on a set measuring 12 x 14 metres by architect Kaj Koed for a cost of 50,000 kroner. No American set designer could have done such a great job, Pink would boast, and at such a moderate price. The wondrous miniature recreation sat for a while on display in a studio on Annettevej.

Model artist, Orla Høyer, crafted two fearsome looking replicas to play Reptilicus. One was a small rubber and plastic puppet with giant fangs that resembled a Chinese dragon, while the other was an articulated dummy ten metres long that consisted of only the head and half the body. The big Reptilicus was large enough for two men to climb inside. They could then operate it so that its head whipped about and its nostrils shot smoke.

Early attempts to animate the little puppet with the likes of visible chicken wire flopped, and the entire production appeared to be doomed until Denmark's reclusive stop-motion photography master, Bent Barfod, grudgingly agreed to give it life. Barfod taught it to fly, swim, roar, smash buildings and even pick up a pedestrian and fling him into the crowd.

Pink was greatly impressed, but others were less so, such as the reviewer for *Kristeligt Dagblad*, who likened Reptilicus in flight to the peacock in Tivoli that adorns the mime stage. In fact the effects work on the monster would run the gamut from very effective to hopelessly pathetic, although who was responsible for exactly what is difficult to ascertain today.

Pink had written a spectacular scene into the film where, in a disastrous attempt to prevent Reptilicus from entering the city, a panicked drawbridge operator raises the gates of Langebro bridge as terrified residents of the island of Amager flee across it.

Against all rational advice, Pink proceeded to plan the scene for which no rehearsals would be possible. "I didn't know all the reasons why such a scene couldn't be done," Pink would state in his book, "so I went ahead and did it."

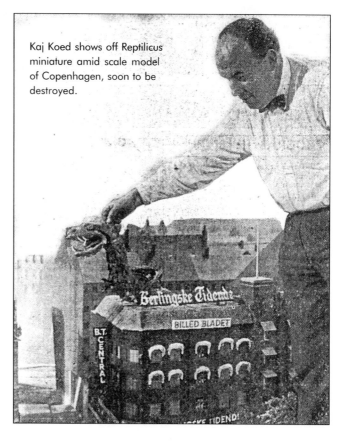

Kaj Koed shows off Reptilicus miniature amid scale model of Copenhagen, soon to be destroyed.

He insisted on having shots of people on bicycles spilling off the bridge and into the water. Why? He wasn't sure himself, but he knew it had to happen. The professional stuntmen refused to do this so his producer found a bicycle club badly in need of funds and they agreed to do the stunt for 10,000 kroner (about $1,500), with Pink offering to double the fee if it worked. A mob of 1,000 people from the Værløse Athletic

Tours Through Genre and History

It Came From Beyond Belief

Club served as volunteer extras and fled across the bridge in terror (although some of them seem to be trying their best to repress grins). It was a scene of such chaos that it prompted two daily papers to wonder how on earth Amager could be safely evacuated if a *real* disaster ever struck.

Massive crowds of spectators gathered on the day of the drawbridge shoot. Press coverage was heavy. Five cameras were set up to film the scene: two on the roofs of the tallest buildings overlooking the bridge, one in the bridge control booth, one in a boat below and a hand-held camera in the crowd.

"Action!" The drawbridge began to rise… here myth intrudes again. Pink claims the camera in the booth shoot was the talk of Copenhagen for months to come.

The jam-packed Danish premiere was held at the big Saga cinema on Vesterbrogade on February 20, 1961, with the Poul Bang domestic version screened. Pink recalls how shocked he was at how bad Bang's film was and how maddeningly slow it was. The Danish press blasted the film without mercy, calling it badly acted, appallingly directed and amateurish and implausible in every respect. To this day, *Reptilicus* is responsible for some of the most colourful and excited prose in the entire history of Danish film criticism. The Catholic paper called it unbearable and found Asbjørn Andersen's concluding plea for solidarity among human beings — completely cut out of the

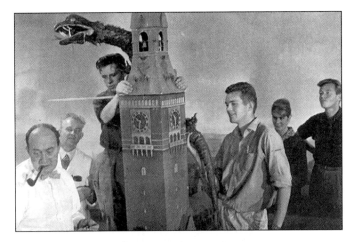

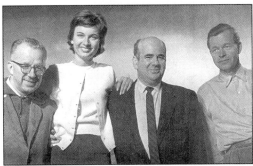

ABOVE LEFT Rare *Reptilicus* production shot. Kaj Koed is on the left (with pipe).

BOTTOM LEFT Rare shot of Sidney Pink. From left to right: *Reptilicus* production executive J H Zalabery, script girl Gitte Müller, Pink and cinematographer Aage Wiltrup.

Photos: Thomas J Wiltrup, with special thanks to Kip Doto

ABOVE RIGHT Ib Melchior.

jammed while the camera on the best situated building had a film break four minutes into the scene. Ib Melchior (who had nothing to do with the production of the film and wasn't in Denmark) says nobody remembered to tell the cameramen to start filming, but that one fellow decided to start shooting anyway and that's what they ended up with.

In any event, the drawbridge scene is by all accounts the most spectacular scene in the film, and the recent video release — so pompously grandiose that it made their reviewer physically nauseated. Only the financial paper, *Børsen*, gave *Reptilicus* a positive review.

Pink was amazed by the gales of laughter when Reptilicus started smashing up buildings. He asked Fleming John Olsen what the laughter signified. "We Danes feel that our buildings are indestructible," Olsen replied, "and we know that when we come out of the

theatre, they will still be standing. To us that scene is hilarious." "So much for the weird Danish sense of humour," Pink surmised, apparently impervious to the film's unintentional humour. The tabloid BT reported laughter at all the wrong places and noted that by the end of the film the rabble had been whipped into a frenzy of shouting, whistling and laughing. One could only gag or laugh hysterically at the film, added the reviewer for Land Og Folk (Land And People), with most opting to laugh. Land Og Folk also commented ironically on the plot twist that put an American general in charge of the Danish army, and along with others criticised the military for putting their resources at the disposal of Saga studio and thereby drawing Danish taxpayers into the travesty and heightening the sense of national humiliation. While the Danish armed forces had performed admirably against an imaginary puppet monster, many were left to wonder how they would fare against a real foe.

In the face of such a disaster, Saga blushingly buried Reptilicus. Would it be that the beast was so easily destroyed!

THE MONSTER NO CRITIC COULD KILL

In April of 1962, AIP finally bought the film from Pink for American distribution and in 1963 set it loose on the drive-in theatre circuit, double-billed with the Italian-made Marco Polo. One Danish writer observed with some bemusement that the film was playing well at drive-in theatres where over sexed American teenagers were probably too focused on other activities to actually watch the movie.

A September 1965 article in BT reported that Reptilicus was drawing huge crowds of romantically inclined youth to Australian drive-in movie theatres, and bemoaned the fact that this was likely to be the only Danish film most Australians would ever see.

In 1979 the Danish Science-Fiction Circle Club attempted to dig up the hibernating Reptilicus to show at its convention. They succeeded, but only after complicated efforts to secure screening permission and to locate the last remaining print hiding in the Danish Film museum archive. (In 1992 the same print screened at the Delta Bio and later at the Biffen kino in Aalborg, and in 1998 it featured as main attraction at a Danish Cult Film Fest held at The European Film College in Ebeltoft where Bent Barfod was the special guest.)

On January 24, 1981, the Danish correspondent for Jyllands-Posten in the US, Arne Myggen, aired his thoughts after seeing Reptilicus on American TV. Danish gastronomic comforts like black bread, Danish snaps and Carlsberg beer were easy to find in The States, he wrote, but Danish film culture was a rare treat. Thus when Dirch Passer's face was used to promote an upcoming TV movie, Danish-American households cheered — until they saw the movie: Reptilicus. The film was so inept, Myggen wrote, that even the legendary pairing of Dirch Passer and Kjeld Petersen — reunited briefly here — yielded no magic. Cheers turn to groans of pain. Even Birthe Wilke's scene had been chopped out.

Reptilicus would become known as one of the biggest flops in Danish film history. But it was so much more!

Reaction of Danish viewers today runs along generational lines. Many younger viewers, with some exposure to the American B-movie aesthetic by way of video, appreciate the camp value of the film, rejoice in its glorious trashiness, and feel something akin to pride.

Older viewers, however, and the Danish film community at large, judge the film to be a complete disgrace. Denmark had no tradition of science-fiction filmmaking, let alone the grade-Z variety, and most just didn't get the joke. Here were some of the most beloved and respected Danish actors trapped for eternity in an artless, foolish film that refused to die a dignified death. They should have known better. Didn't these people have agents to nix these kind of deals? Deprived of any shred of competent direction or motivation, they were, in the "international" AIP version, even robbed of their own voices thanks to the American-English dubbing. Not until eighteen years later when the flower of British drama (John Gielgud, Peter O'Toole, Helen Mirren) appeared in the American hardcore porno film, Caligula, would an entire nation feel so painfully disgraced on the movie screen.

The flying (or swinging) reptilian beast would become as closely associated with all things Danish as Godzilla would become linked to all things Japanese. Reptilicus and Denmark were, like it or not, joined forever in a shotgun marriage. Sidney Pink had seduced a fair number of Danes with his over hyped clout as an American movie producer who could make a Danish film that would play big and earn lots of money in foreign markets. And they had seduced Pink by giving him the respect and cooperation he did not have back home.

But as noted, the honeymoon was short-lived, lasting about as long as it took the next day's newspaper bundles to hit the streets.

In America, Reptilicus was only a moderate hit, but thanks to frequent late night TV play, its cult status grew and its popularity refused to wilt. The Monkees sitcom of the late sixties used scenes from the film as a running gag for years, while out-takes were mulched into any number of other horror films, such as The Bees

from 1978. Lots of cheap horror movies had ridiculous rubber monsters in them, but in some inscrutable way, *Reptilicus* was special.

Pink never sold his rights to the film, and, even though he says he cannot comprehend why the public likes it and claims to be eternally ashamed and disappointed by it, it remained a steady income earner for him.

Reptilicus flapped its way into cult film legend, and it also flapped its way into a pornographic paperback adaptation which — to Pink's horror — was packaged and sold by Monarch Books as a monster story for young readers.

"She stood still momentarily," read one passage…

letting him look at the perfect breasts… she kicked off her shoes and rushed across the room, flinging herself onto his lap… in a matter of seconds his garments were strewn all over the room… He put his face between her breasts. 'We don't know how long it will be before Reptilicus is sighted over Copenhagen, but until he is, let's make every moment count.'

Okay, a little more…

She was stroking his back. For only a moment did she playfully resist, then she brought him close, hugging him to her, revelling in the riotous sweep of his hands on her naked flesh, instinctively shifting and moving her body to accommodate him… It was as if he had touched something electric deep within her. For now her whole body seemed to come alive. He felt himself completely enveloped and from his mind fled all thoughts of Reptilicus, of danger, of everything save this woman who was all female, all savage wanting, bringing him to a fruition of pleasurable feeling such as he'd never known.

In an effort to clear his good name, Pink successfully sued AIP, who had licensed the rights to Monarch without his permission. By 1970, however, his puritan streak had apparently faded and he himself produced a hardcore pornographic comedy entitled *The Man from O.R.G.Y.*

Reptilicus ends with a shot of a bloody claw lying on the sea bottom waiting to regenerate into a sequel, but Pink decided never to do a follow-up. Next to bubonic plague, nothing could have panicked Denmark more than rumours of a *Reptilicus* remake.

JOURNEY TO THE CENTRE OF THE WORLD'S SMALLEST SOUND STAGE

Pink had screened *The Angry Red Planet* for Bent Barfod, who was a member of the Space Travel Club of Scandinavia, back when he was trying enlist his help on *Reptilicus*. Barfod sat through it in silence. Pink switched off the projector.

"That is one of the worst movies I have ever seen!" exclaimed Barfod. "I admire your chutzpah in not only making it, but in showing it to me." Yet, as Pink recalls in his autobiography, Barfod was impressed with his imaginative approach to the future of inter planetary travel and he had agreed to animate Reptilicus on the condition that they would next collaborate on a space travel film made in Denmark. That film was to be *Journey to the Seventh Planet*.

Inspired by the theory that the human brain is so complex that no one can use over twenty percent of their grey matter capacity, Pink penned a script about a race of highly advanced beings with super brain power who survive in the bowels of an otherwise frozen planet. He chose Uranus as the setting since it was one of the least known about planets and he was less likely to be challenged on scientific detail. The idea had strong resemblance's to his own *The Angry Red Planet* as well as to the 1948 Ray Bradbury story, "Mars Is Heaven." In fact the basic concept exists in numerous variants in science-fiction lore.

With script in hand, Pink signed another production deal with Saga that gave him deferred payment on studio rental and lab and negative costs in exchange for Scandinavian distribution rights, and he moved his family to Copenhagen and got to work.

AIP again had Ib Melchior do a rewrite of his script, completed November 21, 1961, under the erroneous assumption — according to Pink — that Ib was his writing partner. Although Pink credited Melchior with defining the Uranian world for him in visual terms, he criticised his rewrite for slowing down the action and filling it with banalities and wordiness, flaws he attempted to correct in the final rewrite.

Pink's claim that Ib's contribution to the final version of the script was minimal is disputed by writer, Robert Skotak, who in a 1996 piece in *Filmfax* magazine claims Pink only provided the basic idea. Skotak, a friend and unabashed advocate of Melchior's, scored Pink's "poverty row production" for its inability to do Melchior's great ideas justice. The truth, whatever it might have been, appears to be a victim of the growing animosity between the erstwhile collaborators, but in any case Melchior admittedly had nothing whatsoever to do with the *production* of the film.

The film was to be shot entirely indoors on a tiny

Land of a Thousand Balconies

20 X 44 Saga sound stage. There were no Danish nationality requirements on this picture so Pink had more flexibility in casting and once again desperately sought to make the film marketable outside Denmark.

This was not a comedy so there was no part for Dirch Passer, but there was for Ove Sprogøe, who was cast as one of the astronauts and turned into an Irishman, apparently because he was short. Peter Monch, a popular German actor, signed on as another astronaut and was allowed to stay German. American B-film vet, John Agar, was brought over to play the captain, with Danes Carl Ottosen and Louis Miehe Renaud rounding out the space ship crew.

Pink wanted a well-known American female lead to dilute the Danish flavour of the production, and he did get an actress from America, Gretta Thyssen — but she was Danish! One of the first of the imported "Scandinavian sex bombs", Thyssen had earned some name recognition as a bit player in some major films at the time, and had also appeared in some of the last Three Stooges shorts. According to Pink, she'd pleaded with him to return in triumph to her homeland as the star of his picture and had agreed to sign a minimum guild contract.

Pink claims her looks were all fabricated with wigs, padding, cotton and adhesive tape, and that one day out of the blue she informed him that if he wanted to screw they should avoid shooting days since she had to get her beauty sleep. Thyssen reportedly attempted to upstage Agar whenever they would film together, imperceptibly angling to the rear so that Agar's back would end up facing the cameras. Finally he forced her to the edge of the backdrop so she had no other choice than to play it equal. That was one advantage of a small shooting stage.

Mimi Heinrich was back for Pink in *Journey to the Seventh Planet*, playing a beautiful hallucination who seduces a homesick astronaut on Uranus. (Heinrich, who would go on to a career in live theatre in America, returned to the Danish stage in 1994. On February 24, 1995, she was invited to a special screening at the Danish Film museum — which she claimed was her first viewing of the film. Introduced to the audience as a leading player in "another film you might know better" — *Reptilicus* — she received a wild ovation that clearly surprised her. (See: KOSMORAMA NIGHTS.)

The Danish film community looked on with disbelief and ridicule as Pink set about to create a fantastic interplanetary space adventure in a little sound studio in Hellerup. The *Reptilicus* debacle had hardly enhanced his clout in Denmark, and, unable to attract investors, he dug into his own pockets for the $75,000 to finance the film — of which $25,000 would go to Thyssen and Agar. While he enjoyed having full creative control on *Journey*, he would forever curse the Danish lack of imagination, as he saw it, that precluded him from giving the picture the production values he thought it deserved. For example, Melchior's original suggestion to shoot the exteriors of Uranus on location in Greenland to give an "other worldly" feel, was financially prohibitive.

Bewildered studio carpenters and effects technicians who constructed the Uranian caverns, "quicksnow pits" and ice crystal forests never quite understood what they were doing and never fully trusted Pink due to a general consensus that he was nuts. When the giant brain had been built and sat pulsating in its cave, its eyelid slowly blinking over a car headlight lamp meant to pass for a lone eyeball, they laughed like hell. They also constructed a papier mâché mole lizard beast and a fanged serpent monster.

To create the "high tech" rocket ship control room, A Saga sound engineer installed a bunch of dials and meters into credible looking banks of control panels — at least credible for 1961. Pink even dragged in a film editing table as added gadgetry, reckoning nobody would know what it actually was. A couple of jet-fighter ejection seats, loaned by pals at the American embassy, completed the picture. In one of the film's photo-stills, Thyssen is draped seductively over one of the seats, smiling radiantly.

In an attempt to give the control room the feeling of constant motion, Pink resorted to an old burlesque stage lighting trick and installed a pair of large grills on each side of the room behind which spotlights and

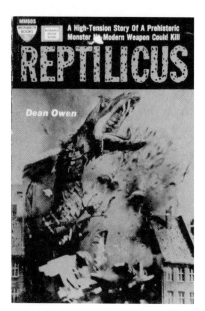

Reptilicus novelisation

gelatine-coated colour wheels were placed. Over the two grills he then affixed signs reading "Port Atomic Engine" and "Starboard Atomic Engine".

Suggesting but not actually showing that the rocket ship consisted of more than just one junk-laden room was difficult in the small confines, but it was imperative to allude to staterooms existing above and below the main cabin. Pink hit on a novel — and cheap — solution. In the opening shot of the film an immediately homesick and horny John Agar ogles a girlie photo in a locker room above and then descends down to the main cabin in an "elevator", that being in reality a fork-lift truck fitted with a futuristic looking cage and lowered on cue.

While it was hard to infer the spatial dimensions of the rocket ship on a small sound stage, attempts to recreate the "vast desolation" of a lost planet drove just about everyone mad. Searching for a maximum long shot to produce the illusion of distance, they crawled up into the rafters at the far end of the studio and shot down at a painted backdrop horizon on the far wall, using a rare 12mm lens but sans the bright lighting such a lens normally requires. The scene was supposed to happen at night anyway so they just shot it … and it worked. Extraterrestrial dimensions whipped up in a space the size of two large living rooms.

Pink had let his imagination run riot when describing the inhospitable Uranian atmosphere ("a weird, wondrous, frightening cacophony of form and matter that defied description") and overwhelmed the capabilities of the set designers. To create swirling, gaseous clouds about to freeze solid, a fog machine was imported from abroad but the results were more suggestive of back street Victorian London than a far distant planet.

Pink began to hunt for some "dry ice" which he knew would produce the desired effect, but was stymied when nobody knew what he meant by the term dry ice. One day an ice cream truck drove past his house. Pink's son, Phillip, mused aloud that such trucks probably used dry ice, and Pink took off after it, chasing it for two blocks and shouting at the top of his lungs. Soon he had his supplier for dry ice — frozen CO^2 — and had his effect.

PLANET IN MIND
Low Budget Surrealism

Journey to the Seventh Planet plays out as an endless trek by five clumsily space suited astronauts. They slowly clamber through a series of caves, grottos and stony chambers while encountering the kind of weird subterranean phenomena that Salvador Dalì could have appreciated. At times the caverns resemble overdone Christmas shop front displays, and other times they seem to be the result of a psychedelic nightmare. It's surrealism born from the illegitimate intercourse of shit-luck and accident rather than great art, but surrealism nonetheless. When confronted at one point by a giant spider-monster, the astronauts retreat to a black-

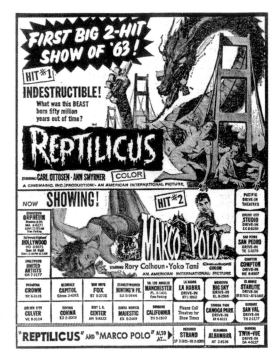

smith forge in an old Danish farmhouse — on Uranus — complete with exposed beams and straw roof. Here they build a ray gun with which to slay the beast. Such a scene transcends the merely inept and would be hard for even Monty Python to match. But since everything was a hallucination, everything was permitted. Purely as a staged effect, it was closer to the conventions of avant garde theatre.

The claustrophobic feel of the film also suggests, if unintentionally, that the landscapes you are seeing exist in the mind rather than in any kind of supposed reality, much in the same way that experimental theatre so often parodies or foregoes the orthodox trappings of the stage in an attempt to signify to the viewer on another level. Similarly, what ends up on the screen here is a ticket, a door to somewhere else, not the final destination. If one can see the film in this light and indulge it, then the obvious fakery of the sets can be viewed as an asset rather than a drawback. The small cast, the limited sets and the claustrophobic subterranean geography in which the story plays out all serve

Land of a Thousand Balconies

to corral and focus the imagination. One is spared the vast, emotionless dimensions of high-tech outer space voids that feature in most big-budget film fictions and are prone to be sterile and ponderous.

Pink, of course, was not trying to create surrealism or to indulge in metaphor. He was trying to create gripping science-fiction within the genre stylisations of the period, but he had no access to the standard props available to and recycled among the Hollywood B-film directors, and he madly improvised. He wasn't a professional like Roger Corman or Stuart Gordon and the film actually benefits from this and stands out from the maw of AIP science-fiction as something unique. Pink was far away in Denmark making this film and Arkoff and Nicholson couldn't show up suddenly on the set and ask him what the hell he was doing. They had only his wildly enthusiastic reports to go on.

Defying all rational advice and straining under every conceivable handicap, something uncanny was born: a film that was a sum total of all its minuses. The slow pace, robotic acting and (dubbed) dialogue delivered by actors who appear to be drugged, actually produces an eerie atmosphere and forces the viewer's imagination to engage instead of passively receiving. Less becomes more. Other directors would have filled up the empty space with all sorts of overwrought emotional pyrotechnics or state-of-the-art special effects, but here the viewer is lulled in almost hypnotically... trance-like.

ATTACK OF THE CYCLOPS-RAT-DINOSAUR

Cinematographer, Aage Wiltrup, created a lot of the optical effects "in-camera" with his bulky old Pathé, like making ray guns appear and disappear in mid air, saving Pink the time and expense of dealing with a special effects lab.

In the meantime Bent Barfod continued on a separate track with his own special effects creations, conjuring up the astronaut's subconscious demons that attack them at the command of the giant brain. His results, like the one-eyed snake creature pulled from the mind of Peter Monch, thrilled Pink who declared his

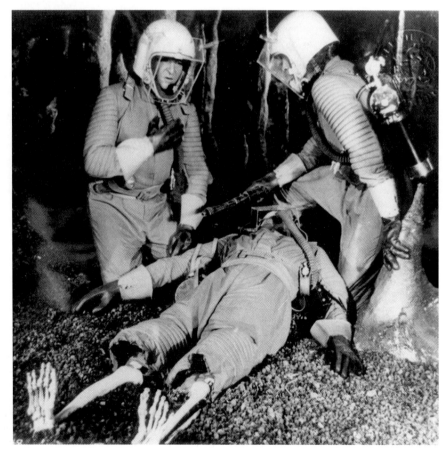

Carl Ottosen (left) and fellow astronaut find dead colleague, whose legs have been eaten away by substance exuded by giant brain monster (next page). *Journey to the Seventh Planet*

(claymation?) techniques to be "fresh and new" — dispensing as they did with miniatures and stop-action puppets.

To depict the rays coming out of the ray guns, Barfod, according to Pink, adopted an approach so low-tech as to be almost revolutionary and scratched lightning bolt visuals onto the precious negative by

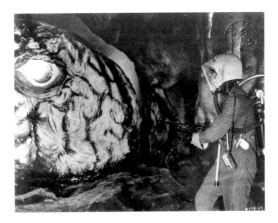

hand as a nervous Pink looked on. These ray gun blasts turned out to be oddly effective, although at Barfod's first viewing of the film — amazingly in 1998 at the EFC screening — he adjudged the ray gun bolts to be too crude to be his own work.

Pink cut *Journey* with the same woman editor who had conformed *Reptilicus*. She spoke no English and he communicated in pidgin Danish and with the help of his Hungarian co-producer's son, John, who had progressed more rapidly with his Danish lessons.

Sidney was in a rush and tensions ran high. On the tenth day the woman shot him a look of monumental disgust and stormed out, never to return. He learned to edit on the unfamiliar equipment and managed to finish cutting the picture himself, but then ran aground again for lack of effective sound effects, prompting more improvisation. He also managed to get well known Danish actor and singer, Otto Brandenburg, to record the fabulous original theme song that's heard as end credits roll and a rocket ship wings through space.

The final step was to mix in a music score that would weave through the whole film. All involved deemed *Journey* to be, if nothing else, different, and innovative music was sought to differentiate the film from the rash of other sci-fi space flicks.

Barfod introduced Pink to a young Dane named Axel who was experimenting with computer music, then still in its infancy. Axel's unconventional sound compositions struck Pink as perfect accompaniment to Barfod's visuals and he was assigned to score the film. Sidney was thrilled with the total result which evoked the foreboding, alien atmosphere he sought.

Tragically, this version of *Journey to the Seventh Planet* never survived. After Pink delivered the film to AIP, they cut out most of Barfod's special effects and shot some new scenes and dumped in some stock footage. "Barfod created all our monsters of the mind in such a frightening and supernatural way that Sam Arkoff, with his Midwestern naiveté, could neither understand nor appreciate them", bitterly complains Pink in his autobiography. "Those marvellous photographic effects Bent created were destroyed and replaced by the more conventional creatures the geniuses of AIP could comprehend." They also created a new sound mix, dumping Axel's computer music score and re-dubbing the dialogue.

AIP saw a need to quicken the pace, and claimed the effects they cut out were so tacky as to be unworkable — and this from a studio that never met a rubber monster it didn't like. Certainly some of the monsters and effects created by the Saga studio carpenters were ultra tacky, but its hard to judge the original version since all that remains, after AIP destroyed the original materials after recutting, are Pink's recollections and they are seldom specific. Melchior also apparently viewed Pink's original version, but the passing of time has diminished his recall of the technical specifics, and, additionally, anything he has to say about the film today is colloured by his dislike for Sid.

Barfod remembers little about the film except that Pink was difficult to work with. In a letter to this author dated April 2, 1997, he had these comments after the screening at the Film College:

I hate to criticise a film in which I have played a part, and I was a little paralysed in my opening remarks, therefore I did not give Sidney Pink what he deserved. He used my materials as it suited him. It was my intention, as I made clear to Pink, that the girls should appear in the "light-forms", which he abused roughly, etc. etc. Also the blue-green spectrum had disappeared on the old copy that was shown, and that was too bad.

Barfod was indisputably a skilled and innovative animator and effects craftsmen, and considering that AIP's primary goal was to make the film marketable to American teenagers, it's logical to assume they had little use for new or novel approaches. Pink, on the other hand, never admitted to second thoughts about the quality of the monsters, and claims that at a wrap-party screening the cast and crew were much impressed. But then,

after *Reptilicus*, perhaps his judgment wasn't to be wholly trusted.

Some of AIP's revisions are clear. They cut out the giant fanged one-eyed serpent and the clawed lizard-mole monster, undoubtedly created by Saga set designers. These monsters exist now only in original photo stills. At another point in the film an astronaut has his legs eaten away by a corrosive substance discharged by the giant brain. That scene was cut by Melchior who worked with AIP to reshape the picture, and only survives in a still photo showing skeleton legs sticking out of a space suit as Ove Sprogøe looks on with deep concern. To juice up the film's special effects punch, Melchior also added a "hypnotic swirling" to some scenes when the master brain is in the process of communicating.

To replace the monsters they cut out, AIP lifted the giant spider from Bert Gordon's *Earth vs The Spider* (1958), tinted the footage blue and plopped it down in *Journey*. They also threw in a "Cyclops-rat-dinosaur", created by Jim Danforth of the stop-motion effects lab, Project Unlimited, after his first monster had been rejected by AIP because they thought it looked too much like a teddy bear. Pink claims, additionally, that he shot everything indoors on the studio set. This would lead one to believe that the outdoor scene, where they astronauts are chased through some very earth-like looking woods by dino-type monsters, was a reshoot done by AIP.

While these patched-in monster sequences and the hypnotic swirling effects did liven up the film in a fifties-kitsch sense, it was essentially just the usual hokum and altered the film in very basic ways. Upon learning of AIP's cut-and-paste job, Barfod requested that his name be removed from the film. It wasn't, however, and remains prominently displayed in the concluding credits crawl.

A "Danish version" of *Journey to the Seventh Planet* was never made, and there is no evidence that the final AIP version was ever released in Denmark, leading to the conclusion that Saga studios came out soundly on the negative side of the ledger in their dealings with Pink. Ultimately, one longs to see the original version. Pink was convinced that it would have made Bent Barfod a worldwide celebrity.

SIDNEY PINK FLIES AWAY

After completing *Journey to the Seventh Planet* in 1962, Sidney Pink packed up his family, left Denmark and never came back. In his book he claims it was because they disliked the idea of spending another winter in Denmark, although in Denmark other stories circulate. In any case, it's doubtful that his departure was totally amicable.

He moved to Spain where he wrote, directed and co-produced twenty-five movies over the course of the next seven years. In 1969–70 he made two films in Puerto Rico and then returned to the United States for good, settling in Coconut Creek, Florida, where he published his autobiography and continued his long distance feud with Ib Melchior, who lives in Hollywood.

Saga Studios, where Pink shot all his Danish films, was torn down in 1965. The grand Saga theatre on Vesterbrogade where all his films premiered became by turns a sleazy grindhouse, a porno theatre and finally a rock concert hall before closing down several years ago. Today it stands boarded up, gutted, wrecked and occupied by squatters.

But traditions live longer than rotten lumber, and in Denmark Pink is part of one that may last forever: anyone in the Danish film industry who lets the infamous name of Sidney Pink pass his lips is instantly obligated to buy a case of beer for all within earshot.

Today the very concept of low budget science-fiction film-making is obsolete. Hollywood has usurped the science-fiction genre and pumped it full of money and technology. Today people think science-fiction has to include expensive special effects like computer graphics and the latest digitalisation processes. There's no room for the nuts, the cranks, the delusionals, the "possessed amateurs" and the dreamers that populated the genre in the old days, armed with, if nothing else, extravagant imaginations… the days when Ove Sprogøe was an Irishman and Copenhagen quaked in fear of a giant reptilian buzzard.

Postscript

Sidney Pink passed away on October 12, 2002 at his home in Pompano Beach, Florida. He was eighty-six-years-of-age.

FURTHER READING

So You Want To Make Movies: My Life as an Independent Film Producer, by Sidney Pink
Pineapple Press Inc, Sarasota, Florida, 1989

Reptilicus: The Screenplay, by Kip Doto
Bayou Publishing, 1999

A MILLION FRIGHTENED TEENAGERS

In Praise of THE LOWLY GIMMICK and a High Priest Named WILLIAM CASTLE

More than any other mass-entertainment medium, the motion picture business has always been in a state of constant technical evolution. It has continuously been tinkered with, improved on, reworked and reimagined as inventors and engineers joined with corporate showmen to pioneer and implement revolutionary technical innovations and new presentation techniques. All this to keep movies eternally "new". From the advent of colour film processes and "talking pictures" in the early years of cinema up through to the late forties and fifties, when alarmed movie executives reheated 3-D and whipped up a slew of new wide-screen formats like Todd-AO, CinemaScope and Cinerama to put TV in the grave, the industry has fought to stay competitive and novel. In the seventies new audio processes like Sensurround appeared, and today we have DTS, THX and Lucas Sound. And at the top of the heap, there is Douglas Trumbull's Ridefilm Corporation that specialises in the creation of movie environments that actually move in sync with the on-screen action. What next?

Although most of the aforementioned processes were superseded by evolving technology or simply fell out of fashion, they were essentially *innovations* — not mere "gimmicks", and jet-setting showmen like Mike Todd and pioneering scientists like Dan Comstock and Herbert Kalmus, who co-founded the Technicolor Corporation, are as important to motion picture history as any actor or studio boss.

Far below this plateau of visionary science and entrepreneurship, and far less important — or at least far less respected — dwelt the lowly, humble, besotted gimmick... nothing but what it was, a creature created for only one purpose; to make cash registers ring and then to be tossed into the trash can like an old skinhead wig when the job was done. Way down here in this subterranean realm dwelled the dodgy fast buck merchants, the fly-by-night producers, the hustlers and the scam artist showmen in cheap suits who scrambled at the bottom of the scrum to give their pictures some kind of "edge". And in spite of all the talk about great art and all the movie folk who would come to regard themselves with such a sense of inflated self-importance, film was in fact a medium prone to gimmickry from the word go. These chisellers were right at home.

From the mid fifties through the sixties, and well into the seventies, a kind of "Golden Age of the Gimmick" flourished. No concept or scheme was too flimsy or preposterous to foist on a movie audience as an army of rogue producer-directors targeted the teenagers of America with hundreds of low-budget horror, science-fiction and teen-sploitation pictures. Competition was fierce and any half successful idea instantly beget a score of imitations.

During this Golden Age of the Gimmick, viewers had more than just the movie to pay attention to. They

Land of a Thousand Balconies

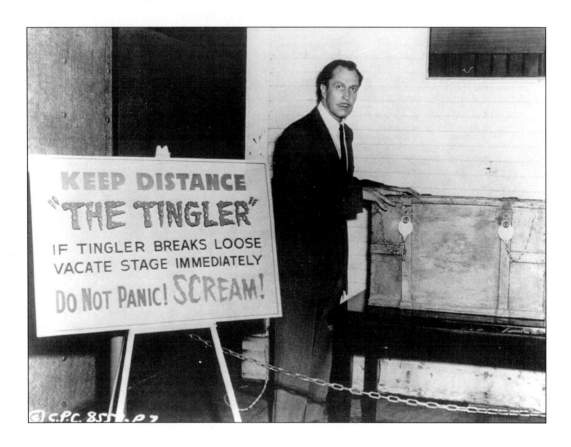

were given things, promised things, made to sign things... they took "tests" and they entered contests. They chanted and they screamed and they were entranced, hypnotised and zombified. They were chased, grabbed, dragged on stage by guys in gorilla suits and practically assaulted, all in an effort to give them more than just a movie — to give them a thrill. And they loved it.

HISTORICAL ROOTS OF THE GIMMICK

The gimmick tradition has roots back to the thirties and forties when roadshow exploitationists like Dwain Esper and Kroger Babb brought a carnival aesthetic to movie promotion. At one point Esper got his hands on a mummified human cadaver, christened it "Elmer The Dope Fiend" and toured it with his 1932 drug drama, *Narcotic*. And later in 1949 when he was promoting the Tod Browning film, *Freaks*, he hired a troop of real freaks to perform from high stands in the theatre lobbies, covering the floors with sawdust. Kroger Babb, for his part, foreshadowed modern day movie merchandising tie-ins by peddling everything from sex-education booklets to miniature Bibles to make-up kits for the ladies from coast to coast, bilking gullible audiences with more cash than sense.

But director William Castle, who made his best films from the late fifties to the mid sixties, would be crowned "King of the Gimmick".

Castle first employed gimmicks in live theatre when in 1928, as a fifteen-year-old assistant stage manager with a roadshow production of *Dracula*, he stuck a real coffin up outside the theatre, burned oriental incense to evoke atmosphere and rigged up Dracula so that he would vanish on stage in a cloud of smoke to suddenly reappear in the audience, snarling at the frightened spectators. In 1944, as director of the stage play, *Meet A Body*, he had the killer jump from the stage and flee through the audience, with six cops firing blanks in hot pursuit. All in an ongoing effort to make the audience part of the show. He would later adopt these approaches to movies in an effort to make a dead medium come alive.

GIMMICK TYPES AND METHODS

But why wait for the show to start? Gimmick promotion could begin even before the movie got to town.

Theatres were encouraged to promote coming attractions in advance by, among other methods, employing people to walk the streets dressed in bizarre costumes and clad in sandwich boards inviting passerby to "ask me about...!" Countless were the hairy gorillas peddling bicycles around the streets to plug big ape monster movies, and the chronically unemployed could always get low-paid work clambering around in spacesuits or monster disguises while they waited for their luck to change. Studios had whole departments dedicated to thinking up outrageous promotions of this type. For *Corruption*, from 1968, which featured Peter Cushing as a body-snatching plastic surgeon who goes to insane extremes to keep his wife looking young, Columbia suggested that theatres employ a man wearing dark clothes and a top hat to walk the streets with a doctor's bag under one arm and a female mannequin's head under the other.

Other gimmicks had wheels attached to them. To promote the movie, *Son of Sinbad*, a troop of sexy gal "sinbadettes" toured the country by train. The director of *The Creeping Terror* hauled the film's pathetic hairy monster around Hollywood in the back of a pick-up truck to hype one of the worst movies ever made, while a ghastly "butcher-mobile" navigated the streets of New York City to promote the 1979 picture, *Dr Butcher M D (Medical Deviate)* — proving there was

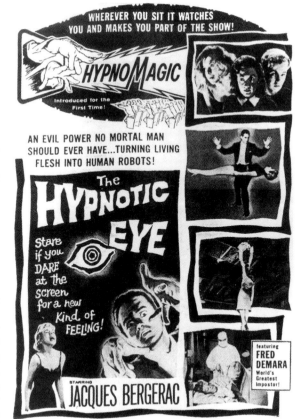

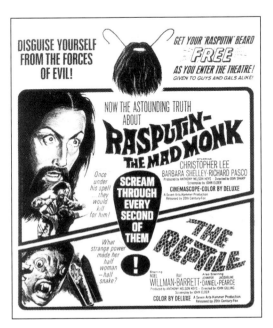

no statute of limitations on the use of cheap gimmicks. Mobs of real midgets, for their part, were sent out into Times Square to drum up attention for *Tom Thumb*.

But all roads lead back to William Castle. No director was more dedicated to the gimmick concept or willing to make himself a part of the spectacle then he was. For example, he arrived in a black hearse for the 1958 Minneapolis premiere of *Macabre*. Dressed in a cape, he then climbed into a coffin which was dragged out onto the sidewalk in front of the theatre. The stunt quickly drew a large crowd of gawkers. (The lid accidentally shut, however, and Castle panicked and knocked himself unconscious trying to bang his way out!)

It was the era of the freebee, the giveaway. Once the hordes of teenage thrill-seekers had filed into the theatre lobby, they were handed all manner of strange apparel to wear by duteous ushers. They were given magic "ghost viewers" for Castle's *13 Ghosts*, and for Julian Roffman's *The Mask*, they got masks to don and were instructed to do so whenever the psychiatrist

Land of a Thousand Balconies

in the film slipped on his, enabling them to see the inner horrors of the psyche — in 3-D! In *Plague of the Zombies*, girls were given "zombie eyes" (glasses) while boys got vampire fangs. Patrons at other shows got removable scars, fake claws, magician capes and other such Halloween-ish accoutrements. For *Rasputin the Mad Monk*, boys *and* girls got free beards — to "disguise yourself from the forces of evil!"

Once the movie started, a ticket-holder had his subconscious pounded and tossed like pizza dough in a score of flicks like *The Hypnotic Eye*, *The Thrill Killers*, *A Date With Death* and *Terror in the Haunted House* that hypnotised, seduced and subliminally manipulated (and fleeced) the no doubt horrified customer.

Audiences were endlessly warned, prepared and braced for promised thrills and horrors by all manner of devices and strategies. In the aforementioned *Corruption*, some theatres had, at Columbia's behest, female mannequin heads hanging by their hair from lobby ceilings. In *Curse of the Living Corpse*, customers were asked to sign a "fright release". William Castle, in on-screen narration, warned the audience to "scream for your lives!" in *The Tingler*, while a nurse on duty at the morbid triple bill of *The Undertaker and His Pals*, *The Embalmer* and *The Corpse Grinders* offered free blood pressure tests. A flashing red light went off to warn viewers of the approach of bloody scenes in *When The Screaming Stops*, while *Cannibal Girls* had a warning bell. Ad art for *The Hatchet Murders* took the easy way out and just told frightened viewers to pinch themselves. William Castle (again) stopped his 1961 feature, *Homicidal*, before the end and offered money back to anyone too scared to stay for the supposedly shocking conclusion, while *Drive-In Massacre* ended with a voice — purportedly that of the theatre manager — warning that the killer was loose in the lot and that *you* might be the next victim.

Since teenagers were famous for ignoring the advice of adults, concerned theatre managers offered them a variety of talismans for protection. In *Frankenstein Meets The Space Monster*, they were given "space shield eye protectors" to "shield patrons from high-intensity cobalt rays and prevent abduction into outer space". They were offered chairs with seat belts in Castle's *I Saw What You Did*. At screenings of *Black Sunday*, viewers were given a card with a special chant printed on it, while ticket-holders for *Burn, Witch, Burn* were given a little sack of magic salt and the verses to an ancient incantation. In *The Flesh Eaters*, patrons were offered packets of "instant blood" in case the cannibals escaped from the screen and tried to get some of theirs, while many were the films — among them *Beast Of Blood* and *Mark Of The Devil* — that offered that last and lowliest of comforts: the vomit bag.

If all else failed to protect them, viewers were offered cash compensation if they dropped dead from fright in *Macabre*, *Night Of Bloody Horror* and a host of other flicks… while any poor schmuck who died at *Castle Of Evil* just got a free funeral.

Hell, today you (or rather your next of kin) could probably sue and get a whole theatre chain for that!

Other films provided amulets of a more malicious, attack-minded nature. At *Strait Jacket*, Castle gave viewers "bloody" cardboard axes, while packets of "fright seeds" were doled at *The Torture Garden*, enabling recipients to grow their own torture gardens. At *Castle Of Blood*, audience members got a rare chance to win "one frozen dead corpse and a female scalp". God only knows what that was all about. Some viewers at *Ben* got free photos of the star rat, while Andy Milligan offered customers the chance to win a live rat "for your mother-in-law" at his grade-Z horror spree, *The Rats Are Coming, The Werewolves Are Here*.

But all the melodramatic warnings in the world and all the bloody cardboard axes couldn't protect viewers from the hands-on horror they faced at screenings of films like *The Robot vs The Aztec Mummy*, *The Vampire's Coffin*, *The Thrill Killers* and *The Incredibly Strange Creatures Who Stopped Living And Became Mixed-Up Zombies*. Here live monsters, spooks and psychos ran out from the wings and from behind the screen to rampage through the aisles, spooking the audience and occasionally grabbing and "abducting"

Tours Through Genre and History

teenage girls. If William Castle was "King of the Gimmick", then Ray Dennis Steckler, who made the last two films and specialised in this more confrontational brand of live mayhem, was the court jester. At other shows, the horror stayed on the stage, like the live worm eating contest that kicked off the Las Vegas premiere of *The Worm Eaters*.

Sometimes the gimmicks themselves went wildly awry, creating even more hysteria than intended. At the premiere of William Castle's *House on Haunted Hill*, held at San Fancisco's Golden Gate Theatre in 1958, a twelve-foot plastic skeleton was, at a specific point in the film, suppose to emerge from a black box by the screen and travel up over the audience to the balcony on guide wires. As the skeleton dangled over the crowd, the wire suddenly snapped and it fell into the audience. "The kids rose in their seats, grabbed the skeleton and, hollering, bounced it up into the air", Castle would recall years later. "The theatre was a mad house!" Other snafus were less dramatic and less funny, like the screening of a film this writer saw in 1968 where one of the "ghouls" humping down the aisles was tripped by some wise guy and ended up out cold on the floor. The proceedings were halted while an ambulance was summoned, and the show was eventually cancelled.

GIMMICK REVIVAL FESTIVALS
Focus on Castle

Gimmick retrospectives or festivals have taken place on several occasions through the eighties and nineties, with William Castle usually serving as the focal point.

In 1988, San Francisco's Strand Theatre screened his film, *The Tingler*, and hired a local theatre stuntman and electrical engineer named Barry Schwartz to wire up the room in a recreation of "Percepto", the film's original gimmick. This stunt, as Castle designed it, involved the installation of small motors under some (but not all) of the theatre seats. (These motors were from radar cooling units and had been refitted with lopsided cams to increase the vibration). They would then be activated on cue by the projectionist at the appropriate place in the movie, and the resultant vibrations would supposedly create something akin to the sensation of the monster being loose on the floor under the seats — a scary situation that was actually happening in the movie itself. In the darkness of a theatre and to a highly suggestive audience ready to be scared, the gimmick worked.

But Schwartz decided to *really* shock the audience and went under the floor to wire up the seats with electrodes that were attached to metal strips implanted in the arm rests. The show drew a capacity crowd, and when the right moment came in the film, the projectionist threw the switch, sending out a surge of voltage. But with all the seats occupied, there was too much resistance for anyone to feel much of a shock. Then during the intermission, when many patrons had left their seats to visit the restrooms or buy concessions, they tried it again — and those still seated got one hell of a shock!

In 1991, The Roxie Theatre, also in San Francisco, contacted

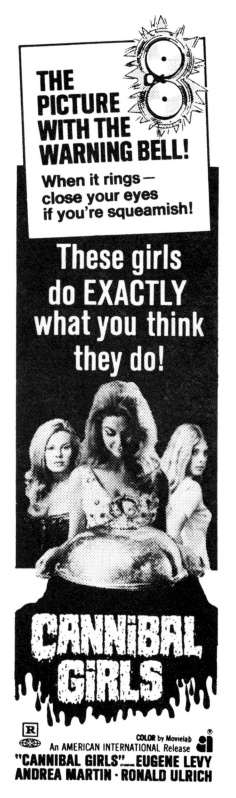

Schwartz about rigging up a gimmick accompaniment in their cinema for a planned William Castle tribute. In the end, however, they opted for the safest and easiest gimmick — simply obliging ticket holders to sign "death by fright" insurance policies (designed for his 1958 film *Macabre*).

Four years later, in October of 1995, San Francisco's Castro movie palace presented their own William Castle retrospective, and again Schwartz was called in to install the gimmicks. Recalling The Strand's "shockfest", however, and fearing very real lawsuits if someone with a weak heart actually got electrocuted, they dissuaded him from wiring the individual seats and instead he rigged up an electrical contraption on stage that zapped the audience instead of buzzing their butts.

Vincent Price in *The Tingler*.

In January of 1996, the Dutch Film Museum in Amsterdam presented their own two week gimmick-functional run of *The Tingler*. Improvising — as all theatres must in this day and age when an original Percepto mechanics installation manual is as rare as a Gutenberg Bible — they bought hundreds of defective vibrators from a porn shop wholesaler and wired them directly into the seats to create an effect that perhaps caused more pleasure than terror in some patrons when the projectionist threw the proverbial switch. To this version of Percepto they also added a Schwartz-like electrical zapper and audio sampling enhancement of the original sound score, all of which heightened the scary effect in a way that Castle surely would have approved of.

In March of 2000, the Nova Theatre in the heart of Brussels screened *The Tingler* and put their own twist on it. One scene in the first half of the film finds Vincent Price locked into his laboratory where he injects himself with a dose of LSD-25 (the first screen appearance of the drug) to stimulate his "fear glands". He then proceeds to have some rather half-hearted hallucinations marked by lame double vision effects and his trademark overacting. He then cringes in fright up at some unseen horror, and at this point they introduced a "hand held" slide projector with an image of a rickety old ghost which now circled above Price and then flew about the theatre. It worked beautifully! Later when the lobster-like Tingler monster appears, they took an over stuffed, home-made facsimile of said beast and unceremoniously heaved it over the balcony, where it landed with a thud in the midst of bewildered patrons below.

For sophisticated, modern day film scholars intrigued by cutting edge developments in interactive media, the "Exploding Cinema — exploring the digital revolution" sidebars of the Rotterdam Film Festival are the place to be. At the 1996 edition, Glorianna Davenport, a top authority on the subject from the Media Lab at the Massachusetts Institute of Technology, reported on the most current advances in the field as workshops and seminars were held and the latest hardware and software was displayed. Interactive technologies from video adventure games to CD-ROMs to computer cut-ups were plugged in next to various web sites as visitors explored cyberspace and virtual reality in this new electronic arena where — amazingly — audiences can actively "be part of the show"!

Included in that Exploding Cinema program and lost amid all the high-tech conceptual jargon was a screening of a 16mm print of William Castle's *Mr Sardonicus*. This was the film where Castle gave audiences two endings, allowing them to chose via thumbs-up or thumbs-down cards (that glowed in the dark) whether Mr Sardonicus should be punished or spared.

It was a tribute to the days when movies were, if not "interactive", then at least hyper active.

FURTHER READING
Step Right Up! I'm Gonna Scare the Pants Off America, William Castle
Pharos Books, New York, 1992

3-D MADE EASY

A theatre marquee on a Hollywood night back in 1952. A passer-by named William Castle stops to stare with a look of chagrin at the huge block lettering: "3-D — THE NEW SENSATION!" On the sidewalk in front of the theatre police are trying to control excited mobs of people waiting to buy tickets for 'Bwana Devil, a 3-D jungle adventure directed by Arch Oboler.

"A lion in your lap!" and "3-D: newer than television!" read the exciting looking posters in the lobby display case.

3-D, or "stereoscopic cinema", had always intrigued Castle. Two years earlier he himself had tried to sell a novel idea to Universal Studios: a modern adaptation of Jules Verne's, From the Earth to the Moon — in 3-D. He had fond memories of going to the movies as a kid in the twenties and seeing Pete Smith short films in 3-D, ducking when a baseball or pail of water was thrown into the audience, clumsy green and red glasses planted on his nose.

Universal turned him down flat. The studio wasn't interested in science-fiction, and furthermore, as studio exec, William Goetz, patiently explained, the 3-D glasses would be too expensive to supply and audiences wouldn't wear them anyway.

Now, two years later, here was 'Bwana Devil, a smash hit that was making millions in spite of being, by most accounts, a very poor film. (Producer Sidney Pink recalls in his autobiography that people leaving the theatres would often yell at those standing in line not to waste their money.)

Despite what the posters said, 3-D was not "newer than TV". Experimentation and development of 3-D had been underway in still photography since the later part of the nineteenth-century. Developing a workable 3-D motion picture process would prove far more challenging and elusive, although that wouldn't stop people from trying. Lots of people. It seemed every crackpot inventor had come up with his own 3-D process: by the end of the silent era, over 200 different 3-D systems had been patented and tried out. One system, for example, projected two images alternately, onto the screen via a shutter device, while other systems projected two images side by side which merged into one 3-D picture when viewed through a special device. None of these systems, however, proved to be commercially viable.

The most practical system, developed by Edwin S Porter and William E Waddell in 1925 and used by Paramount when it released a series of shorts called "plastigrams" in the early twenties, was called the Analyph process. Here two cameras, running synchronously, shot the same scene from slightly different positions. The two rolls of film were then printed in different colours — usually red and green — on a single, two-layered release print. Audiences then viewed the film wearing glasses with cellophane lenses coloured to correspond to the two tints used in the film (again, usually red and green). Each lens blocked out one image and drew that eye's attention to the other image, making it appear that there was just one picture on the screen, and producing (relative) clarity. This process effectively mimicked the binocular viewing capacity of human vision, which allows us to see in depth. When the film was viewed without the glasses, it was hopelessly blurred because then both eyes saw both images. When the glasses were put back on, the screen image was once again "decoded" as it were, and an artificial depth reappeared.

In 1935 MGM studios released a series of "Audioscopiks" that employed the same process, yet it was impossible to get full colour from the Anaglyph method and picture quality remained fairly poor. The public's interest in 3-D subsequently faded.

Land of a Thousand Balconies

"You'll SHRIEK as the FRANKENSTEIN MONSTER pours hot, molten lead right at your face! Then you'll SHRIEK AGAIN when he hurls the pot! These are just TWO of the 21 certified shocks in 'MURDER IN 3-D', a real, old-fashioned mystery meller-drammer, with spooks, spiders and skeletons that come right at you! It's the greatest novelty in show business!" — Part of the ad campaign for the 1941 film, Murder in 3-D.

As the fifties approached, Hollywood, panicked by a rapid decline in movie attendance after a post-war peak, added 3-D to its arsenal of new wide-screen and colour processes in its war against a dangerous new competitor — television. Hollywood had to give people something TV could not and 3-D was just such a thing. And this time the public wouldn't just get novelty shorts, but full-colour feature films that boasted picture quality heretofore unmatched.

The specific 3-D process favoured in the fifties was the Polaroid process, first successfully demonstrated with the Italian film, *Beggar's Wedding*. Now (relative) full-colour was possible. With this process, a single camera with twin Polaroid lenses placed two-and-a-half inches apart (the separation distance of human eyes), recorded the scene on two separate rolls of film which were printed as such. In the theatre, an interlock projector projected the two rolls of film together at the same time on the screen, superimposing one image on top of the other. (This type of projector uses one motor so that speed stays constant for both films and precise sync is maintained.) Although achieved in a different way, here again the basic principal of 3-D was put into practice: the superimposition of two images which were shot from slightly different angles.

There always had to be some kind of decoding device, and the viewer was once again supplied with glasses, but this time both lenses were tinted grey. The film was now being screened through polarised lenses in the projector, producing a polarized image which was then decoded by the lenses of the viewer's glasses, each of which was different and blocked out one of the

Tours through genre and history

projected images. In this way each eye was again directed to a separate image and the illusion of depth was achieved. (A knowledge of what "polarised" means is necessary for a true understanding of this process but is beyond the scope of this text. See suggested sources at end.)

By 1952, 3-D was no longer just a gimmick — it was a potent commercial force. And it was something more, or at least appeared to be: the magic in a bottle that Hollywood had always been searching for — that easy additive that could turn a mediocre film into a guaranteed money maker.

3-D's moment had come, and the following year, 1953, saw theatres across America invaded by a swarm of 3-D movies of wildly varying quality.

Cat Women Of The Moon, directed by Arthur Hilton, and *Robot Monster* — the cheapest 3-D feature ever made — by Phil Tucker, were two 3-D films of such appalling ineptitude that they have become celebrated "Turkey Film" classics, and have won devoted cult followings much in the manner of Ed Wood.

And in 1953, William Castle finally made his own 3-D movie, for Columbia, a western entitled *Fort Ti*. "Every evening I took a large pot," Castle would recall in his autobiography...

and practiced throwing things into it: knives, forks, spoons... anything I could lay my hands on. My wife thought I was crazy, but my aim was becoming perfect.

I attended the preview of Fort Ti. The audience, with glasses perched on their noses, ducked constantly. Tomahawks, balls of fire, arrows and cannonballs seemed to fly out of the screen. Smiling, I said to me wife, "I'm not a director — I'm a great pitcher."

Other notable stereoscopic films from that year included *The Maze* which featured some intriguingly surreal set designs, and the Howard Hughes project, *Son of Sinbad*. But of all the early 3-D feature films, two by an ex-actor and documentary film-maker named Jack Arnold clearly stand out: *It Came From Beyond Space* (1953) and *Creature From The Black Lagoon* (1954). They still rank as classics of the science fiction and horror film genres, irrespective of the debatable execution of 3-D technique which in particular haunts the former.

Based on the Ray Bradbury story, "The Meteor," *It Came From Beyond Space* depicts the monster from its own point of view, a novel approach that would be effectively copied by a host of subsequent science-fiction films including such non-3-D offerings at *Cult of the Cobra* from 1955. *Creature From The Black Lagoon* was Arnold's more formalistic contribution to the monster movie genre. Yet despite working within a more traditional film form, he manages to put an interesting twist on the proceedings, injecting issues of scientific fallibility into the mix and coaxing out real drama from a set of rather stock characters. The creature is presented in an oddly sympathetic light, and the film had lasting impact. Arnold exploits the 3-D process better in this picture, even though it was in B&W. Underwater sequences of the monster lurking in the kelp and swimming beneath a lithe Julie Adams remain among the most striking scenes in the annals of stereoscopic cinema.

Also from 1954 was Andre de Toth's remarkably atmospheric *House of Wax*, a remake of *The Mystery Of The Wax Museum* from 1933. This launched the career of a thus far little known character actor named Vincent Price, and as since been acclaimed by many as the finest 3-D film ever made. Although the film exploits what are now perceived as horror film clichés and formulas, it is a visual and stylistic delight. The 3-D process here actually creates atmosphere rather than just decorating the set in novelty fashion.

Alfred Hitchcock shot *Dial M For Murder* in 3-D the same year. The film was based on a play by Frederick Knott, and, shot mostly on a single set, evokes the kind

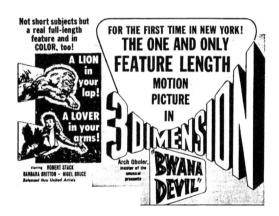

of compressed, set-piece atmosphere common to most movie adaptations of live theatre. But despite this, and the fact that Hitchcock only seldom deigns to exploit the 3-D process, the film is a masterful and enduringly popular murder mystery. It is generally considered to be the highest calibre production ever filmed in 3-D, even though it wasn't actually released in its 3-D version until 1980. (It should also be noted that many films only used 3-D in some sequences, and that most

3-D films were also released in regular "flat" versions.)

By 1955 the 3-D craze was again on the wane as the novelty began to wear off. The popular wisdom goes that the films made in 3-D were not very good, as well. Yet interesting films would continue to be made with the process as producers both desperate and daring continued to grab for the ultimate gimmick. *The Mask*, aka *Eyes of Hell*, is one such noteworthy straggler. This occult thriller from 1961 uses, as mentioned in the accompanying gimmicks text, 3-D in spots to visualize the terrors of the subconscious, audiences being cued to put on their masks (with 3-D lenses over the eyes) when the psychiatrist in the movie puts on his.

In 1966, Arch Oboler made *The Bubble* in 3-D, dubbing it "space-vision", in a doomed attempt to recapture the box-office magic of *'Bwana Devil*. But *The Bubble* burst without much notice.

In the early 1960s 3-D had begun to appear in sexploitation cinema. *The Playgirls and The Bellboy*, a "nudie-cutie" from 1962, was one such example. It was directed by Fritz Umgelter and a first-time American director named Francis Ford Coppola who basically just re-edited existing footage. Coppola would leave 3-D behind and go on to greater glory as we all know. *Paradisio* was a 3-D nudist film shot the same year. In 1968 a nadir of sorts was reached when *The Stewardesses* became the most popular 3-D softcore film of all time and sparked a rash of imitations that continued through to the mid seventies.

When hardcore pornography began to be theatrically exhibited in 1969–70, it didn't take long for some genius to realise the potential of shooting a film in 3-D, and several years later God gave us the imaginatively titled *3-D Movie* and *Blonde Emanuelle*, among others. Several gay male hardcore porno films were also made, *Heavy Equipment* and *Man Hole* being two of them.

The concept of the 3-D sex film became obsolete by the mid to late eighties as producers of pornography began shooting exclusively on video for the home market. 3-D and video was never a natural, although it could work on a TV screen. Living in LA in 1982, this writer recalls the great enthusiasm that greeted the first 3-D episode of Elvira's horror movie show. People rushed to Vons' supermarkets to get their blue/red glasses and see the films — and her cleavage — in 3-D.

The use of 3-D in science fiction films also fell out of fashion as blockbusters like *Star Wars* and *E T* put the emphasis on big budgets and expensive state-of-the-art special effects. 3-D was now seen as an item of fifties nostalgia, not a way to depict landscapes of future worlds.

Only in the horror film genre would 3-D remain viable. Of all the later period 3-D horror films, the most stylish and witty — and grotesque — remains Andy Warhol's *Frankenstein* (aka *Flesh For Frankenstein*), directed by Paul Morrissey in 1974.

By the eighties, a single-projector 3-D system had been developed. These projectors were much easier to install than the bulky interlock machines and provided improved picture quality. (However if polarized prints were being shown, as per, for example, the frequent revivals of *House of Wax*, interlock projectors were necessary). On the new system, films were shot with one camera that contained a single lens with two optical axes places slightly apart. The two images appeared on the film either super-imposed or side-by-side on a 35mm frame. As one can see, the basic principal of 3-D, to put two images on the screen at one time, had not changed. And decoding devices — glasses — were still needed.

Friday the 13th Part 3, *Jaws 3* and *A Nightmare On Elm Street: Freddy's Dead* (the third instalment) were some of the 3-D horror movies filmed in this new 3-D process.

3-D grew older but it never grew up. In 1981, a 3-D "spaghetti western" called *Comin' At Ya!* hit the screens and became a hit. Director Fredinando Baldi stole a page out of William Castle's book and attacked the audience with everything he could throw at it. And in the process, like so many other 3-D films, reinforced two popular beliefs: that they were basically just dependent on gimmicks, and that they were a hell of a lot of fun.

3-D, like the ghouls and zombies that haunted so many stereoscopic movies, never seems to stay dead — or alive — for long. And just when you think it's safe to come out...

FURTHER READING
3-D Movies: A History and Filmography of Stereoscopic Cinema, by R M Haynes
McFarland & Co., 1989

Four Aspects Of The Film,
by James L Limbacher,
Brussel & Brussel, NY, 1968

THE JUKEBOX THAT ATE THE COCKTAIL LOUNGE

The Story of SCOPITONE

More than just a new style, a new sound or a new technology, Scopitone was a full-blown cultural phenomenon, a creature of its time as rooted in the mid sixties as the Nickelodeon was rooted in the first decade of the twentieth-century.

The Scopitone movie-jukebox was brashly promoted at its west coast unveiling in 1964 as nothing less than a "revolutionary" new concept. It was hailed as the most remarkable innovation in entertainment since television, a device that combined the best features of music motion pictures and TV. And yet in spite of all the red-hot hype, Scopitone flared out surprisingly quickly and today the metallic monstrosities float free in an outer orbit of America's pop culture past... tumbling, clanging robotic pieces of junk.

No doubt today a last remaining few of these boxy machines loom silent, dust-covered and forgotten in dark alcoves of old warehouses, half draped with greasy blankets and ready to throw a tingly chill into the young teenage burglar or stock boy across whose bug-eyed expression falls the long shadow of one of these alien contraptions.

FROM EARTH IT CAME
A Mutant is Born

The "visual jukebox" was actually born in 1939 with the invention and placement of the Panoram by the Mills Novelty Company of Chicago. A wood cabinet jukebox fitted with a 17 x 22.5 inch translucent screen upon which the image was rear-screen projected, the Panoram played eight three-minute musical shorts which were spooled up on a single reel to play in a set sequence with no rewinding needed. Suddenly nightclubbers were treated to the trill of *seeing* as well as hearing their favourite stars and acts.

Hollywood-based Globe Productions produced thousands of the 16mm B&W films. They became known as "soundies" and featured most of the known jazz acts of the day, although comedians, torch singers and dancers were also filmed. Film production was halted when American went to war and by 1946 the soundie craze — which had seized the public's imagination and loose change in 1940 — was abruptly over.

The end of WWII in Europe produced a scarred peace, the tentative beginnings of international reconciliation and a new world order. It also produced tons of junk. Vast stockpiles of mechanical war surplus would now have to be scrapped or converted to peacetime uses. In the spirit of the times, two French technicians began to tinker around with the notion of building a visual jukebox out of military surplus stock.

They began by taking a 16mm camera mechanism that the French airforce had installed in planes for high altitude reconnaissance and then reconverted it into a 16mm projector. (The mechanics of a movie camera and a movie projector are almost identical — in fact the earliest motion picture projectors were reconverted cameras.)

Land of a Thousand Balconies

A shot of the "Bat Girl" strip act filmed for a Scopitone at Big Al's Topless Strip Club in San Francisco, circa 1966. Three more "topless" Scopitones were filmed at Big Al's, including *Topless A Go Go*.

Not until the late fifties was the project finished to satisfaction. Obtaining bright enough projection light and dependable automatic threading and rewinding for 16mm film were complicated technical issues of the time. The heart of the machine consisted of a film magazine drum that resembled a squirrel cage and rotated on a vertical axis, providing individual selection, play and rewind for thirty-six short films. Two major improvements over the Panoram jukebox were the screening of *colour* film and the customer's freedom to choose specific selections instead of whatever happened to be next on the reel. These might seem like minor details but in fact they were revolutionary breakthroughs that gave this jukebox the impact of a new invention.

The company that developed this new prototype of the movie juke box had a name straight out of a Jules Verne novel; Compagnie d'Applications Mécaniques a L'Electronique au Cinéma et à l'Atomistique (CAMCA). Located in St Denis, France, CAMCA was a subsidiary of the giant Paris electronics firm, CSF, often refereed to as "the RCA of Europe".

The strange looking machine was christened "Scopitone" (pronounced scope-a-tone). Early in 1960 CAMCA readied its first model, the ST-16, for placement on the European market. The base of the ST-16 had a squat, bottom-heavy appearance to it that incorporated a classic fifties design style, although the pyramid-shaped "neck" that jutted up from the selection panel and supported the twenty-six-inch viewing screen

The Jukebox that Ate the Cocktail Lounge

— which resembled a head — suggested the profile of a robot rather than a jukebox. The films stocked in the machines were two to three minute song-and-dance performances shot on inexpensive sound stages or, more often than not, outdoors.

The Scopitone ST-16 was a success for CAMCA, but despite the pan-European appeal of French pop stars in the early sixties, and the filming of some Spanish, German and English language acts, Scopitone never became nearly as popular in other European countries as it was in France.

In 1962 CAMCA introduced its second model, the ST-36. While the engineering of the ST-36 remained virtually unchanged from that of its predecessor, the cabinet was redesigned for the sleeker stylings of the sixties. It was slimmer and taller. Like the ST-16, the ST-36 had a detachable head, but the screen was now more integrated into the overall profile of the machine.

THEY ARE AMONG US

In 1963 word about this amazing new movie-jukebox filtered back to America. The idea seemed to have strong profit making potential in the US and the timing appeared to be right. By the late fifties the jukebox and slot machine trade had begun to feel threatened by the growing popularity of television: people were opting to stay home and watch the tube instead of going out to arcades and night spots.

A new invention was needed to pick Americans up by their heels and shake the coins out of their pockets. Scopitone looked like the answer to a number of US businessmen who had begun to investigate licensing possibilities with CAMCA. Alvin I Malnik, a young Miami lawyer who had been tipped on Scopitone by contacts in the William Morris talent agency, stepped forward and bought US and Latin American rights to Scopitone for either $33,000 or $5,000 (both figures are cited in published reports) and royalties. He did this by bringing in eleven co-investors to provide the fledgling company with working capital, and Scopitone Inc was formed.

Among the eleven individuals was Irving Kaye, a Brooklyn billiard equipment manufacturer, and Abe Green, a New York City slot machine baron whose documented links with mob figures would surface in the future to put a hex on American Scopitone interests. But for the moment everything looked good. Almost too good. Malnik "quietly" tested out the machines at sites in Miami and Miami Beach over the winter of 1963–64. They were so popular and prompted so many requests for installations that Malnik, who never had any desire to get into production or distribution, turned to contacts on Wall Street for advice.

A broker put him in touch Aaron A Steiger of Tel-A-Sign, a Chicago-based manufacturer of large illuminated plastic signs used by gas stations, super markets and other retail outlets. Tel-A-Sign was shopping for auxiliary product and Scopitone appeared made to order.

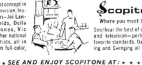

A partnership between Malnik and Tel-A-Sign was formed. In April of 1964, Tel-A-Sign bought an eighty percent interest in Malnik's company. Scopitone Inc became a subsidiary of Tel-A-Sign with Malnik continuing on as President. On May 12, 1964, *Variety* weighed in favourably on Scopitone's West Coast debut at the Ambassador Hotel in Los Angeles where "reception was distinctly positive". At this point 250 Scopitone jukeboxes had been put into operation in the US, concentrated in the North East and the Miami/Miami Beach area. All were ST-36 models imported from France and all playing French produced films which *Variety* lauded for their "jet-paced editing, exceptionally vivid colour and generally top-drawer production values".

Land of a Thousand Balconies

While no one could dispute the novelty value and initial draw of the machines, it soon became clear that US Scopitone would be doomed without the introduction of American films. These French productions, which *Variety* had praised perhaps too generously, would not indefinitely hold the interest of American coin poppers, no matter how frequently pretty mademoiselles flashed bikini clad flesh or lacy underwear. Moreover, even the top French pop acts of the period had virtually no name recognition value or record sales in America, let alone the more obscure acts whose comedy and song routines often came across as just plain stupid. Tel-A-Sign was already casting around for an American film production source in Hollywood, although at this point nothing had been finalised. From the outset Tel-A-Sign had tried to avoid direct competition with the long established and territorial jukebox industry, staunchly maintaining that Scopitone was never considered a competitor to the jukebox, but rather was a new entertainment medium in its own right. In any case Scopitone aimed for a more mature audience. The twenty-five cents price per selection was expensive for the day, and the "class" resort hotels, cocktail lounges and downtown restaurants Scopitone targeted with some success — and where jukeboxes had never been known before — were off-limits to teenagers.

Yet Scopitone aimed for installations in a wide variety of locations, from bars, bowling alleys, and bus and train terminals to dormitories, service men's clubs and even off-shore oil-drilling rigs and logging camp canteens — in fact any place men might hanker to see images of pretty women.

"A Scopitone machine attracts new customers", sang a trade blurb, "and makes them 'regulars' at your establishment. Patrons will spend more time at your location increasing their consumption of food and beverages!" The jukebox industry eyed the emergence of Scopitone with alarm. Competing coin-op visual jukebox makers like Color Sonic, Phono-Vue and the Italian originated Colorama, looked on with envy as Scopitone cornered market share and the public's imagination. Scopitone was also unpopular with local musician's unions since the devices occasionally succeeded in putting piano players and other live performers out of business in some spots.

By mid-summer of 1964 some 500 machines were "on location".

On August 21, *Time* magazine reported on this "monstrous new machine called Scopitone". "For a quarter a throw, Scopitone projects anyone of thirty-six musical movies on a twenty-six-inch screen, flooding the premises with delirious colour and hi-fi scooby-ooby-doo for three whole minutes. It makes a sobering combination." Amen. Malnik chimed in with characteristic brashness, claiming a backlog of 2,500 orders and promising to fill all the machines with American films which he himself would produce. "There's just no end to the story-book-film devices we can prepare", he enthused with the unbounded optimism that typified all the public utterances made by Scopitone/Tel-A-Sign execs at the time. *The New York Times* picked up the ball on November 8 with a picture piece headlined "NEW JUKE BOX FINDS POPULARITY":

Imagine a coin-operated music machine — a jukebox in Broadway slang — combined with a movie projector. Add a first class musical film in brilliant colour and high fidelity sound... that is Scopitone.

In the meantime Tel-A-Sign had purchased manufacturing rights from CAMCA and was tooling up a plant on Chicago's Far Southwest Side for production of the newly designed 450, "the American model", which was slated to roll off the line in early 1965.

The 450 boasted a solid-state sound system in place of the tube amplifiers found in the French machines, while the cabinet design was even more understated and vertically stressed than the ST-36. The "neck" had been eliminated and the screen, no longer detachable, was fully incorporated into the more monolithic body. An almost absurd seven feet tall, the 450 weighed 650 pounds crated. Domestic production of the jukes would simplify and speed up instalments in addition to making them much easier to service now that the component parts could be manufactured in the US.

Steiger coolly predicted to *The New York Times* that they intended to manufacture about 5,000 machines in 1965, double that in 1966 and hold to a 10,000 annual quota for "some years".

Scopitone had become much more than an "auxiliary product" for Tel-A-Sign. It already dwarfed its parent company on paper if not yet in hard financial return: for 1965 Steiger forecast $6 million in total sales for the plastic sign company against twenty million in total sales for Scopitone. "The acquisition of Scopitone will increase our 1965 volume five fold", confidently announced Steiger to *The New York Times*.

LITTLE SHOP OF SPLENDOURS
Harman-ee Comes to Hollywood

The need for new American made films was more pressing than ever, and in December of 1964, Tel-A-Sign inked a five year contract with Harman-ee productions, a subsidiary of the Beverly Hills based

The Jukebox that Ate the Cocktail Lounge

the screen:
Twenty-six inch, high-definition screen displays motion picture in color with perfect steadiness and sharpness. This performance is made possible by our licensor's 30-plus years' experience in the field of professional motion picture equipment.

sound system:
High fidelity sound is faithfully recorded on a magnetic track laid on the film. It is picked up by a magnetic reading head, thus insuring fidelity over the whole acoustical frequency scale, and allowing full dimensional sound reproduction. Volume control can be adjusted to fit specific acoustical values on location. SCOPITONE is equipped with remote control volume selectors and remote sound boxes.

selection system:
Vision-Line Program Selection panel assures smooth pre-selection of from 1 to 36 productions. Patrons may choose as many plays as they desire in advance by inserting coins in the coin mechanism. The Memory Selector Board automatically generates plays—up to 21 an hour. There is no delay between selections. Remote control selectors will soon be available.

projection system:
SCOPITONE uses a continuous-running 16mm projector in which the feed system applies no strain to the film. The screen brightness allows film projection even under the worst lighting conditions: daylight or artificial light. Film is stored on a sturdy, revolving carousel that rewinds each "play" during the projection of the following play.

produced by TEL-A-SIGN, Inc.

Beauty in Design — Simplicity in Maintenance — Excellence in Operation

Land of a Thousand Balconies

Harman Enterprises which was owned by Debbie Reynolds and managed by ex-Columbia Pictures Vice President, Irving Briskin. Harman-ee would become the main supplier of American films with a deal to produce forty-eight acts a year.

The first Harman-ee act brought before the cameras in late 1964 was by no small coincidence Debbie Reynolds herself singing If I Had A Hammer. As the glittery, sequined centrepiece of this stupifyingly lavish production number, Debbie steamrolls the social protest content out of the song and dazzles the viewer with a high voltage Vegas lounge interpretation that turns the whole thing into a glitzy sexual come-on. It would have been the crown jewel of any Elvis movie.

Most Harman-ee acts would do at least a pair of films, aping the "follow-up mentality" of the record biz, and for Debbie's encore she took everybody outside to a horse ranch for a rousing romp in the tall grass to the tune of We'll Sing In The Sunshine.

That was actually a song that Gale Garnett had made a hit. Garnett was signed to make a couple of films from other songs, perhaps as a concession from Reynolds after she snatched her biggest hit.

Scopitone's fortunes continued to gain throughout the winter and spring of 1965 as American made films became available.

The summer of 1965 would mark Scopitone's sunniest moment, both as a pop culture phenomenon and as a business enterprise. Prospects looked good for the signing of new acts, and on the financial front Scopitone had stirred the interest of traders and sent Tel-A-Sign stock soaring. From a low of $1 per share on the American Stock Exchange in early 1964, Tel-A-Sign common stock had rocketed to $9.50 by mid 1965.

About 1,000 machines were now on location, 400 on the west coast, with back orders stacking up. A new timing device called a "stimulator" was being attached to the machines, automatically activating the jukes to spring to life and replay the last selected number after a period of inactivity. The stimulator reportedly prompted an increase in collections.

Tel-A-Sign intended to continue importing films from France, Steiger stated in the July 10 issue of Billboard, but by year's end most of the films in machines would be English language productions. In the same article an anonymous Scopitone exec discussed the impact of American made films over the long term:

First comes the spurt, with high revenues and many locations seeking the novelty. This may lead to saturation. Familiarisation leads to a levelling off — the second stage. Frequently machines are pulled out in this stage. But now, with the availability of a variety of American films, we are seeing a third stage — a steady income stage.

The ST-16 Scopitone jukebox, the first version of the French model. Depicted is the working, fully stocked jukebox located in the town museum of Örnsköldsvik, Sweden — purchased and maintained by Olle Dahlbäck, who bought it for the museum twelve years ago.
Photo: Olle Dahlbäck

Scopitone was taking on a new identity as it underwent a metamorphosis from a novelty dependent on French product to a solid "exposure medium" for popular American recording stars who were beginning to see the light. In early July, Tel-A-Sign announced the release of thirteen new films, among them Bobby Vee singing The Night Has A 1,000 Eyes and Jody Miller with Queen Of The House, her popular answer song to Roger Miller's recent smash hit, King Of The Road. Scopitone was getting, if not hip, then at least a bit more "with it"...

FROM SAUCY TO SURREAL
The Land That Reality Forgot

Harman-ee was now producing some amazing films marked by a unique sense of stylisation and, if one dares to use the word, a philosophy. Hal Belfer di-

rected all the Harman-ee Scopitones while Fred Benson coordinated talent and production under the supervision of Executive Producer, Briskin. Steiger himself took an avid interest in the signing of new acts. All the films were shot in 35mm Technicolor and printed down to 16mm for play in the jukes. Sound was laid onto the film with a magnetic strip that produced higher fidelity than the standard optically-read soundtracks. Each film cost between $6,000 and $11,000 to make, with union crews employed. Star artists received $1,000 for their performances and a forty cent royalty per print. Lesser known acts would get $250 for performing. Dancers and prominent extras, some of whom Belfer recruited from racy stage shows at Hollywood clubs like Ciros on the Sunset Strip, got about $50 a day. After the films were made and edited the performers were usually invited up to the Harman-ee office to crowd around a Jukebox and watch the finished product.

Harman-ee was putting big money and talent into its films, crafting a distinctive high gloss style that was in stark contrast to the French films heretofore available which were much less ambitious and printed on Eastman colour stock. Films playable in Scopitone machines would also be made by Continental Cinema, Color Sonics and various independents. Harman-ee wasn't the only source of American films, but they were the only ones working in Technicolor. By contrast, the earlier French productions were mostly no-budget affairs frequently filmed in the woods, on beaches or even in junkyards with worse than usual lip-sync and nil use of props or costuming. French cover versions of English language hits like *Twist And Shout*, *Goldfinger* and *On The Street Where You Live* ended up halfway between hopeless and uninspired, although there were actually a lot of other great French films that defied their threadbare origins.

Many French films utilised historical settings and themes such as, for example, a mock-up of a nineteenth-century bordello, a gay nineties piano bar, an old dockside beer hall and a WWII battlefield. Such material was ill-suited for American audiences who were prone to consider anything before 1955 prehistoric.

A thoroughly French aesthetic is brought to bear in films like *Jolie Môme* by Juliette Greco and *Si Mon Amour* by Isabelle Aubret, which play out as morose romantic dirges. Camera work is static, editing is almost non-existent and action is confined to torch singers who wander in existential angst amid inventive fabric backdrops, surreal ruins, sculptures, fake flora and cafe tables in studied disarray. Such treatments almost resemble paintings more than films, and the contrast with the hyperactivity of American films is stark.

At best this extreme from the French camp has an entrancing beauty about it, at worst they're interminable.

The French could also bring an artistic touch to more overtly musical numbers with deft strokes of subtlety, counterpoint and off-kilter camera angles. French rocker, Johnny Hallyday ("The French Elvis") raves away on his guitar in *J'suis Mordu* while an unimpressed high-society beauty in dress gown wanders over in front of the camera, then casually circles back in front of the frenzied Hallyday to take a seat on the stage, bemused, aloof and teasingly untouchable. Its great use of counterpoint, both spatial and emotional.

Johnny Hallyday, the "French Elvis," in an early French-made Scopitone film.

THE DAY THE EARTH TURNED TECHNICOLOR

"A new dimension of thrilling colour makes the world of musical entertainment come alive!" gushed Scopitone hype back in America. Indeed. Colour, one of Scopitone's main innovations and selling points, was now being used by Harman-ee as colour had never been used before — with almost reckless indulgence. Much like Hollywood in the fifties had manipulated in-your-face action sequences to take advantage of the new 3-D technology, Harman-ee now manipulated set design and costuming to take advantage of the juicy colour reproduction of Technicolor stock. Glowing, bright primary colours fill the screen like candy for the eyeballs. No feature film could ever sustain the use of colour in this fashion: the viewer would simply overdose. But in small hits it was pure pleasure.

The fantasy, theatre style sets combined with the use of wilfully unnatural, hyper colours to present a world of exaggerated artificiality, a never-never land of pink bathtubs, purple walls and AstroTurf grass lawns. Kay Starr sings *Wheel Of Fortune* in a casino setting while behind her a glittering roulette wheel spins with

Land of a Thousand Balconies

such dazzling brilliance that it looks like it must be a rear-screen projection.

Wholesome-as-a-glass-of-milk January Jones shimmies through a jazzed-up version of *Up A Lazy River* with rapid-fire bikini changes. Filmed in a lush outdoor setting of green grass and hills, Harman-ee managed such a bright and vivid look to the production that it somehow appears more real than reality… or something. And the colours remain just as vivid today, while the Eastman colour films have faded to shades of red and pink.

In their efforts to visualise pop songs, Harman-ee created some astonishing set designs. While the three-storey silver staircase in Debbie Reynold's *If I Had A Hammer* was probably the most expensive piece of set construction, nothing beats the multiple dreamscape environments of Gale Garnett's *Where Do You Go To Go Away?* for ornate tackiness.

The deep-voiced singer relives some old romantic adventures that drop her into medieval England where she perches on a throne, exotic Bombay where she sits side-saddle on a huge stuffed elephant, and finally Hell where she briefly fondles the chest and private parts (off screen) of a statue of the Devil. The film ends with Gale standing under a sign post pointing out the pathways to "confusion", "frustration" and, her new direction, "true love." A happy ending, Scopitone style.

Another outstanding set was created for Barry Young's film, *One Has My Name, The Other Has My Heart*, where the two rooms, split by a common wall, signify a life of domestic drudgery with his wife on one side and exotic, erotic penthouse living with his glamorous mistress on the other.

The films are sanitised of any trace of human emotion except on occasion when we see extras trying to suppress broad grins at the ridiculousness of the dance steps they've been instructed to execute. Scopitones were geared to pure entertainment, not any kind of faithful recreation of the pathos of the songs. People were reduced to decoration. They were lip-syncing, gyrating dolls and puppets and mannequins.

THIS PAGE The Scopitone film *Little Miss Go Go* features these two go-go dancers gyrating to the title song, by Gerry Lewis and the Playboys.

NEXT PAGE Gale "keep your hands where we can see 'em" Garnett gets familiar with the Devil in *Where Do You Go To Go Away?*

THE AMAZING MOVING PEOPLE
Dance Steps from Space

Harman-ee could appreciate that the movements and contortions of Scopitone dancers needed to be somewhat exaggerated to reach out and grab viewers on the small screen (an approach that could render the films that much more exaggerated when magnified on much bigger movie screens where they were never intended to be shown). Scopitone was not about subtlety.

The dance crazes that swept America like a swarm of tornadoes throughout 1965 were made to order for Scopitone dancers as they rolled up their clam-diggers and waded into the fray. Scopitones like *Sea Cruise*, *Little Miss Go Go*, *Land Of 1000 Dances*, *High Boots* and *Pussycat A Go Go* survive today as time capsule relics from the age of the dance craze. And with everybody twisting like crazy they didn't need the high gloss production treatment afforded to older stars like Jane Morgan and Kay Starr.

Belfer also created his own original choreography. Some of the dance routines are so bizarre that they leave modern audiences drop-jawed. The bored housewife in Barry Young's film waltzes around the kitchen

The Jukebox that Ate the Cocktail Lounge

in her nightgown spraying air freshener and grabbing the box of Wheaties while executing spins and rolling her eyes. Casino gal dancers in *Wheel Of Fortune* gyrate, spin on their knees and dangle their forearms like loose-jointed slot machines. In *Queen Of The House*, a delicious trio of leggy housemaids execute risqué manoeuvres with feather dusters, hump broom handles and sneak peeks into three lined up ovens as Jody Miller dreamily sashays through what appears to be a giant candy coloured Barbie dollhouse. The opening scene of *Around the World* features a large globe wreathed in smoke around which ethereal, nymph-like women dance, holding hands and garbed in sheer flowing dresses.

TV and B-movie star, Joi Lansing, joined the Scopitone roster of stars in November of 1965. Among the feature films to her credit at that point were *Hot Cars* and *Atomic Submarine*. The amply endowed blonde actress would go on to win "Miss Armed Forces Day Of The World" in 1967 and star in *Hillbillys in a Haunted House* the same year, but without a doubt *The Web of Love*, a Scopitone she shot in early 1966, was the most outrageous kitsch of her whole career. Clad in cave gal skins and prowling a set overgrown with trashy jungle atmospherics, Joi takes a dip in a smoking stew pot as her witch doctor stirs and hops about maniacally, and ducks out for several other outrageous costume changes. She lip-syncs and mugs her way through the song with the heavy-lidded and melodramatic sexuality of a female impersonator.

PLANET CAMP
When Aesthetics Collide

If Joi stole her technique from anyone, it was the John Waters' star, Divine — except Divine didn't exist yet!

The Web Of Love wasn't created as camp. The aesthetic was unknown to Harman-ee producers, ensconced in Hollywood as they were, and any overt traces of camp in a Scopitone film would have gone unrecognised by the generally "square" juke-pix audience. Rather, Joi's film epitomises Belfer's technique of visualising a pop song by drawing the eye to exaggerated shapes and colours that would resonate on the small jukebox screen, follow-the-dot fashion, and grab the viewer's attention in an environment full of competing distractions. Sometimes he literally spelled it out for the audience, as in *Where Do You Go To Go Away?* and *One Has My Name, The Other Has My Heart*. Joi herself has a kind of exaggerated cartoon look that might represent the ideal cave girl to any prepubescent thirteen-year-old boy. In any case, nobody was searching for authenticity or realism up on a jukebox screen in some cocktail lounge, and Belfer wasn't trying to give it to them. The fact that these pop stars

Land of a Thousand Balconies

were obviously lip-syncing to their hits exacerbated the atmosphere of the unreal. And although Scopitones were shot and played on film stock, nobody in any way considered this "cinema". Harman-ee was simply trying to provide addictive, joyous fun for three minutes, but without knowing it they were also fashioning an unparalleled sense of camp cinema. Two brothers from the Bronx in their early twenties, Mike and George

Kuchar, were at the same time shooting 8mm and 16mm short films that cheerfully championed flimsy artificiality, cheesy costuming and juicy colours. Their films, particularly *Sins Of The Fleshapoids* by Mike, in 1965, would pioneer an awareness of the camp aesthetic in the milieu of underground and avant garde film, while popular TV series like *Batman* and *The Monkees* would soon bring camp to the mainstream masses — but nothing would ever surpass the jaw-dropping excesses of the Harman-ee produced films for sheer "guilty pleasure" power. What effect Scopitone had on the day-glo flowering of the sixties' camp movement can only be guessed at, but they did not go unnoticed: in her seminal 1964 essay "Notes On Camp", published in the intellectual *Partisan Review*, Susan Sontag spotlights Scopitones as examples of pure camp.

THE GENRE OF LOST WOMAN
It's a Man's World

Sex was the spice of Scopitone, and into the mix Harman-ee poured over generous amounts of T&A to get the guys to start popping quarters as they became addicted by their favourite flicks. But you got more than just frosting for your loose change — you got a glimpse into an ever sunny world where male pop stars like James Darren, Vic Damone and Andy Russell lived on a high as they wandered through an exotic paradise of divinely stacked babes who were happy, willing, smiling and numerous.

Well-built gal stars like Joi Lansing and January Jones were dressed in revealing bikinis or skimpy cave gal skins, while even more modestly endowed balladeers like Jody Miller and Gale Garnett were given the show-a-little-cleavage treatment by Harman-ee, with mixed results. Older showbiz veterans like Jane Morgan and Kay Starr were allowed to stay fully dressed but were certain to be surrounded by phalanxes of younger bikini-clad gal dancers. The sex on display was almost always female — the outlook invariably male.

Once in a while the woman was in command, as in the poolside gal group lament, *Johnny Liar* by Molly Bee, where cheatin' playboy, Johnny, is finally shoved into the water by his wronged woman. A sultry Barbara McNair (in an Eastman colour film) also lords it over the men with saucy insolence in the all-black-cast *The Best Is Yet To Come*, filmed in San Francisco's classy Fairmont Hotel. But more often than not — and undoubtedly more to the taste of the lonely liquored up travelling salesman feeling for quarters in a Midwest motel lounge — the nearly naked gal protagonist would pay the price of some transgression in the coinage of playful S&M or bondage. At the conclusion of Frankie Randall's *Yellow Haired Woman*, the leggy, flaxen-haired, man stealin' vixen is collared in one of the skimpiest bikinis ever and trotted off down main street tied to the saddle of a horse. Jody Miller's *The Race Is On* features several bikini-clad dancers tethered and bucking like randy racehorses — just one more piece of Belfer choreography that would go over like a lead balloon in today's politically correct environment.

Scopitone jukeboxes were installed in a wide variety of public places, and toplessness — let alone pornography — was never part of the plan. The main aim of the majority of films, however, going back to the

The Jukebox that Ate the Cocktail Lounge

earliest of the French productions, was to simulate or signify sexual content, and this was done with the same sense of play-acting and follow-the-dots exaggeration that had been brought to bear on set design.

The "signifying", executed with both shameless intent and almost childlike playfulness, could at times achieve a vulgarity that for some surpassed that of actual pornography. Camera shots often consisted of close-ups on gal's crotches, and lady dancers executed leg kicks and leg spreading manoeuvres that would give new meaning to the term prurient.

If Russ Meyer's mammary obsessed films could be called "tit operas", then Scopitones could be called "crotch operas". Yet the crotch shots were usually done with such disarming obviousness and choreographed so artfully that films like Françoise Hardy's *All The Boys And Girls*, with skirts blowing up on a circus ride, and Jane Morgan's *C'est Si Bon*, with dancers lifting skirt draped legs with chorus line precision as they lay on their backs, seemed charming rather than sleazy.

Some topless Scopitones were put into distribution for machines in strictly adult locations, the one notable exception being a film called *Africa Ablaze* which was struck in large quantities and dumped into general distribution. Shot on a barren sound stage in France, the film featured the Guinean national touring dance company, Les Ballets Africains — still active today — in a frenzied group dance that revealed with *National Geographic*-style matter-of-factness the bare breasts of the black female singers, one of whom was particularly well endowed and athletic.

Crazy Horse Saloon sponsored a series of top-less, stripper themed films shot in both France and America. The strangest of these was undoubtedly *Touchdown Girls*. Here we see a chorus line of grim faced strippers laced into revealing shoulder pads and helmets as they march in place to the shop worn frat house anthem, *Mr Touchdown*. The action cuts between the robotically shimmying strippers and archival football footage circa 1940.

PREVIOUS PAGE French pop singer Françoise Hardy in *All The Boys And Girls*, and (right) Billy Lee Riley performing *High Heeled Sneakers*.

THIS PAGE Unknown girl in Jody Miller's Scopitone, *Queen of the House*.

Topless stripper films of American origin also surfaced here and there, cranked out by independent producers. One features the Bat Girl strip act at Big Al's club in San Francisco's North Beach neighbourhood. Accompanied by a band called The Rejects who pound out the Batman theme song, Bat Girl flails wildly in her bat cape while strobe lights flash. Another film made at Big Al's was called *Topless A Go Go*.

None of the topless films, however, could match the smouldering sexuality of an always decently if barely clad Joi Lansing — dubbed "the Scopitone bombshell" — who would record two additional numbers for Harman-ee: *The Silencer* and *The One I Love Belongs To Somebody Else*.

Joi's magic would survive the years, as witnessed at the Plainsman Museum in Aurora, Nebraska on a hot summer day in the mid eighties when a bus from the Soldiers and Sailors Veterans Home in Grand Island pulled up. A group of old guys out for a quiet and boring visit to the museum. Then one of them discovers the Museum's refurbished Scopitone jukebox and starts popping quarters to discover… Joi Lansing! "To hell with museum — this is where its at!", they agree, gathering around the screen, laughing and carrying on.

41

Land of a Thousand Balconies

IT AIN'T ROCK 'N' ROLL BUT THEY DON'T LIKE IT

In September of 1965, Aaron A Steiger and three associates personally purchased all of Malnik's Tel-A-Sign and Scopitone holdings. Irving Malnik leaves Scopitone considerably enriched. When Tel-A-Sign had acquired the eighty percent interest in Scopitone in July of 1964, $8,000 of Scopitone stock had been traded for Tel-A-Sign stock having a market value of 3,320,624. All in the original Malnik group had profited fabulously. For his own block of $4,963.00 Scopitone stock, Malnik had received 499,500 shares of Tel-A-Sign stock with a market value of $2,060,437.00.

On October 9, 1965, Harman-ee signed a contract with Mercury Records and their affiliate labels to produce films for a host of new acts including chart-toppers such as Johnny Mathis, Roger Miller and The Walker Brothers. Scopitone's fortunes continued to rise throughout early 1966. In the February 23 issue of Variety, Briskin boasted about a "tripling" of print orders and a "more cooperative attitude on the part of wax labels and performers", and forecasted a doubling of current output to 100 films produced annually.

Briskin noted that Harman-ee's inventory to date didn't include much hard rock material, or in his words, "long hair" music. In fact almost nothing filmed for Scopitone could be termed real rock and roll, as distinguished from the teen-oriented pop that jammed the radio waves in 1964–5. European films featured the likes of Johnny Hallyday, Paul Anka, Dion, Petula Clark and Sylvie Vartan, while acts like Neil Sedaka, Leslie Gore, Bobby Vee, Bobby Rydell and Dick and Dee Dee starred in American made films along with The Hondells and Gary Lewis and The Playboys — all of it solidly in the pop-rock vein, accent firmly on pop.

One surprising exception was a Scopitone featuring Procul Harum singing A Whiter Shade Of Pale. Intercut with shots of hippies hanging out in Trafalgar Square, this rare home movie style curio presents the young English mop-tops, garbed in psychedelic fashion as they run through fields in slow motion. The Condors, a black vocal duo from America, made one of the rockin'est Scopitones with their white band mates and a mess of wild go-go dancers — Ain't That Just Like Me, a rock version of the Humpty Dumpty nursery rhyme.

Scopitones survive as valuable visual records of period singers and groups that one might otherwise only hear today.

For some who starred in Scopitones, life would wouldn't always be as happy as the endless frugging and grinning might imply. More difficult times lay ahead for Danny Whitten for one, who was lead singer in the group known as The Psyrcle, which made three Scopitones in one day, including Land Of 1000 Dances. Danny and two other band mates, Ralph and Billy, later joined Neil Young to form Crazy Horse. Danny died of a heroin overdose. (Needle And The Damage Done was written by Neil Young about Danny Whitten; Billy and Ralph both appear in the Jim Jarmusch film, Year Of The Horse.) Love Me, Please Love Me, performed by French singer, Michel Polnareff, has significance too since soon after he suffered mental problems and started wearing sunglasses which he never took off again. Reportedly this Scopitone is one of the few instances where you can actually see the singer's eyes. Back to the rock angle, we had The Exciters, a black Philadelphia girl group who recorded two British-produced Scopitones for their chart hits, Tell Him and He's Got The Power, and Ike and Tiny Turner recorded a song at some point, as did Nancy Sinatra.

Over-the-hill Rockabilly stars, Billy Lee Riley and Vince Taylor filmed Scopitones. Riley was filmed performing High Heeled Sneakers at The Whiskey A Go-Go in LA, and the lanky Vince Taylor recorded renditions of Peppermint Twist, Whole Lotta Twistin' and Twenty Flight Rock which featured the duck-tailed singer and his band mates astride blue Harleys. Taylor's hottest number was an electrifying reverb-laden cover of Shakin' All Over in which bad-ass Vince prowls a surreal set construction that looks like a ramp to oblivion. Freddie Bell and The Bell Boys, with Roberta Lynn, were serious pretenders to the rock 'n' roll throne in the fifties and appeared in the groundbreaking 1956 feature, Rock Around The Clock. By 1964 however, their career was on the skids and they were appearing in schlock like Get Yourself A College Girl (which producer, Sam Katzman had originally entitled Watusi A Go-Go.) By the summer of 1965 they had hit rock bottom and Freddie and Roberta, sans The Bellboys, were on location in Las Vegas filming two Scopitones, Tweedlee Dee and the impossibly kitschy, For You — a wild west romp in covered wagons. Scopitones were no plus for acts seeking youth market credibility.

Although some country and western and jazz flavoured acts would film Scopitones, the strategy was to focus on acts that were acceptable in all areas of the country. The bulk of jukeboxes were placed in locations frequented by adults and stocked with songs that grown-ups wanted to hear — familiar artists singing familiar songs, mostly library stuff that had "legs". Scopitone was more interested in recording Donna Theodore singing Femininity, a song from 1958, than in winning over the younger set who didn't have many quarters to spare anyway.

Had Scopitone ever attempted to seriously exploit

The Jukebox that Ate the Cocktail Lounge

LEFT The Kessler Sisters in *Quando, Quando*.
RIGHT Dion in *Ruby Baby*.

rock 'n' roll, they would have needed a major re-think as well as a crystal ball since nobody knew that this "long hair" music would stick around to become a multi-billion dollar a year industry. Since the cost of making a Harman-ee Scopitone was a lot higher than cutting a single, more risk was involved when gambling on the unpredictability of this "long haired" sound. New groups were coming out of the woodwork every month. Probably it was just a passing fad.

So scopitone passed.

STRONG ARMS AND STRIP POKER
The Other High-Heel Drops

In March of 1966, Harman-ee filmed a song called *The Mighty Mississippi* by The Backporch Majority, a chorus group with country leanings. Conceived as a rousing old fashioned hoedown in the mould of *Seven Brides For Seven Brothers*, it turned out to be more about "a river boat gambler who loses his shirt (and everything else) to three smart cuties on his double-or-nothing roll of the dice", as a Scopitone spot blurb described it. The finished product contained too much cheesecake for the group's management to swallow, not to mention a highly suggestive fade out. They claimed that the smut had been added without their consent and filed a lawsuit against Scopitone for five million dollars. The suit was unsuccessful, but it foreshadowed a wave of bad luck that about to come crashing down on Scopitone so suddenly that they barely had a chance to look up.

On April 26, 1966, *The Wall Street Journal* ran a damaging piece headlined "Movie Jukebox Probe: Grand Jury Looks into Everybody Linked With Scopitone: Tel-A-Sign assails inquiry".

According to the article, for more than a year a Federal Grand Jury in New York had been "digging into the background of everyone and everything connected with Scopitone" as part of the Justice's Department's continuing search for possible gangster involvement in legitimate businesses. Bobby Kennedy's hunt for Mob vultures was about to bag an unlikely prize — Scopitone.

As the paper stated and reiterated in follow-up reports, the integrity of Tel-A-Sign management was never in question. Rather, the investigation focused on whether hoodlums had muscled in on some of the independent Scopitone distributors, and whether the Mafia had played a hand in the original partnership group formed by Malnik — specifically via investor, Abe Green. The investigation seemed to be more than just a fishing trip; convicted mobsters Gerardo Catena and Joseph "Doc" Stracher had been involved in Green's Runyon Sales Company. Reached by phone in his cabana at the swank Eden Roc Hotel in Miami Beach, Malnik asserted there had been "no undesirable elements in Scopitone to my knowledge".

Mob bosses like Meyer Lansky and Thomas Eboli were being questioned and subpoenaed. Even Roy Cohn's name popped up (he'd been a major holder of Tel-A-Sign stock in the early sixties). A parade of shady characters were being called before the Grand Jury as the whole thing puffed into a noxious cloud of bad press. It was a public relations nightmare.

But Scopitone was still flying too high to be shot down by a few slugs of bad press. A month later Harman-ee proudly announced the signing of hit makers Gary Lewis and The Playboys to an exclusive five year contract. Behind the scenes, however, fallout from the arti-

Land of a Thousand Balconies

cle was being felt. In May only three machines were sold as it became almost impossible to close any contracts. People connected to Scopitone found it nigh on impossible to obtain financing due to the negative publicity. Film revenues plummeted, stock value skidded.

Nonetheless in June, Eartha Kitt, Vicki Carr, Bobby Vee, April Stevens, Herb Alpert and other stars signed exclusive contracts to make Scopitone films. By July, 1966, Scopitone estimated that 2,000 jukeboxes were "on location".

If the ground was shaking you couldn't tell it by the big front office smiles. The August 20 issue of *Cash Box* magazine ran an upbeat factory report on Scopitone in a seven picture spread. The piece presented Steiger at his glad-handing best, posing with a model 450 jukebox as division plant manager, Fred Leuthesser, looked on. The article focused on assembly line production of the jukes, field service training for mechanics and print inventory. Yet, for the six month period ending August 31, Scopitone reported a $148,000.00 loss.

At the annual Tel-A-Sign shareholders meeting in early November, a chastened Steiger expressed guarded optimism but laid it bluntly on the line to the forty or so attendees.

On the plus side, a new distributor for Scopitone had been found, print shipments for November were expected to be the highest in history, and Tel-A-Sign had renegotiated a more favourable agreement with CAMCA over royalties and guarantees. In addition, Tel-A-Sign was planning to alter the machines to permit the insertion of paid advertising.

More than 1,600 machines were in use at present, he stated (revealing recent public estimates to be clearly puffed), and more would be produced "as needed". He admitted conversations had taken place regarding sell-off of the sign division where profit margins had been "slim".

Steiger admitted that *The Wall Street Journal* article had been a shock to the Company and blamed it for putting a freeze on sales. On top of everything, a major west coast distributor had crashed and burned, leaving behind a $1.4 million default in the wreckage which had hit them with a cash loss of $1,100,000, of which $640,000 had been written-off. Some of the jukeboxes shipped to the distributor had been "recaptured" by Tel-A-Sign, Steiger reported.

The remainder of 1966 and the start of 1967 brought no good news. Scopitone's Chicago plant did not produce a single machine through the first three months of 1967.

THE FALL OF THE HOUSE OF SCOPITONE

As the purple gloom closed in around Scopitone, they threw a party. The bash was held in the ornate Empire Room of Chicago's Palmer House Hotel in February of 1967. A A Steiger capped a dinner reception awash in self-congratulation by personally presenting January Jones a Scopitone award as "Most Popular Scopitone Artist of 1966". It would be the only award ever given to a performer by Scopitone.

Sometime later, January got up for a glass of water in the middle of the night and tripped over the statuette, breaking her big toe. Steiger's luck was even worse...

Within two months of the Palmer House presentation, he was ousted from Scopitone/Tel-A-Sign. Instead of the wave-breaker for a "fantastic new entertainment medium" that Steiger had ceaselessly plugged, Tel-A-Sign was now just another foundering business operation fighting rear guard actions on several fronts.

Enter J C "Jack" Gordon, a fifty-year-old industry veteran who had performed in a variety of roles with a major jukebox manufacturer, Seeburg Company, since 1946. Gordon tried to reverse the tide by developing a new model of the Scopitone jukebox, the "Theater 16". Basically a modified 450, the Theater 16 came with a larger 35 x 34 inch built-in screen or an attachable five-foot by seven-foot auxiliary screen designed to hang three to five feet in front of the jukebox.

The Theater 16 was short-lived and had negligible impact, yet its resemblance to big screen video projection so popular today suggests an invention ahead of its time.

Due to a modicum of demand for the Theater 16 model with the built-in screen, a follow-up model was introduced in 1968 — again a virtual copy of the 450 with only slight cabinet restylings and a larger screen. It came and went virtually unnoticed.

Tel-A-Sign's pulse was still beating — if barely.

On October 28, 1969, a small article appeared in *The New York Times* announcing the indictment of Vincent "Jimmy Blue Eyes" Alo, sixty-five, for giving false and evasive answers in a Securities and Exchange Commission investigation into the financial affairs of Tel-A-Sign, a publicly held company, "which has been under investigation since 1964 when it acquired Scopitone."

The investigations never amounted to more than this: a sideshow of hoodlums and character studies out of *On the Waterfront* caught in a murky web of largely irrelevant lies and evasions. But it hardly mattered now. In November of 1969, Scopitone Inc went out of business.

A combination of mistakes, miscalculations and plain bad luck had proven fatal to a business enter-

The Jukebox that Ate the Cocktail Lounge

prise that only five years before appeared to be riding the crest of the wave of the future.

Scopitone's meteoric rise resulted in insupportable growth and unrealistic expectations. Coupled with the "novelty" tag the jukeboxes could never shake, this hexed the company as a solid, stable, long-term investment. And although never proven in a court of law, allegations of stock manipulation, statement rigging and mobster ties wore away at the company's credibility and gave ammunition to its enemies in the coin-op field who battered away with an organised smear campaign that ironically also helped tar competing juke-pix concerns.

Scopitone's relationship with inexperienced and in some cases unreliable and dishonest independent distributors — who were given unwise latitude in setting policy — definitely hurt. And, at least towards the end, the company itself engaged in shady tactics like serial-number shuffling to make it appear jukebox production was higher than it actually was.

The machines themselves are reputed to have been bug ridden film eaters, in other words, junk. Their supposed mechanical unreliability is often cited as a major factor in the demise of Scopitone, but is frequently disputed by collectors of the machines today. Considering the more complex mechanisms involved and the fragility of 16mm film stock compared to record vinyl, it's fair to say they were more or less satisfactorily engineered and built. Ultimately the biggest blow to Scopitone may have simply been the changing tastes of an ever fickle public. The same impatient public that had abruptly lost interest in soundies two decades earlier — the American public. By 1969 things had changed a lot from the heyday of Scopitone in 1965 when, for example, comedian George McKelvey's silly protest singer parody, *My Teenage Fallout Queen*, drew yucks from Scopitone quarter-poppers by goofing on physical mutations caused by an atom bomb blast. Scopitone had been swept up in a cloud of radical style and consciousness change and left in the dust. The public wasn't in the mood for "the same old song" anymore and Scopitone wasn't positioned to deliver on the new beat that might well have carried them into a new era.

THE GRAVEYARD YAWNS
Return of the Soul of the Slightly Living Jukebox

After the death of Scopitone, a company called INFORMX was contracted to find other uses for the jukeboxes. Training films were shown to medical staff on Scopitones, NASA showed films of rocket launchings to Space Center visitors, and machines were even installed in French coal mines to screen shorts promoting safety and security procedures to miners. Other machines were hauled to peepshow arcades, fitted with discreet "viewing hoods" and stocked with nudie and porno films in much the same fashion that Panorams had been ignobly reconverted twenty years before. Many of the monster machines, however, lacking any real value on the jukebox collector market, were junked for scrap metal or component parts. Others, heavy to move and expensive

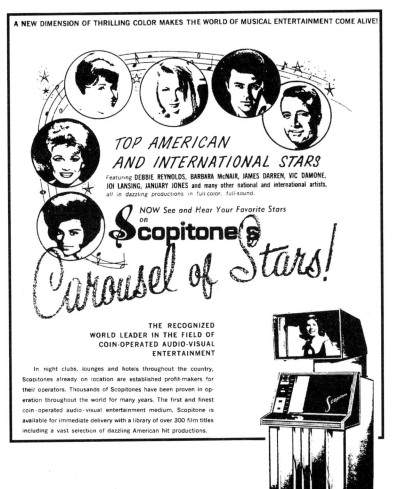

to ship, just sat where they were, forgotten and gathering dust in storage sheds and garages. Some were refurbished by collectors, a few found their way into various types of museums. For all that the general public knew about these things, they might as well have been sitting next to the Moon Rocks display.

It's been said that writing about Scopitones is like trying to breath life into an Egyptian mummy. But the mummy would rise: Scopitones are now generally conceded by those in the know to be forerunners to MTV music videos in format and style.

In France the general public has been reintroduced to Scopitones. The films are shown on TV and collected on video. They are celebrated manifestations of French pop music culture from the sixties. The same has not happened in America where, despite the reintroduction of soundies via TV specials and video releases, Scopitones remain an unknown quantity.

Sixteen millimetre film collectors have begun to seek out the films. Harman-ee productions are especially sought after with their Technicolor hues still aglow and fabulously vibrant. As noted, the rest, which were printed on Eastman colour stock, have faded, some quiet severely. The necessity of obtaining a magnetic-sound 16mm projector — rare in America — to show the films has contributed to their obscurity, and TV specials focusing on the phenomenon have reportedly never taken off due to complex film and music copyright issues.

Soon after its demise, Scopitone passed into the twilight of an American pop culture mythology already a-jumble with old coke machines, Victrolas and Wurlitzers.

To discover one of these jukeboxes still "on location" today would be the stuff of a *Twilight Zone* episode. But in fact at a jukebox convention in Chicago in 1985, Scopitone collector and newsletter publisher, Fred Bingaman, talked to a man who had a jukebox service route in Michigan. During their conversation the fellow told Fred that he still had one operating Scopitone on his route. It got very few plays per week, he said, but he still kept it on. Returning home to St Louis after the convention, Fred was full of questions about it and wrote to the guy.

He never heard from him again.

Italicised song titles in this chapter refer also to the existence of the song on Scopitone film.

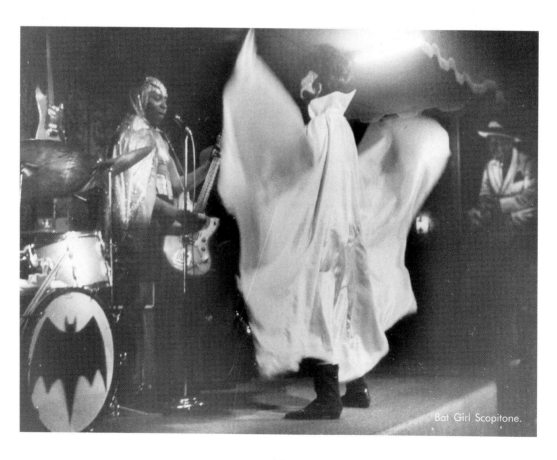
Bat Girl Scopitone.

A SECRET HISTORY OF CULT MOVIES

A Biblical tale of the Holy Unlikely

The Brattle Theatre.

FEBURARY, 1953 Under the management of Cy Harvey and Bryant Haliday, the barn-like Brattle Theatre that adjoins Harvard University in Cambridge, Massachusetts launches a booking policy of reviving famous actors then considered passé, including — even though he has yet to appear in The African Queen — Humphrey Bogart. The student clientele connects with Bogart's sense of style and a Bogart cult, based on Casablanca and fuelled by the fraternal college spirit, spontaneously emerges.

The Brattle's "Bogart Week" becomes a popular annual tradition at final exam time in May. The Bogart cult spreads across the country and many other college town theatres begin to book Bogart weeks in May as well.

Ritualistic response to the films grow increasingly formalised and obscuritanist. Rites of passage include tossing off the names and imitating the mannerisms of minor characters from Casablanca, and deducing the chronology of all of Bogie's films by reckoning solely on his receding hairline. Students boast to each other how many times they have seen the film, and chant lines along with their screen icons who also include Claude Rains, Dooley Wilson and Peter Lorre.

SOME TIME EARLY THAT SAME YEAR, ACROSS THE COUNTRY, IN HOLLYWOOD, CALIFORNIA "Twenty-six thousand dollars!" screams a rotund, perpetually worried little man, his face growing red and his tone rising as if some slumlord had just tripled the rent on his shabby studio complex. On the other side of his desk sits a fresh-faced young novice director named Ed Wood. Wood has just completed his first feature film and is being screamed at by his producer, exploitation mini-mogul, George Weiss, who has to his credit a string of programmers with titles like Pin Down Girls and The Devil's Sleep.

Weiss had assigned Wood to make a low-budget pseudo-documentary intended to exploit public fascination still swirling around Christine Jorgensen's recent sex change operation, and instead Wood delivers an over-budget and incomprehensible slice of skewered surrealism with lots of horror movie hokum dumped in for good measure. The film, Glen or Glenda?, is as personally felt as it is ineptly constructed. The pic is released in April and soon sinks into oblivion despite sales to some foreign territories. Had Wood crafted a slightly more professional piece of exploitation fodder, the world would never have known of him.

Land of a Thousand Balconies

THREE YEARS LATER, SOMETIME 1956 A phone rings in a cramped, grubby little office and an ill-shaven flim-flam artist named Dwain Esper picks up the receiver and answers in a monosyllabic and deeply suspicious manner that gives no hint that this is any kind of a "business". An old window fan clangs away, blowing hot air from the city street two storeys below over a mess of papers and film stills.

After a couple minutes of terse conversation, a smile spreads across his gaunt face... this broad on the other end of the phone seems to have money and she wants to buy this piece of crap called *Freaks* that he hasn't shown in years! The broad does indeed have money: she is Mrs Willy Werby of San Francisco, par-

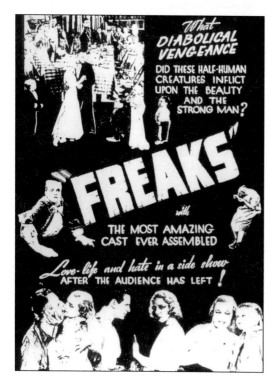

tial heiress to the Folgers coffee fortune. She runs the Camera Obscura Film Society in San Francisco and, at the urging of local Satanist, Anton LaVey, wants to include *Freaks* in a retrospective of classic horror cinema. This phone call represents the culmination of a long and frustrating search for the slippery Esper, who is also sought by a legion of lawyers, lawmen and bilked theatre owners.

Back in 1948, Esper bought rights to the MGM pic which was directed by Tod Browning in 1932. Despite uneven domestic box-office, the film was widely censored, cut and in a number of foreign countries banned

outright. It was a financial flop. Moreover the picture had been an embarrassment to studio brass from the outset. It had been buried at sea — almost literally, since rumour circulated that the negative had been dumped into San Francisco Bay.

Renegade roadshowman, celebrated shyster and charter member of the notorious "Forty Thieves", Esper had taken his customary approach with his post-war re-release. He jazzed up the publicity paper with lots of lurid hype and flogged his prints around on the roadshow circuit. In cities he played the seedy "main street" theatres, and in the countryside he would play any small town house that would take him, often "four-walling" or even playing tent shows just outside the reach of hostile law enforcement officials. As drive-in theatres began to proliferate at the end of the forties, he was there, invariably packing his "magic bullet" — a short "square-up" reel of actual nudity to satiate angry customers who sat through *Freaks* without encountering any of the depravity his posters so lavishly promised. He even hired a troop of real freaks to accompany the film, dressing up shows like circus acts with big canvas banners and the freaks performing live on sawdust spread out in the lobbies.

But all that seems like ancient history to Esper today as he sits in this shit hole office trying to fiddle up new schemes to save his sorry ass. His hey day had been the thirties and forties... time was passing him by.

This phone conversation will soon result in a meeting between Esper and Werby — and the resuscitation of the "dead horse" called *Freaks*, as she buys the rights (but must find her own print since he has no idea where there is one).

FIVE YEARS LATER, THE FREEZING COLD NIGHT OF FEBURARY 20, 1961 The Saga Biograf on Vesterbrogade in Copenhagen is rocking with laughter and whistles while up on the screen a winged reptilian monster is gamely attempting to smash a miniaturised version of Copenhagen while fake blood drools out of its mouth and its head lolls pathetically from side to side.

Sidney Pink, rotund, balding American theatre owner-cum-producer/director, is confused by reaction to his film, which, according to a reviewer from the Danish tabloid, *BT*, is capped off by hysterical crowd reaction.

A "prestige production" that had given rise to great anticipation in Danish film circles, *Reptilicus* would prove a bomb of gargantuan proportions. Saga Studios would quickly bury the thing but Sid Pink's reputation would live on — in infamy. To this day in Denmark, rumour has it that anyone in the film industry

who utters his name is tradition-bound to buy all within earshot a case of beer.

SAME YEAR, FIVE MONTHS LATER In The New Yorker Theater at Broadway and West Eighty-eighth Street on the Upper West Side of Manhattan, a toiling, unknown fashion photographer named Diane Arbus sinks into her seat as she gazes transfixed up at the screen. She's come every night so far this week to see this weird little depression era monster movie called *Freaks* over and over again. The movie has a very profound effect on her and will soon exert an influence on her work, on her vision of the world.

New Yorker manager, Dan Talbot, has booked the film for a week's run from the infamous indie distributor, Raymond Rohauer, who acquired the rights from Willy Werby. This run at The New Yorker, along with exposure at the Cannes Film Festival the following year, propels the film into full-blown revival status.

SOMETIME 1966, A HOT, STICKY BALTIMORE SUMMER NIGHT A skinny local film freak named John Waters journeys all alone to a drive-in movie theatre to witness *Faster, Pussycat! Kill! Kill!* after hearing a radio blurb scream that "it will leave a taste of evil in your mouth!"

Waters is electrified by Russ Meyer's tale of three evil, leather-clad, hell raising wildcats (women) out on a sex-and-violence spree, and he goes back to see the film night after night, dragging along anybody he can or sitting alone in a borrowed car. Up on the screen, Tura Satana's red hot glare and overstuffed curves menace the landscape for miles around. Waters joins up with the City's underground newspaper just so he can heap feverish praise on the movie, ostensibly in the form of film reviews.

The picture, in which sexploiter Russ Meyer had dropped the usual nudity so it could play the drive-in circuit, is a money loser that he soon writes off. He's entitled to a dud once in a while.

SOMETIME 1968, SOMEWHERE IN SAN FRANCISCO A skinny guy in his early twenties with greased back hair, bad skin and a real name that will never be known to anybody except cops and angry landlords, strips to his underwear and sinks onto a creaky mattress with a busty, sleazy broad about same age wearing too much make-up and a ratty blonde wig. They are in the process of struggling through an astoundingly inept thirty-minute softcore porno flick. Shot on the streets of San Francisco, in a porno bookshop on Sixth and Mission, and in the bedroom of a skid row flat, the pic is entitled *My Father's Call Girl* for no real reason, has no cred-

its and no record of its existence will survive its very short shelf life. This bedroom scene vividly reveals some of the most unappetising human flesh ever bared for a movie camera, and is so uninspiring that midway through their pawings the fake blonde pauses to reach into a drawer and put on even *more* lipstick.

The film, fodder for San Francisco's burgeoning porn cinema scene, plays a couple weeks at in Tenderloin storefront theatre before the reels are unceremoniously dumped into the back room to make space for the new XXX hardcore stuff coming on strong.

This film will never end up in the middle of a Ted Turner colorisation scandal (actually the colour *is* quite stupendous), this film will never be packed into a time capsule and fired into space, along with other masterpieces of human culture, to be found by some distant alien race and puzzled over.

But it will, in a less spectacular way, travel through time.

SAME YEAR, OCTOBER 16 Fledgling film director, George Romero, flips open his new copy of *Variety* to see what they've written about his horror film, *Night of the Living Dead*.

Talk about horrors…

Until the Supreme Court establishes clear-cut guidelines for the pornography of violence, Night of the Living Dead *will serve nicely as an outer-limit definition by example.*

Such a slam by the prestigious trade weekly, and the fact that the pic is clearly too extreme for mass youth consumption, seems to suggest that a premature burial awaits. The film opens at the Walter Reade in New York in December of 1968 and quickly fades.

LATE DECEMBER, 1970, NEW YORK CITY A nameless hippy sits in the balcony of a decrepit 600-seat New York City theatre called The Elgin and lights up a joint without worry. He ain't alone — the place is filled to capacity with other head cases waiting to have their minds blown. Is that John Lennon over there?… He figures he must be higher than he thought. (In fact Lennon was said to have attended these shows three times.) The lights dim, darkness envelopes the rabble and the projector beam slices through the reefer smoke to splash the first scenes of Alexandro Jodorowsky's surreal opus *El Topo* on the screen. It's playing at midnight because, as a poster announced, it's "too heavy to be shown any other way". The film was discovered by Elgin booker, Ben Barenholtz at a Museum of Modern Art screening. Barenholtz convinced the

Land of a Thousand Balconies

film's distributor, Alan Douglas (who at one point was Jimi Hendrix' manager) to allow him to play it at The Elgin, and the midnight movie craze is born.

LATE 1972, NEW ORLEANS John Waters, now broke and living in a squalid flat in New Orleans with two of his actors, is standing at an outdoor telephone booth making the nervous hand gestures of someone in an agitated state. With the help of a fraudulent credit-card number he's making another desperate phone call to his distributor New Line, in New York. He's trying to light a fire under their ass to get his recently completed feature, *Pink Flamingos*, shown. A disastrous "premiere" has already taken place at the South Station Cinema in Boston, a renegade gay porn house, where reportedly there was more action in the toilet stalls than in the theatre.

After a number of such calls, Waters gets New Line to convince The Elgin to give him a one shot slot at midnight on an upcoming weekend — with no advertising included. *El Topo* is fading out and they could use another "hit", although nobody is yet convinced that this might be it.

Waters drives straight up to New York City without sleeping, piloting his junk heap through a bad blizzard. Once there, he camps out at a friend's flat and tries to convince everyone he knows to attend the Elgin show. He manages to half fill the old barn and response is good. The Elgin gives him another weekend... Waters arrives to find lines around the block — all by word-of-mouth. The Elgin has found its next big hit.

SOMETIME 1974, SOMEWHERE A nameless copyright clerk in some office makes a typing mistake which allows the rights to lapse on Frank Capra's 1946 film, *It's A Wonderful Life*. The movie, a sentimental tale partially set during Christmas, is now in the public domain. A number of TV stations seize the opportunity to broadcast the film for free during the holiday season, and a revival is sparked for a movie that sank out of sight after disappointing reviews and box-office upon it's release.

EARLY APRIL, 1976, THE WAVERLY THEATRE, NEW YORK CITY The Waverly's low-paid janitor is sitting in the manager's cramped office complaining like hell. This new film they started running at midnight, and plan to play for months, is making his work a 1,000 times harder with all the rice and crap he has to clear from the floor in the morning. In fact, despite the janitor's bellyaching, *The Rocky Horror Picture Show* will stay on for a long run, and the Waverly's relaunch — instigated by a canny Fox Studio executive who noticed the picture had a loyal repeat audience — will send the film into orbit. All by word of mouth, since the advertising budget is virtually non-existent.

DECEMBER 1978 (EXACT TIME AND DATE UNKNOWN), NEW YORK CITY A twenty-four-year-old Brooklyn-born painter, guitar player, hipster and fifties movie buff sporting the pseudonym, Rudolph Grey, approaches the ticket booth of the Thalia movie theatre on Manhattan's upper west side. He has come to see a movie called *Glen or Glenda?* by a favourite director, Ed Wood, whose poverty row sci-fi features

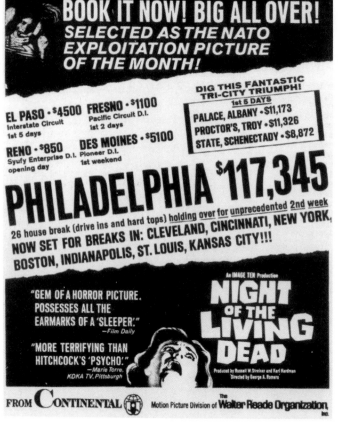

A Secret History of Cult Movies

used to pop up on his TV set in the early sixties.

He buys a ticket.

No force on earth can now prevent him from walking through those doors, but when he does, his life will be changed forever.

Upon seeing the film, he experiences, in his own words, a "revelation", and he will spend the next fourteen years of his life on an obsessive and quixotic quest to document the life and filmmaking of Ed Wood. What he lacks in financial resources or commitments from publishers, he compensates for with an unshakable faith in his cause as he sells off his movie poster collection and borrows money to fund his research. He will conduct hundreds of interviews, many of which he must travel to Los Angeles to conduct.

The book is rejected by twelve publishing houses. Grey is undaunted.

DECEMBER 10, 1978, 5636 LAUREL CANYON BOULEVARD, LOS ANGELES Ed Wood dies of a heart attack. Rudolph Grey will never get to meet Ed Wood in person, a fact that can only deepen, enlarge and magnify the mystery for him. Wood is no longer mortal man. He is now myth and legend and will eventually become the patron saint of all unjustly slandered and forgotten films and directors, a point of light in the void of darkness.

MID-SUMMER, 1981, EAST 42ND STREET, NEW YORK CITY The little Harold Clurman Theatre is screening a special show. John Waters, now America's foremost cult director, has been invited to program a double feature and has selected his own *Female Trouble* to pair with *Faster, Pussycat! Kill! Kill!* by Russ Meyer. A year before, in his book *Shock Value*, he published an interview with Meyer, and thanks largely to his efforts, by the mid eighties, *Faster, Pussycat* will be cult legend. He calls himself "the world's greatest fan" of that film, and if he has uttered only one truthful statement in his entire life, that is it.

The small theatre is only half full on this sunny, Summer's day. The author of this book, then living at the YMCA on Thirty-fourth St, is in attendance. He realises Waters, his idol, is there too, but he makes no attempt at face to face human contact and afterwards melts back into the crowds milling around Forty-second and Eighth…

SOMETIME 1983 The Medved brothers publish their book, *The Golden Turkey Awards*, proclaiming Ed Wood to be the world's worst filmmaker for his 1956 pic, *Plan 9 from Outer Space*. This sparks the first of several Ed Wood revivals, and his films start playing at

TOP John Waters
ABOVE The Elgin cinema, New York

colleges and repertory theatres.

Rudolph Grey, meanwhile, continues on his own lonely path. He detests the spirit behind this "Golden Turkey" Ed Wood revival which he feels is steeped in sarcasm and motivated by a smug and ironic condescension… essentially, a sacrilege. He perseveres in his search for splinters of the true cross: photo-stills, ad art, facts, memories, testimonials, lost films, rumours of lost films, articles of clothing, porno paperbacks, hardcore loops…

SOMETIME 1986, SAN FRANCISCO, CALIFORNIA Writer and film buff, Jim Morton, has just edited a book on cult and B-movies entitled *Incredibly Strange Films* in which he has included an essay on Ed Wood

Land of a Thousand Balconies

that refers to Wood's "obsession for cashmere sweaters". He quickly receives a note from Grey in the mail: Wood was obsessed with *angora* sweaters — not cashmere.

JANURARY 20, 1987, 1AM ON A COLD WINTER NIGHT IN THE HIGHLANDTOWN GHETTO OF BALTIMORE, MARYLAND Two robbers break into the row house of Johnny and Robert Eck. For two hours they ransack the house and terrorise the elderly brothers, demanding repeatedly: "Where's the money at?!" Johnny, born without a lower body, is pinned to the floor helpless. At 3:15AM the robbers finally leave with what meagre possessions they deem of value. "We feel very lucky," Johnny later writes to a friend...

they could have easily killed us and we would have lain here for days. (We have no caring neighbours). Our nephew shows up once a week on Fridays.

Johnny, whose role in the movie *Freaks* constitutes his "fifteen minutes" of fame, is forever changed and embittered by this event. That the robbers had repeatedly asked where the money was is ironic, because there was no money at all. The year before MGM/UA had

Johnny (left) and Rob Eck, with their pet dog, shortly before their robbery and assault.

proudly re-released the film on home video with elaborate packaging, but for Johnny this meant only a new cycle of harassment as a new wave of "fans" pestered him for his time and attention, driving him into seclusion. Since the early sixties, the film has undergone constant revival in different contexts, but for its charismatic young co-star, now grown old and despondent, it has brought no benefits. He refuses ever again to discuss it.

MAY 19, 1991, 8:50PM, ON VALENCIA STREET IN SAN FRANCISCO The Club Chameleon, a beat-up punk bar in San Francisco's squalid Mission District, is packed. A canvas screen, tied to water pipes, hangs above the stage while a 16mm projector is duct-taped on to a precarious tower of beer boxes in the back of the narrow room. Spectators crowd the bar for last minute beers. In ten minutes the gloriously obscure *My Father's Call Girl* — retitled *Sixth Street Love* in honour of its local roots — is set to play.

A print of *My Father's Call Girl* had been discovered in the basement of a house where an old porno projectionist lived and the thing begins to circulate, achieving some kind of threadbare underground notoriety via a round of screenings in clubs, bars and living rooms on clunky 16mm projectors.

A hardcore cult of about eighty worshippers are drawn to the film like a giant magnet. They quickly memorise the minimal dialogue and recite it along with the film or just whenever they happen to run into each other on the street corner or in a public bus. This phenomenon has parallels to the "cult of Pete and Ray" — two argumentative drunks (and roommates), whose years of absurd mutual abuse were taped by neighbours, released on cassette and circulated all over America to popular critical acclaim. Here in the movie, a similar jarring reality is achieved by the actors' complete inability to act, recite dialogue or in any way effectively pretend they are in a film. Hence the three principal characters, "the boy", "the girl" and "the old man" assume real life significance to adherents. No pretence of art, plot or "meaning" exists to filter or dilute the impact of their presence on film.

The movie embodies with unintentional brilliance the underground techniques for which artistes like Warhol had been deified: e.g. improvised dialogue, use of non-actors, non-editing, retarded camera work and a feeling of "real time" stretched out to torturous extremes. In short, it was a film of such appallingly "bad" quality that it became something much greater than just a failed film — it became an icon whose forty-minute running time was an ordeal to be gratefully suffered again and again and again. But unlike Warhol, this unnamed director wasn't intentionally dabbling in effete decadence and self-aware camp. *My Father's Call Girl* wasn't a put down, it wasn't irony. It was... well, nobody knows *what* is was, but anyway it was a hit.

A Secret History of Cult Movies

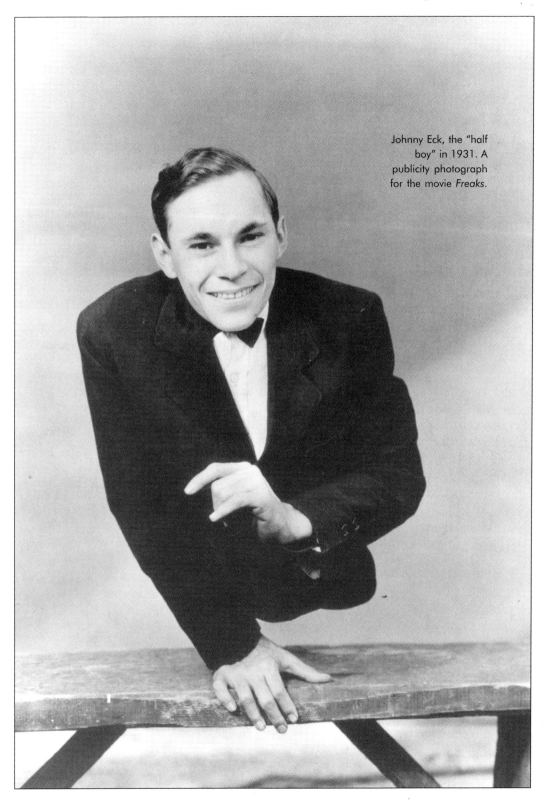

Johnny Eck, the "half boy" in 1931. A publicity photograph for the movie *Freaks*.

Land of a Thousand Balconies

SOMETIME EARLY 1992, THE HELL'S KITCHEN NEIGHBORHOOD IN NEW YORK CITY In a second floor walk-up papered with old movie posters and littered with old record albums and singles, Rudolph Grey reclines in a favourite overstuffed chair and tears open a padded envelope he just fetched from the post-office. It contains an advance copy of his book, *Nightmares of Ecstasy: The Life And Art of Ed Wood Jr*, published by Feral House.

After fourteen years of wandering in the wilderness, Rudolph Grey has found the light and delivered it. What he holds in his hands will lead to the resurrection of Ed Wood, a man he missed meeting in the flesh by mere weeks.

MARCH 5, 1992, THE CORNER OF 16TH AND VALENCIA STREETS, SAN FRANCISCO Tonight the Roxie Theatre is celebrating its sixteenth birthday party with a screening of founder Robert Evans' favourite film, *Female Trouble*, by John Waters. There'll be free champagne, door prizes and a competition of rotund Divine imitators. People stand in line for two blocks on grubby Sixteenth St to get in. It's a sell-out to be sure. There's a strange electricity in the air.

The motley collection of would-be Divines take the stage and attempt to scandalise an already jaded audience. One eager and bulbously overweight transvestite rubs a hunk of raw meat between his/her legs and hurls it into the crowd. An audience member flings it back at the stage and it hits the screen with a thud (evoking expressions of real horror from staffers who know the high cost of movie screens). Finally a winner is declared! It turns out to be a man who once led a normal life until his family was incinerated in a car accident and he shucked everything to go on the professional "Divine Imitation" circuit. He has clearly outclassed the competition.

During *Female Trouble*, an undertow of low, discordant mumbling becomes apparent… the audience seems to know by heart every line of dialogue, and reflexively they chant along like a crowd of head-injury patients at a hospital church service.

SOMETIME 1992 (NOBODY ON EARTH SEEMS TO REMEMBER EXACTLY WHEN), SAN FRANCISCO The Golden Peacock, a beat and tawdry function room on Lower Haight St near the seamy intersection of Fillmore, is — surprise — open tonight. A week ago some guy off the street handed the owner 200 bucks to open up and host some kind of low-tech multi-media fandango, the nature of which won't become any clearer even after it's over. Fifteen minutes before show time, with a light rain falling, no one is there… but soon people inexplicably start streaming in and by show time the room is full.

A loose cadre of boho-punk musicians have been meeting in a dingy Mission flat for a couple of months now composing a musical score for the legendary — and by now fabulously lucrative — cult movie, *Night of the Living Dead*, which serves as spiritual backbone for tonight's fricassee.

Three movie screens are tenuously strung up in the faded Sixties lounge room and a bunker of 16mm projectors are implanted among the tatty gold-vinyl couches while nutcase performers and eccentrics

THURSDAY, MARCH 5TH
★★★ THE ROXIE'S SWEET 16 PARTY…JOHN WATERS'
FEMALE TROUBLE… 7:00 & 9:30 … LIVE! DIVINE ★★★
★ LOOK-A-LIKE CONTEST (Applicants R.S.V.P 431-3611) 7:00 SHOW ONLY…
Celebrity jury… FREE DOOR PRIZES… FREE CHAMPAGNE!
ROXIE
3117 16th (at Valencia) 863-1087

Tours Through Genre and History

A Secret History of Cult Movies

projectors beam out images of bats, live birth footage, religious sermons and other flotsam in a choreography of frenzied free-association which organiser, Jacques Boyreau, has created with the most profound of intentions.

AUGUST 27, 1993, A NAMELESS WAREHOUSE IN THE CHINA BASIN DISTRICT, SAN FRANCISCO
Boyreau strikes again in a large industrial loft inhabited by a collective of punko squatters. Another inexplicable multi-media orgy with a line-up of local underground bands this time, and, of course, again, the movie that obsesses him: *Night of the Living Dead*. All three reels of the film are shown simultaneously on three 16mm projectors, the images aimed at white sheets above the bands at odd angles to give the film an hallucinogenic quality.

SOMETIME LATE 1993, LOS ANGELES, CALIFORNIA
Tim Burton is in the midst of directing his new $18 million B&W film *Ed Wood*, when he spots Rudolph Grey hanging around on the other side of the set. Burton gives a few low-key instructions to a nearby studio flunky and a minute later Grey is escorted off the set. Burton can do without Grey's purist input as he sets about repackaging the Wood legend for mass consumption.

Burton, like Grey, first encountered the films of Ed Wood on late night TV in the 1970s — the showcase that would prove to be a seedbed for the cult revivals of other Z-grade directors, such as Al Adamson and Larry Buchanan. These low-budget Don Quixotes who struggled thanklessly to make movies at the margins of the industry would offer up a new set of saints to a lost TV generation seeking beatification.

In 1992, Burton reads Grey's book. Here finally was sufficient documented background material on Ed Wood to support a feature-length bio pic. A reported $250,000 is paid to the publisher for the film rights with Disney's Touchstone Pictures producing. A-list talent such as Johnny Depp, Bill Murray and Martin Landau are signed to star.

Ed Wood is released in the summer of 1994 and, despite ho-hum overall box office, generates enthusiastic press and proves a strong attraction at film festivals. It even enters competition at Cannes. Its merchandising spin-offs are many, while a tie-in reissue of Grey's book, with new cover, is rushed to the printers. A script book is soon also published while a welter of Wood related film and video documentaries surface like mushrooms after a hard rain. The last and mightiest Ed Wood revival is in full force. All the old Ed Wood films are put back in theatrical distribution —

The Roxie anniversary bash.
TOP Divine in action… genuine or imitation?
ABOVE The Roxie cinema today, at Sixteenth and Valencia Streets. Loitering drug dealers attempt to shield their faces from the camera.

ready themselves. The show starts with *Night of the Living Dead* unspooling on the main screen. Below, in a makeshift "pit", the orchestra (drums, French horn, oboe, electric guitar, etc) strikes up on cue between slabs of dialogue with skewered musical interludes while various imponderable live acts, including a tap dance, spring to life. The audience is bewildered… but happy. They respond with lusty applause. The two other

Land of a Thousand Balconies

even in Helsinki, Finland! Soon every extra who ever appeared in a crowd shot of an Ed Wood film is touring the movie convention circuit, surrounded by hyper fanzine editors.

Ed Wood is now being revived and marketed in a way that few B-filmmakers ever dreamed possible. With an $18 million wave of the wand, Disney rolls away the rock from Ed Wood's tomb and the figure that emerges looks uncannily similar to the one that appeared on a joke 3-D Christmas card in the late fifties: Ed Wood in the robes and supplicating pose of Jesus Christ.

AN OCTOBER NIGHT, 1994, AARHUS, DENMARK Down in a basement cinema club they're showing *Reptilicus* tonight. The fifty seats are starting to fill. Bottles of Thor beer are sold for cheap over the makeshift bar as a buzz of expectation charges the atmosphere in this mouldy stone crypt.

In fact most of crowd already knows the film. The thing is a revered Danish cult classic and has regenerative powers equal to its star monster. It survived a premature burial after its disastrous premiere only to rear its head on late night television sets worldwide to the mortification of all serious Danish cineastes, the kind of folks who are also bewildered when Nordisk Film tries to distribute *Ed Wood* here. But a younger generation of Danes, plugged into the American B-movie aesthetic, feel a kind of patriotic tingle when they see the winged reptile smash up the scale model version of Copenhagen.

Reptilicus is finally beloved... although it might take another thousand years for Sidney Pink's reputation to recover.

JULY 19, 1996, THE LOWER EAST SIDE, NEW YORK CITY On a sweltering New York City night in a small unventilated movie theatre at 116 Suffolk St, owner/operator, Dennis Nyback, walks up to the screen and turns around to face the pathetically small crowd that has showed up for his "Marsha Brady Fetish Night". In fact only six people are here to see his collection of *Brady Bunch* episodes and sex education films starring Marsha Brady, aka Maureen McCormick, whose perky, plastic presence has earned her cult status as the ultimate seventies' suburban doll face. Now he must give away the award for best Marsha Brady look-alike... even though only two of the six people in attendance are females, and neither of them looks *anything at all* like Marsha Brady...

In three months, The Lighthouse theatre will be closed, but over the course of its year-long existence, it will function as a temple — or at least a crash pad — of cult film, screening gems like *The Meatrack*, *Wild In The Streets* and a collection of Mormon soap operas, just to cite a few examples of cult arcana from Nyback's archive.

NOVEMBER 19, 1996, AT 18:50 ON A RUSTY CARGO SHIP MOORED IN SVANEMØLLEBUGTEN HARBOUR IN COPENHAGEN Bizarrely costumed figures tip up the gangplank to the floating cinema ship, Hela, outlined against the deepening blue of the autumn night sky. They have come to experience *The Rocky Horror Picture Show* on the twentieth anniversary of its rebirth, and now descend down a cramped, circular staircase to the "theatre" where the boat's

owner has installed 35mm and 16mm projection (with future plans to construct a bowling alley below in the hold). Old car seats and patio tables have been installed to create a cosy if surreal cafe atmosphere in the viewing room, while a truncated pølse Vogn has been brought down and reassembled to dispense frying sausages, beers and wines. The owner, who bought the ship cheap at a police auction (after it was im-

pounded from drug smugglers) plans to sail the tramp freighter to Poland at some point, but it hardly looks seaworthy. It recently served as a location in *Breaking The Waves* — it was here where sadistic captain Udo Kier savaged Emily Watson.

This is the perfect atmosphere in which to watch *The Rocky Horror Picture Show*. Since its relaunch at the Waverly it has gone on to become the greatest cult film of all time… And when a big ship sails by, the whole production rocks languidly.

DECEMBER 5, 1996 *The New York Times* runs a substantial piece on the fiftieth anniversary of *It's A Wonderful Life*, paying tribute to what has become perhaps the most beloved cult film of all time. "Thank God those fools let the copyright lapse," Capra remarked before his death at ninety-four in 1991, "otherwise no one might have ever seen it."

Thus is offered up a messy slice of cult film lore. There is nothing "definitive" about it because nothing about the subject is representative, typical or, least of all, predictable.

Cult is antithetical to current movie making and marketing wisdoms which dictate that every aspect of a film must be quantifiable, the grist of endless script and shooting conferences. Any ambiguity is steamrolled out by script doctors and consultants sitting next to a stack of test-screening surveys.

Cult film is all about the individual *discovering* something — not being *sold* something. It is about being divinely *touched*, not *targeted*. It is about being consumed by a film, not consuming it. And it is all about being surprised or even ambushed by a film, rather than having it pre-digested for you by a legion of critics and pundits. Whereas journalism "makes" a mainstream film, it more often than not "kills" a cult film which cannot be introduced second-hand to a wider audience without destroying it. Marketing and journalism in the orthodox sense were never part of the cult film picture.

Today, nothing "uncanny" seems to get through any more. "Word of mouth" is all but dead, and conservative exhibitors don't let strange little films stick around long enough to find their audience. More often than not the weirdo titles just go straight to video, a more financially feasible option as renegade independent exhibition gives way to a mass-market multiplex approach nourished by big-budget "blockbusters".

In essence, cult film is the history of the damned, the forgotten, the obscure and the misunderstood. It's a story of miracles unwittingly conjured up by acts of fortuitous timing, startling coincidences, bolts of shit luck hurled from outta the blue and simple book keeping mistakes… a string of wrong turns that suddenly lead in the right direction, or at least lead into the sunlight… or at least for a few seconds. It's the story of movies that refuse to stay buried. Dumped into early graves, they emerge again to haunt the living. Some are way ahead of their time, some are way behind.

If in some cases it all seems like divine fate, in other cases — as we have seen — it owes all to acts of individual persistence, obsession and almost inhuman self-belief that calls to mind the stuff of the early Christian martyrs and saints.

Equating cult film with religion is an all too obvious and overused analogy, but on the other hand *It's A Wonderful Life* probably got more people to believe in angels than Christianity ever did. Ed Wood's transformation in 1953 from Glen to Glenda, surrounded by dutiful extras spinning pirouettes like idiot schoolchildren, was an intensely religious transformation, a transcendent moment. And while no director as yet turned stones into loaves of bread, John Waters turned dog shit into gold — and a career.

On a cold day in November, 1996, outside a movie memorabilia shop in suburban Detroit, a mob of people shiver for hours waiting to meet a fifty-six-year-old woman named Karolyn Grimes who was long ago employed a Hollywood bit player. In 1946 she was cast as Zuzu, the little daughter of George Bailey (Jimmy Stewart) in *It's A Wonderful Life* — and her own life would be forever changed.

People cry when she finally appears. One man claims the movie has saved his life. She is a beacon of hope and innocence.

She is something to believe in.

THE GOOD, THE BAD AND THE STRANGE

Christmas Cult Movies

Christmas has always been the most spiritually profound and emotionally packed holiday of all, and this is reflected in the wide range of Christmas films that have been produced. This special day, so richly encrusted in fantasy and legend, has proven to be particularly fertile ground for take-offs, parodies and variations on its theme, and by this, Christmas has staked out its own territory within the cult film genre. Not all cult films have a Christmas connection, of course, but no other holiday, including Halloween, effects us so deeply, inviting us to believe — or disbelieve — with such emotion.

Americans plug into the myths and fantasies of Christmas in wildly schizophrenic ways. It is the season of violent mood swings and extreme sentimentality, a season which demands from us good will and compassion and yet deals out tons of dashed hopes and expectations, as witnessed by the record number of breakdowns and suicides that invariably occur during Yuletide.

And like anything passed down from antiquity and bathed in a halo of religious purity, it begs for reaffirmation as well as debunking, inspiring both maudlin veneration and blasphemous, bloody satire as filmmakers seek to offer updates on age-old motifs.

Christmas cult movies fall into two distinct and opposite camps; those which seek to reaffirm the basic goodness in the human heart, and those which use the festive trappings of the holiday season and the pervasive spirit of trust as ironic counterpoint to man's crude and evil urges, presenting Christmas as an impossibly idealised concept begging to be defiled.

Those films that seek to reaffirm the goodness in humankind are usually soaked in nostalgia and tagged with tear-jerker happy endings, and we are all too familiar with them; *It's A Wonderful Life*, *A Christmas Carol* and *Miracle on 34th Street*, being three of the best known. But during a time of the year when there is so much pressure to be virtuous and happy, some people naturally rebel. It is, in short, the perfect time of the year for things to go disastrously, and sometimes hilariously, wrong. And those films that seek the badness instead of the goodness — now *that's* a lot more interesting, fun, scary, and in a lot of cases downright therapeutic.

Cult film-maker, John Waters, was always keenly aware of the potent duality inherent in Christmas, and unforgettable Christmas scenes highlight two of his biggest underground hits. In *Pink Flamingos* (1972), the evil Connie and Raymond Marble gift wrap a dog shit in a box and mail it to Divine, a 300 pound transvestite, on Christmas, as Christmas carols blare on the soundtrack. In *Female Trouble* (1974), Divine plays the role of teenage schoolgirl, Dawn Davenport, with glorious implausibility as she towers above her parents. Pissed off with her present, she flies into a rage on Christmas morning, stomps the unwanted gift to pieces like a bull elephant and pushes the Christmas tree over on her mother in a scene that just might be Water's most hilarious. Christmas seemed to bring out a kind of slavish devotion to family values that set John's teeth on edge. If others saw the holiday as a time to look inward and find the goodness, he saw it as a time to look inward and find the weirdness.

Another gift wrapped atrocity from 1974 was *Black Christmas*, a stalk-and-slash fest from Bob *Porky's*

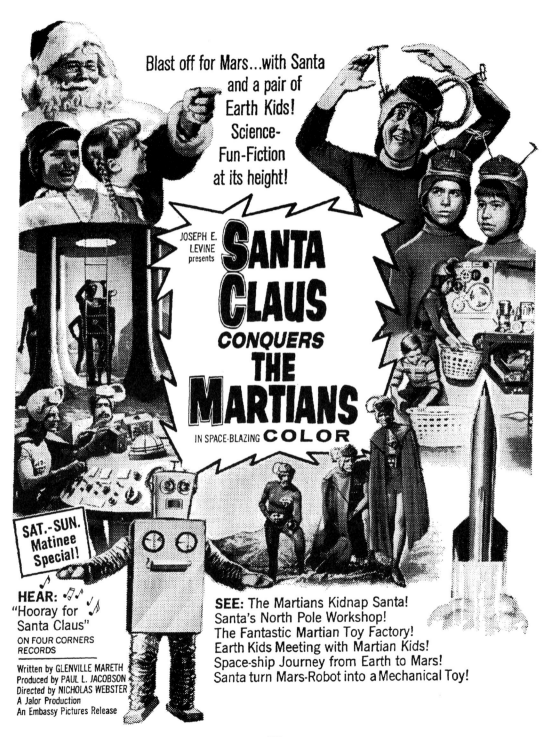

Land of a Thousand Balconies

Clark. Ex-Juliet, Olivia Hussy gets terrorised in this fan favourite and shows how fast careers can go down hill.

While both Waters and Clark went on to more mainstream styles in the eighties, other film-makers, like Jon Moritsugu, held firm to the low ground, and it is in his short movie from 1988, *Sleazy Rider*, that another notable underground-style Christmas burlesque appears.

A wholly irreverent ransacking of *Easy Rider*, Moritsugu's film is a crude, low-tech trash tale of two mean teenage biker chicks who terrorise the innocent, take drugs and generally act awful as they trip across the country on Harleys. At one point they arrive in Pleasantville USA, and, looking for gas, invade the home of the "Virgin Mom", a psychotically cheerful

and wholesomely middle-class lady played with nauseating niceness by Wendy Edwards. Of course when they break into her home it happens to be Christmas! They destroy her house and Christmas tree and slash the stuffing out of her stuffed donkey to boot, only to later die in disgusting fashion from the Christmas cookies she had slipped to them with the sweetest holiday smile — poisoned as they were with PCP and LSD.

Other cult films offer dark permutations on the sacrosanct figure of Jesus. Although not a Christmas film, Roman Polanski's 1968 cult masterpiece, *Rosemary's Baby*, gives the proverbial manger scene a reverse twist by placing the Devil's baby in a crib and surrounding it with evil, grinning witches instead of the gently smiling wisemen and shepherds.

But in America the face of Christmas is the face of Santa Claus. Old Saint Nick offers a host of dramatic and perverse possibilities. Here's a fat man in a weird costume, face hidden by long hair and a beard, who sneaks down the chimney into your house without permission and messes around while everyone's asleep. Parents line up in department stores to let their children sit on his lap and confess their fondest desires — even though we know he's a total fake.

Santa has long served as a tempting target of sometimes pornographic parody, and has also been cast as an inscrutable menace who disguises evil intent behind the cheery smile of the nicest man on earth. (Anyone to whom we give our complete and unqualified trust is naturally in a position to betray that trust and do evil.) An evil, murderous Santa Claus is more shocking than Halloween's stock procession of witches, ghouls and devils precisely because he is cast against type.

In the eighties, while the splatter film genre still had some blood pumping through it, a number of variations on the "evil Santa" theme cropped up in several commercial horror pictures that explored the dark core at the heart of the fat man in red. The 1980 film, *Christmas Evil* (aka *You Better Watch Out*, aka *Terror in Toyland*) centres on the dangerous delusions of a toy factory foreman, played by Brandon Maggart, traumatised at youth when he witnessed his mother having sex with "Santa", an experience that left him obsessed with all things Christmas. Now grown, he obsessively indulges in the rituals of Christmas, such as keeping lists of which children have been "naughty or nice". Finally, in full Santa costume, singing "Santa is Coming to town", he sets out on a murderous rampage. (The film's tagline was "He'll Sleigh You".) The picture was rereleased in 1983.

In 1984 the Charles Sellier-directed splatter film, *Silent Night, Deadly Night*, stole the spotlight. The film centred on an axe-wielding psychotic disguised as Santa Claus, and was, despite being a very effective little horror movie, universally and savagely slammed by critics upon release. Roger Ebert, America's most influential movie critic, worked himself into a self-righteous rage over the movie on his nationally syndicated TV show, damning it as indefensible bad taste. And this from a man who once co-scripted a film (*Beyond the Valley of the Dolls*, 1970) about an LSD-tripping gay Hermaphrodite mass murderer running around in a cape and fake tits and swinging a sword. Hermaphrodite killers on LSD we could swallow, apparently, but

Tours Through Genre and History

The Good, The Bad and The Strange

not a bad Santa!

The outrage over *Silent Night, Deadly Night* was overwhelming and exceeded anything that the *Halloween* films ever provoked. Theatres were picketed and angry editorials were dashed off across the land. "What's next?", moaned critic, Leonard Maltin, "The Easter Bunny as a child molester?" Thanks to the outcry, the film achieved minor cult status and spawned a sequel in 1987.

Santa has thrown spooks into kids on a much subtler level as well, and is no less frightening for it. The nightmare sequence that opens the visually stunning, 1995 French film, *City of Lost Children*, about an evil scientist who invades the dreams of children, is a case in point. It begins innocently enough, but the apparently kindly Santa who first enters the little boy's room multiplies into a roomful of sinful doubles, one of whom guzzles booze and throws up on the kid's floor.

An earlier film that also portrayed Santa as an ambiguous spiritual presence was the 1959 Mexican film, *Santa Claus*, directed by schlockmeister, Rene Cardona. It later played for America kids thanks to the efforts of K Gordon Murray who released it in the US. In this sub-epic, Santa battles the mischievous "Old Pitch" for the soul of a peasant girl who desires a doll for Christmas, and a rich boy who longs for nothing more than the loving attention of his night clubbing parents.

Other portrayals of Santa rendered the old fatty as a more benign if simply bizarre figure: who can forget Crispin Glover's brief but effective cameo as a loony psycho Santa Claus in David Lynch's 1990 film, *Wild At Heart*? And who can forget the 1964 film, *Santa Claus Conquers the Martians*? A lot of people, apparently.

The story unfolds as Santa and two earth kids are kidnapped by green Martians and a robot. Santa is forced to make toys until he leads a revolt and escapes back to earth just in time for... Christmas! Acclaimed as one of the very worst movies ever made, this poverty row science-fantasy oddity, directed by the obscure Nicholas Webster, was certainly one of the most outlandish. The film's cult status is enhanced by the fact that Girmir, the green Martian midget, was played by a perky little actress who would grow up to trade in trash of a more mature nature, acting with camp abandon in films like *Butterfly* and *Lonely Lady* that were loaded with incest, perversion and rape. And that was Pia Zadora. But it was as Girmar that she made the greatest contribution to cult lore.

Santa might escape from Mars, but nobody, it seems, can escape from Christmas. And whether or not Old Saint Nick is showing someone the meaning of life or showing them their own intestines, he's the big guy we love. Even if he *can* be strange.

OF CULT RELIGIONS AND CARS THAT FLY

A Look Back at the Future that Never Came

Now that the New Millennium is upon us, "the future" — a concept and creature quite separate from the mere recorded progression of time — has returned to haunt us in all its fantastic and frightful glory.

Having closed the lid on the second millennium, it's time to take stock of some of the more extraordinary ways in which this chimera, the future, has taken shape and substance on film.

In a post-war America flush with optimism and prosperity, the specific and quantifiable commodity known as the future was born. It was the password to fabulous luxuries and comforts to be had in a space-age world of all things possible, a world cast in new miracle materials — many of them recently developed for military purposes — and draped in new fabrics. The future was fashionable, and one never grew tired of it because it never actually arrived.

But it did eventually end, or at least our love affair with it did. That ended in the early seventies when economic and environmental crises brought us all back to earth. An earth of finite resources and fragile balances. Technology became the devil, not the saviour. The concept of "future shock" was introduced in a book by Alvin Toffler and a documentary film of the same name hosted by Orson Welles.

The golden age of the future then, as it existed in a distinctly American context made possible by post-war prosperity and privileged isolation, spanned from the late forties to the early seventies. Within this period a series of "futurist" styles in fashion, architecture and consumer product culture were born and faded away. This type of consumerist futurism, distinct from the formal artistic movement, became an end in itself: it was the act of foretelling the future in some marketable, new creative expression that mattered, not the accuracy of the prediction. The styles produced by this movement, transitory by definition and wholly imaginative, dated rapidly.

Of course innumerable science-fiction films — by nature "futurist" — have visualised the future for purposes of dramatic entertainment. But this genre of

The FX-ATMOS, a future experimental car model designed by Ford in the fifties. Note the tail fins that indicate the car might be able to swim or fly.

feature films, so often addressing bold and profound themes and reaching a zenith of sorts in the thirties, was basically escapist, while the future discussed in this article was consumerist and born in the post-war period. If a portable jet pack was involved here, it was so a man could fly to work, not to Mars.

From a sociological perspective then, it's more interesting to set aside consideration of science-fiction feature film-making and concentrate on the depictions

Artist's conception of life in the future that appeared in an American magazine of the fifties.

of the future as they were manifest in the typically short, 16mm, non-commercial films of the "parallel" cinemas. This encompasses a largely unheralded body of work produced by educators, religious groups and industry to be screened in classrooms, church basements and at employee training conferences.

Here in these secret corners of exhibition the illusive concept of the future took form in some of its most unusual variants.

FUTURISM FOR PROFIT
Consumerism Unbound

Dreaming about the future was a luxury few Americans could afford in 1940, as the country entered into a war that the Allies were in the process of losing, but that didn't stop the General Motors car company from producing a twenty-two minute film entitled *New Horizons* which promoted a concept dear to the auto industry: personal — not mass — transportation. The film depicts a sixties style futurist landscape centred around the automobile.

Although he had different ideas about the future world order, Hitler was on the same page with General Motors here. His backing of the Volkswagen, or "people's car" which ideally every German could afford to own, was a concrete manifestation of this philosophy.

Following the war, industry was retooled to produce consumer goods, and this trend was reflected in films like the 1947 promotional, *Looking Ahead Through Rohm And Haas Plexiglas*, which demonstrated how Plexiglas, used extensively in airplane cockpit canopies during the war, could now be used in the manufacture of paperweights, toys and vases.

The film also depicts a bizarre "Dream Suite", a room appointed wholly with Plexiglas materials. Such wildly impractical visions were created by advertising executives training consumers to "dream', not by designers or engineers concerned with the practicality of everyday use. "Dream" was the key word in this era of all things possible, and in a style sense, the strange and almost surreal excesses of the products and lifestyles envisioned made them unique.

The Detroit-based Jam Handy film company — named after founder, Jamison Handy — made both of the aforementioned promotionals and stood as the most prolific and influential producer of industrial informational films, staying active into the seventies. Jam Handy worked with almost every major industry to promote everything from coloured telephone sets and new refrigerators to the construction of the interstate highway system and the first major American suburb, Levittown. Its films read like a roadmap to the future as it unfolded in the fifties.

At the heart of the future lifestyle existed the white, middle-class nuclear family which enjoyed unlimited consumer consumption and leisure time. Ad execs were not troubled by as yet non-existent issues of race and class, exploitation of the environment and unfair distribution of wealth and natural resources. The fifties were bounded only by the limits of the ad man's imagination as he sat in front of his sketch pad and... dreamed.

"Nuclear engines, radar, retractable wings, a pressurised, water tight body?", speculated a late fifties promotion for the auto industry.

Land of a Thousand Balconies

Perhaps by 1964 these features will be standard — your family sedan will fly and swim too. But one thing is certain: Detroit will never compromise with the sound functional engineering that has made American cars the envy of the world.

As impractical, as impossible, as doomed (and arrogant) as these consumer-driven dreams appear in retrospect, they added up to create a strange and coldly beautiful world, a modular, prefabricated and preassembled world that lacked only living, breathing people... people who would spring to life in films like *Design for Dreaming* that featured a couple dancing around futuristic night-time cityscapes.

A Touch of Magic, produced in 1961, again by General Motors Corp, unspools as something of a "cooled down" version of *Design for Dreaming*. "All we see in *A Touch of Magic*," notes industrial film historian Richard Prelinger, "are the new 1961 car models — where have all the dream cars gone? Could it be that the future has finally arrived?"

Not according to the Ford-Philco Corp, which produced the twenty-five-minute *Year 1999 AD* in 1967 to commemorate their seventy-fifth anniversary by envisioning the lifestyle of the "family of the future". Although a futuristic automobile makes a striking appearance at the start, the film concentrates on the more mundane accoutrements of domestic family life.

The Arrival, a film by the Unarius Academy.

The idea of the future was embodied by that most coveted of consumer commodities, the automobile, which one in every five American workers would be in some way contributing to the production of. It was here that the common man could own a piece of the dream. Automobile design is stressed in many films, one of the more extraordinary being Jam Handy's 1958 film for General Motors, *American Look*, in which futuristic "dream cars" are displayed alongside other futurist consumer products.

Reality soon began to intersect with the dream. The common man would never get his hands on a dream car prototype which might only be displayed at an auto show, but he could buy a 1958 Thunderbird with its exaggerated tailfins and an aerodynamic design that suggested it really could fly.

Starring popular TV game show host Wink Martindale as the father, the predictably white family of three in *Year 1999 AD* sport hairstyles and social attitudes that are straight out of the sixties. The film introduces technologies already then in the developmental stage, and accurately predicts modular home construction, home computer shopping, and the use of video monitors for surveillance. Other "innovations", such as a closet that shakes and steams clothes clean while still on hangers, are simply absurd. References to the "central home computer", on the other hand, where the family's collective "vital information and its 'secrets'" are stored seems downright sinister.

The film attempts to present all these advances as liberating, but the overall impression is of a lily white family isolated by its wealth, controlled by its comput-

Of Cult Religions and Cars That Fly

ers and imprisoned in a sterile environment by supposedly beneficent technology.

FUTURISM FOR SPIRITUAL SALVATION

While the future appeared to hold out the promise of boundless material gains and comforts, in its imponderable vastness it also held the key to our spiritual awareness and salvation. A very different and more complicated kind of future is depicted in the films of religious organisations as diverse as the Church Of Latter Day Saints (Mormons), the Paulists and the Unarians.

For Time or Eternity, a twenty-five-minute drama directed by Wetzel Whittaker for the Morman church in 1970, visualises Mormon concepts of pre-existence and immortality where souls, not products, are the coin of the realm. Characters in romanesque robes and sixties flip hairdos debate spiritual issues in a cushioned and pillared state of "pre-existence" which translucent superimpositions imbue with an aura of other-worldliness.

Whittaker's film is as woodenly moralistic as the Jam Handy pictures are coldly, if stylishly, manipulative. Unburdened by any pretensions to great art, both kinds of film-making, however dissimilar in philosophy, deliver their messages in terms so amateurishly straightforward that they attain a kind of uncanny sincerity. One is entering the realm of the true believer.

In 1977, the Paulist media production group in Palisades, California, produced *Christmas 2025* — a half-hour episode of their *Insight TV* series which starred many of the top actors of the period in hard-hitting dramas that sought to address the topical moral issues of the day in a relevant, modern style.

This episode, directed by Douglas Meredyth, plays out as an absurdly low-budget take on *Nineteen Eighty-Four* and stars a young James Cromwell as a Christ-like figure named George in what must be the most bizarre performance of his career.

We see the soulless, frightening world of 2025 where individualism is subservient to the new God, National Efficiency; where the utterance of words like "love" and "Christmas", or the display of any

ABOVE Images taken from *The Arrival*.

BELOW A scene from *For Time or Eternity*, and (right) Uriel, Cosmic Visionary.

human emotion, is punishable by death. When tempted to express natural feelings, citizens are instructed to stare into a "reality gauge" in which their reflection appears as a skull.

The most ambitious attempt to depict the future in a spiritual context is found in a one-hour film from the mid eighties entitled *The Arrival*, a "space saga" made by the Unarius Academy of Science of El Cajon, California which, among other activities, offers courses in past life therapy.

"This is a true story of reincarnation," we're informed in the Academy's publications catalogue…

inspired and re-enacted by individuals reliving their past on the continent of Lemuria 156,000 years ago. Zan, an aborigine, is contacted by an immense spaceship. In telepathic conversations with the Space Brothers, he is awakened from his psychic amnesia to become aware of the reasons for his mental frustration and discontentment with life.
Zan relives his past as a spaceship commander of an Orion battle cruiser, at a time 200,000 years previous, when he helped to destroy an entire civilisation of people!

Despite drawbacks like the hypnotic acting style, the use of poorly concealed skinhead wigs and a sub-*Star Trek* look to the space cruiser, the film delivers its message with a naïve sincerity that is strangely effecting, and the special effects are stupendous. "Cosmic Visionary" Ruth Norman, one of the founders of the Academy, appears in space amid sparkling blasts of colour as a kind of galactic Good Witch Of The East.

Predicting the future will continue to remain a participant sport for ad men, amateur inventors and religious proselytisers alike, and their predictions will consistently prove to out-do what finally arrives in ways both oddly compelling and wholly revealing.

We don't have to wait for the future itself to experience the strangest extremes of futuristic styles, attitudes and products, and we don't have to wait for the future to come to find salvation within it. As we've seen, all this already exists, captured on the archaic medium of celluloid 16mm wide that's clipped onto a clanking old-fashioned movie projector whose beam flickers back into the past… to take us into the future.

A future that never came.

VIDEO SOURCES
Prelinger Associates, Inc.
http://www.prelinger.com/
http://www.archive.org/movies/index.html

Unarius Academy of Science
145 S. Magnolia Avenue, El Cajon,
CA. 92020–4522, USA. Fax: 001-619-447-6485

HAIL, THE CONQUERING THIEF!

Forget Orson Welles and Alfred Hitchcock, but remember Dwain Esper and Raymond Rohauer! Welles and Hitchcock could *make* a good movie — Esper and Rohauer could *steal* a good movie.

There is an old wisdom that says a movie only has value if its grinding through a projector and being *seen* — not sitting in a steel vault being preserved, not living its life being celebrated on the pages of film journals, and not being financially dissected and exploited in absentia by accountants... but being seen in a movie theatre by a public. If this wisdom rings true, and surely it does, then we must pull these two guys feet first out of the stinking garbage can into which proper film historians have consigned them and place their much maligned asses on thrones (however unsteadily they would remain there, since both are long dead)!

Dwain Esper as previously noted single-handedly revived the 1932 "monster movie" *Freaks*, after the studio disowned and buried it, while Rohauer, who moved in somewhat different circles, took over the film later on. That movie had more dirty fingerprints on it than anything else that ever came out of Hollywood. Rohauer's *modus operandi* was specialising in violating existing copyrights and creating new ones by tracking down the author of the story upon which the film was based and buying the rights, thus acquiring them retro-actively long after the film was made. In this way Rohauer stole *The Sheik* away from Paramount. He had once worked as a gravedigger and apparently knew something about body-snatching.

Esper, a member in good standing of a group known as "the forty thieves", specialised in the outright theft of prints from both studios and independents. He then ran them to death on the road-show circuits, all the while dodging cops, creditors and a herd of angry lawyers.

So what if they were greedy, crafty, *evil,* lying, cheating sonsofbitches? So what if they left a trail of bad debts and broken promises behind them and made bitter enemies of everyone with whom they ever had a single business transaction? So what? They must have had *some* good qualities... maybe. But in all their tarnished, illegitimate glory, they *did* put films on the screen (however cut or poorly duped some of them might be) and became folk heroes after a fashion. They were also thorns in the side of many film *institutions*, and for that they deserve credit. Many people feel that film exhibition is the exclusive province of such institutions, what with their governing boards and their funding and their aura of proper taste and right decisions and general "legitimacy". If two individuals could make a dent in this world, let alone lay waste to it, more power to them.

In fact these guys were the *real* Americans in my opinion, and thinking about them is the only way I can manage to stir up an inkling of patriotism. Forget John Ford, forget modern auteurs like Lynch and Tarantino. And remember James Cagney and Bonnie and Clyde. Film distribution and exhibition was one of the few legit businesses where actual criminals could flourish and gain a modicum of respect... or at least clout (or at least *cash!*).

The recently deceased and highly respected film historian, William K Everson, knew Rohauer and considered him a fascinating, complex character whose story would have made for a better "old Hollywood" yarn than The Player. Everson had a certain respect for Rohauer — despite the fact that Ray once tried to get the FBI to bust him — crediting him for reviving dead films and forgotten film personalities. Others simply disdained or downright hated the man. Kenneth Anger describes him as a master of "low cunning". David F Friedman, in a letter to this author dated February 25, 1998, recounts a probably not atypical example of the effect Rohauer could have on people:

Yes, I knew Raymond the Rotten. One day back in the sixties he was walking down Cordova Street [in LA's Film Row] across the street from our offices. Dan Sonny spotted him through the front window then ran out of the building and across the street and smacked him in the mouth. Dan was (is) a BIG Calabrese with hands the size of hams. Raymond screamed like a stuck pig, threatening a law suit, etc. But I guess he couldn't find any lawyer to take the case. It was clearly a case of justifiable mayhem.

Rohauer died of cancer in 1987, and his passing did not plunge the film community into throes of grief. But however vilified he was, Rohauer loved movies and the movie game and he added immeasurably to its lore. There is no disputing that he was a very colourful character. (Black is a colour, right?)

The underhanded craftiness of Dwain Esper has been similarly celebrated, most notably by David Friedman in his 1990 book, *A Youth In Babylon*. Brimming with lively stories about this con man and jack-of-all-trades, the book also gives a very good overview of the whole milieu. In a "career" that spanned six decades, until his death in 1982, Esper took the art of misleading movie promotion to new levels and even tried to sell *Freaks* as a sex picture! He is the man most responsible for keeping the drug scare hysteria alive in America with a string of scandalous melodramas like *Reefer Madness* (as distributor), *Marijuana: Weed with Roots in Hell*, *Sinister Menace* and *Narcotic*. Sex, drugs and… sex.

Rohauer and Esper and their outlaw compatriots spent their lives dodging the law, bilking the gullible and even bilking the wise. They used the American legal system to the maximum and sent off lawsuits like some people mail Christmas cards. As someone once said of Rohauer, "Instead of paying you the money he owed you, he'd rather pay it to some lawyer to fight you in court." Ditto with Esper. Their constant recourse to legal measures was clearly not, however, out of any great respect for the law.

Raymond Rohauer interviews Groucho Marx

Although the movie business no doubt has its share of chisellers today, they're all faceless white collar criminals working on behalf of big companies and foisting their charades on computer screens. No more back alley muggings. No more stories.

Instead of dealing in dope or guns, the old boys dealt in celluloid. Back when the movie business was run more like the Mafia, complete with punk enforcers, protection peddlers and shakedown artists. They managed to carve out a living and stay alive long enough to enshrine themselves in the folklore of American petty criminality.

To them and their progeny — we salute you!

FURTHER READING
A Youth In Babylon: Confessions of a Trash-Film King
by David F Friedman
Prometheus Books, Buffalo, N Y, 1990.

"Raymond Rohauer: King of the Freebooters",
William K Everson, *Grand Street* No 49, 1994.

THE ACTOR WHO WOULDN'T DIE

A Tribute to Ham

There is a theory circulating in film buff circles that "professionalism" is causing the slow death of cinema, that nothing is worse than steady, workmanlike proficiency. Give us the grandiose failures and the eccentric, unlikely little masterpieces and keep everything else in between, all the films that constitute that yawning mass of product seamless enough to be "watchable", but otherwise soulless, lifeless and unmemorable.

Palm readers attempting to finger the source of cinema's decline have identified the main culprit: good, serviceable acting. Acting that is mass produced just like any other interchangeable component and smoothly fitted into the prefabricated finished product. Acting that has rendered the most human element of motion pictures subservient to the computer-generated, test-screened and mass-marketed whole. Acting that abhors that dusty and obnoxious stereotype that haunts its past like a Shakespearean ghost — the ham.

"Ham", as defined by the Oxford dictionary, is "an inexpert or unsubtle actor or piece of acting". Yet the ham occupies a much more prominent place in our collective consciousness than this innocuous description suggests, calling to mind the long-burlesqued stereotype of the wildly overacting hack thespian.

A shot rings out. "You got me!" he declares wide-eyed, clutching his chest, motionless… for what seems like eternity. Hams love best to go insane or die. The ham falls about, rolling off tables and chairs, knocking over every lamp on the set while the director pulls out his hair and makes "cut" gestures with finger across throat, to no avail. Finally the ham hits the floor like a sack of flour, to twitch and flop… forever. And it's only the beginning.

DAWN OF HAM

The roots of ham are firmly implanted in the silent era of motion pictures. It was a young art-form that borrowed its traditions from the stage, where ham was born.

To watch silent films today is to witness a fundamentally different style of acting, one marked by a preponderance of mugging. Exaggerated facial expressions were useful tools in silent film where actors had no recourse to dialogue to define characterisation, but nonetheless we've come to equate mugging with ham. Exaggerated body language was also employed to get the point across.

Mugging and flopping: the tools of ham.

Vaudeville formalised a style of comedic delivery heavy on ham, and comedians like Abbott and Costello and Jerry Lewis who borrowed from this tradition tended to "ham it up" unmercifully in a fashion that today seems not only out-dated but positively irritating.

Lou Costello, short, dumpy, in baggy pants, could go on forever making with the goofy, rubbery facial expressions and infantile sound effects while audiences roared. God help us. The definition of hell is to be marooned on a desert island with a baggy-pants comedian and no gun to shoot him with. This is not the ham we need to defrost, this is rancid ham.

Whether or not Abbott and Costello were true hams

Land of a Thousand Balconies

Ham on Cruise Control. Vincent Price in *Confessions of an Opium Eater*.

or were just following period style is debatable. The Marx Brothers, for example, although relying very much on physical comedy, were not hams, while The Three Stooges were "beyond ham".

What many reckon to be one of the great ham performances of all time can be found in *Maniac*, the 1934 poverty row horror picture by Dwain Esper. In this exploitation milestone, actor Theodore Edwards portrays the mad rapist, Buckley, who thinks he's an ape. "I can't stand it!" he screams at one point, bug-eyed, twisted and hunched... "This torture! Steeeeealing through my body! Creeeeping through my veins! Pouring through my blood!... A dash of fiiiiire in my brain!!!" In a later scene he goes berserk (again), knocking aside a flimsy, conveniently placed item of furniture to grab the somnolent heroine and steal away shrieking and squealing, all the time playing to the camera.

Edward's shameless overacting pumps adrenaline into a film otherwise on life-support.

The other great ham performance of thirties exploitation cinema belongs to actor, David O'Brien, who goes psycho at the end of *Reefer Madness* (1936). "A twitchy, eye-rolling nut job who sits around cackling to himself and chain-smoking joints", is how J Hoberman describes him in his book, *Midnight Movies*. O'Brien is driven to insane glee by a dame's hopped-up piano playing..."Faster!... Faster!" he shouts, grinning hollow-eyed as he puffs wildly on a joint. "The most wonderful ham performance I have ever seen in a movie", breathlessly declared the late underground film celebrity, Jack Smith, in an ode to O'Brien published in *The Village Voice* in 1972.

In the early forties, actress Maria Montez, "The Queen Of Technicolor", set a different standard of ham acting in a series of Universal jungle/desert/slave dramas such as *Sudan*, *Gypsy Wildcat*, *White Savage* and *Cobra Woman*. Montez couldn't act, sing or dance

A Tribute to Thieves, Hams & Prophets

The Actor Who Wouldn't Die

to save her life but something else not wholly definable glimmered through the maw of studio exotica and fake palms.

In fact, ham was not something fake, but something genuine, preached Jack Smith in a published paean (*Film Culture*, 27/1962–63) to Montez that oscillates between rapturously elegant prose and beatnik incoherence:

"… if something genuine got on film, why carp about the acting?… Maria Montez dreamed she was effective, imagined she acted, cared for nothing but her fantasy…" To call this angel ham is like calling a butterfly a whale, but capture she did the positive essence, the quick-silver of ham. What she put up on the screen was naked self-belief, and the fantasy followed. "Those who could believe", wrote Smith, "did. Those who saw the world's worst actress just couldn't and they missed the magic. Too bad — their loss."

Ham was believing. Believing with every fibre of your existence… like Dudley Manlove, who played Eros, commander of the alien space ship in *Plan 9 from Outer Space*, believed. The scene in which Manlove seemingly spontaneously erupts into a passionate and near-hysterical diatribe about the stupidity of earthlings was both touching and transcendental and encapsulates what is best about B-movies. For a few precious moments Manlove wasn't just a ridiculously costumed actor in a hopelessly shabby science fiction movie, but all of a sudden he was nothing less than the saviour of the world, the diviner of truth and the prophet of doom.

THE ESSENCE OF HAM

Premium ham is not just a berserk-o, nuts-o performance. It's a performance so self-absorbed that one actor sucks the entire rest of the movie into the worm hole of their own ego, and for a moment, time stops. It's not about radiating, it's about absorbing, and given half a chance a real ham can suck all the special effects in Hollywood into a black hole.

Acting is, by definition, phoney anyway. Cinema is, undeniably, a fake art with "actors" reciting "lines" and "emoting" on ready-built sets draped with cables and cue marks and crowded with electricians, grips, script girls… If one actor, in the grip of delirious out-of-control self-absorption, can penetrate the artifice of the medium and create something imperfectly real that not even the editor can "fix", why damn it simply because it violates the sacred dignity of "good acting"?

Bad acting alone is not ham acting, far from it. An actor trying to make the best of bad lines by overdramatizing is not ham acting, because the actor lacks self belief. It's just technique. Utterly inept acting is not ham acting because an inferior actor probably does not believe in himself, although inept acting can similarly impede the flow of a film. But a true ham doesn't just impede things, he / she disrupts the well oiled hum of the machinery, and for that crime many cannot forgive him, especially critics who believe in the gospel of "good acting" and imagine that they possess objectivity.

Sometimes the ham creates something more interesting and joyful than what the movie had going for it in the first place. Long is the list of movies saved from oblivion by the unconscionable antics of hams — hams who would probably be dead if the director had access to a loaded gun (and the last thing you want to do is shoot a ham).

But ultimately ham is in the eye of the beholder: one person's divinely inspired ham is what another might deem complete garbage. It's an area of total subjectivity, which is why ham is such an affront to critics.

Here are some off-the-cuff judgement calls from out of the blue:

The bald-headed psycho running amok on bad LSD

Maria Montez, "The Queen Of Technicolor."

through a shopping mall in *Blue Sunshine* is not ham acting, while Nick Cave, on the other hand, hams it up to beat the band as a bad-ass convict in one brief scene in *Ghosts of the Civil Dead*. The film was misleadingly billed as a Nick Cave movie, and no doubt all concerned wanted the scene to leave an impression. Cave struggles wildly as guards cuff him and

knock him around, but one gets the impression the real struggle is to get him away from the camera. Theoretically rock stars should make good hams because they are not trained actors and they are fantastically self-absorbed. All the potential is there, but usually they disappoint because they can't get beyond believing in themselves to believing in more minor stuff like saving the solar-system. They cannot believe they are saving the world because they believe they *are* the world.

Schwarzenegger is incapable of ham, he's too inert to either radiate or absorb. He's impervious. Nicolas Cage frequently comes close but is too well trained to break the ham barrier. Vincent Price was ham on cruise control, while Tom Cruise could never rise to the ecstatic heights of true ham. Fred Williamson is all ham all the time, while Steve Railsback overacts, but is no ham. Jayne Mansfield sucked her movies and everything else in the room into the black hole of her own self-absorbed persona, but was too inert to overact in true ham fashion and begs the invention of a new classification. Zsa Zsa Gabor, who flounces and brightly smiles her way through *The Queen of Outer Space*, is all self-consumed ham wrapped up in the glittering imagination of her own performance.

Low-budget films offer the best hope for hams because they are shot full of air holes and actors get high on all the oxygen. Big budget Hollywood pictures are too air-conditioned and oppressively "professional" for their own good. *Titanic* needed a ham or two to reestablish the human dimension, but the actors were so hopelessly overshadowed by the boat and the special effects that not even the longest "I'm shot!" scene could save it. No hams in *Godzilla* either since it's hard to believe in yourself when you're playing to special effects that haven't even been put into the picture yet.

When nobody is paying attention to the people in a movie, it's hard to cook up real ham. And people don't just get shot anymore, they get nuked or eaten by giant rubberised monsters or vaporised.

Overkill is the death of ham. The fine art of dying is in danger of dying.

And dying.

And…

THE CULT OF TECHNICOLOR

A Séance

Most normal people think Technicolor is a colour film process. They're wrong — it's a religion.

A thorough examination of the existence of Technicolor in the Twentieth Century which illuminates its technical, aesthetic and historic origins reveals the truth: it was a cult religion in the guise of a business, and prefigured the way in which modern computer companies like Apple and Microsoft have evolved into religious-like entities complete with "chosen" holy men who issue spiritual dictates and demand obedience from true believers (employees).

Technicolor had its own prophets: the early pioneering scientists who invented a variety of colour movie processes in the Teens, like Chronochrome, Prizma and Zoechrome to name just a few of many. While the defects of these primitive colour processes soon rendered them obsolete, they were chasing the vision of something better, preparing people for a technology that would inspire awe and belief in the form of an amazing colour process... preparing the world for a technology that would soon come but whose name nobody yet knew.

Then in 1917 it appeared, and it was good. And it was called Technicolor, having been invented at the Massachusetts Institute of Technology by two visionaries named Herbert T Kalmus and Daniel F Comstock. Instead of Technicolor coming to earth in a manger in Jerusalem, it came to earth in an abandoned railroad car in Boston which housed their laboratory.

That same year they set out on a historic trek, taking the car down to the land of eternal sunshine — Florida, where they produced the first Technicolor movie, *The Gulf Between*.

Their pursuit of perfection and purity would reward the masses with great pleasure and deliver them into a state of rapture. Audiences would soon have the chance to reach a more beautiful "higher plain of existence", and you didn't even need to lead a good or holy life — you just had to have enough dough to buy a movie ticket. It was spiritual solace of a very non-judgemental, democratic kind.

In 1922 Kalmus and Comstock developed a new camera which employed duel beam-splitting prisms. The light coming out of the back of the camera lens entered the prism through the hypotenuse side of the first prism, and after passing across it was split into two beams by the semi-reflecting filter layer. This resulted in a new, better two-colour subtractive process.

By 1932 Technicolor developed the superior three-colour process in which the beam-splitting prism produced three primary colour images which were recorded on three separate rolls of film winding through the camera. It was a revelation: full glorious colour!

The mid thirties to the mid fifties would stand as the Golden Age of Technicolor.

Purity of exhibition had then reached its highest pinnacle. For that brief moment in recorded time Nirvana was possible, and the seeker would find it sitting in a grand old acoustically-perfect movie theatre watching a mint three-strip Technicolor print being shown by carbon-arch projectors onto a slightly curved glass bead screen. Fittingly the movie would probably be some religious epic like *The Robe* or *The Twelve Commandments*, since most of them were shot in Technicolor, and the movie might even be in

Land of a Thousand Balconies

Technirama — Technicolor's cinemaScope process.

This was the fabled state of heaven on earth which is today unobtainable to mere mortals since the above combination of factors can no longer be recreated.

Around this time a kind of arcane mythology developed. It was believed by some that a person wasn't "real" or in any way worthwhile unless photographed and projected in Technicolor. These people could only relate to the *projected* Technicolor image and lived their emotional lives inside movie theatres.

What was assumed to be reality, they believed, was just the feeble glimmering of a pallid, parallel universe rendered in B&W or washed out colours, a kind of purgatory. With Technicolor, the blacks were deeper and more saturated than the darkest night, the blues richer, the purples luxurious and sensual, the reds blazing and the yellows vibrant and positively alive. Colour as pure pleasure, as pure belief… as primal life force. If the *movie* was bad, they didn't see it.

The Technicolor Company acted to protect its patents and assert its influence with an unyielding determination that gave the impression that they considered themselves god's gift to film-making. To shoot a Technicolor movie, a director had to use one of their patented cameras, and you could only *rent* it — never *buy* it. It was also obligatory that any production shot in Technicolor had to employ a "colour consultant" on the set to arrange

The Cult of Technicolor

or design the colours of the film down to the smallest details. These colour consultants acted as a sort of de facto clergy. They had all received spiritual training by Technicolor, which understood that all human spirituality could be guided by choice and combination of colour.

The iconography of Technicolor also had religious resonance. The basic symbol upon which the whole technology depended was the triangle or pyramid: the beam-splitting prism inside the camera. The prism, like the obelisk, wheel, cross or swastika is likewise a symbol whose misleadingly simple shape belies its profound and universal application and importance. If Technicolor had its own crest or emblem like the Masons or the Knights Templar, it would be the triangular prism split by three beams of light — a symbol that in fact devotees claimed to have discovered carved into crumbled stone monoliths deep in the Amazon jungle.

Technicolor had its own orthodoxy: there was "pure" Technicolor and there was less pure Technicolor. In 1950, as film author, Barry Salt writes, "Technicolor improved their three-strip process yet again, making the emulsions more sensitive… Eastman colour appeared in 1953 and Kodak invented a monopack camera which could also reproduce the full colour range and Technicolor's Three-strip camera was phased out, and from 1955 onwards the name Technicolor only represents a laboratory carrying out a unique printing process", not a shooting process. Even today many films still credit "printed by Technicolor" — a heresy that means almost nothing.

Technicolor had its canon of worshipped icons: *The Wizard of Oz*, *Written on the Wind*, *Vertigo* (recently restored to holy-relic status), etc. And Technicolor inspired pilgrimages as nostalgics and fanatics alike flocked to special Technicolor film festivals.

Technicolor is often referred to in histories as "The World of Technicolor", like an ancient civilisation might be referred to as "The World of…". And like a great civilisation, it had its royalty: Maria Montez, exotic B-star of early forties Universal pictures, was billed as "The Queen Of Technicolor", while Doris Day and a host of other stars also lay claim to the crown.

And like an ancient civilisation, Technicolor had its "rise and fall", and its "golden age". As noted, its decline began in the fifties as the battle with inferior but cheaper colour process like Eastman colour and MetroColor for market share raged. The drawbridge was secretly lowered by front office businessmen concerned primarily with costs, and the infidels managed to breach the crumbling castle walls. They soon swarmed to a dominant position, and brought the temple pillars crashing down as a small circle of holy men — the company technicians who were the only mortals on earth who knew how to properly print a Technicolor film — watched the carnage from the short-lived safely of the barricaded Citadel. Once they hung up their starched white lab coats for the last time, in 1977, when the last print of *Star Wars* rolled off the machinery, Technicolor joined stained glass window painting and illuminated manuscripts as one of the world's great lost arts.

Thanks to the Chinese, of all people, the rock was rolled away from the tomb of Technicolor and the last surviving plant was built and continued to operate for many years on mainland China. (Rumours persist that the Chinese didn't really quite know how to work the complex and exactingly precise processes, and the colours were coming out rather strangely…) While in the West, capitalism had sold the people false dreams at cheap prices, and, as all the colours faded to murky reds and pinks, they reaped what they had sown: a ruined film culture and the end of visual pleasure. But every so often some technician foraging in an old film archive lifts open the lid of a film can and is greeted with (theoretically) a blinding radiant light: it's a Technicolor print that has not faded at all since the day it was made.

Today, a cult of true believers persist, plugging their ears to the heresies of soulless modern technologists who tell the people that our only hope for good colour in the future lies with digital technology. Burn them!

These true believers gaze into a night sky that isn't quite black enough, and to the moon and stars that don't shine quite bright enough, and they know that Technicolor will come to earth again.

Amen.

MOVIE THEATRES & UNIQUE EXHIBITION SPACES

An Introduction

The element of "place" in the movie-going experience is rapidly disappearing. The accent on atmosphere that was once a big part of what cinemas had to offer has given way to new trends in theatre construction that stress neutral environments in which comfort and uniformity are the primary concerns.

Of course the film industry wants their product to be received in a standard, uniform way, inoffensive and easily available to the greatest number of customers. Customers who demand more and more comfort. Demands which in turn have given birth to chairs that have more leg room and arm and head rests and drink holders and popcorn holders, chairs like grand airliner seats with plush upholstery that gets softer and softer and softer until it's hard to even stay awake...

Once upon a time there were theatres you would be *afraid* to go to sleep in. (More on that later.)

The plain fact of the matter is that however thoroughly market-tested they might be, movies are not homogenous entities. To the contrary, they are very subjective experiences in which the viewer's state of mind plays a very big part. And theatre environment in all its glancing intangibles is key to the viewer's state of mind. That environment can actually change a film. Technically what is printed on the celluloid remains constant, but the experience from venue to venue can differ so radically that one movie becomes many different movies, good movies and bad movies and movies where terms like good and bad are irrelevant.

This effect that the screening environment has on the movie, or rather the viewer, is an X-factor that is no longer taken into account when the conversation turns to film. All the talk today is about the stars and the directors and even the critics, about how much money the movie made and when the sequel is coming out.

Studios don't want the theatres to actively imprint the experience, and they certainly don't want the theatre to be more exciting or attention-getting than the movie itself! They prefer the theatre environment to anaesthetise rather than antagonise, to sedate rather than excite, to harmonise rather than horrify. Otherwise you could just lock a bunch of people into a spooky theatre and forget about the film and they would all be the better off for it. In fact once upon a time there were theatres where the movies were the lesser of the attractions, theatres that were open twenty-four hours a day and actually had people living in them.

Suffice it to say, the screening environment has the power to make a movie something *special* — in the most ambiguous sense of the word. Keeping in mind that these places are probably not where you would go to see *Three Men And A Baby*, we now invite you to take a tour from grind house to light house, from ship to cellar, from America to Europe.

Here's your ticket — the show is about to start. All bags must be checked at the door and remember: no booze, sleeping bags or weapons. And the balcony is *for couples only*.

MARKET STREET

Movie Theatre Graveyard USA

Famous Market St cuts through the middle of San Francisco like a river of dirty asphalt. It's a bustling, noisy swath of activity which forms the main line off of which San Francisco's street grid juts and intersects. All buses, subway and cable cars end up there. Long the proverbial haunt of shore-leave sailors, tourists and assorted hucksters and street preachers, it is a thoroughfare of clashing urban contrasts in a city otherwise composed of insular neighbourhoods segregated by culture and geography.

From The Embarcadero, up near the waterfront, to Powell St, Market is walled by banks, office buildings and upscale retail outlets and cafeterias that service the white-collar clientele of the financial district.

At Powell the tenor of the strip changes abruptly. Things become grimy and ragged, "low rent". Loitering black youths laugh and slap at each other in front of a video arcade while a nervous gaggle of well-dressed tourists pretend not to notice. A hooker leans against a boarded up shop façade puffing a cigarette. A homeless vet clutching a dirty bed roll lurches by while punk street kids race past on skateboards. This is Market from Powell to Hyde: a clutter of cheap Chinese cafeterias, Army-Navy surplus shops, discount camera emporiums and clothing outlets peddling flashy gang chic and blasting rap music out onto the sidewalk.

This is the stretch of Market that city officials variously attempt to "clean up" and ignore. It's classic inner-city American street life in all its unsavoury, unpredictable menace and vitality. It defies rezoning, upscaling and all attempts at "pretty-fication". Hard to imagine this was once San Francisco's "Great White Way" — a fashionable promenade of classy nightclubs, fine restaurants and showpiece theatres.

It's here that the soul of San Francisco's moviegoing past lies buried.

THE EMBASSY ON MARKET STREET
Just west of Seventh St on Market, across from the United Nations Plaza with its stone slabs and fountains, stood the historic Embassy theatre — the oldest movie house in town.

Construction of the theatre, originally known as The Bell, began in 1905. It survived the 1906 earthquake and resultant fire with minor structural and smoke damage and was rechristened The American Theatre for its opening on January 21, 1907. It had 1,200 seats, a massive balcony and a full stage and orchestra pit to accommodate the live acts and musicians that were part and parcel of movie shows of the day. It established itself as a legitimate pre-vaudeville theatre during the era of the Nickelodeon.

Between 1910 and 1933 the theatre underwent numerous identity changes. In 1910 it was renamed The Rialto, and in the early twenties it ceased to function as a movie theatre altogether and instead a college was housed on the premises. It reopened as The Rivoli in 1923. Following that it was taken over by

Land of a Thousand Balconies

Making Market Street safe for movies again

Examiner Katy Raddatz
Theater owner Michael Thomas, the Baron of Market Street

Warner Brothers, rechristened The Vitaphone, and beat out Los Angeles for the 1927 west coast premiere of the first (partial) talkie, Al Jolson's *The Jazz Singer*. The house was finally renamed The Embassy around 1933.

In November of 1938, Dan McLean, a thirty-six-year-old Florida native with a varied job history behind him, including a stint as elevator operator at the nearby Golden Gate theatre, took over management of The Embassy. McLean was a natural born showman at a time when it mattered in the movie game, and soon he had turned the venue into a popular second-run house catering to the family trade. Business boomed during the War years and on any given night cadres of smartly uniformed usherettes armed with flashlights could be seen seating well-dressed patrons throughout the theatre.

McLean's greatest contribution to motion picture lore was "Movie Roulette", a bingo style giveaway game he later dubbed "Ten-O-Win" and billed as the "Thrill-a-minute Movie Game". According to theatre historian, Steve Levin, Ten-O-Win evolved from a game that was created for the Treasure Island World's Fair.

McLean redesigned it for cinemas and marketed it to other theatres across the country, running it at The Embassy up until the early eighties. The somewhat complicated rules of Ten-O-Win required movie-goers to match their ticket numbers and colors to a spinning wheel of fortune pulled out onto the stage during intermissions. The prize was awarded in silver dollars that ushers clanged in metal pails as they strode up and down the aisles in search of winners. Ten-O-Win proved so popular during the war years and through the late forties that overflow crowds often played the game out on the sidewalk. McLean franchised the idea to 1,000 other movie theatres nationwide and made heaps of dough.

In 1960, McLean — dubbed "the yowzah yowzah King of San Francisco" by one local scribe — bought The Embassy. At one point he converted some old dressing rooms in the back of the theatre into a two-story apartment where he would flop late at night when he was too tired to drive home to Marin county.

Yet the movie business on Market Street was changing along with the nature of American society itself. Cities were undergoing demographic changes as the more affluent moved out to the suburbs. This refigured the neighbourhoods adjacent to Market and eroded the family trade. Additionally, black patrons began to venture into Market St theatres as segregationist barriers began to loosen, resulting in a series of small-scale racial incidents throughout the summer of 1960.

In the late sixties, Market St began its storied demise as the fancy night-clubs and restaurants began to move out or close down.

McLean ran the Embassy until his death in March of 1983 at eighty-one years of age. He had experienced the long decline of both Market St and the movie business in general and he had grown cynical. He was a tough-talking showman of the old school stranded in the modern age. He had dumped a lifetime of hard work and energy into what was now, due to factors beyond his control, a rapidly depreciating investment. He saw no hope for The Embassy and refused to put any money into it.

After his death, his widow sold The Embassy to a real estate development company that wanted to raze it and construct an office building with street-level retail shops on the site. These plans were thwarted for two years by the San Francisco planning department which asserted that The Embassy had Historical Landmark Status. By then the real estate market had collapsed in San Francisco and so The Embassy staggered along as a movie theatre on a diet of, as one critic put it, "irredeemable trash".

Movies like *Dragon Zombies Return*, *Stripped to Kill* and *Fast and Filthy Fist* played to crowds of snoring sleepers and hopped-up speed freaks who shouted back at the screen. The place was a den of vice, a hive of addicts, perverts and thieves, many of whom had wandered over from the Greyhound bus station around the corner to kill time or hide out. Thanks to its cheap all-day ticket prices, the cavernous, smelly, poorly maintained theatre now functioned as a free zone for the criminal element and a grand, decrepit flophouse for the homeless. There were brawls and knife fights. The cops were going in almost daily. Vandals trashed the seats and toilets… the washrooms and balcony became haunts of menace.

August, 1987: enter Mike Thomas, energetic young film programmer and driving force behind the revitalisation of several other old area movie theatres. Thomas, who had already "saved" The Strand theatre next door, took over management of The Embassy and immediately went to work. He and partner, Greg King, cleaned, painted, laid carpet, replaced seats and installed a padlocked iron gate to close off the monstrous balcony which they later hoped to "twin" into a separate room for first run films.

In the catacomb-like basement area lay fifty years of movie flotsam collected by pack-rat McLean: discontinued Ten-O-Win wheels, cancelled cheques from 1942, court transcripts from an anti-trust suit he once filed and a cloth banner with "Jimmy Stewart" in sewn-on lettering, to name but a few artefacts. Off the backstage area old dressing rooms lay in rot and ruin, infested by pigeons and littered with plaster-dust and debris. Many staircases above, in the projection booth, old photographs of Market Street lined the yellowed walls.

"It's the last of an era", King would tell a reporter at the time as he led a tour around the ancient building. "We're basically working on something here that is long gone in most cities."

Tough work lay ahead to build a new audience. Security guards were hired and a hard-line policy was instituted against loafers and troublemakers: one offence and you were barred permanently. A sign in the box-office window announced a strict ban on drugs, liquor, walkmans and sleeping bags. All bags, bundles and parcels were checked at the door and subject to a fifty cent search charge.

It worked.

Within nine months of reopening, Embassy grosses rose fifty percent on the strength of a new and better behaved clientele. Ten-O-Win was resurrected for once-a-week spins and the massive concessions bar was stocked with eclectic items like liverwurst sandwiches, tamales, lobster soup and hard-boiled eggs.

Land of a Thousand Balconies

Nobody had dreamed The Embassy could be saved but Thomas was succeeding. To hard-nosed movie biz insiders and sidewalk strollers alike, it was nothing short of a miracle to see the place reborn. To help matters, the crime-plagued Greyhound bus station moved out of the neighbourhood in 1988.

Yet The Embassy's revival was to be short-lived.

In 1988 a Hong Kong investment group decided to buy up the entire block in which both the The Embassy and The Strand were located. Plans were made to demolish the buildings and construct a giant shopping complex. The Hong Kong firm had bought out nearly everyone on the block when the Loma Prieta earthquake rocked the city in October of 1989 and changed everybody's plans.

Having already survived the 1906 earthquake, The Embassy was not so lucky this time: It suffered serious structural damage and was shuttered for good. With the investment group subsequently going broke, the bank took possession of the theatre and it sat for years vacant and boarded up.

Homeless people eventually found a way into the theatre through the back and a loose tribe of urban wanderers began to dwell there. The stage became a platform for shopping carts and raggedy bundles, and the floor was littered with chunks of plaster, syringes and shattered liquor bottles. Out of the pitch blackness of the place the ghosts from a better time looked on in horror.

Suddenly, in October of 1995, without forewarning, or, apparently, any debate, The Embassy was completely demolished, and only a gravel hole remained. Reportedly Greg King had some advance warning and spirited out a couple of Ten-O-Win wheels as souvenirs. The city claimed the place had become an unenforceable health hazard and fire trap, but for all intents and purposes the theatre had died long ago and its demolition was little mourned. In fact it received no ink at all in the local press.

THE STRAND ON MARKET STREET

The smaller 725-seat Strand theatre located at 1127 Market St, right next to The Embassy, reflected the changing fortunes of the avenue in even more dramatic fashion. And it seems to have more lives than a cat.

Built in 1916, The Strand was always a movie house, unlike other Market St theatres. The nearby Golden Gate Theatre, for example, was built for stage plays, switched to movies and then finally converted back to legitimate live theatre just in time to save itself from grind house hell. Like all old theatres, The Strand had a stage by which to accommodate the live music that invariably accompanied silent movies. In fact its atmosphere would always have a bit of the "live show" in it, harkening back to its days on the periphery of vaudeville and burlesque. It would always have the feel of a "B-joint."

Originally known as The Empress, The Strand was part of the Grumman theatre chain. It was soon after sold to M L Markowitz and rechristened The Strand. Frequent policy changes from the outset hampered its success. In 1925 the room was sold to the Rothchild chain and largely rebuilt. It changed ownership again in 1939.

In 1940, West Side Valley Theatre Company was charged with operation of the house. Attendance

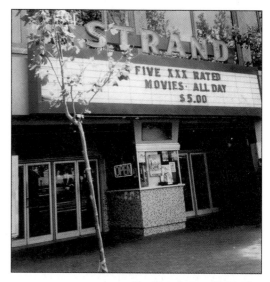

ABOVE The Strand circa 1995, after conversion to xxx hardcore video projection.

NEXT PAGE To the left of the Strand was the Embassy Theatre, torn down soon after this picture was taken.

boomed as people flocked to the movies during the war years.

As the 1940s came to a close, The Strand, along with other inner-city theatres, suffered a fall-off in patronage caused primarily by the rise of television as a competitor, and by migration to the suburbs. This, as noted, deprived all Market St cinemas of the "family trade" upon which they had established themselves.

"Main Street America" was changing. And Market St was the epitome of Main Street.

The Strand continued strong through the fifties and sixties but suffered along with the rest of Market St in

the late sixties and seventies as adjacent neighbourhoods started going to hell, thanks to a number of factors including failed Urban Renewal policies and the influx of drugs. While crusty old showbiz types like McLean damned their skidding fortunes, profits fell and Market St just got meaner. McLean himself was mugged at one point in an alley at the back of The Embassy.

The West Side Valley Theatre Company bailed out of The Strand in April 1977, citing a fifty percent drop in business over the last five or six years. But the real reasons for The Strand's demise would become the stuff of local legend as years later veteran film buffs would horrify friends with hair-raising tales about brave forays into the theatre during this period. The joint had turned into an old dark house of real live movie horror.

On the face of it The Strand was still a functioning movie theatre right up to the end, programmed in classic grind house fashion with a new triple-bill every other day and nightly bingo games to compete with the Ten-O-Win next door. But while West Side executive, Roy Cooper, had blandly attributed the downturn in business to the reluctance of people to attend entertainment on Market St at night, it would seem by all other testimony that The Strand was more of a culprit than a victim in all this. The house catered to an elderly clientele with seventy-five cent senior citizen tickets, but the crowd could hardly be characterised as a bunch of helpless old men since it was common knowledge that no female in her right mind would ever venture near the place — alone or escorted. Apparently not since medieval times had such a vile collection of rogues, perverts and criminals found common refuge. It also became a sort of folk wisdom that one should sit with one's feet propped up on the backrest of the chair in front 'lest rats begin to chew one's ankles. Respectable citizens shunned the place out of the same sense of self-preservation that compelled ancient Greeks to take the long way around cave-dwelling leper colonies.

With its long, narrow dimensions, steep balcony, old wooden stage and high ceiling, the theatre seemed to have entombed the spirit of every tragic, ruined movie star that had ever graced it's screen, every over-the-hill B-girl that ever hoofed out a pathetic Burlesque routine on its stage… every cadaverous old roadshow svengali whose nicotine-stained fingers shelled through a roll of greasy sawbucks made on someone else's misery. The room seemed to be the depository of the sins of a long-ago time for which the customers

Land of a Thousand Balconies

of today were being made to pay. The soul of the place was somehow stranded permanently in time — back in the twenties or thirties.

To add to this old-time atmosphere, by 1977 there was rot and decay of a much more immediate variety: cockroaches, peeling walls, clogged urinals, busted chairs, sticky muck-covered floors and a ripped movie screen yellowed by decades of cigarette smoke, all of this largely veiled in an impenetrable and menacing darkness that no other theatre could quite duplicate.

A negative karma had taken over Market St and had seeped into the theatres as well. No crack or crevice could escape it. "A horror movie come to life" was the phrase that local journalist, Stanley Eichelbaum, used to describe the street at this time. He recalled a not atypical experience he'd had in a Market St theatre of the period: "I found myself sitting next to a youth cleaning his fingernails with a switchblade knife. Bored with that, he started ripping apart the seats, and, having not yet found anything to interest him on the screen, he proceeded to set fire to the upholstery."

But if dark forces were working against movie exhibition on Market St, there was an almost unstoppable force working *for* it — Mike Thomas. In 1969 Thomas had turned a failing North Beach grind house called The Times Theatre into a successful repertory cinema. The Times went under in 1975 but Thomas remained a player in Bay Area exhibition with several theatre restoration projects in Humboldt and Arcata.

He and a partner bought The Strand in 1977, and soon after acquired a string of other Market St theatres including The Warfield, The Embassy and The Crest, which became The Egyptian and later The Electric. Thomas became known as "The Baron of Market St" — a sobriquet the plain spoken Lodi native disliked for its pretentiousness.

Thomas took to the battle ahead of him with the zeal and moral certainty of a preacher, lambasting other theatres that coasted along on a diet of mindless exploitation: "If you play nothing but nasty, violent movies you get nothing but nasty, violent people." He blamed the decline of the movie district on the cynicism of the managers: "If you think your customers are animals and give them nothing but exploitation pictures, they'll treat your theatre accordingly."

With 20,000 dollars they laid new carpeting, painted, replaced seats and installed a new screen and sound system. To relaunch The Strand they distributed 100,000 flyers in 800 locations around the city. Thomas planned an adventurous and ambitious schedule of repertory.

A revitalised Strand opened its doors again in June of 1977 with a ballyhooed revival screening of the Howard Hughes' western, *The Outlaw*. In 1942 Hughes had decided to open the controversial film in San Francisco. He plastered the town with steamy posters of provocative star, Jane Russell, that were captioned with tag lines like "Sex has not been rationed". This papering of the city caused an uproar and the billboards and posters were taken down, but that didn't stop wartime audiences from flocking to the pic. Now Thomas was bringing it back, along with period newsreels, a live orchestra and even Jane Russell in person. The show was a sell out.

Changing the crowd at the theatre was a real battle. Thomas hired security guards to patrol the aisles and they had to throw out a considerable

Market St

number of troublemakers who couldn't take a hint. But eventually the theatre was repopulated by a new audience composed of students, senior citizens from the neighbourhood and film buffs from all over town who appreciated extras like the restored decor and displays of original one-sheet lobby posters.

The Strand re-established itself on a diet of subtitled foreign films, widescreen epics, vintage Hollywood pictures and cult "specials" like house-filling bargain-priced marathons on Sundays, and a "Scary Movie Festival" every Tuesday. Thomas sought to maintain a classic grind house style of exhibition in the manner of his beloved old Market St movie houses. This meant continuous programming, daily multiple-bills stacked with cartoons, shorts and trailers. No intermissions… non-stop movies. The lights never went up.

That such programming could flourish in a cinema-savvy city like San Francisco was no surprise. That it had succeeded on Market St in the seventies was! Thomas was in effect turning back the hands of time. "If a city is a real city", he would say, "you should have the whole spectrum of movie theatres: your art houses, your first-run houses, your downtown action houses and your grind houses. I feel it's sort of in the proper ecology of things."

Thomas brought a lot of big name movie stars to The Strand for in-person tributes. Lana Turner, Josh Logan, Sophia Loren and Rudy Ray Moore came. Mae West came with the San Francisco premiere of Sextette. They drew sell-out crowds to the new Strand and added to the rich well of San Francisco movie lore. Thomas organised these events with the help of partner, Phil Sinclair.

A significant early coup for Thomas was inheriting The Rocky Horror Picture Show from The Powell Theatre which was shuttered in 1977. The nationally-hyped cult film drew instant crowds to Friday and Saturday midnight screenings and gave the theatre's relaunch added impetus.

But The Rocky Horror Picture Show turned into a real horror on Saturday night, December 30, 1979, as a jubilant rabble of punks, gays, tourists and film freaks stood outside The Strand waiting to get in. A patron, Dennis Sesock, was suddenly stabbed by an embittered thirty-seven-year-old derelict named Frederick Chavez. Chavez had been living for two years at The National Hotel, a few doors down from The Strand, and had been hanging menacingly at the edges of the crowd. Sesock died at the hospital later that night. It was a brutal murder with no apparent motive, the kind of crime that confirmed people's darkest preconceptions of Market St.

Weathering the bad publicity, Thomas continued on and marked the theatre's third anniversary on Monday, June 2, 1980, by screening Baby Doll with star Caroll Baker in person. Another hit show.

Although Thomas was involved in other theatre operations that ranged as far afield as Palo Alto and Hollywood, The Strand remained his pet project and "play toy", as he termed it. It soon became revered by film buffs all over the Country, if only on the strength

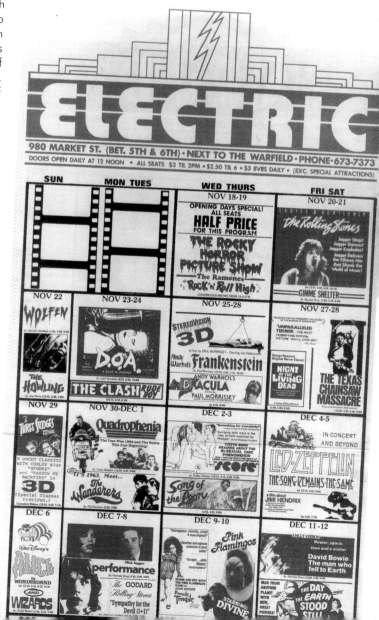

of its reputation and the distinctive Strand mailout schedules that envious, far-away film freaks could only drool over.

Thomas personally booked and oversaw daily operation of The Strand and could usually be found in his secluded office up behind the balcony. This was accessed by a metal stairway of the type one might expect to find in a flying saucer. Floor-to-ceiling windows in his office afforded a view across Market St on to the increasingly seedy United Nations Plaza where winos occasionally took showers in the fountain. This U N Plaza and a refurbished Orpheum Theatre had been seen in the late seventies as key to a general "renaissance" at Eighth and Market, a renaissance that Thomas had foreseen The Strand participating in and benefiting from. In fact it never came to pass.

Thomas helmed The Strand through the eighties and weathered another potent threat to his beloved Rep style programming: home video. 1986 would go down as the worst year for Repertory theatres and the best year for video, leading some wags to predict the extinction of the movie theatre as we know it. The Strand survived this period, but other celebrated local Rep houses like The Cedar, The Avenue, The Surf and The Parkside did not.

When the curtain came crashing down on Mike Thomas' dream in October of 1989, at least it came in suitably dramatic fashion: the Loma Prieta earthquake. The Strand and Embassy were immediately closed so that public works officials could assess the damage. The Embassy, as noted, would never reopen. The Strand was luckier — if in fact there was any luck left on Market St.

It was reopened sometime later by Howard Taormino's Silver Screen Amusements. Mike Thomas had sold out and was now working for the unaffiliated distribution company, Strand Releasing, although he continued to book the house for Taormino. But the hope of a turnaround on Market was clearly over.

Thomas had long ago divested himself of the Warfield, which had been unable to overcome the stigma of Market St. It was now — had been since the early eighties — a concert hall booked by Bill Graham. His 250-seat Electric Theatre had, despite his best efforts, reverted to a seedy flophouse and he got rid of that too. As with most theatres on Market St, the front rows were unofficially reserved by the homeless for sleeping. The Electric folded in the late eighties and reopened in 1994 as a porno establishment called The Crazy Horse. Porno seemed to be the future of Market St.

After the earthquake, and with Thomas essentially gone, the drunks, the drifters, the sleepers and the derelicts filtered back to The Strand, despite the continuation of repertory style booking. Hell, it didn't matter *what* was on the screen. The old karma came back. This was another day. The magic and the crowds were gone for good. Market St had no more movie miracles left.

The Strand, which had once been, to quote a 1925 article by reporter George Warren, "ideally located for a motion-picture playhouse", was now instead, like all Market St cinemas, locked helplessly in the gravity grip of the dark zone the street had become, and from which no amount of revivals or reopenings or infusions of new red neon could free it.

In June 1994, Silver Screen Amusements pulled out of a losing situation and the Strand closed... only to return from the dead a few weeks later like some kind of zombie as a hard-core porno theatre exhibiting projected video. As of late 2002 The Strand is still functioning in this capacity.

An inglorious end ...

Or is it?

With thanks to JIM MORTON for his assistance on this chapter.

THE NYBACK CHRONICLES (IN TWO PARTS)

1. NOTES IN THE KEY OF B
The Pike Street Cinema

Once upon a time in Seattle, in the mid seventies to be exact, there was a small, cozy theatre in the city's Pioneer Square called the Rosebud Cinema. It was run by a silent movie aficionado and projectionist named Dennis Nyback who wore a thin pencil moustache and was almost always nattily attired in vintage clothing from the thirties or forties. He closed that operation a few years later, and by the time I rolled into Seattle in the summer of 1990 (in a 78 Mercury cougar that had almost no brakes left since I had burned them off coming over the Rockies), he had joined with two other guys in reviving The Jewel Box Cinema. That was a beautiful little art deco gem of a theatre located in the rear of the rather rough, tough drifter bar called the Rendezvous, which was to be found in the city's Bell Town neighbourhood.

I laid in bed with a phone book in The Pacific Hotel for days, my money running out, calling various Seattle contacts to see where I could show the films I had packed in the boot of my car. All trails led to Dennis. He wanted to do the shows, even before he knew what I was packing. And so a month later I had a week at The Jewel Box. By that time his other two partners had more or less peeled off the operation and he was running it on his own with help from wife, Elizabeth Rozier. The two of them also co-owned The Spade and Archer mystery book shop. The Jewel Box came to an unceremonious close about a year later when one of the two bar owners, an irascible old drunk, stole his

Photo: Dennis Nyback

projectors. Not long after that he and Elizabeth opened The Pike Street theatre on the other side of town.

Sandwiched between a punk clothing shop, a tattoo parlour and Seattle's sleaziest bar, the cinema occupied a store-front formerly inhabited by a day-labour pool. The upper floors of the old brick building comprised the city's cheapest surviving flophouse SRO (single residency hotel). Neighbouring businesses were happy to see a cinema replace the day-labor dispensary where every morning at 5 AM an unruly rabble of winos and drifters would collect to fight, drink and raise general hell as they waited for the labour pool to open and start dealing out ultra-low paying day work.

With the help of friends, Dennis and Elizabeth re-

Land of a Thousand Balconies

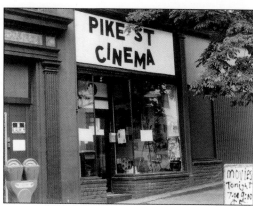

Dennis Nyback applies lettering to the Pike Street Cinema sign.

paired the place, built a screening room by raising a new wall and constructed a projection booth in the loft. All of this owed a lot to the assistance of a their electrical genius pal, Doug Stewart, who wired the booth and installed two 35mm projectors and a top rate sound system. Seventy movie theatre seats were brought in, a screen was hung and the walls were draped with plush red velvet curtains purloined from an old abandoned theatre. A piano, which would come in handy for the live musical revue productions that the room would host on occasion, was rolled in.

The upshot was a comfortable, offbeat little cinema with good technical presentation. The front room functioned has a ticket booth, an office, a "live-in" poster display case and a kind of a lobby. They decorated the windows with antique movie equipment and posters for upcoming shows. Bookshelves were built floor-to-ceiling and soon held the entire contents of their book shop which they moved into the theatre to save rent. This contributed to the room's cosy atmosphere. The screening room itself also had a unique feel to it, what with the piano, all the fabric on the walls and an overstuffed couch that had been moved up into the loft next to the projection booth to serve as a kind of poor man's box seat.

At some point Dennis and Elizabeth separated, and after she moved out of Seattle, Dennis ran the cinema by himself most nights. He would take tickets, introduce the show and then dash up to start the projectors. Candy and soda was left out in a pile on the front desk. People would wander out, take what they wanted and leave their money. It was now basically a one-man operation.

The location of the cinema occasionally caused problems and injected an unexpected drama into the mix. Someone once threw a pot out one of the windows above and it smashed the windshield of Dennis' car. The pot even still had food in it. He stopped parking his car at the curb out front after that. And one night after watching a horror movie at The Pike Street, the audience departed the theatre to find the street crawling with cop cars. Upstairs in the hotel a guy had just knocked on the wrong door by mistake and the angry occupant of the room had come out and stabbed him. Most of the crowd waited around to see them bring the body out. Here was a real life ending to their horror movie.

Shortly after he had opened the cinema, three people had been slashed to death in the syringe-and-beer can littered alleyway out back, the result of some altercation originating in the bar next door, The Nikko Garden Tavern — the same bar that Kurt Cobain bought his drugs at, or so it was rumoured. The Cinema's plate-glass front window was shattered at one point, and another time Dennis ended up with broken glasses after throwing out a big Indian hobo who had just come in to panhandle change and wouldn't leave. Every morning before opening the cinema, empty beer cans had to be cleared out of the doorway.

I spent a night on the cinema's couch in the summer of 1993 when I doing shows there. Voices of haggling nocturnal crack addicts gathering in the doorway out front mingled indistinguishably with the distorted inhuman commotion coming through the walls of the bar next door. All the while, up above in one of the hotel rooms, somebody was stomping and raging

madly about (I really quite enjoyed it all).

The noise caused some problems early on. Audible sounds of the jukebox from the bar next door, and/or the thuddings of somebody getting their head knocked against the wall from the same bar room, didn't particularly enhance an old Chaplin film, and the Sunday screenings of old silent movies became problematic. Additional soundproofing and supplications to the otherwise hostile bar owner to reposition his jukebox speakers eventually helped a bit.

At some point somebody was dumping buckets of noxious, festering bile out of one of the hotel windows up above. It would splatter into the back alley, invading the cinema with a vile odour and forcing Dennis to clean it up because nobody else was about to. He complained to the landlord, and was given eighty dollars off the rent whenever it happened. At the time he was struggling financially and, much to his own chagrin, found himself missing these buckets of bile when they ceased to fall. Combined with additional deductions for a super-leaky ceiling, his rent was nearly non-existent for a while.

At one point during that summer of 1993 when I was there doing shows, Dennis, Elizabeth and I were in the back lounge area behind the screening room when we suddenly heard a clatter and saw a pair of legs dangling and twisting in front of the window. Apparently somebody from the hotel was fleeing a rent bill or some freshly committed crime, and had swung out of his window on the drain-pipes which had immediately collapsed and almost sent him swinging back through the cinema's window below. We watched as he regained his hold on the ledge and vaulted onto the adjoining roof top, scrambling away to freedom.

It was a constant challenge to make the movies as exciting as what was happening around the theatre.

In the meantime, there were also movies playing. In fact without a doubt the theatre offered the most diverse programming in the Seattle area at the time, everything from classic Hollywood fare to jazz and silent films, vintage animation, exploitation, cult, porno, G&L, s&m, trailer marathons, Hong Kong action movies, avant-garde, underground, war propaganda and "pot luck" marathons where the bewildered few were treated to a discombobulating barrage of anything that happened to be lying around the ever cluttered projection booth that night. You and your date might be in for *The Estrogen Cycle of a Rat* double screened with a spool of sixties laundry detergent commercials, topped off by a bloody driver education film. To the uninitiated things could get plenty strange and there was a certain amount of dada implicit in these screenings, but Dennis had a smooth manner about him and a certain ability to talk people into buying a show that on the surface seemed completely far out.

He was always complaining about the low crowds, and immediately thereafter coming up with ever *more* eclectic and bizarre programming ideas. But like others who have been bitten by the movie business bug, he remembered those few shows that were monster hits and attracted sell out crowds night after night, the lines going around the block… mobs of people eagerly pushing wads of cash into his hand… and he always figured it would happen again with the next show. And once in a while it did, but of course not nearly often enough.

Perhaps his most bizarre idea was something he dubbed *Hong Kong Hodge Podge* in 1993. I have to confess I played a part in this. I was living in San Francisco at the time and had been given five rusty spools of 35mm film by a North Beach junk collector who had found them in a garbage dumpster located next to a Chinese movie theatre that was being demolished. He didn't know what they were, and I had no way of looking at 35mm at the time, so I shipped them to Dennis by the cheapest possible method. Eventually they arrived and sometime thereafter he got around to looking at them. All five spools were from different B&W Chinese action movies from the sixties. But he detected a vague thread: there was a start and an ending spool, and the other three spools "kind of" formed a plot, accent on "kind of". So he called it *Hong Kong Hodge Podge*, and ran it! The movie *Singles* had just come out and there was talk going around about this episodic, free-associative kind of thing. *He would give them free-associative…*

Only one customer showed up… a nice looking girl. They talked. They had a good time. They eventually started going out together.

So apparently the riddled was solved, one of the central mysteries of modern day cinema was answered: the only reason anybody would go to *Hong Kong Hodge Podge* was if they were sexually attracted to the projectionist.

2 ON THE ROCKS WITH THE LIGHTHOUSE CINEMA

In the fall of 1995, Dennis closed down The Pike Street Theatre, and with his new girlfriend prepared to move to New York where she had an apartment waiting for them. There he planned to open a new theatre on the strength of 10,000 bucks he had received to give up his co-op apartment.

The Pike Street had become a repository for all the film equipment and theatrical accoutrements he had hoarded over the years, and now it was all loaded into

Land of a Thousand Balconies

a rental truck. In went the two old 35mm projectors once used on navy ships to show girlie films and VD cautionaries to horny sailors, along with all of his 16mm and 8mm projectors. He loaded in all the film prints packed in tattered boxes and rusty shipping cans. In went the rows of movie seats, the draperies, screens of various sizes and finally all of his personal possessions. He left the piano behind. They were ready to roll.

One week later they arrived in Park Slope, Brooklyn, where they had arranged to rent a flat. Miraculously, he found a parking space right out in front of the building — and the next morning a parking ticket under the wiper.

The new cinema, still in the theoretical stage, was almost financially torpedoed at the outset when he unwittingly uprooted a large tree and crumbled a section of sidewalk while inattentively backing up the truck that morning. A cop was called. Dennis could see his 10,000 bucks evaporate before his eyes in a confetti of damage claims and parking violations. But amazingly *nothing* happened. The cop went away. Some guy pulled up in a city works jeep and cut down the tree with a chainsaw. The logs were hauled away and the sidewalk was eventually fixed, and he was never fined or charged a penny, and the cinema lived.

He was in love with New York already!

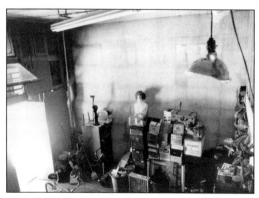

The backroom of the Lighthouse, looking out onto Suffolk Street.
Photo: Silke Mayer

His luck held: he unloaded the contents of the truck into a storage locker in Crown Heights, Brooklyn, and returned the vehicle to the rental agency. The agency guy gave it an apathetic look over. He didn't seem to care about the sizeable dents from the tree and gave Dennis back his deposit in full. Wow! What a town!

Dennis began to spend a lot of time walking around downtown Manhattan, sometimes in the pouring rain, scouting possible rental sites that had the prerequisite low rent and high ceiling space. Originally he'd hoped to find a space within a five block radius of The Film Forum, a well known rep theatre on West Houston Street, since (1) it was in an area where people were used to going to see movies, and (2) he intended to steal and use the nice map that adorned their programs. But to no avail.

A German acquaintance of his who was also living in the city at the time, Johannes Schönherr, had, in his perpetual search for a cheap place to live, come across a space down on Suffolk street on the Lower East Side. This was what Dennis finally rented, a "rough space", twenty-five feet wide and sixty feet deep at 116 Suffolk St, a stone's throw from the Williamsburg bridge. Across the street was the building where Edward G Robinson had gone to grade school, now an Hispanic cultural centre run by Suzanne Vega's father (if that helps anybody get their bearings).

In the early 1900s, 116 Suffolk had been a shop selling children's "sleepers" and underwear. Since then it had been reconverted, if not reconditioned, to a variety of uses, but it still reeked of antiquity in a way that only a New York "rough space" can. It was presently being used for storage by Jaybra's Beauty Shop

Haunted Houses and Illuminated Cellars

which occupied an adjoining space around the corner — the two long rooms connected in the rear in an "L" configuration. The old wrought-iron signs from the original sleeper shop, which read "Rothkopf & Sons" and "Nazareth", were still up over the door of his would-be cinema.

Nyback's first peek inside the space had been hair-raising. Hoisting the heavy, clanking metal security gate up by the chain pulley, streaks of daylight pierced the mouldy darkness to reveal a virtual toxic waste dump of out-dated hair-care products from the sixties and seventies. Bottles of West Point hair conditioner ("It disciplines your hair!") lay leaking inside rotted cardboard boxes… the debris was chest-deep.

A mammoth job awaited. It required a wild imagination to envision this as anything other than a little piece of hell, let alone a movie theatre.

The shifty landlord, Elliot, was ensconced in a squalid little office several blocks away, in a building with no address, behind a door with no number. To assist in the clean-up, he rented the largest dumpster available and it was dropped off out front next to the curb. Johannes and a friend helped out, but by the first afternoon, despite filling the dumpster, they had made little visible progress.

They got an early start the next day in an effort to outpace their neighbours, whom, it was rumored, would fill up the dumpster with their own trash at superhuman speed. People walking by out front occasionally asked if they could have some of the shampoo that was being thrown out, but Dennis tried to warn them off, telling them it was by now so toxic that it would probably eat through their skulls if they actually tried to use it.

Elliot came up with a bright idea to speed the work and sent over one of his idiot henchmen to assist. The dullard began wheeling away cans of garbage and returning for more with suspicious speed. Dennis soon discovered he was merely dumping the cans two blocks away in the middle of the sidewalk. He put a stop to this monkey business and sent the moron packing, only to find that he had stolen his hand-truck into the bargain.

Slumlord Elliot was a piece of work. Although he surrounded himself with a circle of dim-wit factotums and manoeuvred amid the trappings of poverty, he actually owned twenty-eight buildings around the Lower East Side. He was a multi-millionaire disguised as and operating in the manner of a low-level bookie… all in an attempt to divert any suspicion that he might be rich.

Eventually the mass of garbage was cleared out. Dennis moved the contents of the storage vault in Crown Heights into the room and supervised construction of the loft projection booth and the floor-level partition which would divide the space into a lobby and screening area. The loft would eventually include another little two-seat "poor man's" balcony. At one point a welder was needed and hired but never showed up for the first day of work due to his drug problem.

To build the loft, an old interior stairway was ripped out and at one point a secret stash of heroin packets tumbled out from a hollow in the rotted wood. What the Hell was this? Was somebody going to show up to reclaim the stuff?! Not to worry, counselled the carpenter, a character named Kyle who seemed to have first-hand experience with the subject: this heroin was old stuff. Additionally it was rumoured that there had been a fatal shoot-out in the flat upstairs and that the owner of this stash was probably dead. Great.

The loft and partition were completed. A big screen was hung and the seats were installed. The place started to look like a movie theatre… of sorts. A battery of projectors were implanted in the booth behind crudely hand-cut portals and the room was fully wired.

A couple of parties were held in the space before the construction work was finished and they had no problem getting big crowds in for those. Several film shows also transpired while the place was still just a lot of exposed beams and had a skeletal look to it. A number of people told Dennis it looked great like that and he should just leave it. Further use of the space, in its early stages, was made by the director, Claudia Heuermann, who shot scenes from her Jazz documentary *Sabbath in Paradise* there. A number a musicians, including John Zorn, can be seen playing in the theatre.

Johannes, who had assisted in various ways in the founding of the cinema and would co-book it during the first few months, now brainstormed with Dennis for days over what to name it. "The Lighthouse" won out in the end purely by default since there was a pressing need to get the damn place named so they could start sending out press-releases for the upcoming schedule.

Dennis got the first two months rent free since in point of fact Elliot was obligated to clean up the place. This was a good thing since all the miscellaneous expenses of start-up had virtually wiped out his ten grand. What was happening was close to a miracle: a new theatre was opening in America's largest and most important theatrical market, basically on pocket change. Theatre chains battle each other to the death and spend millions to do the same thing.

But the place was still dusty and dirty beyond belief and there was no quick fix for that. Dennis even sealed the projection booth in plastic to prevent the dirty dust from raining down on his projectors and films. Living in Seattle most of his life, he was not used to the

Land of a Thousand Balconies

seediness and dilapidation that was coin of the realm on the east coast. Visitors to the first screenings, after sitting there for about an hour, had a tendency to start hacking and wheezing in the tubercular dampness of the place. From a strictly visual perspective, on the other hand, it was more like sitting in the bottom of a drained and derelict swimming pool, what with the chipped aqua-marine plaster walls. It was like "watching a movie under water", as one early customer enthused.

By this point Dennis had broken up with his girlfriend and had moved his personal possessions into the theatre. Boxes of books, clothes and seventy-eight records now joined the crates and shipping cans of films in the open space up near the screen, all of it partially covered by a canvas tarp that sported a layer of dirt and plaster dust which rained in a fine mist from the gashed-up ceiling. This gave the joint the air of the partially and mysteriously inhabited. He himself now slept on a series of couches in sub-sublet situations, eventually moving into Johannes' ramshackle flat on Houston Street.

In the semi-darkness the place could evoke an aura of romantic neglect, but when the bright fluorescent ceiling lights were turned on — something Dennis only did in the presence of the "initiated" — the stark decay was positively shocking. He randomly highlighted the decrepitude of the room by fixing spotlights on the more picturesque details. For example, he illuminated an exposed water pipe snuggled into a trench of ripped out plaster. Another spotlight shone on a bottle of West Point hair conditioner saved as a sentimental relic and draped with Christmas lights. Coils of rubber tentacles left behind by Alyce Wittenstein after the screening of her latest science fiction film festooned the exposed water pipes on the ceiling.

People started hearing about The Lighthouse.

"It's perfect! Don't change a thing!" declared some local neighbourhood celebrity one day, sticking his head in the doorway before dashing out again and never coming to a single movie. An architectural designer who came to one of the early shows told Dennis that the look of the place was classic "distressed postmodern industrial" and that it was ultra-fashionable these days. Rich people paid huge amounts of money to simulate this look. Dennis could have run the Lighthouse for years on the money that someone might have paid him to *imitate* all of this.

A neighbourhood bum, claiming grandly how much he loved the place, talked his way in for free to all the early shows. Eventually they discovered why he loved the place so much: he was trying to escape a loudmouth girlfriend. She eventually caught on to his dodge and would track him down and start raising hell in the theatre. This could be quite disruptive, especially at early morning press screenings.

To the right of the movie screen, a short staircase led up to a small apartment. It consisted of a tiny "living-room" and a bathroom. The living-room contained a ratty couch and two small, heavily barred windows, one of which looked out onto a desolate, garbage-littered cement courtyard, while the other provided a view down into Jaybra's Beauty Shop. The tiny bathroom contained a toilet, sink and shower stall. Dennis rented these humble quarters out to a bike messenger named Ian for 300 bucks a month, which relieved some of the rental burden and contributed a bit of Dada into the bargain. In the middle of film shows Ian could be seen climbing the steps next to the screen and entering his flat, sometimes to emerge shortly thereafter in a new change of clothes. Until the toilets were installed in the lobby four months after the opening, theatre patrons wishing to relieve themselves were obliged to walk through Ian's room to get to his toilet. Sometimes he would be sitting there on his couch watching TV. There wasn't much else one could do in that apartment, although he was also occasionally known to hire the services of a local prostitute. In the beginning the electricity was prone to go on the blink in the back of the theatre and this necessitated the lighting of candles in Ian's domain, making a trip to the toilet something of an occult experience. For his part, Ian didn't appear to mind living in a movie theatre.

The financial wisdom of having him on board was sometimes questionable, though, as at one point Dennis noticed an unaccounted 300 dollar bulge in his phone bill. Ian eventually confessed: this was the fruit of many calls to a phone sex hotline. Drug-taking was another one of Ian's vocations, although none of this hampered him from being a medium-competent bike messenger.

Soon after The Lighthouse opened "for real" in March of 1996, the beauty shop went out of business and the space was stripped bare. Through the small, barred window in Ian's room, it's dark, haunted expanse glowered in the shadows below (leaving one to deduce that Ian's digs had once been the secret lair of security guards spying down on would-be shoplifters). At one point, in April, Elliot moved a man, a woman and their dog into the vacant Jaybra's space. Their constant quarrels and the barking of their mean dog could be heard in the theatre. Two weeks later and they were suddenly gone.

Despite the fact that the cinema inhabited the ground floor of a five storey building, leaks developed in the ceiling when it rained. Two or three chairs were taped

Haunted Houses and Illuminated Cellars

off-limits for a while until Dennis got a chance to haul out the ladder and rechannel one of the leaks back into another part of the ceiling with an old board.

A major leak appeared in front of the screen during a two week run of *Thundercrack!* — a pornographic, haunted-house melodrama that takes place during a thunderstorm. Here was atmospheric accompaniment beyond anything Hollywood technicians could dream up. The run of this film, which Johannes had booked, got blockbuster press in *Screw* magazine and drew from the bottom of the barrel of the raincoat crowd. Many of the film's customers had a tendency to show

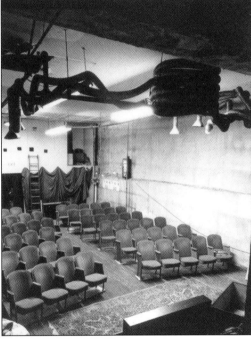

The Lighthouse. From the stage looking back to the projection booth (left) and the 'poor man's box seat' (upper right).
Photo: Silke Mayer

up an hour or so late, only to be assured by Johannes that the movie had just started. Nobody complained.

The screening of pornographic films was frequent in the beginning, largely due to Johannes' input, and started to work against the theatre with the mainstream press. Even *The New York Post*, the friendliest daily which regularly reviewed Lighthouse openings, eventually balked at a schedule laden with so much fucking and sucking. While Dennis had nothing against porno, having worked in Seattle as a projectionist in adult theatres throughout the entire seventies, he knew he had to diversify the programming to avoid being pegged as a smut peddler. In any case, this did not hamper the general positive reception the theatre started getting as the New York City press started paying attention to it with a series of profile pieces.

But the papers had a disturbing tendency to misprint his schedule listings. One night Dennis found himself with fifteen people on his hands who had come to the theatre for the wrong show due to such an error. Wanting them to stay and have a good experience at his theatre (and pay for a ticket!) he pitched them promises of celluloid greatest after his unique fashion. He got them to take seats then foraged through stacks of film cans and came up with a custom-tailored show that included *Death Zones*, a film about school-bus safety, and a 1961 expose on the pointlessness of urban existence entitled *Assembly Line*. Everyone stayed, paid, watched and departed apparently happy and satisfied (as well as a little mystified)...

In April Dennis departed for Europe on a five week film screening tour and left Johannes in charge, assuring him everything was taken care of. Two days after he left, Johannes received in the mail a gargantuan overdue electric bill for several thousand dollars — with a shut-off notice for the previous day!

Over the phone from Europe, Dennis told him just to give it to Elliot, which he did, but the next week was a period of profound uncertainty. That day a photographer came over from a paper to shoot pictures for a profile on the theatre, and all Johannes could do was throw worried glances around at the lights amid a series of heroic, staged poses, sure they would shut off any second. That weekend they had a big premiere opening and Johannes was certain at some point the electricity would go off. But the electricity never went off. Elliot (apparently) paid the bill, which in fact, out of some strange accounting procedure, was for the entire *block*.

These early financial battles against electric companies and telephone sex services left Johannes and Dennis bowed but still standing. On the plus side, there existed in the theatre a mysterious phone installed by Elliot and programmed to automatically "bounce" the call to another location when anybody rang the number. Some kind of front for something. While you could not call the theatre on this phone, you could call out on it, and this they did, to Tokyo, to Copenhagen, to...

It seemed that nothing existed in this neighbourhood that didn't spring out of some kind of criminal motivation. Dennis had long sought someone to operate a cafe in the lobby, but the only serious money ever offered to implement the plan was from a branch

Land of a Thousand Balconies

of the Coney Island Russian Mafia. Dennis nixed the idea, much to Johannes' amazement.

Dennis shied away from placing a prominent sign or erecting a marquee out front lest he draw the attention of public building inspectors or the fire department. He feared these people worse than the Grim Reaper since the theatre was hopelessly in violation of every possible code or requirement. He did hastily spray-paint "Lighthouse Cinema" on a piece of plywood nailed up in the doorway, ever to regret the tackiness of it but never bothering to paint it over. Johannes created a nice window display at one point which was visible when the security gate was rolled up during operating hours, but during daytime, with the gate down, no one could possibly suspect this ancient shop-front was a movie theatre.

This humble public profile did not dampen the ambitiousness of their programming.

They hosted a ground-breaking two week Kuchar Brothers retrospective that far surpassed anything that funded dinosaurs like MOMA or the Film Forum had ever attempted. Mike and George were both in town, staying at their mother's flat in The Bronx, and took the subway down to all the shows. Dennis also booked a run of the dated 1967 CBS documentary, *The Homosexuals*, which had been narrated by famous TV news anchorman, Mike Wallace. He was shocked to get a call from Mike's secretary the day before the first show, deeply suspicious that this was really some kind of set-up to bust him on copyright infringement. Mike planned to attend the show the next night, she said, and they wanted a recommendation on some good nearby restaurant where he could dine beforehand. Dennis told her he didn't know. The truth was he never had enough money to eat in a restaurant. At this point he was living on the two dollar daily special at the Happy Wok around the corner. Mike Wallace did attend the show next evening and candidly discussed the film with fifty audience members.

Dennis whipped up another show he called the "Marsha Brady Fetish Night". It was a tribute to Marsha Brady, aka Maureen McCormick, whose perky, plastic presence earned her cult status as the ultimate seventies' suburban doll-face. The evening would feature a couple of Brady Bunch episodes and a hard-hitting anti-rape educational McCormick had starred in, with Dennis set to give away a free prize to the best Marsha Brady look-alike. Only six people showed up, and neither of the two heavyset women in the audience looked anything at all like Marsha Brady so the prize

Dennis at the controls of the Lighthouse Cinema.

went to a Mama Cass look-alike.

Many had wondered if Nyback's casual Seattle approach could work in a hardass, hardball city like New York. He was led to believe that if he used the honour system like he did in Seattle, not only would someone take all the candy *and* the money, but everything else that wasn't bolted down as well. He had been told that this was the kind of town where you had to drive your truck fast around corners because if you slowed down too much people would jump on the back and steal your cargo. It was to his astonishment, then, that late arriving customers to The Lighthouse would collar him after the show so they could pay.

But suffice it to say, The Lighthouse never turned into any kind of money machine. It had been easy to fill the place for the wild parties Johannes had organized early on, but attendance took a crash drive when they replaced the blasting rock music and cheap beer with mere motion pictures. From a steady twenty to thirty a night, audiences dwindled to five or six per show as early summer approached and the place turned into a blast furnace. Johannes had always maintained that the survival of the theatre depended on diversifying to live music a couple nights a week, but Dennis refused to consider amplified music as a regular feature.

To save money, Dennis moved into the projection booth where he flopped down on an old mattress amidst chaotic stacks of film reels, shipping cans and disgorged projectors. He slept there for about two weeks until an office alcove was constructed downstairs, and then he moved the mattress in there, his slumber only occasionally disturbed by one of his industrial-strength rat traps going off.

Cash from the shows he now stuffed into his pocket without even counting the tickets. This income barely paid the rent. Everything had to be done as cheaply as possible. When he had to pick up a 35mm print one day way up on Thirty-third and Fifth Ave, he walked up with a hand cart and fetched it, making for a trip of over two hours through the city streets. Neither Dennis nor Johannes, who was now back in Germany for a spell, could afford to pay for any extras — like shipping prints. When a 35mm Finnish documentary about Vampira was booked, Johannes figured out a brilliant strategy to have it carried by hand on subways, buses and planes all the way from Helsinki to Berlin to New York without a shipping company getting one red cent of the action.

By this point, Dennis had moved Ian over to Johannes' flat and replaced him in the back apartment with a clever handyman type named Rom who installed toilets in the theatre and fixed the plumbing, all with found scrap-metal. Johannes, who despised Ian, was horrified to learn that he was now living in his apartment. After phone calls and threats failed to budge him, he flew all the way over from Frankfurt just to throw him out. Johannes was none too happy with Dennis either and threatened to cut his body into pieces and feed it to the winos. All of this caused a rift between the two erstwhile partners and Johannes' involvement with the theatre now came to an end.

A bout of extremely hot and sticky weather hit New York City in June and turned the Lighthouse, poorly ventilated to begin with, into an even bigger sweat box than it normally was. But in mid July a bigger problem came walking through the door: a building code inspector. The next day Dennis received a code violation notice in the mail and an order to "cease and desist" and vacate the premises. Dennis called them up and asked if he could run shows for five people, what his average audience had now boiled down to. He was informed that if they caught him screening films for anyone other than family members, he would be issued a summons.

There were ways to get around such things in New York. A whole cottage industry had sprung up to meet this challenge: one could hire a low-level political schmoozer to grease some palms, or a jailhouse lawyer to provide a quick-fix. Dennis couldn't dream to afford either solution, let alone hiring the services of an engineer or architect to secure a legal certificate of occupancy. So he took the cheapest way out and figured he would just shut the security gate while running shows, swearing the small audiences to secrecy, or, if necessary, getting them to sign some paper declaring they were all distantly related. As it happened, none of this was needed since the Cultural Centre across the street offered him a free room to play out the rest of his schedule.

During one of his subsequent conversations with the building code office, Dennis asked what their definition of a motion-picture theatre was and discovered that it was a venue with seventy seats or more. He told the guy he only had sixty seats. After some paper shuffling and long pauses the guy told him "you can continue doing what you were doing before". Apparently they had no idea *what* he had been doing before. He dropped from the status of violator back into his original status as terminally unclassifiable.

Meanwhile the press stayed attentive and for the most part positive and supportive as Dennis single-handedly bucked a twenty year trend of Independent theatre shut-downs. "... the space has the indefinable but palpable feeling of sorely-missed Manhattan movie houses like The Thalia" wrote reporter Bob Satuloff for *The New York Native* in a three page rave entitled:

"Welcome to the Lighthouse — where Mormon Propaganda meets *Battleship Potemkin* and *Wild In The Streets*". Other writers were similarly smitten by the delirious eclecticism of Dennis' programming.

Others, for different reasons, were not amused. A *Village Voice* writer at one point lifted a phrase from crime reportage and described the theatre's location as a "senseless killing" neighbourhood, holding out the prospect that one had a reasonable chance of getting murdered if one went to The Lighthouse. Dennis was not happy. Cathay Che, from *HX* magazine, slammed the theatre as "hot, smelly and pitch black inside… another dumpy loft where two slacker artists and a cat live." Truth be told, a girl Rom knew and a cat now lived in the theatre, with Rom still installed the back apartment. If Che had stuck around long enough, she would have seen that Dennis himself was also living in the office. But none of them were "artists"! Dennis should have sued.

Che had come to review Greg Wild's *Highway Of Heartache* which Dennis had over-optimistically booked at five shows a day over two weeks. She hated the film into the bargain. As for the movie, audiences dwindled radically after the first few screenings and Dennis spent a lot of introspective moments sitting in the ticket booth waiting to start shows for zero customers. Even Wild failed to show, having driven back to Vancouver in a rented car without telling anybody. The run was a flop, in part because it was planned as an adjunct to Wigstock, the NYC transvestite festival/street fair, which was cancelled at the last minute.

The Lighthouse theatre itself was about to be cancelled: in August Elliot told Dennis he planned to sell the building and wanted him to vacate the premises by October 1. Dennis negotiated an 8,000 dollar cash settlement to terminate his lease prematurely. The show was over, or soon would be. Dennis saw the colour of 5,000 bucks, but to this day, Elliot still owes him 3,000. (Maybe he should forget about it since Elliot was later alledgedly involved in the murder of a well-known neighbourhood squatter activist.) In fact he never sold the building. Dennis would later speculate that with all the people actually living in the theatre, Elliot feared it would turn into some kind of squatter commune. In any case, Dennis made more money with the lease termination deal than he ever had by selling tickets to customers.

In the meantime the stuffy *New York Times* planned a major feature on the Lighthouse and sent down their best photographer to snap pics. Dennis was also contacted by a TV crew from a major Japanese station. They had a TV series in production on strange New Yorkers and Dennis had been tapped as a candidate. For two whole days he was driven around New York with the Japanese TV crew to recreate for the cameras his mundane daily routines. They all piled into the cheap café where he read the paper every morning and had a cup of coffee… and so forth. The crew's director was a pretty Japanese woman named Sally who would be introducing the show: "Today's New Yorker is…"

The Lighthouse had become something of a mirage. A lot more people were reading and hearing about it than coming to it, and you could now add to that fifty million Japanese TV viewers. People were under the impression it was doing great, and Dennis was building an army of fervent supporters and sympathizers he never saw in the flesh but who would rush into the breech with suggestions and too much unwanted good advice as the end approached. He was offered a range of possible substitute locations, from a Synagogue basement to a loft over a pizza parlour.

On September 18, he ran his last show, "Cigarettes And Beer" — a mix of surreal and nostalgic TV adverts and short subjects on… cigarettes and beer. He got two big crowds that night, all through word-of-mouth.

He arranged for storage of all his equipment and possessions, but right up until the last moment he had no place to actually live himself once he was forced to evacuate the theatre. He considered a cheap room on The Bowery. It was only five minutes away, and it was… cheap. Being an aficionado of the thirties and forties, he had, as noted, amassed a large collection of authentic vintage clothing. Probably the same stuff, if cleaner, than the garb his new neighbours would be wearing. And he'd been showing films like *Street Of Lost Hope* and *On The Bowery* (1961) out of a love of their gritty, realistic, noir-ish qualities. Now he might actually be living there himself. His movie life and his real life were starting to merge.

The Lighthouse got a burst of glowing press just before he moved out. He got "Best Of…" picks in both *The Village Voice* and *The Downtown* paper. The phone was ringing every twenty seconds as he sat in the dark lobby waiting for the truck to arrive.

"What's playin'???"

Postscript

After the Lighthouse went under, Dennis eventually ended up out in Portland where he became involved in the relaunch of that city's fantastic old grind-house, The Clinton Street — one of the oldest continuously running theatres in the country. With his encouragement, it was bought and is now owned and operated by his ex-wife, Elizabeth Rozier. But like they say, that's another story…

EUROPE IN THE RAW

Underground Cinemas Show It All!

A sardine processing plant, a dive bar, a basement bowling alley... a pencil factory, an old horse hospital from Victorian times and a tramp freighter. What all these locations have in common is that today they are all actively functioning cinemas.

As the movie-going experience increasingly comes to be associated with the uniformity and sterility of multiplexes, Europe's off-cinema network, of which these venues are a part, survives as a last bastion of individuality, independence and grass-roots activism.

In opposition to the existing corporate wisdom that movie viewing should be a controlled, uniform and passive experience, here, off the beaten track, one finds a wide diversity of physical spaces and programming approaches that are anything but passive. Here movie viewing is treated as a participant sport where the engagement and energy of the audience is essential and where atmosphere is key.

All this isn't really new — most countries in Europe have their own traditions of independent cinema exhibition going back to the sixties and seventies. For example there is the Dutch "Second Circuit", which had its origins in the northern student city of Groningen in the early seventies. It might be described as "activist art-house", while the more recent and more rough-hewn (Dutch) "Third Circuit" tends more towards American exploitation, and the radical and transgressive works of the Underground. The later can also be said to have originated in the early seventies since these cinemas and screening spaces are largely housed in buildings that were "squatted" and came to serve as underground culture centres at that time. As the years wore on these culture houses became officially "recognised" and often, at least in part, subsidised. Today they typically include concert halls, gallery spaces and restaurants as well as cinemas. (The idea of such a place is alien to Americans.) Yet these "cinemas" only began to function as a loose network in the early nineties and in fact it was never really more than a loose collection of non-conformist young programmers who only occasionally cooperated.

The "Kino Komm" circuit in Germany is similarly subsidised and some of the buildings were also originally "squats". Among the most legendary is the Kino Komm Nürnberg, housed in an ancient monstrosity erected in central Nürnberg in 1910 as a Künstlerhaus (House of the artists). It was used by the SS during the war and suffered major bomb damage. From 1945 into the early sixties, it was used as an American Club by the US Army. From the early sixties into the early seventies it was occasionally used for exhibitions (Joseph Beuys filled one of the rooms with lard), but was essentially an abandoned building. In 1975 it was occupied and used as a "Kommunikationszentrum" by leftist and youth groups, and the Kino im Komm was founded on an upper floor. The place hosted giant booze-soaked rock concerts and ticketholders were frequently obliged to climb stairs teaming with junkies, punks, and hoodlums to get to the cave-like cinema space. In 1997 the city "repossessed" the building and turned it back into an artists' house (called K4) minus the anarchist excess but still with a cinema. Recon-

Land of a Thousand Balconies

struction was completed in 2001.

The "Folkets Bio" (People's cinema) circuit in Sweden was founded in the early seventies on more socialistic and political precepts, and the atmosphere could be spartan: a screen on the wall and folding chairs. It continues to survive today in a somewhat more populist and less politically focused form. It is much closer to something that could be called a formal circuit, but is still a grass-roots type of cinema association with its programming in an open-access mode.

Most countries have a Film Klubb circuit, and here just about anything can be screened on a "membership" basis. Norway has a particularly strong circuit, and its bookers are able to screen more extreme films in a country where film distribution is regulated by the government.

And then there are the totally unique cinemas like the "Byens Lys" in Copenhagen's Christiania, an old army base occupied by hippies and anarchists in 1970. This unique screening space survived for many years with its rustic sandy floors, couches, wood burning stove and (according to at least one viewer annoyed by delayed reel changes) stoned projectionists. It survived unfunded and with an aggressively non-capitalistic attitude.

To attempt to categorise any of these venues as "underground" quickly becomes problematic, not to say pointless, but what one *can* say about this diverse collection of cinemas and screening spaces — what unites them after a fashion — is that they share a renegade mentality dedicated to "free programming". By this, it can loosely be characterised as an "off-circuit".

Following are ten of the most interesting examples that I, as an American, have come across in my nine years as a film distributor and tour organiser in Europe, and all are interested in making contact with film-makers. Each venue — whether part of a circuit or not — is the product of a unique set of circumstances: first and foremost they're products of the people who struggled to establish them and who toil to sustain them, often without pay. Furthermore, each cinema is very much a product of the city or town, the country and culture, in which it exists. From the stone cellar rooms of Slagtehal 3 in Århus, Denmark to the Babylon movie palace in East Berlin and everything in between, these venues stand in opposition to the globalisation and mainstreaming of the movie-going experience.

This off-circuit finds no parallel in the US where lack of funding, lack of activism and lack of access to the physical spaces required has always precluded its formation, aside from a few struggling individual cinemas. It seems that the activist cinema traditions that also existed in America in the sixties and seventies have been extinguished, though hopefully not.

THE NOVA, BELGIUM

The Nova, located in the heart of Brussels, Belgium, is a volunteer collective which occupies a building that 100 years ago presented cabaret. Thereafter it changed to live theatre, and from 1935 to 1987 it was an art cinema. In 1987 the building was bought by Belgium's biggest bank which evicted the cinema and prepared to convert it into office space. Those plans stalled and in 1997 a group of arts activists talked the bank into donating the building to them rent free. Under the auspices of a non-profit community association, it was refitted as a 200-seat cinema complete with a balcony and a labyrinthine stone cellar housing the bar and exhibition space.

Programming is loosely done by the committee, or "team" that runs the place, but individual initiative is encouraged. They show underground, animation, cult, exploitation, ethnic fare, and even Belgian feature premieres. They have open screening nights where anybody can walk in off the street with a film, and they've hosted visits by film-makers and artists from around the world. Films are often screened in conjunction with live music, or art and performance components as exemplified by one of their biggest recent successes, a Moroccan "Halqa" festival where each day for two weeks films and concerts lasted until the end of the night, resulting in an incredible ambiance. The Nova also participates in the annual Brussels Fantasy Film Festival in an semi-autonomous capacity which allows it to bring in more transgressive and cutting edge acts that otherwise would not be invited.

The cinema exists as a free space for all voices in a country that can tend to subdivide into ethnic or linguistic enclaves, and it has remained free from harassment by political groups or the police despite the extremes to which it's programming can go. While the survival of the Nova seemed tenuous the first few years, the building's new owner has assured them they can stay — and start paying rent.

Haunted Houses and Illuminated Cellars

Europe in the Raw

35mm projector at the 3001 Kino.

THE WERKSTATTKINO, GERMANY

The Werkstattkino is a fifty-seat cinema that has existed since 1974 in central Munich — before that it was a one-lane basement bowling alley. Like The 3001, the cinema itself gets no financial support although they occasionally get funding from the city culture office for specific projects like festivals or retrospectives. Today the Werkstattkino (Work shop cinema) also runs a large film rental library, and has over the years become one of the most influential and inspirational venues on the busy German off-circuit. It is programmed and operated by five or six committed long-time volunteers who work strictly as individuals — not a collective, and the array of films presented is probably the most wide-ranging of any cinema in the world. In its nightly functioning it's a classic one-man (or one-woman) operation; one person takes tickets, goes back and projects the show and then picks up the empty beer bottles and locks up.

THE 3001 KINO, GERMANY

The 3001 Kino in Hamburg, Germany — previously the site of a pencil factory — was founded by four guys who originally organised 16mm shows in a Hamburg bar called Duckenfield, named after W C Fields (William Claude Duckenfield), and Fields is still something of a mentor to them. After two years of reconversion work, The 3001 opened its doors on May 1, 1991 as a ninety-six seat cinema. Today it is run by a group of five who, without funding (except occasionally for specific festivals or projects), attempt the ever difficult task of making a living from this "little shop of horrors" (as one of them puts it) by programming films they like. Thanks to Hamburg's notoriously rotten (hence "cinema friendly") weather, that is (barely) possible and the cinema has continued to contribute in a major way to Hamburg's active independent film scene which also includes kinos like the Metropolis, Fama and Abation, and festivals like the Hamburg Shortfilm Festival in which the 3001 always participates.

The 3001 is part of the German "Arbeitsgemeimshaft" Kino Circuit where contacts and ideas are actively exchanged. In the beginning The 3001 was attacked by some political groups for their programming, but they, like most off-venues, refuse to knuckle under to any form of censorship. Their biggest recent hit was a Cuban movie called *Lagrimas Negras*. Like most off-circuit venues, they have the capacity to screen video, but *prefer* to show film prints — I have not included any video clubs in this survey, there are hundreds.

Over the years it has been attacked from every conceivable direction — from feminists to the State's attorneys to political groups right and left — for programming that is truly without limits or censorship. Even liberal journalists are disturbed because the cinema is everything and nothing — something that writers-with-agendas find most disturbing. Once they got public funding for a series of films on the subject of death — they got attacked for that too. Another time the cinema was literally besieged by radical "autonome" leftists when they screened the documentary by Winfried Bonengel, *Beruf: Neo-Nazi (Occupation: Neo-Nazi)*. A truckload of cow manure was dumped into the courtyard passage, stink bombs were set off inside and one programmer actually had to sleep barricaded inside the theatre to prevent them from breaking in and destroying it.

THE BABYLON, GERMANY

The Babylon was built near Alexanderplatz in East Berlin at the end of the twenties and opened its doors in May of 1929 as an art deco movie palace with full sound-film capability. It came complete with a stage, orchestra pit, organ and balcony. The building emerged from WWII hardly scathed and became the main East Berlin premiere cinema at the start of the communist era. In the beginning of the sixties, now under the direction of the GDR State Film Archive, it was transformed into an art-house/repertory cinema. Its commit-

Land of a Thousand Balconies

THIS PAGE The Werkstattkino (above) and The Babylon.

NEXT PAGE The Hela (above) and the main entrance to Slagtehal 3.

ment to screen fascinating retrospectives as well as interesting, controversial and sometimes banned films, with space for discussion, made it popular with students and cinéastes, although by now it had become somewhat shabby and never properly heated up in the winter.

In January 1990 its future looked uncertain when it was shuttered for repairs, but substantial outcry from the community ensured its survival, and in December of 1991 it was given protected status as the community art house cinema of East Berlin. In 1993 the supporting beams for the roof caved in and the auditorium was closed for repairs — repairs which would be delayed for years due to restitution requests filed by a group of heirs to the former Jewish owner who had to sell the cinema in 1938. To keep it operating in the meantime as a movie theatre, the lobby was converted into a much smaller screening room. The restitution issue having been settled, and repair work completed, the theatre re-opened in all its splendour in 2001.

The Babylon is committed to screening international and art cinema yet is determinedly non-elitist and also works actively with the local community from filmmaking and broader cultural perspectives. While it might seem odd to include a state-funded architecturally-protected movie "palace" in the context of underground cinema exhibition, the Babylon has, in fact, done a great deal to fill the "activist" programming gap left by Berlin's underground Kreuzberg cinemas which flourished in the eighties but have since mostly closed or become more mainstream.

Europe in the Raw

THE HELA, DENMARK

The Hela of Copenhagen was a tramp coaster seized for drug smuggling by the Danish maritime police and put up for auction in 1995. It was bought by film enthusiast and Danish Film Institute employee, Jørgen Foght, who set about converting it into a floating cinema. He installed a 35mm Bauer projector along with 16mm and video projection in the main hold where he also reassembled a complete pølse vogn (grill-kitchen wagon). The main viewing room was outfitted in lounge style with couches and café tables and the walls were papered with movie posters. A wood-heating stove and chaotic stacks of donated films and archaic equipment added to the appropriately casual and rough-hewn atmosphere. The experience of watching a movie here was further enhanced by a gentle swaying whenever another ship passed.

Docked at various locations around the main Copenhagen shipping channel, The Hela soon achieved a reputation as a great party space, and Foght always made sure there was a film component attached. Additionally he founded The Hela Filmklubb which weekly screened a mix of shorts, independent features, cult faves like *The Rocky Horror Picture Show* and even Danish feature premieres.

At one point he began construction of a one-lane bowling alley in the bottom hold, all the while talking about his main plan to sail the ship across the Baltic Sea to Poland and screen a series of sea-faring classics in the process. You can see the main cabin of The Hela in Lars von Trier's *Breaking The Waves*— it was here that a depraved Udo Kier savaged Emily Watson.

Where's The Hela today? Who knows. Last time I was in that part of Copenhagen it had sailed away.

SLAGTEHAL 3, DENMARK

Slagtehal 3, in Denmark's second largest city, Århus, was founded in 1986 in an old slaughterhouse (slagtehal) down by the harbour. In 1991 it moved to a basement space previously used for storage. You walk off the street through an old passageway and into a cobblestone courtyard where you climb down a crumbling stairway to the left. "Turning the room into a cinema wasn't a big deal," a spokesperson for Slagtehal 3 will tell you. "We inherited some chairs from an old cinema, stuck a piece of canvas on the wall and that was that." (In fact, today their technical presentation is quite good.) The fifty-seat viewing room, complete with an old floor lamp, is intimate and atmospheric while the adjoining room serves as a bar and lounge. You can smoke, eat and drink during shows and some-

Land of a Thousand Balconies

times even sleep overnight on the couch if it isn't taken.

An unpaid five person group runs the joint strictly on bar money, ticket sales and what they make from an annual outdoor benefit film party they throw. It's unfunded and "non-profit" but not officially so, and in fact it's not "officially" anything — it's in every way, shape and form an underground film club in the purest sense. And they've even managed to pay the rent all these years and occasionally invite film-makers and speakers.

Programming the weekly shows is done with no overriding philosophy or agenda, the only goal being to "make rare, forgotten and unknown stuff available to ourselves and our audience". The accent is on cult, underground and horror-exploitation in 16mm and video. They've never had any interference from political groups or police, perhaps largely due to the famous Danish sense of easygoingness. They can't remember any "flops". If only a few people show up and like the film, that's a good show too.

Inside the Cinemateket.

CINEMATEKET BERGEN, NORWAY

Cinemateket Bergen, a ninety-two-seat state-of-the-art screening room, is part of the Kuturhuset (Culture House) USF which additionally includes two concert halls, a cafe and gallery space — all of it built in 1992 from scratch out of what originally had been a sardine processing plant. Aside from an operations manager employed to care for daily tasks, the theatre is staffed by volunteers. The two projectionists are, roughly translated, "conscientious objectors" (young men who refuse to participate in obligatory military service and are allowed to do other work - a common arrangement in Scandinavia). The Cinematek draws a mixed if largely student clientele and screens everything from horror to trash to revered classics.

The theatre broke boundaries and caused a national uproar in the Spring of 1999 when it challenged State censorship precedent and screened *Deep Throat* in a sex-in-cinema retro. The show galvanised opposition from a range of groups from Christian punks to radical feminists who even flew Linda Lovelace over from America to confront each ticket-holder personally before they entered the theatre.

Programming is done through collective discussion by an ever changing panel of board members who also program the Bergen University Filmklubb. Nothing is ruled out per se, and by screening controversial films in a non-exploitative atmosphere where debate is encouraged, they sometimes are allowed to show movies that would normally only play in the National Filmmuseum Cinema in Oslo. They have hosted visits by film-makers and speakers from around the world, but seem to be witnessing a slow decline in their audience base due to the proliferation of video and DVD which has effected all specialty exhibition venues to varying degrees. They get very little public funding and sustain themselves on ticket sales, membership fees and rental paid by the University for use of the room for screenings or lectures.

KINOKULTURE, GREAT BRITAIN

KinoKulture is a London screening space that was born in 1996 as Kinodisobey, an offshoot of the Disobey nightclub that hosted monthly industrial noise events through the mid nineties. Kinodisobey's opening show was an intense, feature-length experimental jam session by the German band, Can — and the energy in the room was extraordinary. Reformed as "KinoKulture" in May 1997, its screenings in video, 16mm and DVD now took place in The Horse Hospital, a building that had originally been, in Victorian times, a horse hospital attached to a hackney stables. The screening room comes complete with the original tethering hooks still on the walls, red lighting and a screen framed with red velvet curtains — and portable chairs that came from The Department of Defence. Seating capacity is seventy, but they are happy to overcrowd the place. The basement of the building is occupied by a wardrobe company that rents period street fashions to film and TV crews shooting historical scenes.

KinoKulture receives no public funding at all and the programming, by an unpaid collective of three, is fiercely subjective. They are committed to diversity and juxtaposition of genre and content. Films are often screened in conjunction with live music or performance pieces or as adjuncts to art or photo exhibits in the adjoining Chamber of Pop Culture gallery. On a diet of features, documentaries, pop promos, new shorts, cult classics, rarities, visual experiments and found footage, the venue finds itself straddling the line be-

Europe in the Raw

tween a rep cinema and an underground film club.

Despite the extreme nature of some of it's shows, it has never been attacked by political groups or leaned on by the police, though sometimes audiences have reacted physically by, among other things, fainting — necessitating one of the programmers to stand guard for a while with a glass of water.

ABOVE The Horse Hospital.
RIGHT Projector at the Cinemateque.

CINEMATEQUE, GREAT BRITAIN

Cinemateque Brighton, is, along with The Horse Hospital and The Cube in Bristol, a truly renegade uk film venue that is not, like almost every other "independent" theatre, partially funded and programmed by the mother of all film institutions, the BFI. It was founded in 1996 when two local fellows who had been staging film/video shows in local shops, warehouses and colleges, joined forces and convinced a local media centre that it needed a cinema. With the help of a small nucleus of film-makers, enthusiasts and oddballs, they built an intimate sixty-seat room on the second floor of a former tax office, and it wasn't easy: the 35mm projector that a recently closed cinema had donated to them was hell to transport and install — today somebody is still walking (limping?) around Brighton with a permanent injury that occurred when the monster projector fell on them. Their proposed projection booth proved too small and a wall had to be knocked down and the ceiling carved up.

The two bookers/founders are "solely interested in programming non-mainstream films, experimentation and rarities free from pretension and art-house elitism" and are also receptive to suggestions from the audience. Programming conflicts do arise but they see this as an advantage rather than a drawback. The cinema was not funded at all until recently when a grant allowed them to expand their programming and pay three core workers a minimum wage. Guest film-makers and speakers have always been on the agenda, has as a flair for unorthodox publicity: "early on we engineered some front page controversy by 'invocating' Aleister Crowley — supposedly buried in a nearby graveyard — to attend a Halloween screening."

OFF OFF, BELGIUM / DENMARK

The Off Off dwelt in Copenhagen's notoriously sleazy Vesterbro neighbourhood, better known for addicts, prostitutes and porno shops than avant-garde cinema, but here it managed to preserve and at times flourish. Sitting on a wedge block, the triangular building originally housed a dive bar, with walls permeated by nicotine, for almost a century. After that it was a gas station. In 1984 it was converted into the Trekanten (literally, "the three-edged", or The Triangle) audio visual gallery by a group from the Danish Society of Electronic Music. In 1990 its name was changed to Off Off. It seated about forty in a minimalist beat café atmosphere, with screenings in 16mm and video.

Programming fell into three categories: (1) Providing one of organisers had time and some pocket money to do advertising, any film-maker from anywhere could do a show there for the

asking. They would get no fee but the show would be advertised — and the next day they could do their laundry in Copenhagen's roughest, "most happening" Laundromat. (2) An annual theme connected to avant-garde/underground/experimental film programmed by a group of several people who more or less ran the place, and (3) special retrospectives or festivals organised and run by individuals.

All considered, Off Off had the most open-access policy of any venue here, and by design *and* necessity depended on an engaged local public to keep it going. Since its inception it has gone through periods of feast and famine, but any examination of old programs will show that in regard to the screening of experimental and personal cinema, it was one of the most dedicated venues in all of Europe.

Though no one was paid at Off Off, public funding was necessary to keep it running and they had ongoing battles with local cultural authorities about this.

Postscript: In 2001, the Off Off moved to Belgium. Plans to reopen its screening space are still pending (check website for details).

The Off Off.

The 3001 Kino, Germany
3001 Kino, Schanzenstrasse 75
D-20357 Hamburg, Germany
Tel 0049-40-437679
Fax 0049-40-4303150
Web www.3001-kino.de

The Babylon, Germany
Berliner Filmkunsthaus Babylon,
Rosa-Luxemburg-Str. 30,
D-10178 Berlin, Germany
Tel 0049-30-2425076
Fax 0049-30-2424510

Cinemateket Bergen, Norway
Cinemateket USF, Georgernes Verft 3,
N-5011 Bergen, Norway
Tel 0047-55-318580
Fax 0047-55-318582
Email post@cinemateket-usf.no
Web www.cinemateket-usf.no

Cinematheque, Great Britain
The Media Centre, 9–12 Middle Street,
Brighton BN1 1AL, Great Britain
Tel 0044-1273-384300
Fax 0044-1273-739970

Email cinematheque@yahoo.com
Web www.cinematheque.org

KinoKulture, Great Britain
KinoKulture, Horse Hospital,
Colonnade, London WC1N 1HX, Great Britain
Email popculture@btclick.com
Web www.thehorsehospital.com

The Nova, Belgium
Rue d'Arenberg 3 , Bruxxel
Tel 0032-025-112477
Email nova@nova-cinema.com
Web www.nova-cinema.com

Off Off, Denmark / Belgium
Web www.artvideo.dk/offoff

Slagtehal 3, Denmark
Slagtehal 3 Co., Mejlgade 50, kld.,
8000 Århus C, Denmark
Email scriver@mail1.stofanet.dk
Web www.slagtehal3.dk

The Werkstattkino, Germany
Werkstattkino, Fraunhoferstr. 9,
D-80469 München, Germany

I, AN ART-HOUSE

The Agony and Ecstasy of Copenhagen's Art Film Scene

Movie-going in America has always been a pastime pitched to the common man, going back to the teens when mobs of working class immigrants crowded into the sweltering nickelodeons. From the movie palaces of the thirties which welcomed the family trade to the decrepit "main-street" and grind house theatres of the forties where a mix of B-movies and live acts played to crowds of hooting, whistling sailors and transients, cinema has always been the most democratic and accessible entertainment medium — the movie theatre a garish, circus-like temple tailored to the pleasures of "the man in the street"... or "the man in the car", who by the fifties could watch a movie at the drive-in without even getting out of his automobile.

But a sanctuary did exist where movies could be enjoyed in a quiet, tasteful and sophisticated setting, a place where the high ticket prices at the door and the challenging sub-titled movies on the screen ensured that the man in the street would stay out on the street, and that the distracting hubbub of ill-behaved crowds would never be heard.

That sanctuary was the art-house theatre.

A product of the immediate post-war period, the art-house gave cultured urbanites and college students an opportunity to see the new foreign pictures that were coming out of Europe and changing the language of film itself, neo-realist movies like *Rome, Open City* (1945) and *Paisan* (1946) by Roberto Rossellini, and *The Bicycle Thief* (1948) by Vittorio de Sica. These were films that dealt with adult subject matter in bold and intelligent ways. These were films that could be *discussed*.

Located in college towns and in the upper-class neighbourhoods of big cities, the several hundred theatres that came to comprise the art-house circuit would continue to do good business through the fifties and sixties as French New Wave directors like Resnais, Truffaut and Godard, and Scandinavian auteurs like Bergman and Dreyer, came to the fore. These were films for serious, thoughtful viewers, and the right theatre atmosphere was deemed essential for enjoyment of these pictures.

Manhattan's Paris Theatre, opened in September of 1948 by the French Pathé company at the posh intersection of Fifth Avenue and Central Park, typified the sense of style and atmosphere that the classic art-house aspired to. The vestibule through which patrons entered was set into a limestone facade with a marble base, and the lounge, located below the foyer-lobby area, was furnished in a modern, minimalist style and conveyed the feel of a comfortable private dwelling. Patrons were encouraged to use the lobby to play backgammon, bridge or chess, while small cakes, good coffee and tea and bouillon were served at no extra charge. Polished glass cases which displayed the handiwork of French industry gave the lounge area a continental touch. The auditorium, for its part, was designed in the Bauhaus style and appointed in subtle shades of grey.

Other art-house theatres were created out of the confines of existing second-run venues, such as The Esquire Theatre in Chicago which changed its booking policy — and interior design — right after the war and did extremely well. Large leather-upholstered easy chairs were installed in the lobby for the comfort of patrons who were at A couple more....liberty to browse through a copy of *The New Yorker* while they waited, classical music playing discreetly in the background. Art galleries were often attached to the theatre lobbies. The Esquire had one off the mezzanine which exhibited the work of local painters, while The Fine Arts Theatre in Manhattan had a gallery for experimental painting. The Fine Arts Theatre also boasted

Land of a Thousand Balconies

THIS PAGE The Grand Theatre and its lobby.

NEXT PAGE View of the Palace Hotel, which actually constitutes the front of the Grand Theatre.

Most American art-house theatres fell upon hard times in the late sixties and early seventies, due to a number of factors, and closed down. The art-house had always been a creature of its time, and times had changed.

By the late seventies, the art-house theatre was practically extinct. The market for foreign movies was now being serviced by repertory theatres, such as The Harvard Square Theatre in Cambridge and The Elgin in Manhattan, to name just two. But while they were keeping foreign films on the screen, they were dispensing with the kind of amenities that film aesthetes had come to expect. These were big old barns, tough to heat in the winter, and unlike classic art-houses, they showed a new triple bill every day and were closer in spirit to the infamous urban grind houses. These were bohemian lairs inhabited by student film buffs and fans of midnight movies, the kind of customers who often turned the upper reaches of the balcony into a cloud of cannabis smoke.

Today in America specialty exhibition in any form is virtually a thing of the past, and only a handful of art-house (or repertory) theatres remain. The Brattle Theatre in Cambridge, Massachusetts, a revered institution in the Harvard community since 1953, is one such survivor. Yet the Brattle was always a prototype of the college-town art-house, and when it came to snob appeal these were always poor second cousins to the kind of upscale venues that existed, for example, on the Upper East Side of Manhattan.

Today one must return to the point or origin — Europe — to find any remaining vestiges of the art-house aesthetic.

And apart from Paris, what city would seem to be more thoroughly steeped in cinema tradition than Copenhagen, Denmark? It is the home town of world renowned directors such as Benjamin Christensen, Carl Th Dreyer and Lars von Trier, as well as the site of Nordisk Film company, the oldest continuously operating film studio in the world. Here the art house movement took on new momentum — and new wrinkles — in the sixties and seventies, but the aim was essentially the same: to show thoughtful, important and artistic *European* films.

And here a handful of art-house theatres still exist to serve the original concept, to offer viewers a commodious and atmospheric alternative to popular movie-viewing environments, which in this day and age means the multiplex. Ironically the struggle to define film viewing as an intellectual and aesthetic experience rather than just another form of entertainment as never been more relevant, the need to offer viewers

state-of-the-art reclining chairs, a smart move since patrons of art-houses expected first class treatment.

Many art-houses advertised via mailing lists. Single films, not double or triple features, were screened, and they played long runs that often lasted months. Garish advertising in the form of posters, banners or neon marquees was generally avoided, and some houses like The Esquire simply posted a card outside with the name of the film and its stars. Preview trailers were rarely shown at the typical art-house and popcorn was never served.

I, An Art-house

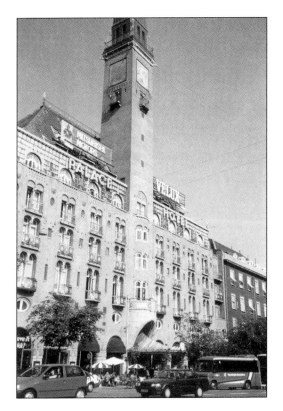

an exhibition environment free from extraneous chatter, popcorn-chomping fellow customers and the cacophony of the video arcade out in the lobby never more pressing.

And while the practical demands of running a viable business in the year 2002 have forced at least three of the city's four art-house venues to deviate from the concept of "pure" art-house programming, they all, albeit in different ways, offer a unique sense of style and ambiance. That sense of style has always defined "art house", in all its variations, as surely as the movies themselves, and harkens back to a day and age when movies were all about passion rather than consumption.

THE GRAND
Getting the Royal Treatment

The Grand theatre was designed in the art nouveau style by one of Denmark's most prominent architects, Anton Rosen. His most celebrated work was The Palace Hotel (1908) which faces out onto Town Hall Square. The Grand occupies the rear of that structure, opening out onto Mikkel Bryggersgade, a narrow, winding thoroughfare that has existed in the heart of Copenhagen since the middle ages.

The theatre's main (and until 1975, only) auditorium is a classic Rosen design, its original stucco ornamentation in a bird motif and its royal box having survived to the present day. Originally the room was used for concerts, and the story goes that King Frederick the Eighth (1843–1912) helped to finance it so the Queen would have a suitable venue by which to indulge her passion for music. A room connected directly to the rear of the balcony was used by the royal party when they wished to retire in privacy and also still exists, sparsely but finely furnished in a style that hints at its original purpose. A circular stairway leads down the lobby.

In 1913 the auditorium was transformed into a cinema and for the next ten years offered screen fare of a decidedly "popular" nature, catering to noisy crowds whose rough behaviour was perfectly in keeping with the tenor of the street at the time.

In 1923 Urban Gad bought the theatre. Renowned director of such films as *The Abyss* (1910) which starred his wife of the time, Asta Nielsen, Gad had just returned from a self-imposed creative exile in Germany and had his new wife in tow, Esther von Westernhagen — an actress who had earlier been employed in the theatre of Max Reinhardt.

Gad named his new theatre the Grand and began programming "quality" films that had artistic merit, and in so doing created Denmark's first "art-house" decades before the term came into popular usage here.

While the Grand laboured to some degree in the shadow of the majestic Palads (Palace) theatre, it nonetheless soon became known as "the Royal theatre of film" — high praise indeed considering that film was still very much considered a poor second cousin to live theatre.

Until his death in 1947 — a year short of The Grand's Silver Jubilee — Gad worked hard to make sure that film viewing at the theatre was a quality experience. And he got the audience he wanted. In the thirties, for example, it was primarily to the Grand that refined and well-dressed patrons flocked to see the latest French films.

Following his death, Esther took over the theatre and attempted to run it in a similar style through the fifties and sixties, difficult times for all theatres. In 1974 she sold it to the thirty-four-year old Peter Refn, who was, like Gad, a director, and who at the time also co-owned his own little art-house, Camera cinema. Refn was likewise committed to screening quality films that possessed artistic merit — which was to say in the seventies, broadly speaking, films for thinking people that both challenged and entertained them in provocative ways — films that preferably didn't come from

Land of a Thousand Balconies

America. He soon founded his own import-distribution company, Camera Film A/S, and it was through the importation of foreign films, particularly French films, that the Grand secured its niche in the rapidly changing world of film exhibition.

Over the course of the next two decades, Refn worked hard to bring the theatre into the modern age, periodically altering its booking policy as well as the physical space.

Shortly after buying the house he launched into ambitious reconversion work, redoing the lobby in a turquoise motif with decorative images and designs added by the theatre painter, Helge Refn, his father. A number of smaller auditoriums were also added to give the theatre programming flexibility.

In the mid eighties the theatre almost lost its independence and became chain operated.

In 1987 Refn built yet another auditorium, a room designed by architect Bent Weinrich which was built out into the back courtyard. While the building as a whole still retained impressive touches of its original elegance, the trademark "Grand experience" of viewing a film in the main room no longer applied if your film-of-choice happened to be screening in one of the smaller auditoriums. Alas…

More screening rooms were added in the nineties. Some of these rooms were small and oddly shaped, and projection in one of them for a time was designed to beam down from projectors above the ceiling and on to the screen via a mirror device. Architects had to be creative when trying to find new space in such an old building in the centre of the city, but adding new rooms was the only way to stay competitive in an environment dominated by multiplexes.

The renovation work in 1987 also included a complete rebuilding of the lobby which doubled its size. Architect Bent Rohde supervised this project.

The old toilets, which in the estimation of architect writer, Henrik Sten Møller, vaguely called to mind a Greek temple, were removed and new facilities were installed in the basement, where one of the humbler screening rooms had also been placed.

Rosen's distinctive oval window on the street side of the lobby was now framed by a free-standing, domed, glass-panelled structure that housed the ticket booth, a striking construction that called to mind early-century beach house or park architecture in miniature. The other dominant feature was a curving L-shaped bar with a plexiglas front bathed in a backlit turquoise glow. The floor was inlaid with black and white flag stones, and a plush wine-red sofa was installed. Bentwood chairs grouped around cast iron tables with inlaid marble tops added to the air of refined yet casual elegance. A semi-detached alcove existed in the rear for those who preferred relative privacy. Coir matting, a tasteful pastel wall colour selection and warm lighting added to an intimate, light and pleasant cafe atmosphere — an atmosphere that resonated with tradition but without slavish insistence on detailed period recreation, that evoked the past and yet was creative and new in its own way.

Peter Refn died in 1994, yet both The Grand and Camera Film continue on to battle the inevitable ups and downs of independent film exhibition under the guidance of erstwhile assistant, Kirsten Dalgaard, and with the aid of the good reputation and loyal public the theatre has cultivated and kept.

Programming remains heavily tilted towards European and especially French product with approximately sixty-five to seventy percent of films screened non-American, a significant achievement in light of the fact that seventy to eighty percent of all the movie tickets sold in Denmark are to American films. Some films open in both The Grand and the multiplexes, with a stable segment of the audience preferring to see them in The Grand.

The cinema has remained remarkably consistent in its vision over time, and after almost eighty years in existence it remains Copenhagen's art-house supreme.

THE VESTER VOW VOW
And Then There Was One

The Vester Vow Vow was founded in 1975 by a collective of ten student film enthusiasts. Their idea was to stage retrospectives of favourite stars and directors such as Nicholson, Polanski and Bergman and to give quality first-run films a longer life on the screen after they had been jettisoned from the bigger cinemas.

They chose to construct their cinema in an old building on Absolongade in the heart of the lively inner-city neighbourhood of Vesterbro, here where a paint and varnish shop that had been in operation for seventy-five years was about to close. The building, completed in 1867, had originally housed a Roman bath and then briefly a tea house before the paint works had moved in. It adjoined the Copenhagen City Museum and opened out upon the cobble stoned and gas-lamp lit stretch of Absonlagade that intersects with Vesterbrogåde and whose appearance had been preserved from the late 1800s.

Reconversion work was undertaken by the collective and their friends, an architect named Jesper Due among the later. Work was finished just in time for an invitation-only screening on September 9, 1975 of the film from which they would borrow their name, *Vester Vow Vow (At the North Sea)* — a classic Danish

farce from 1927 that featured the Danish comic duo of "Fy & Bi" who preceded (and inspired) Laurel and Hardy.

In addition to the fifty-six-seat auditorium off the upper deck of the split-level lobby, they had fashioned a bar and café in an adjoining two storey room that still retained its original butterscotch glass-panelled ceiling, an iron-railing catwalk and a spiral metal staircase that led up to second floor rooms they would use for office space. Tall windows street side provided plenty of natural light.

The theatre was very much a product of the times. Copenhagen had more than a few brave little shopfront cinemas run by collectives of ambitious and idealistic film buffs. Film exhibition at that time was a participatory sport.

But times changed — ten years later the collective was down to five and independent / repertory exhibition was struggling against the rise of home video and general audience indifference. Although their commitment to giving "small" but important and artistic films a life in Vesterbro had not slackened, they had to change or die, and that year they opened a second room in the basement.

By 1988 they were obliged to change, or rather to expand, their repertoire: The extra room would now run weekly "re-premieres". Now with a mix of foreign art-house imports and second-run screenings of films "moved over" from bigger art-house theatres such as the Grand and the Dagmer (once booked by Carl Theodore Dreyer himself but today virtually indistinguishable from a chain theatre), they found a niche that they have occupied to the present day.

That year they also sold half interest in the theatre to the owners of Café Bio in Odense who had long been looking for a base in Copenhagen. Two-and-a-half million kroner were now invested in a comprehensive upgrade of the cinema with a new focus placed on the café where income from the sale of beer and coffee was expected to hold the theatre afloat in somewhat the same fashion that so many commercial cinemas the world over had been held afloat for decades by popcorn and coke.

Not so in this case. The rebuilding left them in a precarious, not to say near terminal financial condition, and a year later only one of the original ten was left standing, Torben Wolsgaard, who had been running the daily operation of the place for some time.

The cinema got a bit of economic relief in the nineties, thanks in part to some amount of public support from the city and the fact that, along with The Grand and Posthusteatret, they became a member of the European Cinema Association which provided subsidy if a theatre showed a certain percentage of European films. There was also money available from The Danish Film Institute to assist with the import of films, but the smallest art-houses seemed to benefit the least from this fund.

By 1998 Wolsgaard owned the theatre himself with two "sleeping" partners — his sister and brother-in-law. Running the place was still a struggle as he explained to reporter Mette Olsen in a September 17 interview in the daily, *Jyllands-Posten*. "We operate the whole time with our backs against the wall. There is water damage in the ceiling and the carpet is held together with duct tape. The place looks like a dive bar, but we can't afford to lose income and lock up for a couple of weeks to paint it. And all the while it extracts a high personal price. Your family has to understand that — this is a shop that's open every day. As for me, I've already been divorced three times."

The Vester Vow Vow and its lobby.

Land of a Thousand Balconies

Despite all that, Wolsgaard and his staff have continued to run the theatre with boldness and battle spirit and have stayed true to the founding precepts. They hosted the entire Film Workshop Festival in 1994 and participate to the maximum every year during the Night Film Festival. And they continue to screen risky "little" films that they themselves sometimes import.

The humble entrance to the Post Office Theatre.

POSTHUSTEATRET
Taking it Personally

The origins of The Posthusteatret (The Post Office Theatre) can be traced back to 1969, to a accidental encounter on a street in Paris where disenchanted theatre school graduates, Carsten Brandt and Trine Blichmann, had gone to get away from it all for a while. Recalled Brandt many years later:

One day we stood on Boulevard St Germain, and discussed whether we should turn to the right or the left. We ended up going to the left and soon, completely by chance, discovered a little stage theatre called Kaleidoscope that lay in a back courtyard. There we saw a play called Les Fraises Musclées... and that performance gave us back our faith in the theatre.
We bought the Danish rights to the play, and when no theatre producer in Denmark would gamble on it, there was only one thing to do — we had to build our own theatre.
... Had we turned to the right that day on Boulevard St Germain, the Posthusteatret would never have existed.

They chose cellar space on a corner lot as the site for their theatre, below a post office at the intersection of Brolæggerstr. and Rådhusstræde. Their entrance faced out onto a corner of Copenhagen's old Nytorv square. The space had originally been a small egg-packing plant and later was used as storage for wine casks. It took Brandt, Blichmann and a third partner, Marianne Tønsberg — all three actors — and friends and supporters two years to have sixty tons of soil removed, the roof raised and the placed wired. A stage was built and toilets, bar and box-office were installed. Ninety theatre seats were fetched from a boarded-up cinema while the entrance way was salvaged from the demolished Bellevue Strand hotel. The bar was an old "købmandsdisk"— a kind of sturdy wooden shop counter full of drawers and cupboards, prized by antique hunters.

The Posthusteatret opened its doors on October 21, 1973. It would offer both theatre productions and film screenings. "Our concept was to present quality theatre and quality film that no one else would dream of importing to Denmark," Brandt recalled on the occasion of the theatre's silver jubilee. The small projection booth originally had only 16mm equipment, but eventually a state-of-the-art 35mm rear-screen projection unit was installed.

The first year they played films in the afternoon, then a theatre performance at 8PM and then another film screening at 10PM. For a while there was also a jazz club that ran until 4AM in the morning.

In spite of precarious finances, Brandt has imported approximately fifty films over the years. In a bigger country even specialised art-film titles are usually handled by commercial importers, but in tiny Denmark, which has such a small audience for specialized screen fare, it was left to idealistic and committed *individuals* to give life to commercially marginal (non-us) films. To own your own small cinema and import company and battle for the films you personally believed in was a noble calling answered by more than a few Danish cineastes in the seventies.

Six of the films Brandt has imported — including Akira Kurosawa's *Dersu Uzala* (1975), Gavin Millar's *Dream Child* (1985), Patrice Leconte's *Monsieur Hire* (1989) and Nikita Mikhalkov's *Burnt By The Sun* (1993) — have been nominated as the year's best film in Denmark. He proudly proclaims that no American film has ever played in his theatre and vows that it will never happen!

On a patch of white plaster on his lobby ceiling, between the exposed beams that run throughout the space, are hand-scrawled greetings and salvos of encouragement from esteemed visiting directors. "It's so

I, An Art-house

good to know that cinema is in such safe hands here", writes Peter Greenaway. "Long may it stay like this." Agnes Varda and Patrice Leconte are also among the honoured signees.

From the very start the theatre has had an on-again, off-again existence. In 1975, for example, they ran out of money and decided to close, but it just so happened that the play they were running was proclaimed the best Danish production of the year and they ended up with a 350,000 kroner grant from the Culture Ministry — and were back in business. At five or six points thereafter they did close.

The precarious nature of the theatre's existence, which in recent years has revolved mostly around film, has strengthened their belief in the power of divine intervention. No matter how hard they work, the ways by which audiences as well as films find their way to the theatre more often than not seem to hinge on fate. While most theatres subscribe to the wisdoms of demographic studies and marketing strategies, The Posthusteatret leads a much less quantifiable if a much more simplified existence. If they like a film they find a way to play it.

Public funding has been sporadic but essential for the survival of the theatre, and despite a new government (elected in November 2001) that seems much less committed to public support for the arts, the Posthusteatret seems poised to continue into the foreseeable future and has recently made renovations. A new lobby area containing a second bar — serving drinks and cakes — has recently been added, and soon a podium area will be attached to that, almost doubling the size of the original interior.

The design style of the new area conforms to the original theme: intimate and refined. Brass fittings and carefully placed flower arrangements harmonise with antique furniture and mirrors in a very conscious but not ostentatious attempt to create an atmosphere suited to the movies. A beautiful place to enjoy beautiful films. One has the feeling of being in the living quarters of a private upper-class dwelling. The screening room in turn features plush, inclined seating anchored onto broad varnished floorboards. The low ceiling would normally be a drawback for film projection but this problem has been solved by projecting from behind the screen.

An emotional Brandt waxes horrified at the prospect of giving up the theatre some day. "I'm attached to every single brick and nail in here. If I were to one day walk past this place and discover that instead of the theatre there was now a clothes or a bicycle shop, I could never again bear to step foot in central Copenhagen. I would have a heart attack."

The Husets Biograpgh (building in the centre with the garret windows).

HUSETS BIOGRAPH
The Cinema in the Attic

Although founded the same year as the Posthusteatret (1973) and located only two blocks away, at Magstræde 14, Husets Biograph (The House's Cinema) is as different as can possibly be: it's located in an attic rather than a cellar and its history has been marked by numerous changes of ownership that would lead to an identity in flux.

The cinema dwells in a large old brick building entered via a courtyard on Råhussstræde. It was one of the first buildings occupied by Danish squatters in the early seventies. The squatters were expelled and the city decided to turn it into a youth house, under the moniker of Project House, and soon it became known as simply The House. By 1973 the situation had stabilised enough for a cinema called The Delta to open on the top floor. It was run by Jesper Høm, a respected cinematographer. Various bars, cafes, restaurants, galleries, theatre spaces, etc would also inhabit The House over the years.

Høm ran The Delta in The House until 1977, after which, thanks to a lot of money he made on a film called Æblekrigen, he moved to a location several blocks away on Kompagnistræde. (There it earned a reputation as one of the city's more daring art houses until it closed in the early nineties and was converted into an Indonesian restaurant.)

In 1977 a collective of nine people took over the vacant cinema space and renamed it Biografen i Huset (The Cinema in the House). Their programming, done collectively but with room for individual initiative, touched on just about all bases, and they even imported some of their own films (everything in 16mm). They played political films, women's films, Marxist films

and experimental underground films along with "quality" Danish films, and did not shy away from controversy — all in the spirit of the times. They cooperated with other art houses, primarily the Vester Vow Vow. They had great ambitions. And integrity.

And they went out of business. In 1982. For two years the theatre lay vacant.

In 1984 a collective of five took over the cinema and renamed it "Luna". In an interview to mark the launch, group spokesman, Klaus Hansen, weighed in on the problems that had put their predecessors out of business. "At that time The House had some problems which made a lot of people a bit afraid to go there, and these problems are now being solved. You can feel secure again about moving around in The House".

All five were experienced in the art-house scene. Hansen and one of the other founders had worked at The Klaptræet (Clap-Board) cinema, while more recently he and his German-born wife and a German pal had run a Kino on Kurfürstendamn in West Berlin. The fifth member of the group had been a gofer on the set of Lars von Trier's *The Element of Crime*. They would run The Luna as a repertory house and eventually import their own films. Their energy, spirit and dedication keep the theatre afloat for five years until they too went out of business.

In 1989 the cinema was again resurrected, this time by a group of three. With an upfront investment of 100,000 crowns, they seemed to be on solid financial footing. They dubbed it The Grasshopper and opened on September 1 with Ettore Scola's *Splendour*. They would show a classic every Sunday along with "small" quality films and select reruns of pictures like *Blue Velvet* and *Sammy and Rosie Get Laid*. But they wouldn't import their own films — that was expensive stuff and one of the reasons that Luna had gone out of business.

Three years later they too were out of business, and in April of 1992, the cinema's current owner, Børge Nielsen, took over and changed the name to Husets Biograf. It was now a one-man operation.

Nielsen got his start in film in the early seventies as the booker of a film club connected to a Marxist education association. He later managed The Delta in its Kompagnistræde location, and also ran a company that specialised in the import of Eastern European films (before the fall of the Wall).

Like all previous occupants, he had no expectations of getting rich running a theatre here, but The House wanted a functioning cinema in the building and gave him a very low rent. And he has no payroll to meet since he does everything himself — from booking films to running the projectors to taking tickets, making coffee and mopping up — so with the low overhead and some minimal funding, he's managed to survive for ten years and keep the machinery and sound modernised into the bargain.

The physical space is also well maintained. The lobby is an unspectacular but attractive room with a varnished hardwood floor and red ochre walls hung with framed photo art. A curved stainless steel art nouveau bar from which tickets and drinks are dispensed dominates the room which is also supplied with wooden café tables and chairs. The cosy, sixty-seat screening room is, with its slanted ceiling, indicative of an attic space but is roomy enough. Perhaps most importantly, Husets Bio is the only art-house left that has 16mm projection capability in addition to 35mm, and this opens up a wide array of programming possibilities.

The programming is naturally enough dictated by Nielsen's personal preferences which run to both American and Foreign independents like Jim Jarmusch, Aki Kaurismaki and Wim Wenders, and to thematic presentations of ethnic cinema that in recent years have focused on Asia, Iceland and The Czech Republic, etc. Yet he has also programmed festivals and marathons of exploitation and underground fare from America that have yielded up cult nuggets like *I Drink Your Blood*, *Foxy Brown*, *Shanty Tramp* and *The Trip… and* he hosts a very successful children's film club as well. Additionally, no theatre is more active when it comes to inviting directors and archivists to present their work in person.

Husets Biograf has, simply stated, the most flexible and diverse programming of any independent theatre in Denmark.

THE PORTABLE DRIVE-IN-MOVIE ELECTRIC ACID TEST

In Search of the Perfect White Wall

The makings of an outdoor movie show are easier to put together than you could imagine. Add one projector, stir in a couple of long extension cords and top it off with some speakers. An amplifier may or may not be needed. Shake until the concoction starts to fizz and you're there. The projector doesn't necessarily need to be a super-strength arch or Xenon type, although it will probably help unless you are able to find a very dark place to show your film. Bring different lenses for the projector if you have them. If you have no access to an electrical outlet, a car battery can be used as a power source, and you can load everything into a van or stationwagon and you're mobile. I heard that there was at one point a group that staged mobile, improvised screenings like this in San Francisco.

The hardest part is finding a proper screen. If you put up your own screen, the wind might knock it down, or if it's just a bed-sheet it might look pathetic and much too small when you string it up. This is the great outdoors we're talking about. The best idea might be to find the screen first and build your show around that. A big unbroken expanse of white wall is ideal, and you should be able to find several in your city.

I found the perfect white wall once, in Seattle. It was that summer of 1990. I was in town showing films at The Jewel Box theatre with Dennis Nyback (see: THE NYBACK CHRONICLES). The idea of doing an outdoor show occurred to us one day when we went over to the building across the street where his partner, Jeff, had storage space. We climbed up on the roof to discover that it looked down on a parking-lot, which was fenced in on the other side by a big white concrete wall. Our screen.

We did advertising and managed to get notices in the papers for this ad hoc drive-in show of ours. We would screen *Viva Las Vegas* and *Hell's Angels On Wheels*.

The night of the show we strung electric cables up onto the roof, planted my 16mm arch projector on a rickety card table and arranged speakers down in the parking lot. About 200 folks showed up that night, some arriving in vintage convertibles, others bringing lawn chairs. Unfortunately the parking-lot also served as a staging grounds for the neighbourhood's vocal minority of hobos and drifters, and a loose platoon of about twelve winos were there drinking when we began setting up and as people started arriving. Most of them wandered off with the exception of one cantankerous old bastard who sat against the wall and swore and threatened the perplexed early arrivals with great vigour. He threatened to beat everybody up. He couldn't be easily ignored because he'd planted his butt midpoint against the white wall — at centre stage, so to speak. People were coming in and dutifully parking in neat rows in front of him, presenting him with a captive audience. At one point I thought we should cancel the films and hear out his bizarre and pugnacious ravings. His presence added an element of Dada to the evening. Eventually he fell asleep directly under the "screen".

There was a lamp post near by. We feared the light would wash out the movie image and we debated shooting it out or sending someone on a suicide mission up the pole to cap the light with a black plastic

garbage, but the projector proved powerful enough to shine a bright image onto the wall. We had no official permission to do this, and when a cop car swung around to investigate, there were some apprehensive moments. We wouldn't be in trouble because we could easily flee across the roof, but they could easily roust our customers (it was free, anyway). "It's a giant Elvis", we could hear one of the cops deadpan to his partner. They drove off soon after without further comment.

When the show ended, I, now fairly drunk, picked up the still-running projector in my arms and shined the image off the sides of skyscrapers blocks away. I harassed pedestrians minding their own business on distant sidewalks — accidentally knocking a can of beer onto a stack of films and demolishing the cardboard table in the process. This was real power.

One of the "free use" junk cars parked at the Drive-In Copenhagen, which has the city's biggest screen.

After this spiritual awakening, I realised that showing movies outdoors was the natural and original order of things, and a whole lot of stuff started to make sense to me. When Moses parted the Red Sea, for example, of course that didn't really happen! It was a *movie*! Of course most of that stuff in the Good Book didn't really happen, it was movies. And what about those terrible explosions that demolished projection booths in the early days of cinema and set theatres ablaze? They say it was nitrate film exploding but in reality it was a sign of God's anger for the blaspheme of showing motion-pictures indoors. Then in 1930 God blessed the drive-in movie pioneers with huge profits, even though the films they showed were bottom of the barrel. And in California they even have drive-in church services.

Simply stated, God intended the film image to be shown as large as possible to enhance the power and the glory of it all, and to keep people from finding themselves in that devil's liar called a balcony where all sorts of unholy stuff could take place (although he hadn't reckoned on that devil's lair called the back seat of an automobile). Movies are always better against a backdrop of hills, mountains, deserts and starry night skies. Designers of art deco movie palaces duplicated these outdoor wonders on the ceilings of twenties and thirties' theatres. They created movable moons and clouds of stardust in all their fully functional glory. This was an unconscious urge to move the movies outdoors, and if that wasn't possible, to bring the sky inside.

Since then, others have had the same urge.

I heard that in San Francisco some years ago a movie was projected outside against the side of a building. The audience was obliged to watch the film from inside an adjacent abandoned building in which bleachers had been constructed. They viewed the movie out of a large window specially created for this show, and by this the element of voyeurism was raised to the fifth power.

In this way viewing conditions totally overwhelm the impact of the actual films being screened.

I know of two separate instances, in Hamburg and in Copenhagen, where movies were screened outdoors in auto junk yards while viewers sat squeezed into the wrecked cars and enjoyed (?) the films. In the case of the Hamburg arrangement, the screen fare consisted of classics of American driver education scare cinema like *Signal 30* and *Safety or Slaughter?* Wrecked cars also are part of the experience at the Drive-In Copenhagen, where several "free use" junkers are permanently parked in front of the screen for the benefit of customers who arrive on bicycle.

Although Europe is not known as the home of the drive-in, various film clubs and collectives screen movies outdoors in the summer, like the Nova cinema in Brussels, and WAND 5 in Stuttgart. The Kino Komm in Nuremberg held similar screenings. *Street Trash* was shown in a junkyard and *The Shining* was shown in the winter in the middle of a snowy field. The possibilities are unlimited.

The summer in Europe is a time of desperation. People want to get outdoors and enjoy the brief span of warm weather they get and they take the movies with them. Almost every city has outdoor screenings on some scale, while more underground approaches are taken with film festivals like the one held every year in Weiterstadt where everybody just basically camps out and there are movies going on everywhere.

But whether you're showing *Viva Las Vegas* in a parking-lot or *Night of the Living Dead* in a graveyard or *A Bucket of Blood* in a beatnik café, the logistics are easier than you think.

Go out and do it.

THE PASSIONATE PLASTIC PLEASURE MACHINE

Or, CAMP FILM about to turn Fat and Forty

Camp has been with us ever since Susan Sontag "officially" discovered and isolated this amorphous base element in her 1964 essay, "Notes on Camp". It has become a sensibility, a fashion, and a cause and a comfort to drag queens worldwide. It's an ingredient that figures in practically every new pop culture equation and a vehicle that carries the virus called irony. It's loved and it's hated and it's overexposed. With irony now permeating practically every aspect of modern life, many wish to simply flee it all and see things for what they are and when they are. Fat chance.

Camp has become so pervasive that it virtually defies definition or quantification. But we shall try.

Camp is, of course, based on nostalgia. Nostalgia is a mental selection process which enables us to remember a past with all the mundane and unpleasant elements filtered out, leaving only an amorphous feeling of the pleasantness of the past. This provokes a sad, sweet feeling and allows us to "come to grips" with the past, albeit superficially. In this way it is a kind of survival instinct. The emotional end product is a yearning for this idealised, non-existent time and place.

Nostalgia can take extreme forms and can become pathetic and unnatural. It can become excessive and embarrassing, for example, when a corny old pop song starts playing in a department store and provokes one to tears. It can become unnatural when we feel nostalgia on an intense personal level for a period of time that occurred long before we were born.

Yet camp is not just nostalgia, but rather a distillation of its pleasurable essence. It is the sweetness of nostalgia detached from the overpowering personal memory that drives one to tears. Camp is sublime joy, not tears... it's atmosphere, not agony. It's an appreciation of the *feeling* of nostalgia detached from any specific personal memory. Camp is the depersonalisation of memory. It's for the masses — it's democratic. Camp allows us all to leisurely dip into the collective pool of memory and sip its vague sweetness. And it affords some dignity in an easily cast off pose: no one wants to be driven to tears in the mothball scented fabric department of Woolworths by a pop song they know is maudlin. That's when it becomes personal, when it controls us instead of us controlling it, this strange "it". Camp is impersonal. Camp allows everyone access to the pleasure of a feeling while sparing them the pain of personal loss upon which genuine nostalgia is predicated: loss of youth, loss of love, loss of ourselves (that different person of long ago who is gone forever along with the world they lived in).

Camp, conversely, is all gain, no pain — and no substance, please! Personal detachment renders the noble hilarious, the sentimental ridiculous, and the touching just more emotional kitsch... and we laugh, while the one who has a personal memory of it is driven to tears and outraged that we can make sport of it.

And camp is good sport.

Land of a Thousand Balconies

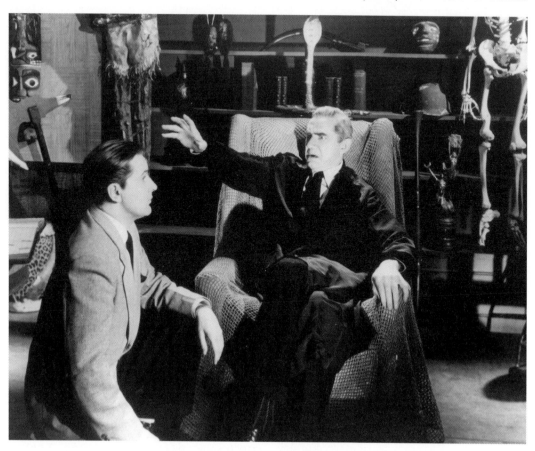

Ed Wood Jr and Bela Lugosi in a publicity still from *Glen or Glenda?*

Sontag clearly identified camp's affinity for the medium of film, but her seminal essay offered little more than casual ruminations about what camp cinema was. And most of the texts that have dealt with the subject since have attempted little else than to spotlight favourite "bad films", or elaborate on the lore of over-advertised Hollywood stars.

Thus, rather than celebrating favourite masterpieces of camp, which is always easy, enjoyable and tempting to do — and which we shall do — it is perhaps more constructive to take an analytical look at the functioning mechanisms of camp. This might best be achieved by observing how Camp has evolved in the thirty-nine years since its birth in print.

There are three main functional characteristics of camp: (1) Double Meaning, (2) Passionate Intent, and (3) Escape into Artifice. An examination of these three points will also clarify the important distinctions between "Pure Camp" and obvious or "Deliberate Camp".

DOUBLE MEANING

Something that is camp is something that can often be appreciated in two very different, often opposite ways.

Usually this is accomplished by gazing at the object through the rose-coloured prism of passing time, which thereby reveals a duel or layered meaning that the thing did not possess, or that was not visible, when it was created. For example one audience might see a film when it is originally released and find it to be a straightforward horror film, while thirty years later audiences howl with laughter. In this case, the two different audiences are separated by both time and mentality.

Sometimes the two audiences are separated only by mentality, not by time or physical space. For example a mixed crowd can watch a film in the same theatre and everybody likes it very much, but for very different reasons, a thing quite apart from half the audience liking it and the other half hating it. This kind of duality

The Passionate Plastic Pleasure Machine

is supposedly a new concept, and it is tempting to say, as some have said, that "in the old days" everything meant what it was supposed to mean, and whether it failed or succeeded was the only issue. I am, however, not sure that this is true and suspect it to be the conclusion of near-sighted historians.

An object of pure camp might also achieve double meaning *unintentionally* from circumstances beyond its control, circumstances that accidentally come into play and alter reaction to the film in dramatic ways. A movie can, for example, become a victim of history if one of its bit players goes on to shoot the President or becomes a highly publicised auto-erotic fatality. Or a film can become a *cause célèbre* through no fault or intention of its own. For example, one of the actresses might go on to become worshipped by lesbians many years later for reasons inscrutable to the general public or even the actress herself.

Other films can achieve pure camp without the divine invention of circumstance simply by remaining so defiantly themselves in changing times. By whatever means and in whatever version, pure camp is three-dimensional while deliberate camp is flat and one-dimensional — although the latter can still possess true spirit, and if well crafted can also assume multiple meaning and begin to weave and shimmy through time with a double whammy effect.

PURE CAMP VS DELIBERATE CAMP
Specific Examples

To further define the concept of double meaning, one must understand the difference between pure camp and deliberate camp. Let's take some specific examples.

In a random list of seventeen artefacts that Sontag deemed the essence of camp in her 1964 essay were Scopitone films (see: THE JUKEBOX THAT ATE THE COCKTAIL LOUNGE: THE STORY OF SCOPITONE). These were three minute 16mm song-and-dance films that played in Scopitone "visual jukeboxes" that were fitted with movie screens.

Developed in France in 1960, Scopitone films delivered up the "yé yé" pop music that was then popular in the early sixties. In 1963 Scopitone jukeboxes were imported to American bowling alleys, restaurants, bars and cocktail lounges, reaching a peak of popularity in 1965 before fading from fashion in the late sixties and sinking into the quicksand of American pop culture disposability.

Throughout the eighties and nineties, Scopitone films were disgorged from junked jukeboxes and hoarded by collectors, while the Scopitone phenomenon periodically resurfaced in articles penned by amazed scribes who believed they had just discovered artefacts from a lost civilisation.

That Scopitones made an impression on Sontag in 1964 was not remarkable since anyone sitting near a suddenly activated jukebox was blasted, as *Time* magazine put it, "with delirious colour and hi-fi scooby-ooby-doo for three whole minutes."

That Scopitones made it into one of her learned essays, long before pop culture was considered fair game by academics, *is* rather remarkable. Sontag saw Scopitones as the essence of camp: exaggerated, vulgar, gleefully superficial, scrubbed clean of any deeper emotions. The weary travelling salesman, however, sipping a Manhattan at a roadside lounge as he popped coins into a Scopitone jukebox, saw only pure entertainment and a glutton's helping of cheesecake — not camp.

A quite different example of pure camp is the 1962 feature film, *What Ever Happened to Baby Jane?*, directed by Robert Aldrich. The film was, in the beginning, not camp. Although she dressed right, Bette Davis' Baby Jane character was too tragic to be camp: she was the dark twin of nostalgia's bright emptiness. This was a masterfully realised psychological horror film and was generally judged as such upon its release.

At the time that the film was made, the two leading ladies, Bette Davis and Joan Crawford were highly respected Hollywood professionals and the movie was submitted as evidence of their top rate acting abilities. Yet given all the scandalous personal disclosures that have since accumulated around the two, the film has inevitably assumed a camp lustre, if a reflected one. Nothing that Davis or Crawford ever did would look quite the same in retrospect, and a double whammy curse was retroactively put on their entire filmographies. The 1981 Crawford biopic, *Mommie Dearest*, was almost immediately proclaimed a camp masterpiece and hit the midnight circuit straight after first run play.

It was again the rose-coloured prism of passing time — in this case more of a jaundiced yellow — that gave the thing its special glow.

The Wizard of Oz is another film that can be included in this category. It was created as a masterpiece, a grand epic of fantasy film-making, and the passing of years has only served to further confirm its status. Yet the presence of a young Judy Garland, whose life would go on to epitomise Hollywood tragedy, and whose visage would be worshipped far and wide by drag queens around the world, imbues the film today with an eerily portentous inflection and adds camp lustre. But as a fantasy, the film still works on all its own terms and defies ironic recycling. It disallows camp

Land of a Thousand Balconies

to remake it but allows camp to enjoy it. A person can enjoy this film on two levels at the same time. Both audiences now exist inside of one head.

A film that qualifies as deliberate camp but still manages to deliver double meaning is the 1970 Twentieth Century-Fox studio feature that Russ Meyer directed: *Beyond the Valley of the Dolls*.

This wildly melodramatic stew of sex, drugs and rock'n'roll decadence set in modern day Babylon — Hollywood — staggered through a disappointing first-run release that left a trail of some of the worst press ever. Yet very soon after that it went into revival status and became the object of cult adoration that continues to grow to this day.

Some clued-in viewers immediately recognised and responded to the sensational exaggerations of the film. (At one point Meyer had described it to a Fox executive as "the first exploitation-horror-camp-musical.") Other less hip or ironically-prone viewers saw it as high blown drama that delivered, not camp put-on. After all, in Hollywood in 1970 real events were proving every bit as far out.

Meyer insisted the movie had to be outrageous, a total put-on, and still work as melodrama. His writing partner, Roger Ebert, recalled in an article published in *King of the Bs* (1975), that "Meyer directed all the actors in an absolutely straight style. This was his intention from the outset: to write a parody and direct it deadpan. If he succeeded, he said, there should never be a moment in the movie when any actor seems to understand the humour of his dialogue or situation."

There was a third principal and sizeable group of viewers that saw the film: those who were simply stunned speechless with no particular pleasure attached to the experience. Meyer had hoped to leave the audience "totally confused… wondering what had hit it" and he succeeded, particularly with critics. One New York critic, Ebert recalled, "found it full of stereotypes and clichés: the critic was apparently unwilling to believe that each stereotype and cliché had been put into the movie lovingly, by hand." (This is the same Roger Ebert who today attacks David Lynch for being bewildering.)

Beyond the Valley of the Dolls is seen today as deliberate camp, but in its first run release it fit the definition of pure camp, a film that could be enjoyed on two completely different levels. Context of exhibition was key to this. The film wasn't playing midnight-movie shows in college towns, or on the New York City repertory circuit with its film buff clientele, or in the drive-ins, where Meyer's films usually played. It was playing the mainstream first-run circuits. And it constituted one of the greatest mass muggings ever perpetrated by a movie director.

But the world was quickly getting hipper and estimation of Meyer grew exponentially. By 1973 he was already being proclaimed as something of an auteur. *Beyond the Valley of the Dolls* became an icon of cult adoration, encased in the amber of its own reputation. Time has not changed the way we see the film, but we see it differently because times have changed. In other words, what viewers see today is pretty much what viewers saw in 1970, but we're not living in the way-out times of 1970 anymore. The film is more outrageous today when seen in the context of much less outrageous times.

Another example of deliberate camp that plays to two separate audiences was the *Batman* TV Series broadcast in America in the mid sixties. It was crafted as camp at a time when one only had to pick up the nearest magazine to know camp was "in", but to kids it was a superhero action show, and its plentiful bounty of innuendo was designed to go safely over their heads. In one episode entitled "Catwoman Dressed to Kill", Robin wonders if the evil, sexy Catwoman (Eartha Kitt) plans to kill the curvaceous Batgirl after kidnapping her.

"Or worse, Robin… or *worse*," deadpans Batman with a pregnant pause before long a fade to commercial.

Beyond the Valley of the Dolls and *Batman* represent two very different examples of deliberate camp

that managed a lively sense of counterpoint and succeeded in being entertaining without being pretentiously self-aware. Yet most deliberate camp it far too self-aware. It tends to be obvious and one-dimensional, inert and utterly lacking in the misguided conviction that fuels pure camp. This is the reason why many are fed up with camp.

Which brings us to the reason why pure camp succeeds...

PASSIONATE INTENT

What Camp taste did, Sontag wrote in 1964, was "to find the success in certain passionate failures."

Passionate Intent is the active ingredient in pure camp. Pure camp is, after all, the product of pure passion, on whatever grand or pathetic scale, somehow gone strangely awry. There is, in fact, a spiritual component to pure camp which contradicts the popular assumption that camp is only concerned with surfaces, with the superficial. But as we shall see, to create it and to experience it are two different things.

The mediocre film can never be camp because it *just* fails. It must fail *gloriously*. Nor can the simply "dated" film be considered camp, even though most camp is about the old and has the mustiness of "the old fashioned" about it. Nor can the merely extreme or freakish be camp. To simply *exist* is not enough, and to be an anomaly of nature is also not enough because camp is not about nature, it's about man. It must exist in a world of counterpoint, and that is a man's world, a human world.

There must exist some implicit relationship between the thing and its creator. Here, between intent and realisation, something "happens". It is in this invisible space camp life is born. And it takes a special pair of glasses to see form in this invisible space, which is why many cannot see it. They are just looking at the end product. A commodity unto itself. Those who can see it are moreover often accused of being part of a hoity toity in-club.

Proficiently pre-assembled studio product can never be camp. Camp in the most positive sense exhibits the director's blind faith in his creation, a blind faith that glows with such luminescence that it tends to obscure the object itself. If we can't swallow his fiction, at least we are respectful, or perhaps in awe, of his powers of self-delusion. Maybe this director doesn't know the tools of his craft but so what? Maybe he has something much greater to offer.

Pure camp is born of sincere motivations; it is a dream that will never die, the movie that will change the world. To discover his film has utterly failed in its originally intended terms and become a "Camp Classic" would naturally offend an elderly but still proud director… whose initial indignation can often only be soothed by the sizeable hunks of cash that his movie starts to earn on the revival circuit.

Pure camp is created against all odds by the naive, stubborn director who in the cynical, hardball, bottom line movie business can still foolishly dream he is creating a masterpiece without money, technical sophistication or (orthodox) talent. It takes blind faith to battle on for one's vision against all these odds. Yet however endearing such displays of passion are, the sum result is still likely to be plain, garden variety failure. There are many film-makers fighting passionately for their projects. In the movie business you have to fight, but that alone guarantees nothing. Only in rare cases does blind faith levitate a movie up from the mud.

ED WOOD
The Cult vs The Revival

These acts of levitation most often occurred in the world of American low-budget exploitation film-making in the fifties and sixties. The conditions were right: lots of product of not necessarily top quality was needed to service the various drive-in and hardtop B-circuits, and the Hollywood B-studios could not fulfil the demand. A guy who owned a gas-station, say, but wanted to break into "the movies" could write a script, rent equipment and actually make a commercial feature that had a dim chance of getting played somewhere. A handful of these rouge independents, or "possessed amateurs", could function and make a living outside of any legitimate studio system. America, with its tradition of the "self-made man", encouraged these hopefuls onward, luring them in most cases over the proverbial cliff and into bankruptcy. A few landed in the conveniently placed stack of hay.

The now famous Ed Wood Jr represents the prototype of this kind of possessed amateur, although only one of his films truly rose above entertaining period kitsch to achieve full-blown camp cult-hood: *Glen or Glenda?*, from 1953.

Sontag's observation, worth repeating, that Camp taste sought "to find the success in certain passionate failures", prophetically crystallised the essence of the Ed Wood revival that has spun on in various cycles from the late seventies to the present day, and in some ways has spun out of control.

"In naive or pure camp", Sontag wrote, "the essential element is seriousness, a seriousness that fails, (but) only that which has the proper mixture of the exaggerated, the fantastic, the passionate and the naive can be redeemed as camp." Although a famous

Land of a Thousand Balconies

joker at parties, Wood was deadly earnest about his films, never "in on the joke" and never putting a single intentionally comic line into any of his movies.

As previously stated, camp is predicated on the existence of an implicit relationship between the creation and its creator which survives the test of time. *Glen or Glenda?*, Wood's most personal film, qualifies here in spades. There isn't a moment when the viewer isn't wondering "who the hell made this thing?!" Yet we wonder this with a sense of... wonder, not hostility, and modern audiences are able to engage the film's fantasy of bi-gender existence, far removed as that is from the desires or experiences of most viewers, by its dislocation in time. This recalls Sontag's observation that, "we are better able to enjoy a fantasy as fantasy when it is not our own."

To put it perhaps too simplistically, Ed Wood Jr didn't become celebrated because he made bad films: he became famous because he wanted to make good films that instead were only good at showing how badly he wanted to make them. (In fairness to Wood, however, it should be noted that this was also a time when audiences accepted and enjoyed much cheaper special effects.) Anyone working under all the handicaps Wood worked under had to be totally driven and fairly immune to the futility of it all, though it eventually took a heavy toll on him.

A clear distinction must be drawn between The Ed Wood Revival and The Ed Wood Cult.

The Ed Wood Revival exploited the obviously campy elements in his films (Ed in Angora sweater, wig, skirt, etc) while the Ed Wood *cult* rejects the contextualisation of Ed Wood as a "camp" figure, since that trivialises Ed Wood *the person*. The Revival chose two specific films, *Glen or Glenda?* and *Plan 9 from Outer Space* and pretty much ignored the rest, figuring audiences had had their fill of Wood. Conversely The Cult, headed by Wood biographer, Rudolph Grey, worships every scrap of film he ever made, even the "lost" and never completed films, even the Super-8mm hardcore porn loops he made in the seventies at the end of his life. The Cult values Wood's individuality. "He (Wood) defies comparison", wrote Grey in the introduction of his oral biography, *Nightmares of Ecstacy* (1992) "... there is no one remotely like him." The Cult views his films and paperback books and all the other artefacts

Maria Montez as featured on the cover of two French film magazines, dated 1948 and 1953.

he left behind as documentation of his life, not as end products in themselves.

The Revival hinges on several books and films that achieved mainstream exposure, starting with the book that immortalised *Plan 9 from Outer Space* as "the worst movie ever made" — the Medved brothers' *The Golden Turkey Awards*, published in the early eighties. *Cult Movies* by Danny Peary in 1981 also trumpeted Wood's return to earth, or at least to the front pages of the fanzines, but the 1994 Warner Brothers commercial feature film, *Ed Wood*, by Tim Burton, was really the force that rolled the rock away from Ed Wood's tomb.

Neither the books nor Burton's movie, despite stated intentions to the contrary, went into any kind of deeper consideration of Wood. The movie opted to exploit the superficial campiness of his films, painted Wood "the lovable loser" in broad strokes and ignored the tragic but poignant elements of Wood's life, capping the whole thing with a requisite happy ending. "Sweet" was the word many people used to describe the film, and sweet it was — disarmingly and dishonestly so. Yet it seemed absurd to argue that it wasn't "realistic". After all, we were talking about *Ed Wood*, right?

Grey's *Nightmare of Ecstacy*, an arduous ten year labour of something beyond love, on the other hand, painstakingly sketched out Wood's entire life including his later years which were a misery. Camp, as Sontag said, abhors genuine tragedy or the provocation of deep or serious emotions. But Wood's life *was* full of genuine pathos. The man himself was the antithesis of a camp object. He was practically *only* pathos.

Ed Wood's films were full of people climbing out of coffins, but Warner Brothers seemed afraid to let the real Ed Wood climb out of his, 'lest they come face-to-face with the monster Hollywood fears most: a real person. The film cast Wood as a lovable loser who nonetheless pursued his dreams, a premise as one-dimensional as a cardboard Dracula. Johnny Depp's hyper, over eager portrayal of Wood was so lacking in nuance that the real Ed Wood never had a chance to breathe. The film was little more than a series of well lit B&W photographs set to motion.

Burton's *Ed Wood* wasn't deliberate camp. Although it exploited as design motif the camp value everybody expected from The Ed Wood story, it was trying to be sincere. It was a perfect example of the doomed nature of second-hand tributes. It was a bridge too far, a fantasy/homage recycled too many times. And like most Burton films, it left a slightly nauseating Disney aftertaste.

All roads lead back to the kernel of Wood's real achievement, *Glen or Glenda?*, which remains a film alone and apart. It was Wood's most personally felt, unique and lovingly (if oddly) crafted work, made before he took the plunge into genre pictures, horror and crime stuff, and later porno (although it desperately *tried* to be a genre picture). And it remains the embodiment of pure camp in its most compelling form. Camp was, as Sontag wrote, "tender, sincere, heartfelt and naive" — *Glen or Glenda?* was surely all that.

Maria Montez

MARIA MONTEZ

In her 1964 essay, Sontag also noted in passing that some movie critics had started to pen lists of "the ten best bad movies I have seen", and she also addressed the issue of "good bad taste", writing that "Camp asserts that good taste is not simply good taste, that their exists a good taste of bad taste." All this was long before Ed Wood Jr became a patron saint of b-movie night-owls, and well before John Waters put the concept of good/bad taste into wider coinage.

At the time, camp was a ghettoised sensibility, one that had taken root in the incestuous New York underground film and theatre communities in which Sontag moved to some degree. Here manifestations of camp consciousness were most evident, and here camp was making itself felt and visible, most pointedly in an approach to acting. Traditional aspirations to "good acting" and professionalism were out: non-acting and over-acting were proclaimed superior to the merely proficient… passionate failures were deemed a million times preferable to assembly line run-of-the-mill successes.

This new view was based on a revisionist appreciation of a number of old ham Hollywood stars, none more important than the Dominican Republic-born, Maria Montez, a Universal Studio actress famed for

Land of a Thousand Balconies

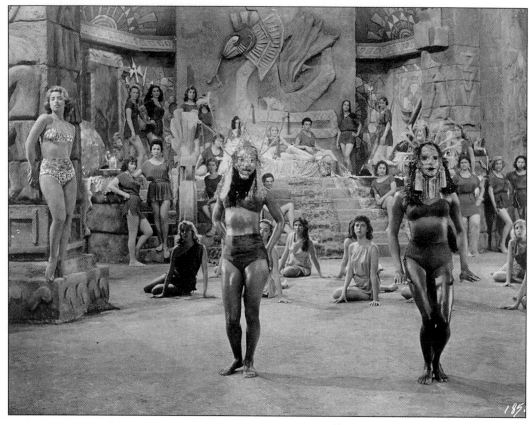

Love Slaves of the Amazons, filmed entirely in Brazil.

her roles in a series of exotic early forties films like *Gypsy Wildcat*, *White Savage* and *Cobra Woman*.

Underground filmmaker and celebrated nutcase, Jack Smith, was one of her leading advocates. He worshipped her with a deranged and occasionally eloquent intensity which was on display in the influential and oft-quoted tribute he penned to her in the Winter 1962–63 issue of *Film Culture* magazine.

Montez died of a heart attack in her bathtub during a program of radical weight loss treatments in Paris in 1951, where she ended up after her career as the quintessential dark-skinned pagan enchantress hit the skids. The Chicago theatre where Smith then worked as an usher screened a retrospective of Montez films to mark her untimely passing, and Smith had found his God.

His adoration of the popular yet talentless actress was shared by others in the largely gay underground, including a Puerto Rican transvestite who changed his name to Mario Montez out of love for "The Queen Of Technicolor", as she was billed. Mario appeared in a number of underground films, among them Jack Smith's

Flaming Creatures and Warhol's *Screen Tests*, thereby becoming one of the first of the Factory's super stars.

But Smith's kind of love was special.

It was a love as genuine and "real" as love could be, but his feelings for Montez differed fundamentally from those of her fans in the early forties for whom lack of acting talent was not an issue, let alone a secret attribute. During the war years audiences sought fantasy and escape from bad news in the cut-rate exotica Universal dished up, and so too was Smith seeking escape, escape from life. Period audiences took it "straight up" and enjoyed it. Today a film like *Cobra Woman* can still be thoroughly enjoyed but *nobody* can take it straight up.

Montez was worshipped in the underground for her passionate intent and her ability to ignore her own lack of technique with such abandon. "Maria Montez dreamed she was effective", wrote Smith, "imagined she acted, cared for nothing but her fantasy…"

Her revival status soon spread beyond the underground and today she is generally acceded to be the reigning priestess of "High Camp", and her film, *Co-*

The Passionate Plastic Pleasure Machine

bra Woman, to be the crown jewel in camp's staggeringly heavy headpiece. But for all the self-aware, oh-so-clever winking irony that camp projects today in its more tiresome guises, Smith's adoration was deep and real, not sarcastic, no pose or put-on.

But the source material could never manage to infuse the derivative versions with much real power (this was also the problem with Burton's *Ed Wood*). Her power is not evident in Smith's *Film Culture* essay, only the power of his love for her. Likewise the performances of her sixties masculine namesake were, however heartfelt, intentionally feeble echoes of "the real thing".

The Montez magic was again reheated in Gore Vidal's 1974 novel, *Myron*, a sequel to *Myra Breckinridge* (which in 1970 Fox made into the deliberate camp feature film of the same name that turned out to be a colossal bomb.)

As J Hoberman writes in his book, *Midnight Movies*, "Myron... ushers its title hero back into the Hollywood of 1948 via a 'through the looking glass' gimmick whereby he passes through a tv screen onto an imaginary Maria Montez epic, *Sirens of Babylon*, while it's being shot. Further developments — including the process by which Myra *becomes* Maria Montez — are relatively anticlimactic."

Exotic jungle pictures hardly went out of style, though, with the death of Montez. To the contrary, the cycle of these kinds of pictures continued to spin on, culminating in the supremely campy *Love Slaves of the Amazon* in 1957.

The quicksilver of passionate intent is, then, essential to pure camp as strictly defined, but the fragility of its chemical composition renders it impossible to recapture or reconstitute. It can be *loved*, and that love can have a power of its own and that love can be taken on faith, but it cannot be passed on second-hand, as, one might be tempted to venture, no true love can.

Derivative or deliberate camp, such as *The Rocky Horror Picture Show* or *Vegas in Space* can be entertaining and successful on its own terms, but the difference between pure and deliberate camp is unmistakable.

ESCAPE INTO ARTIFICE

Camp is not just an escape into fantasy. All movies are that. To put it more precisely, it actively rejects the serious and genuinely tragic by escaping into the sanctuary of artifice where unbound extravagance and exaggeration renders "real meaning" subservient to pure style. Camp declares that escapism, which otherwise has a decidedly negative connotation, is not bad but good. (All of this is encapsulated in *Glen or Glenda?*). In the world view of camp, escapism is empowering, not cowardly, and liberates us to chose what we value in a modern world where most "meaning" is pre-sold to us anyway without our conscious participation in the exchange.

Camp has a natural affinity for certain film genres like horror, science-fiction, and old Christmas movies, which are all prone to escapism and most actively exploit the viewer's "suspension of disbelief" to generate their fictions.

Most science-fiction cinema from the thirties and forties, especially anything based on comic strips, is inevitably camp since the visions expressed are so hopeful and innocent while the production technique is so unabashedly primitive. Old splendidly titled science-fiction series from those two decades, such as *The Purple Monster Strikes* and *King of the Rocketmen*, are hard to see in any other light. Sontag in fact included "the old Flash Gordon comics" in her list of camp artefacts.

These serials are seen in a pleasant and charitable light. And so are their feature-length brethren from the fifties, grade-Z pics like *Robot Monster* and *Missile to the Moon*, both of which quickly tumbled off the bottom half of fifties drive-in double bills, only to reappear in the seventies on late-late-late show radar screens.

Judging from the title, *Sins of the Fleshapoids* sounds like another pulpy old comic book based sci-fi

Jane Fonda in *Barbarella*.

Land of a Thousand Balconies

Julius Middleman, in Mike Kuchar's *Sins of the Fleshapoids*.

serial from the thirties. Comic book style sci-fi it is — but from 1965, not the thirties.

Conceived and directed by a twenty-three-year-old Bronx native, Mike Kuchar, this luridly photographed tale of robot love, sex and rebellion in the far distant future was realised with playful and unpretentious charm, and was very carefully crafted despite its tiny budget. It managed to skilfully essay the old sci-fi serial genre while simultaneously playing off the sense of Camp that was just coming into vogue. It was not so much a case of double meaning as of double *value*. *Sins of the Fleshapoids* was a successful graft of traditional genre form onto a cool, contemporary underground style that connected with hip young audiences. It worked as a dramatic narrative, and it possessed amateur brio. It had spirit and it was new. It became a classic of deliberate camp but sans the usual heavy set of quotation marks. It must also be stressed that Mike Kuchar never read Susan Sontag's essay.

Underground proselytiser/publicist, Jonas Mekas, compared Roger Vadim's much hyped 1967 deliberate camp commercial feature, *Barbarella* — based on the French comic strip of same name — to *Sins of the Fleshapoids* and found the former wanting.

Barbarella — *rich man's science fiction movie. Mike Kuchar's* Sins of the Fleshapoids *was done with only a tiny fraction of the money wasted by Vadim, but Kuchar's movie had much more craft, much more imagination, and was better cinema. Just compare the "love-making" (touching of hands) scene which Vadim, knowingly or unknowingly, borrowed from Kuchar (*Fleshapoids *played in Paris) The difference, I think, is that although both Vadim and Kuchar worked within the camp style, Kuchar never lost his distance, his detachment, Kuchar never lost his cool; Vadim, however, loses his detachment and becomes campy himself — which is his proper and natural level, and it's simply bad.*

The partisan nature of Mekas' rhetoric aside, such a comparison seems absurd today, and *Barbarella*, slammed by critics at the time as bombastic and anti-woman, is now considered by cult buffs a masterpiece of sixties excess. They no longer see Vadim's potentially exploitative relationship with Jane Fonda as an issue, and figure that even if she *did* get a bit bloodied by cute toy creatures with sharp metal fangs on an ice planet, it was a sacrifice worth making for weirdo cinema. Amen.

If Vadim lost his detachment, that seems in retrospect only an advantage. If he created a bombastic, unwieldy, unsubtle, and vulgar film, all the better as long as it was gloriously so. And many have since

judged that it was.

The horror genre also feeds and nourishes itself on prototypes and clichés, and like science-fiction is a creature rooted in the thirties and steeped in old Hollywood lore. By this it also naturally offers itself up for camp treatments.

Roman Polanski's *The Fearless Vampire Killers* from 1967, and the Warhol/Morrissey Udo Kier pictures from 1974, *Flesh For Frankenstein* and *Blood For Dracula*, are three of the more successful entries in the deliberate camp/horror genre, while Hammer Studios rewrote the book on the pure variety.

Hardcore pornographic feature films, which are obligated to attempt to convey some kind of plot and story, are also disposed by nature to camp, since they are walking contradictions, walking irony. By definition a porn feature film can never be what it tries to be, a "real movie", and for lack of money, talent and imagination in various combinations, it can rarely be what it *wants* to be; effective erotic fantasy. It's fated to wander forever in that limbo between intention and realisation.

Pornography is eternally in search of a form, imitating or parodying older genre forms in a hopeless attempt to justify itself or lay claim to some kind of excuse or reason to exist that nobody in the audience gives a damn about. This is most painfully apparent in the large number of hardcore featurettes from 1970–72 that tried to be slapstick comedies. Since there was no commercial hardcore in the thirties, forties or fifties, it cannot, like horror or science-fiction, play upon its own past and exploit its own stereotypes in a humorous or ironic way.

Yet from an aesthetic perspective, the counterpoint between grindingly explicit hardcore close-ups and the fluttering affectations of over-costumed non-actors trying to be, say, characters from *Alice in Wonderland* (there are several hardcore adaptations), creates irony that produces camp of the most vulgar and jarring sort.

It is difficult to bring passionate intent to what is the most perfunctory, formalistic and commercial of all film genres. "Spirited failures" are few and far between in a genre that concerns itself with things other than the spiritual, but there are other ways by which camp is achieved.

Porn, particularly hardcore films made in 3-D, crash through the trash barrier and end up in Campland. This is especially true of gay male hardcore 3-D films like *Heavy Equipment* which features a flying dildo. *Dracula, the Dirty Old Man*, a straight, Z-grade softcore "kinky" from 1969, with its Borsht-belt Dracula slobbering over nudie cuties tied up in his cave, is, it seems, not low camp or high camp but perhaps lame camp, and nonetheless entertaining if eventually unbearable for it. Phil Osco's *Flesh Gordon* is the best known big-

ABOVE AND NEXT PAGE
Frame blow-ups from *Dracula, The Dirty Old Man*.

budget attempt at Deliberate camp humour in the (softcore) sex film genre, while the massively budgeted and ambitious hardcore bomb, *Caligula*, lacks the charity or whimsy of camp and ends up as trash and no less the worse off for it.

Interestingly, Sontag lists "stag movies seen without lust" in her list of seventeen camp artefacts, implying that to appreciate them for their sexual content would deny them camp status since sexual feeling is the kind of genuine, serious and personal emotion antithetical to camp's compulsory emotional disengagement. Old stag films come with a built-in distance that allows us the detachment to see the humour in sex play that is more difficult with newer films. Not that old stag films become funnier, but an intensely personal expression — the sex act — loses its claim to seriousness and becomes viewable. In that alone there is a reflexive humour.

Conclusion

In 1967, three short years after her original essay on Camp had been published, Sontag voiced alarm over the modern phenomenon of "instant communication" that had transformed "a bulky essay in *Partisan Review* into a hot tip in *Time* magazine". Following that, things only got more "instant". In 1973, *Beyond the Valley of the Dolls* was playing midnights to wildly appreciative cult audiences in London — little over two years after its first run had been buried in bad press. In 1995 the forty-million dollar Pure Camp Bomb, *Showgirls*, recouped only half its cost. Almost immediately after the dust settled it opened in Los Angeles as a midnight "cult" movie, and then in New York complete with a crew of hired drag queens to enact scenes upfront and encourage the audience to shout insults at the screen.

Today in our modern self-serve, drive-through culture, communication has become not only instantaneous but accumulative: a film critic today needs to come armed with multiple sensibilities and a whole bag full of glasses, not to mention some heavyweight hardware like Geiger counters, metal detectors, shovels and so forth — the kind of gear any archaeologist needs. They need to know the "put-on" and when to duck all the double whammies.

Nuggets of pure undiscovered camp still exist. Deep space is full of antique flotsam that occasionally gets sucked into the gravity of the latest earthly trend. And as long as somewhere in some forgotten dark corner of the movie business things are so disorganised and inefficient that one possessed amateur can zap his masterpiece to life before he gets fired, "the imperfect", to steal a line from Carl Dreyer, "lives".

TRASH AIN'T GARBAGE

Identifying a New Aesthetic in Cinema

Defined by the *Oxford Dictionary of Current English* as "rubbish or refuse... a worthless person... a thing of poor workmanship or material," trash, in regard to art, has traditionally referred to: (1) sham art (a cheap fake), (2) failed art (a bombastic or pretentious failure), or (3) non-art (an expression of utterly no significance). In broad usage, trash has come to mean a disposable, shoddily-produced manifestation of kitsch culture, devoid of any genuine artistic value or moral orientation but often with pretensions to such. It is an insulting, dismissive term that signifies an object of no value, one that is not worth the slightest consideration on any level.

Within the last twenty to twenty-five years, however, the term has acquired a double meaning and assumed a positive connotation. The word has been expropriated much the same way that Afro-Americans expropriated the insulting term, "nigger" and transformed it into a casual greeting among themselves, thereby defusing its negative meaning. So, too, have white junk-culture youth expropriated the term Trash. They have not changed the meaning, as, for example, the meaning of the word "gay" was changed, but rather they have *inverted* the meaning and transformed a dismissive insult into a cause for celebration. The uninitiated are left confused at how something bad can be good, let alone *exciting*. Like all such terms, it all depends on how the word is said, with a dismissive sneer or with an edge of profound awe in one's voice.

Trash is first and foremost a rebellion.

It is a rebellion against the hypocrisy, fascism and elitism of art and a glorification of all things anti-art, of the transparently cheap. Trash is an anti-art, anti-intellectual movement, if a purposely vague and ill-defined one. Being a thoroughly American invention, it scorns European-rooted conceptualist art and instead deifies the thing and not the meaning of the thing. Trash celebrates the object alone and ignores the creator's philosophy, intention or politics. It spurns the highbrow culture of art criticism (a virus transplanted from Europe) and is itself impervious to criticism. If you dismantle it, there is nothing there. It defies art criticism and is by nature objectionable to all art critics who have a sense of professional integrity. They ignore or dismiss it angrily as mere "trash" — exactly what it always claimed to be. It is a nonentity to critics, a black hole.

To understand trash, one must understand America's relationship to its antithesis, art. In America, "art" is an effete concept, a French conspiracy, something that hangs on the walls in rich people's houses. It was never seen as a spiritual tonic for the common man as it was in Europe. And if one was going to express oneself in a personal way and create art, then film — an expensive, technology-based medium that requires the cooperation of a number of people — was the least practicable format to chose. Film-makers in America have generally never thought of themselves as "artists" creating "art", but rather as entertainers, storytellers or simple businessmen. Hence it was natural that this thing called trash originated in America and within the field of film. Rock'n'roll, for many of the same reasons, was also a nutrient medium for trash,

Land of a Thousand Balconies

Donna Kerness (foreground) was the busty lead in all of George and Mike Kuchar's movies. Here we see the "home-made" milieu in which the brothers worked; their actors watching rushes. (Note boy in Roman garb lying on the floor).

NEXT PAGE Donna Kerness and Hope Morris in the shower. Frame blowups from *Hold Me While I'm Naked*.

but more on that later.

The trash movie aesthetic was founded on an appreciation for the low-budget commercial B-films of the fifties and sixties. Struggling with severe budgetary limitations, directors were forced to come up with slapdash costuming and set design solutions that produced truly bizarre and sometimes unintentionally hilarious results. This gave birth to a specific aesthetic, one which was later borrowed by underground film-makers and coupled with a premeditated, ironic, self-aware style of film-making. They felt an affinity with their poverty-stricken brethren in the commercial arena. They understood. And they were also broke, so doing things in the cheapest possible way and expressing things in this kind of shorthand was also very practical.

Although trash is a retro-rooted style, it is currently being brought to bear on modern subject matter in a variety of innovative ways by a circle of currently active film-makers. Trash isn't just a mere derogatory adjective anymore — it signifies an entire film genre. But first, a more detailed look at the origins of this hairy ape creature.

HISTORICAL DEVELOPMENT

Trash as a conscious style of personal film-making originated in 1963 with Jack Smith's *Flaming Creatures*. A sixty minute B&W short film shot for a hundred bucks on outdated army surplus stock, it unspools as an obscene, apocalyptic transvestite bacchanalia. It was filmed on the roof of New York City's oldest movie theatre, The Windsor, under what were mildly put, chaotic conditions. It displayed a total disregard of proper film form and showcased some of the shakiest camera work known to man.

The film was one hundred percent trash: shot on trash film stock, populated with the social outcast "trash" of society, and permeated at every pass with the cluttered, crumbling decay that Smith loved to wallow in. References to Old Hollywood, "a seedy garbage dump", as Smith termed it, are frequent.

"Jack would plunge himself into the garbage of life," testified long-time friend, enemy and consort, Ken Jacobs. "He had a hilarious and horrifying willingness to revel in dumps, to create some sort of 'garbage culture'". Smith's ramshackle, cockroach infested apart-

Journey to the Centre of Camp and Trash

Trash Ain't Garbage

Sontag, on the other hand, buried the film with words. And after it was seized and suppressed by the Feds, they turned it into a *cause célèbre* and probably the most over analysed and over hyped underground film of all time. They also turned it into exactly the thing it wasn't: a work of art.

Smith *hated* critics!

A less consciously outrageous style of trash filmmaking evolved in the early works of George and Mike Kuchar, twin brothers from the Bronx who were as far removed from Mekes' concept of art as the Bronx was from the Lower East Side. So to say, *far* removed. Yet in the early sixties they would be discovered and embraced by the same circle of people who had canonised Jack Smith.

The brothers had been making 8mm home-movie style "epics" since 1954, canny, adolescent regurgitations of Hollywood dramas populated with friends and neighbours clad in togas made of bed sheets. The brothers shared Smith's infatuation for old Hollywood tropical slave dramas and voodoo and Spanish galleon pictures, but were more enamoured with the low-budget monster movies that boomed in the fifties, largely courtesy of AIP.

They became adept at expressing their ideas in low-budget terms and forged a functional and creative trash style out of… trash. Gaudy fabrics, plastic figurines and miscellaneous junk bought for pennies down at the local thrift shop decorated their Bronx flat which doubled as a film studio. Their house, in any case, was pretty much already full of this stuff.

The disposable "trash" of sixties pop culture, like comic books, short skirts, big blonde wigs, pop songs and rubber monsters, figured prominently in their films. Their low-budget approach to film-making, driven by necessity rather than choice, also contributed to a style with the joints brazenly exposed. For example, in a day before affordable 16mm sound-sync equipment, they had to dub all the voices after shooting. This was done by playing the film through a projector and having the actors speak into the microphone of a tape recorder while watching the action on screen. More often than not, the brothers would dub all the parts, imitating the different voices themselves. George can be heard trying to feign the seductive cadences of sexy women in several films, *Hold Me While I'm Naked* among them. Instead of trying to conceal this technical limitation, they leaned into it with gusto.

Their films bubble over with an appreciation for the beauty of fake things, a beauty all the more breathtaking when set in counterpoint to grim reality. Real food, for example, like George's supper at the conclusion of *Hold Me While I'm Naked*, is depicted as appalling

ment was stuffed with props, junk and mouldy costumes: the flotsam of a hundred unfilmable films, uncompleted projects and unconnected notions. A trash heap. But one brimming with creativity and novel ideas.

Whereas underground compatriot, Andy Warhol, transformed the disposable junk of consumerist culture into high-priced objects of ironic pop art, Smith would never violate or demean trash by turning it into art.

The busy critics, however, would not allow the film to have a life of its own. *Flaming Creatures* was praised to the skies by underground spokesman and drumbeater, Jonas Mekas, who championed Smith as a "film poet" and "artist", albeit a mad one. Intellectual film and culture critics like J Hoberman and Susan

Land of a Thousand Balconies

slop, whereas colourful plastic fruit, beautifully photographed, figures in several of their movies. Fake objects were always depicted in bright colours that were "juiced up" or over-saturated, while the seediness of daily life in The Bronx was treated in jarringly direct and realistic fashion. In this way they used beautiful fake objects as a metaphor, as a kind of portal into a fantasy world of easy pleasure and instant happiness. People might be overweight and have bad complexions, but there was always hope of escape into a world where things were *made* beautiful, where bright glowing colours alone could give joy. They were trading in a kind of "Celebration of Surface" which is integral to trash.

The provocative outrageousness, vulgarity and aggression that would come to characterize the Trash film-making of John Waters in the seventies, Nick Zedd in the eighties and Jon Moritsugu in the nineties, was nowhere prefigured in the cinema of the Kuchar brothers. Their films were possessed by a different kind of spirit. They didn't employ trash as a tactic by which to express violently antisocial sentiments that would be otherwise inexpressible. For them trash was a way to depict their own lives through a Hollywood prism, to put some hot pink lipstick on a dead serious working-class existence, ... to deal with personal feelings by getting some distance to it all with a style that, at least on the surface, was funny and/or entertaining.

TRASH AS SPIRITUAL SOLACE
Meyer, Waters & Morrissey

A score of commercial B and exploitation film directors active in the sixties would unwittingly make key contributions to the construction of a trash aesthetic as it has come to be defined today. None more important than Russ Meyer.

With *Faster, Pussycat! Kill! Kill!* in 1966 and *Beyond the Valley of the Dolls* in 1970, Meyer created the supreme icons of trash sensibility from the commercial camp, as opposed to the thus far discussed non-commercial, underground camp. Most importantly, his films were packed with the raw sensationalism that was coin of the realm in the sixties — the decade that gave birth to trash, the era that modern trash freaks look back to in the same way that Christians look back to the times of the Bible. For modern day youth vainly seeking kicks and thrills in these tepid, politically correct times, an escape back to the movies and garage-rock of the sixties seems the only answer. Russ Meyer turned movies into spectacles rather than into failed (or successful) art, something he never understood nor intended to create anyway.

He bridged the gap between movies and rock'n'roll. Plentiful were the trash-punk, grunge-mental and retro

Two of John Waters' *Multiple Maniacs*.

sixties pop bands that took names, adopted personas and covered songs from his films. Film freaks who knew every line of dialogue in his two aforementioned movies were just as likely to be seen at a Cramps, Ramones, Gwar or Dickies concert. Russ Meyer is even more responsible than John Waters for influencing this generation of rock'n'rollers and creating trash as a two-headed monster: trash movies and trash rock-and-roll.

Technically, however, his films were anything but trash. *Faster, Pussycat! Kill! Kill!* was very skilfully photographed and edited, while *Beyond the Valley of the Dolls* was a slick, professional, major studio production, and both were of standard narrative form. Meyer was a technically skilled film-maker with a very orthodox approach. His contribution to trash is essentially spiritual.

John Waters would be the first film-maker to craft a fully developed trash style.

Like other trash film-makers before him, he sought to create a totally fake world. "I hate reality," he would write in his book, *Shock Value*, "and if I could have my own way, everything I captured on screen would be

Journey to the Centre of Camp and Trash

fake: the buildings, the trees, the grass — even the horizon." But unlike Harmanee's Scopitones, where people were emotionally non-existent, he would populate his fake world with characters who were emotionally exaggerated.

Waters synthesised an aggressive and unapologetic trash style out of a motley composite of influences. From Russ Meyer he borrowed the emotional freneticism of the overplayed and oversexed villains and tough asses who abused and dominated a line-up of all-to-deserving victims. But unlike the old war vet, Meyer, Waters was totally plugged into the electricity crackling up from the underground: the kind of preposterously degenerate outrages that informed *Flaming Creatures* could also be found in his work, along with a sense of gay camp and a Kucharian fondness of oversaturated colours and sordid domestic melodrama. Like Mike and George, who simultaneously lampooned and celebrated their native Bronx, Waters revelled in the trashiness of his beloved Baltimore and sought out the most squalid and derelict locales he could find to feature in his movies. And all out of a pure, patriotic love for the city. These movies, his "celluloid atrocities", were full of a nervous energy and riddled with grotesque provocations and stupifying arcane plot twists. The world had never seen anything quite like it. Here was trash the critics couldn't co-opt.

The movies Waters wanted to make would never have been conceivable or sellable in any other style. What he felt and wanted to say could otherwise never have been communicated. Here was a new set of rules, a new mother tongue, and his three classics from the seventies, *Pink Flamingos*, *Female Trouble* and *Desperate Living* (called his "Trash Trio" in the script book) constituted the Rosetta Stone of this new language and influenced all who came after, even though he himself would go on to a glossier Hollywood kind of style.

Another film-maker important in the development of trash cinema was Paul Morrissey. His 1970 masterpiece entitled, fittingly, *Trash* (made under Warhol's name), turned a street hustler named Joe Dallesandro into underground America's favourite matinee idol and took the technique of non-acting to new levels. Outwardly, Morrissey's (later period) films, like those of John Waters, were character driven narratives that celebrated counter-culture decadence and hinged on the dynamic of non-acting played against overacting. Morrissey in fact, came first and was a big influence on Waters. But in many ways they were complete opposites: Morrissey's style was as glacial as Water's was overheated, and unlike most proponents of trash, Morrissey was dedicated to realism. By the time he got to *Mixed Blood*, (1984) he had crossed out of trash and into realism altogether.

MODERN ERA
Zedd, Baldwin and Beyond

As new film-makers came onto the scene in the eighties and nineties, armed with their own rusty axes to grind and a whole new set of rules and codes to break, trash spun off in new directions.

New York was once again the scene of the crime in the eighties as something called the Cinema of Transgression began to make itself noticed. Founder, Nick Zedd, a friend of the elderly Jack Smith at one point, drew direct inspiration from predecessors such as the Kuchar brothers and John Waters, but the films he went on to create, such as *They Eat Scum*, *Geek Maggot Bingo* and *The Bogus Man*, had their own feel in spite of the obvious debts they owed to both the aforementioned underground film-makers and poverty row exploitationists like Ed Wood. Zedd was above all pure New York style provocation. His film, *Wargasm*, for one, was crammed full of hardcore porno footage, guaranteeing that it would be the target of bans. (More in depth information on this movement can be found in Jack Sargeant's book, *Deathtripping*.)

Craig Baldwin at work in his basement studio.

In 1991, San Francisco experimental film-maker, Craig Baldwin, produced the forty-five minute *Tribulation 99*, a work that set new standards in the sub-genre of trash known as found-footage film-making.

The film is a "pseudo, pseudo documentary", as Baldwin proudly terms it, an onrush of ninety-nine interlocking conspiracy theories that claim to reveal

how the history of Latin American was born out of a collision between CIA intervention and aliens fleeing the planet Quetzalcóatl. From a junk heap of old monster movies, educational films, commercials and newsreels, Baldwin weaves a semi-coherent narrative of fake history charged with scenes of spectacular destruction and the threat of impending apocalypse. The mass of unrelated footage is given unity and force by feverishly whispered narration and slight-of-hand editing. New history is created out of the flotsam of the old.

The film functions on several levels, satirising yet also celebrating the paranoid excesses of "conspiracy nuts" as well as the radical political zealots and mystics from Baldwin's own camp on the left. All of it served up in the same style of relentless sensory overload that the modern broadcast media uses to pummel the individual in our age of spin and wilful disinformation. The film joyfully inventories a wide spectrum of paranormal phenomenon, but at the same time it is an indictment of the political cynicism of the super powers. The sum result is wildly entertaining but also at times vaguely and disturbingly credible.

Extracting any serious political message from the raft of sound and visual fury is impossible since "serious" is the last thing Baldwin is after, but the film very definitely has a political message and it is deceptively simple: how the ridiculous can be transformed into the believable with some clever editing and the injection of some good music and fake drama. The film had its first shows when the Gulf War was underway and the American media was using the same tools to sell the slaughter *en masse* to the world (and seems set to do it again!).

In 1999, Baldwin made another significant contribution to the narrative found-footage genre with *Spectres of the Spectrum*. This film deals with the issues of power and control, from the discovery of electricity to the atom bomb and beyond, again focusing on the struggle between individual freedom and corporate domination. The story involves two "telepathic revolutionaries" from 2007 engaged in a battle with the new electromagnetic order. (Like most of his films, it's difficult to explain on paper.) In the end Baldwin attempts one of his rare homemade special-effects as the two warriors from the near future escape through time and space in an airstream trailer (a miniature suspended by visible wires) — a hilarious effect that harkens back to the best of trash traditions.

Another very interesting film-maker working within the trash genre today is Jon Moritsugu (see following chapter). And there are others, too many others to elaborate on within the limited confines of this study.

In conclusion, we see that trash is essentially a tactic. Like surrealism, it enables the film-maker, via a distorting prism of exaggerated stylisation, to use black humour to deal with shocking, horrifying or otherwise untouchable subject matter that would have been impossible to treat in a more conventional style.

As surrealism used the form of the dream to slip the binds of reality, trash uses vulgarity and exaggeration to free itself, enabling film makers to deal with taboo subject matter in a humorous, not to say hilarious and wilfully cavalier manner. Child abuse is front and centre in John Water's *Female Trouble* and racial violence and prejudice is a pillar of Jon Moritsugu's *Terminal USA*. Trash is unrepentant, trash does not recognise politically correct dictates. Trash allows film-makers to enter forbidden territory in the same manner that surrealist techniques enabled Dali and Bunuel to enter forbidden territory in 1929 and deal with the madness and perversion of modern society in *Un Chien Andalou*. All these films contained subject matter that could not be treated in any approved fashion. Unlike the European surrealists, however, who had social and political motives and were "artists", most of the aforementioned American film-makers are unaligned with any social or political movement and do not labour under the weight of art.

Testing radiant-energy weapons in Craig Baldwin's *Spectres of the Spectrum*.

UNDERGROUND FILM-MAKER, JON MORITSUGU

Turning Rancid Meat into a Beggar's Banquet

A lot of people sacrifice for art, but not everyday does somebody get their tongue stuck to a frozen Cadillac hood ornament for it — something that almost happened to the female Elvis impersonator in Jon Moritsugu's first film, *Der Elvis*. It wouldn't be the last sacrifice an actor was compelled to make for the Hawaiian-born director, who, in a medium increasingly characterised by slick technical polish, has cranked out some of the most strikingly primitive films that ever rattled through a movie projector.

The twenty-three minute *Der Elvis*, made in 1987 as a thesis project by Moritsugu, who was then enrolled in the Semiotics Department at Brown University, unspools at first glance as a sawed-off assault on the King at his most mythical and grotesque. Elvis fans who unwittingly attended screenings (as they did in Århus, Denmark) were outraged. Yet it can be argued that the film is never actually mean-spirited since it never penetrates the layers of myth-making to take a slap at anything that resembles a real person. Stuffed with a mix of multi-media regurgitation and live footage, it resembles a cut-and-paste punk fanzine more than a movie, but it's a fitting approach to take with the twentieth-century's most schizophrenic pop changeling.

In a spastic series of shocks, fits and seizures, it expends the same tortured, bellicose energy at the audience that a bloated and sweaty Elvis expended on the business of living. The film slips and lunges about with the same blind fury that typified Presley's imagined daily attempts to climb out of the bath tub. It seeks to depict the biology and velocity of his legendary top-heavy crash with grainy images of raw meat, a dead killer shark hoisted onto a dock and food slopped onto a plate. In its sound and fury signifying nothing, it echoes the dying trumpet blast of a doomed cultural elephant thrashing about in the quicksand of its own media created myth. The film, too, thrashes. But if it causes damage, it's mostly to itself.

As for insight into the director's working methods, the aforementioned hood licking episode fairly accurately diagrams his approach to standard film-making procedures like obtaining permission for location shoots; Jon and said female Elvis impersonator snuck into said Cadillac dealership in midwinter without permission and filmed for two minutes before they were chased out and the cops were called.

Ironically we have the Kodak Corporation to thank for giving the world one of the most aggressive and caterwauling assaults ever foisted on a movie audience. After Moritsugu had almost completed filming, Kodak, in their corporate arrogance, discontinued their 16mm colour reversal print stock without notifying a soul. It seemed *Der Elvis* would never be made until Jon found a roundabout way to print it — albeit with a sound loss.

"To compensate for this," Jon recalls, "I did a very aggressive experimental soundmix — boost the treble, everything 'in the red' — by which the sound be-

Land of a Thousand Balconies

Jon Moritsugu (left) and Ken Narasaki in *Terminal USA*.

NEXT PAGE *Two scenes from Der Elvis.*

came a major character in the film."

Sleazy Rider, from 1988 — also twenty-three minutes — was a similarly irreverent toss off of *Easy Rider*. A wild road trip with two scurvy biker chicks predictably degenerates into violence and depravity with a weird fairlytale twist. It was all shot without time, a crew, money or permission, mostly in abandoned buildings in the dangerous ghetto of South Providence, which Jon recalls kept things exciting.

The live footage in *Sleazy Rider* was, as in *Der Elvis*, doped up with found-footage flotsam and jetsam like grainy snatches of porn, video games, unreadable charts, comic effects, etc. And, like *Der Elvis*, it was a battle against technical set-backs, primarily a shitty camera than ran at the wrong speed and threw the live sound, being recorded on a cassette deck, out of synch.

"It was in post-production," says Jon, "that I really had to experiment with the actual film medium to come up with a solution for putting together *Sleazy Rider* in an original and kick-ass way that would transcend the technical glitches and equipment failures."

There was another mechanical fuck-up in 1988 — Jon's right arm got caught and crushed in a conveyor belt at the shipping company where he worked. Extensive surgery and months of physical therapy restored use of his arm, and the settlement money restored his bank account and allowed him to plunge onward with his film-making. To this day the X-rays of his mangled right arm sit in a backlit glass case in his living room, in the same manner that a big Hollywood director might display an Oscar.

His next film, the awesomely primitive grunge-punk *My Degeneration* (1989), about a female rock group that sells out to the meat industry, was originally slated for thirty minutes and stretched out with a practically one-to-one shooting ratio into a feature length seventy minutes. Again, the live footage was leavened with all manner of experimental interludes from negative frames to emulsion scratching to model shots and crude animation. Except for being bitten by a rat, this film remains the most low-tech experience you can have in a movie theatre, and while his two previous shorts were usually screened in galleries and bars, the feature length of *My Degeneration* conditioned people to expect something closer to a "real movie" and this made the final product seem all the more radical. While the film got some good reviews, others weren't prepared for such a thoroughly primitive movie-going experience and introduced him to his first rabidly negative press — and it seems to have somehow energised him. *My Degeneration* remains in many ways his most radical and gutsiest film.

Moritsugu was a fan of the French New Wave and the immediacy of those films, but it was John Waters' damn-the-torpedoes gutbucket approach to moviemaking that exerted the most obvious influence on his first three films, all of which were stylistically very simi-

Journey to the Centre of Camp and Trash

Underground Film-Maker, Jon Moritsugu

lar. They figure today as key contributions to punk cinema and led him, in the late eighties, to be lumped in with the NYC-based Cinema of Transgression who were also showing their films in galleries, bars and any underground dive big enough to set up a projector in. But he never fitted in comfortably with the black leather crowd. The fact that he was a university student, and looks back positively on the experience, should be enough by itself to disqualify him from inclusion into this "movement".

My Degeneration burlesqued the eighties punk scene with the same low tech piss and vinegar that Pink Flamingos burlesqued the trash-hippie scene, but it wasn't 1972 anymore and there was no midnight movie circuit to give life to a feral child like this — although amazingly it was selected that year for both the Sundance and Toronto Film Festivals — both bastions of mainstream status quo film ideology. My Degeneration will hang forever like a skeleton in their closets.

Hippy Porn was his next film, made in 1991 with Jacques Boyreau, a pal from Brown. Both filmmakers were then in the process of moving out to San Francisco where the film would have its first shows.

Hippy Porn was a take-off on French New Wave classics like Breathless, but instead of boho Parisian knockabouts, the film focuses in unrelenting cinéma-vérité fashion on the petty intrigues, angst, philosophising and squabblings of a small circle of art school students. The film was a departure for Moritsugu who eschewed the mixed-media effects this time and shared control of the material, and yet it's clearly stamped with his fondness for the French New Wave and his conviction that teen life was as much about boredom and nothingness as it was about kicks. And while it succeeded uncannily at what it attempted, its exhausting length, wilfully superficial subject matter, obnoxious male lead — whom even the filmmakers were ready to kill — and wholly misleading title all combined to jinx it with the public, although it did get relatively substantial exposure and distribution in France.

Right on the heels of his biggest flop, Moritsugu got his biggest break. In 1993 he was one of twenty independent film-makers offered $9000 by the Independent Television Service (ITVS) to submit a script for a series on "American TV Families" that they were preparing to produce and air. He could hardly decline.

His script, along with a submission by Todd Haynes, was among the seven chosen to be produced on budgets of $365,000 per film. He went directly from his minimum wage job as a record shop clerk to spending $80,000 the first week to set up his own corporation and get the machinery moving.

The fifty-five minute Terminal USA was the result — a comically depraved family soap-opera replete with traditional fifties suburban sitcom dynamics but with superficialities swapped for real problems, and caucasian characters for oriental. ITVS wanted something ironic but not necessarily extreme, and the selection committee that had approved his script freaked out when they saw the finished film.

Many TV stations refused to broadcast it, but many of those who got to see it on air or later at a spat of festival screenings or on the European film club circuit proclaim it Moritsugu's masterpiece. It was clearly his most sophisticated, and accessible — if unavailable — piece of film-making to date. Terminal USA showed Moritsugu could use glossy production values to advantage, could spin a straightforward narrative, and could act himself, portraying as he did both "good son" Marvin and "bad son" Kazumi in a classic twin role. His wife, Amy Davis, who has had a lead role in every film since, submitted a excellent deadpan performance as Eight Ball, Kazumi's blasé fashion damaged girlfriend.

Critics raved too, almost in unison, but the film didn't really help Moritsugu's "career" and it shattered

Land of a Thousand Balconies

his youthful idealism into the bargain, souring him on any attempt to work in "big time" film production again. "I had a budget twenty-five times larger than my previous projects but sadly this didn't translate into a film twenty-five times better," he recently recalled, "it just meant twenty-five times more bullshit to deal with… I was used to making films for $10,000. I always thought it would be a good and equal thing to work with people I was paying, but it was a terrible situation. I was boss over fifty people, some of them twenty years younger than me, and I knew they wanted to tell me to fuck off but they wouldn't because they were afraid to lose their jobs."

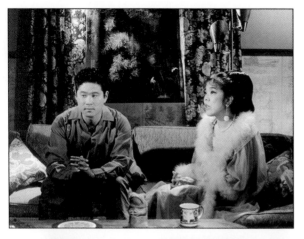

TOP *Terminal USA*
ABOVE *My Degeneration*

It also resulted in a fair amount of negative fallout from the Asian-American community who were unreceptive, in Jon's opinion, to anything but a standard Asian film about the struggles of their ancestors in a new land — the type of thing he found deathly dull. Considering the cocktail of incest, homosexuality, patricide, drug abuse, promiscuity and violence he had served up, he might have foreseen their objections, but he appears genuinely surprised by attacks on what he considers a "pro-Asian" and "forward looking" film. "You don't see Asian Americans on tv. I see this as a *first*, a very Americanised Asian-American family… you never see that on tv which is really disconcerting… As usual, it freaked out the squares, but I did get a lot of support from cool Asians." In a bizarre turn of events, the film was almost selected by North West Airlines to show to passengers in flight — until a North West exec higher up the chain of decision making nixed the idea. The fear was it wouldn't go down so well on flights to Asian countries(!)

Following this unpleasant experience with the film "industry", Jon made *Mod Fuck Explosion* the next year almost as an act of therapy. In another tale of teen lust, boredom and angst, he indulged now familiar obsessions for meat, high speed, and exaggerated gore via dream sequences and *non sequiturs* that entertained but tended to fracture the narrative flow. Meat, in particular, was a key obsession of his that had figured prominently ever since *Der Elvis*, when he had wrapped up press invitations to his very first screening at NYC's The Gas Station in 1987 in strips of raw bacon. "I think meat is the perfect metaphor for our post capitalist, commodified western economic paradigm," he recently responded to the inevitable query about what all the meat means, "… plus it looks cool, feels neat, and tastes great medium rare!"

Mod Fuck Explosion had a polarising effect on viewers. It won best feature film at the New York Underground Film Festival, had hit runs in several American cities and today generally outdraws his other films, partly perhaps because of its great title. It has occasionally been programmed as a "mod" film, on several occasions alongside *Quadrophenia*. When the film drew crowds of mods at the Vancouver Film Festival, Jon took the microphone: "Thank you all for coming, and to all you mods out there, this film has absolutely nothing to do with you." A disgruntled mod later wrote him a nasty letter threatening to track him down and drive his 1964 Lambretta scooter up his ass if he ever set foot in Vancouver again. The Asian group that gave him a $5000 grant for *Mod Fuck Explosion* and expected some kind of "Asian Film" was no doubt also confused.

Journey to the Centre of Camp and Trash

Underground Film-Maker, Jon Moritsugu

In Europe it opened at the 1995 Berlin Film Festival in a huge theatre where the reception bordered on mass hysteria. This unveiling helped to spin off the film as a hit on the German film klub circuit, where it continues to draw. However a lot of people who like other Moritsugu films don't care for this one; some think it lacks the raw, retarded charm of his early films and that the convoluted structure and deadpan acting tends to undercut dramatic tension and make it aimless, which it seems fully intended to be.

Moritsugu's next film, *Fame Whore*, from 1997, is a three part narrative on the absurdities of fame culture in America, and he drew on much of the same local crew and acting talent that he has used ever since his move to San Francisco. Though replete with some characteristic Moritsugu touches, *Fame Whore* stands as his most orthodoxly structured feature film to date and seemed the likeliest candidate to cross over to "above ground" success. But it didn't, despite a smash run in Los Angeles where it garnered good press and a five week hold over at a "legit" theatre.

Although very popular with some audiences, *Fame Whore* didn't make the splash on the festival circuit that could have propelled it to wider exposure, and it did receive some poor reviews from critics who might have been expected to like it. For whatever reason, it didn't generate the expected buzz, and wasn't the breakthrough it could have been, considering its more accessible subject matter and structure and some truly excellent acting.

Jon believes this is due to the fact that the film is markedly different from his other work. "They want you to make the same film over and over again ten times — I refuse to do this." While he could easily make a splash every year on the Underground festival circuit with yet another perverse, fucked-up and provocative film, it must be getting a bit predictable for him. The trouble with *Fame Whore* was, as an industry insider might put it, that it fell into the cracks between the underground and independent market segments and didn't connect solidly in a big way with either audience. But maybe that's because in the tightly controlled world of commercial film exhibition, where a lone self-distributor has no pull at all, it just didn't get the chance.

While Moritsugu has more than his share of moxie about movie promotion and is willing to play the necessary games to give his movies life, he still stuffs his press kits full of the bad as well as the good reviews, still makes 16mm films and edits them by hand on an "old fashioned" flatbed, and only recently broke down and got a fax. And he still self-distributes his films. Considering that many theatres are phasing out their 16mm operations, and those that still show 16mm sometimes charge the film-maker $1000 just to install a projector, it's tough work. And he still finds it absurd when people try to tell him he has a "career".

Moritsugu has reached an interesting juncture today. Despite the fact he is still at heart — and stills defines himself as — an underground film-maker whose work still exults in an unhinged low-budget *joie de vivre*, he appears well "positioned" to cross-over and make an impact in the world of independent commercial feature films.

But can this Christian survive in the den of $20 million dollar lions unleashed by the likes of Miramax and Fineline, who gobble up screen and ad space? Could he ever stand to be caged in the same cocktail lounges with the scenesters, hipsters and industry types he finds so unpleasant?

Maybe he can do all that, and maybe someday he'll have a film playing down at your local megaplex, but it doesn't happen every day. The last film-maker to pull himself up from the underground by his own bootstraps — rather than floating up on a cloud of puffed hype — was a guy named Waters.

Yet regardless of whether a breakthrough ever materialises, Moritsugu's achievements have thus far been significant and unique: he has demonstrated that commercial feature film-making can still display spirit and spontaneity, and that "low-budget" can be a positive, not negative, term — a term of liberation, not limitation.

At least he doesn't get chased out of Cadillac dealerships anymore. And if he ever hits "the big time", maybe he should send a residual check to that female Elvis impersonator who sixteen years ago almost sacrificed her tongue for art... or something.

Postscript

Jon's latest picture, entitled *Scumrock*, premiered at the 2002 Chicago Underground Film Festival. As of writing it is making the rounds at festivals in North America and Europe. Producer Andrea Sperling, who has been on board since *Terminal USA*, put the financing together for this way-out take on the West Coast rock'n'roll scene.

PERSONAL ENCOUNTERS FROM THE PORTABLE WORLD

An Introduction

The following stories originate from my own personal experiences over the last fifteen years as an inhabitant of the outermost fringes of the film world. I travelled in circles that were as far from the moneyed prestige of the "movie business" as one could get, as remote from the cosmopolitan glamour of the festival circuit as possible. I was light years from a paid plane ticket, a million miles away from a steady job.

During this period, as I moved from Boston to San Francisco to Denmark, I stayed active in the various local film scenes and came in contact with other like-minded individuals in America and Europe: film-collectors, film-makers, struggling movie theatre owners with rat problems, jobless bookers driving junk cars, showmen, purists, delusionals and other denizens of the portable 16mm shadow world. These were people who had ideas, grand plans and schemes that I often got sucked into or viewed from the vantage point of a ringside seat. At other times I involved them in my capers.

These things were not intended to last. These happenings, particularly those that transpired in America, were temporary and illegitimate by nature, creatures of the moment that existed outside the boundaries of institutionalised, subsidised film culture. In Europe, as I discovered and will relate, odd ideas *could* get funding sometimes, but in any case, behind every show, every event, every off-the-wall idea is an individual nut case, genius or visionary, and that's usually where the story lies. The term "renegade" pops up perhaps too frequently in these pages but there's no way around it because that's what it is all about. Suffice it to say, the world of movies can be more than just going to the mall or The Museum of Modern Art.

There was, on occasion, some amount of duress and mortification attached to these experiences, but it was always, if not a good time, at least a strange time. Oddly enough, the shows that went wrong are the most fondly recalled. But I wouldn't have had it any other way. I get the feeling, for example, that it was a hell of a lot more interesting/fun/strange to sit on the jury of the Freak Zone Festival (which ran for two years in Lille, France before being run out of town on a rail) than to sit on the jury at Cannes — a job that John Waters once said made him feel like Henry Cabot Lodge.

Some of these stories were solicited by and published as regular columns in the Dutch zine, *Shocking News*. For this I was paid in Mexican dinners whenever I got down to Amsterdam, which was exactly twice over the three year span of my involvement with the publication. I think I've still got one coming...

BOSTON (IN TWO PARTS)

1 THROUGH A REAR WINDOW DARKLY

Boston was always a great film town. Through to the late eighties it had repertory theatres, art-houses and grind houses, and it had up to five theatres down in Chinatown serving up the chop-socky. It had shop front joints like the Off The Wall, specialist bookers like George Monsour and innumerable university film societies.

And then there was Rear Window.

This was a portable 16mm attack squad led by a film teacher and ex-sailor named David Klieler. It had no store front, no home, no funding… it had nothing except a couple of B&H projectors, a fold-up screen, a rubber stamp and a print of *Scorpio Rising* (an extra, sent by mistake, never returned and played *often*).

What it did have in excess was David's boundless energy, his contacts and his knack for original and bizarro programming that cut a swath through art, exploitation and underground cinema. And, at that time it had an audience, one which today has probably been diminished by video and DVD. Over the years — for the better part of a decade — Rear Window perservered, contributing immeasurably to the Boston film scene and staking out territory upon which no one else feared or bothered to tread.

David would show films anywhere he didn't have to pay rent, but this *modus operandi* wasn't just born out of economic necessity, for he understood the great twist that the weird little joints and intimate audiences could give a movie. Through the years he ran screenings in a mind-boggling array of venues that ran the range from health food restaurants, punk lofts and dance studios to dive bars, a back room in a food co-op, a ceramics workshop, church basements, bookshop hallways and even, God forbid, real theatres.

I remember it actually took me months to pin down the elusive Rear Window. I would see a notice in the paper that some great film was playing and then show up at the place, see no projector, no screen, no crowd and think to myself that no, this couldn't possibly be it, and leave. But this was it. It was just easy to miss the beat because they so often came in and set up late, and sometimes the shows were held in a hidden back room. Sometimes it was like waiting for Godot: a few strangers sitting in folding chairs in some strange back room waiting for something to happen. But once I caught the rhythm of Rear Window, I was hooked. A favourite experience was seeing *Last Year at Marienbad* in an overheated ceramics workshop cluttered with amateur sculptures, the air thick with clay dust. And being pretty much alone after most of the audience had walked out. An absurd setting in which to watch a surreal film.

David himself rarely stayed for an entire show, usually rushing in late to check on things, downing a martini or two if the show happened to be in a bar, and dashing out again to where nobody knew. He made the schedules and booked the films and otherwise largely relied on a couple of loyal, barely-paid projectionists, Dema and Phil, to run the projectors. Students and interns were thrown into the breech in other capacities.

Phil Kelly, a quite-spoken refugee from Missouri, was David's main projectionist for years. Being responsible for running shows and dealing with David's manic mood swings and the often scattershot logistics

Land of a Thousand Balconies

eventually took a toll on his psyche. And sometimes the operation was simply the victim of circumstance, albeit the kind of circumstances it seemed to invite. At a lesbian health food café in Cambridge, for example, where David had booked some violent splatter movie with horrid miscalculation, Phil was eventually forced to shut off the projector because it made the eggplant hummus catch in throats of some of the diners. He then had to mount the stage and explain to the half-bewildered, half-nauseated audience how the movie ended. During a packed screening of *Faster, Pussycat! Kill! Kill!* in the Allston food co-op back room, the projector suddenly broke down. Phil was unable to give refunds to the angry audience because David had already arrived, picked up the cash and split. Being a Rear Window projectionist was a little bit like being a tow truck driver fitting cars with Denver boots: you were constantly forced to explain the inexplicable to crowds of angry people. A mob of real bikers once got mean at a screening of *Wild Angels* at Chet's, a sleazy North Station bar, and threatened to crack some heads when the show started late.

It was after that show that I started collaborating with Rear Window and went in on their Chet's operation. I immediately grabbed Phil as my permanent projectionist after a bad experience with Dema. The projector was always stationed right on the bar, propped up on a couple of beer boxes, and at one show the big D had let heaps of film coil off the too-small take-up reel and into the muck of the floor below, while he sat in a booth across the room engaged in some deep conversation with an old girlfriend.

The dire Rear Window dramas that played out over the years could fill a book, a text book on aberrant psychology. Phil himself reached the breaking point in 1988. David was on an exchange program in Holland for a couple of months, teaching and living in some castle. He'd booked the schedule in advance and left Phil to run it. But things got bumpy: going to pick up films that hadn't arrived, equipment snafus, having to get inside buildings without keys (by crawling through windows) to run shows for audiences of two people, etc. Finally the normally easygoing projectionist snapped, and outside a show in Brookline started smashing up his own car. A transcendent moment in Rear Window mythology.

At that instant the nature of what Rear Window was became crystal clear to me. It wasn't a service or an organisation or a club in any normal sense. Despite the fact it had staged years of great shows, it also wasn't in any sense "real". It was an obsession, a phantom, a state of mind. The mind of David Klieler. It was a crease in his brain, a figment of his imagination, and

Last Year at Marienbad

only shock therapy could destroy it or a bullet fired at close range by an enraged film distributor who had waited forever to get paid. And it couldn't be run from Europe, animated by mental telepathy. Without David's manic energy on the scene simultaneously making things both better *and* worse, the ever looming cloud of chaos moved in too quickly and shut down the operation. Even battle-tested veterans like Phil buckled.

With David directly involved, things merely malfunctioned. Without him, people actually started going insane.

Of course that's not being totally fair; a lot of shows went smoothly. Phil recalled one gig that ran like a charm, strange as it was: a movie marathon he projected at some sort of dungeons-and-dragons type convention with everybody walking around costumed like weird Godzillas. And for a while there David was doing a steady gig in a tavern out on Cape Cod. There were other places too, other experiences, episodes, catastrophes as well as sublime successes... One thousand and one night's worth of great films and strange atmosphere. A last gasp, so to speak, of the kind of culture of portable 16mm exhibition that flourished from the sixties into the eighties.

In 1989, David began organising a grassroots campaign to save Boston's last grand repertory theatre, The Coolidge Corner. It was a long shot, and the

good fight took most of his time and eventually succeeded, but it forced Rear Window into semi-retirement.

He became the theatre's programmer, and suddenly found himself in a whole new world of "major market" openings, box-office grosses tracked in Variety, and film festival hobnobbing. The manic energy and mood swings that had propelled Rear Window into outer orbit served him well in this very different if equally exhausting milieu, and for the six or seven years he held this position, he did a top job (although he was still too nerved up to ever watch an entire press screening). But despite his post as a chief booker in one of America's major film markets, he missed Rear Window and periodically threatened to revive it.

After that, if I'm not mistaken, he went on to found the Boston Underground Film Festival.

I'm sure that as long as one battered projector still works, Rear Window is out there somewhere, still alive. Nonetheless, we can say with fair certainty that an era has quietly passed. And those countless Boston film freaks, cineastes and motley unclassifiables, who for almost a decade were treated to a movable feast of film, are the less off for it.

2 THE LOST PICTURE SHOW AT CHET'S LAST CALL

My own involvement with Rear Window began, as noted, after that screening of Wild Angels at Chet's Last Call. I thought it was great: real Hell's Angels threatening to beat up the projectionist. This was excitement. I was ready to book shows, make flyers and lose lots of my own money into the bargain.

The place I had fallen in love with, Chet's, was a beat-up bar room located upstairs over The Penalty Box Lounge. The old causeway street El Tracks ran right next to the place, and on hot nights when the side door was open in a futile attempt to cool the room, you could see and hear the trains rattle past. Beyond the tracks was the old Boston Garden sports arena. At that time the neighbourhood was still vintage inner-city sleaze, with the XXX Pussycat theatre next door and various squalid old sports bars hidden away down dark alleys. Chet's itself had once been a shabby working-class disco. The disco ball was still up and sometimes cast a distracting light on the movie screen. There was no sign outside, you just had to know where the place was, up that long dark staircase. The arch obscurity of Chet's added to the atmosphere in my estimation, and the tacky, intimate feel of the joint was perfect for the kind of sleazy film spectaculars I wanted to pull off, with an accent on trash, gore and porn. And I loved the fact I could combine films and live bands. Chet, a short, pudgy man with a mass of curly hair, didn't care what I did. As long as I attracted a beer-drinking crowd, I could have staged live executions for all it mattered to him.

On November 18, 1986, I launched the Chet's series (dubbed the "Straight To Hell Film Festival") with Freaks and two short films, John Waters' The Diane Linkletter Story and The Karen Carpenter Story, a Super-8 film by a local guy (and not the Todd Haynes film). Live bands that night were The Queers and The Piranha Brothers. The place was packed. We gave out free door prizes and kept up that tradition throughout the Chet's era. At one show we gave out packages of condoms and edible panties I bought down in the Combat Zone and mailed to John Waters to sign. Other more lethal treats included a pair of gold buckle, white patent leather shoes and a Dean Martin song

book, objects I tossed into the crowd in the direction of the first person who attempted to answer the quiz question. Occasionally the door prizes would be lying in the trash on the floor at the end of the night, and I would pick them up to give them away at another show. I must have given that pair of shoes away ten times.

I got a lot of bands who were then prominent in the Boston rock scene to play these film nights. Evan Dando sat in with Julia Hatfield and The Blake Babies for "Drug Night" when we showed The Trip. Other bands

Land of a Thousand Balconies

that participated in these shows included Big Dipper, Cheater Slicks, The Gorehounds, Moving Targets and A Scanner Darkly. And the rockabilly quartet, The Boogeymen. They were booked to play "Rock'n'roll Night", but when *The Girl Can't Help It* didn't arrive and had to be replaced by *Gimme Shelter*, they almost walked out in disgust.

But The Queers were my house band. They played every other show. They were our favourite band and they were also the only band that would show up at two hour's notice.

I returned the favour by staging a benefit for them at the bar. They had cut a record but couldn't get the studio to move on it until they paid off some back debts. "Win A Dream Date With The Queers!"... "Get Behind The Queers Before They Get Behind You"... and "Help Get The Queers Out Of The Poorhouse And Back Into The Schoolyards (and Recording Studios) Where They Belong!" screamed the tag lines on the posters. Joe Queer was a short-order cook up in Portland, Maine, and the night before he had gotten his hands on a genuine fringe leather jacket. Apparently he had lifted it off the restaurant's coat rack. Anyway, he brought that along and we gave it away as the grand prize to a proud winner. Another great moment!

Paying rent on the films that David booked for me and giving Phil some money for running the projector, not to mention paying two rock bands, pretty much always guaranteed that I lost substantial amounts of money. To beat the costs of renting films, I began to borrow short films for free from Boston's Prevention Centre. This was a social services agency that loaned out anti-drug, anti-drinking and sex educational movies for free to non-profit civic organisations and church groups. I would dress up nice and go down on my lunch hour from my mail clerk job to borrow them, posing as some kind of local public-spirited activist, some kind of moral majority vigilante wanting to clean up all the bad behaviour in town. It was a plausible scam since America is full of these fuckers, but in fact they never really gave a shit *why* I wanted the films. Ironically when I showed these anti-drug and anti-drunk driving scare films at Chet's and looked around and saw the dopers and boozers lined up in a row at the bar starring at the screen with glassy-eyed absorption... so what if hardly any paying customers had come that night? I knew the films had found their audience.

Some movies worked better than others in this carnival atmosphere. At a screening of Roman Polanski's moodily atmospheric psycho-masterpiece, *Repulsion*, we had a genuine psychotic in the otherwise rapt and reverential audience. His sporadic, incoherent outbursts prompted Chet to threaten to forthwith kick his lousy ass out the door. This was the one and only time I ever heard Chet attempt to make someone behave. It turns out he was a rabid Catherine Deneuve fan. *If....*, starring Malcolm McDowell, was another mistake, a great film but a stunningly bad choice to show in a sleazy bar. Any film with a lot of quiet, introspective moments was a no-go.

We brought back *Wild Angels* for "Biker Night" and drew a full house. This was Chet's at its best; a liquored-up mob of local hoods, punks, new wave art fags, Chet's circle of sub-Mafioso cronies, bikers, the scum of Boston's trash-rock scene and people with absolutely no interest whatsoever in the movies ducking in and out to buy drugs from the most carelessly unconcealed operation in the city. Some local musclebound tough, drunk and boastfully swaggering, was threatening to beat us all up at one point until he swivelled with a menacing flourish at the top of the staircase and... disappeared. I glanced out the door-

way — he was tumbling down the long stairway. It was horrible, he should have broken every bone in his body but he just got up and staggered off into the Penalty Box Lounge to cause more trouble. Chet's had that kind of magic about it. (Many people had fallen down that staircase!) At the height of the chaos that night, I was called to the pay phone. It was so loud I had to shout into the receiver… it was Chet. He had gone down to the storage room to borrow some cases of beer from The Penalty Box Lounge and had accidentally locked himself in and needed a rescue.

The place was an ungodly sweat box in hot weather. What I ballyhooed as "The Sleaziest Show On Earth" (a director's cut of *Last House On The Left* presented in person by film-maker, Roy Frumkes) fizzled in the June 28 heat, so I slapped "held over by popular demand!" stickers on the flyers, ran it again next week and did even worse.

I once happened to be in Chet's, just drinking, and their pay phone rang. It was for me… LA calling! Some executive from A&M Records had gotten his hands on a flyer for our very first show where we'd screened *The Karen Carpenter Story*. In his own smarmy, transparent way, he was trying to get info on the film so he could sue our asses for music copyright infringement, The Carpenters being signed to their company. I gave the phone to Chet, who, presiding over a pizza and a plate of clams at the bar where he usually held court, promptly hung up on the guy. A&M Records was dead serious, though, and soon after that they sued the Todd Haynes film by the same name out of existence. But calling Chet's? He didn't know who he was dealing with!

It all ended abruptly on New Year's Eve, 1987, when the owner of the building (Chet's uncle) blockaded the stairway with a garbage can and padlocked the door to Chet's. An ignominious but not completely unexpected demise foreshadowed by, among other things, a recent police raid on one of my film nights — not for drugs but because Chet never even had a liquor license. As we discovered that night, Chet's had *never* been a legal tavern. This whole cultural phenomenon called Chet's was just him and bartender buddy, Dave, buying cases of Bud at the liquor store around the corner and carrying them upstairs, or more often than not, getting the customers to carry them upstairs… up to what was essentially an abandoned loft space, up to a bar that was never stocked in any orthodox sense.

I should have known the end was near when Chet offered me the club seven nights a week for my film shows instead of just one.

After the demise of the bar, Chet cleaned up and became a drug counsellor and started using his full Italian real name. The Queers finally got their album out… I think Joe Queer is still at it. I found another space to show films, in a big upstairs hallway of a derelict building over in Allston. One of the rooms off the hallway housed the Primal Plunge bookstore which sponsored the shows. This space was immortalised in the movie, *Hated: G G Allin & The Murder Junkies*. If anyone remembers the b&w video sequence where G G Allin lights a newspaper on fire and drags a girl up to the front by her hair — that was the space I pioneered! (Talk about pathetic name-dropping.)

There were some great nights there too. I remember one show only drew a single customer. The book shop owner was in a bad mood that night and got into a fight with the guy and ended up throwing him down the stairs… He threw our only customer down the stairs.

GUERRILLA CINEMA IN SAN FRANCISCO

I had been living in San Francisco and doing film shows around town for about a year when one day I got a telephone call from a guy named Jacques Boyreau. He was organising some kind of film/music thing and invited me to come down to his squalid Mission District flat and check it out.

That evening I sat in on their rehearsal and witnessed this boho-punko orchestra cranking out the musical score they'd composed to passages of *Night of the Living Dead*. Jacques darted about loading projectors and trying to choreograph the whole shebang — not easy since he was also in the midst of moving and the place was cluttered with boxes and debris, in addition to all the various bizarre types of instruments laying about. He knew about my film shows, and that night I was drafted as guerrilla projectionist into his army of shock troops and cultural 4–Fs.

Two weeks later this one-time-only show took place in the Lower Haight, at The Peacock Cocktail Lounge (see: A SECRET HISTORY OF CULT MOVIES, p.54).

Everything fell together that night and fell apart the next day as it should. It had all worked, somehow, however impossible it was to say how or why. Yet despite the massive amounts of time and effort spent on the project, no one made a dime!

That show began a period of collaboration between myself and young Jacques, a refugee from the Chicago area who was fleeing the damage of an Ivy League education. Now in San Francisco, living with his collaborator and girlfriend (at the time), Liz, he began immersing himself in the junk flotsam of old movies and archaic film equipment. He scoured junk shops and trash bins and bought old films at flea markets and from collectors like the notorious "East Bay Joe". Sixteen millimetre film was the raw material, the nutrient medium that gave life to new projects or happenings, and everything else took a back seat to the growing mass of celluloid and junk machinery that spilled out of every closet and drawer. Jacques' specialty was a boundless energy and a talent for drawing others into the whirlpool of his creative visions — visions which could only take shape in the fog of confusion that his management style encouraged.

And the press in San Francisco was good to us, just like it's good to a lot of SF's refugees.

We got big coverage for our "Peter Fonda Pagan Worship Orgy" which was held at the packed Garage on Tenth St in SOMA. Here we simultaneously projected four Peter Fonda Films (Peter Fonda being his current obsession); *Tammy And The Doctor*, *Race With The Devil*, *The Trip* and *Wild Angels*. (I knew Jacques was completely nuts when he actually hunted down and bought a 16mm print of *Tammy And The Doctor*.) Live bands like Crawl, The Zip Code Rapists and Star Pimp played original Fonda-worship trash dirges they'd penned for the show (later released on record), and again, live performances sputtered to life down in the pit at odd intervals, leaving nobody any the wiser. (Jacques had run everybody through a final rehearsal out front on the sidewalk before the show. He handled that end of it and I kept the drunks away from the projectors and ran the films, *Chelsea Girls* fashion.

I continued around town with my own puritanically film-only shows at dingy Mission bars like the Club Chameleon and punk collectives like Epicentre, while Jacques traded in a witches' brew of multi-media chaos

of which he was usually the most visible victim.

My favourite collaboration with him was at the Club Kommotion where we double-projected *The Green Slime* ("the poor man's 2001") with the Presley vehicle, *Viva Las Vegas*. "Together at last!" ballyhooed the flyers in a blast of shameless hype, "See it! Feel it! Believe it!" The two films playing together side by side up on the screen produced an hallucinogenic chemistry no gypsy fortune teller could ever have predicted. It was thrilling. And it was good, and it was dubbed "Simulvision". Following that we screened the 1970 drug drama, *The People Next Door*, and then the legendary San Francisco non-band, Purple Oblivion, took the stage for a once-in-a-decade performance and played cover versions from the film's rock/schlock soundtrack. At the end of the night Jacques handed me a couple hundred bucks. Nobody had expected that the show would make a dime, but it had made tons of money and now he was walking around looking for people to give it to.

We did a particularly rude multi-projection show on the eve of St Valentine's Day at a store-front space on Twenty-fourth St called "Ocho Loco". I printed up stacks of small flyers and Jacques tramped around the Mission for two days giving them to people, since we reckoned this porno explosion could never be advertised in the papers. It rained almost continually both days as he hit the mean streets and coffee houses, slapping down soaked flyers in front of tight-assed politically correct types and bull dyke lesbians who fixed him with killer stares. We had eight projectors running for that show, beaming out a kaleidoscope of ancient porno flicks to a diehard crowd of about forty people who had to crouch in a tight huddle in the centre of the room to stay

Land of a Thousand Balconies

out of the way of the various projector beams. It was beautiful to see. This was making the audience truly a part of the show.

Another extravaganza was called "Japanese Monster Orgy Rumble". This was held at the large DNA Club where we double-projected episodes of *Ultraman* and the feature classics, *Destroy All Monsters* and *War Of The Gargantuas* as hideous electronic noise band, The Steeple Snakes, improvised with terrifying blasts of pure audio pain while the big monsters rumbled.

Once we took our projectors back to the Garage on Tenth St to find that we weren't on the bill that night. There was some mix up. We set them up anyway and showed films over an unsuspecting and very heavy and very serious Japanese industrial noise band. It was Jacques' usual repertoire of time-lapse flower photography, emergency birth delivery and an oddball item showing a line-up of buck naked guys bouncing into a swimming pool on beach balls. Some of it worked perfectly with the band's sound, but other bits were hilariously mismatched to the gloomy, lead-heavy mood of the music.

The last show I did with Jacques was in the summer of 1993; another *Night of the Living Dead* theme show. The film was an ongoing obsession of his. We ran all three spools of the film simultaneously on three big screens while live bands flailed away down front. Somehow it wasn't working. Then the guitar player for the Zip Code Rapists yanked down one of the screens in a fit a punk nastiness, in turn prompting the projectionist to shine the projector beam into the face of the offending asshole. When this seemed to have no effect, he turned the projector sideways at a sharp angle onto the surviving screen, and the resultant shadowy, dream-like superimpositions were magical.

Jacques did a number of shows without me as well (though usually with my projectors), invariably screening certain "plums" from his collection. The memory of one film in particular survives the years — it was a clinical and ghastly display of physically handicapped inmates on the grounds of a hospital from the 1930s. He also had a favourite medical training film that took viewers on a trip through all the cavities and orifices of the human body, and on more than one occasion he confronted confused club goers with an unplanned trip through the large intestine.

There were others like us in town doing shows, mixing mediums, using multiple projection, folks like Craig Baldwin and the notorious "Church", and plenty of others. Sixteen millimetre lived. It was alive in the thrift shops and the garbage dumpsters, and in the profusion of the city's live-in club spaces, collectives and coffee shops with their big back rooms, most of

which, along with just about every bar in town, were open to doing film shows. Even laundromats were doing shows. And the press would write about anybody who had the initiative to drag a 16mm projector into some sleazy Mission bar on a Wednesday night… and ninety people would jam into the place. No other city was ever this supportive or open minded.

Jacques eventually turned heretic, started a record label and sold a lot of his films. I hear he's making a movie now. I left San Francisco and moved to Copenhagen, of all places. My regular shows at the Club Chameleon had levelled off to a steady fifteen paying customers, all of whom I knew personally by now. (Hell, I could have held the shows in my living room, except those were the last fifteen people I'd ever let into my house.) And since they'd all paid every week for so long, they all wanted to get in free so I let 'em.

A mouldy flea-infested curtain had definitely come down on a small but vital part of an uncharted "scene" that never officially existed. But for a while people saw it and felt it even if they could scarcely believe it. We were always going from one show to the next, each one with a more preposterous theme than the one before. And there seemed to be tons of people around, to come to the shows or be a part of them. There was great energy. And every time Jacques moved into a new crummy flat, he had one suitcase of clothes and five of films and projector parts.

Tales from the Cities

Guerilla Cinema In San Francisco

BELOW Flyer for a series of shows entitled "Hollywood Shrapnel" at San Francisco's Victoria Theater. Art by Werepad member "C X".

THE WEREPAD
The Scourge of Time & Space.
Dead End.
Go.

True enough, the vital, independent, live-in art-space scene that flourished in San Francisco in the early nineties and made possible our portable film activities did come to an end. The city closed down most of those spaces by the mid nineties, and soon after that the dot com-ers invaded town and pushed rents sky high, forcing most of the rest of these art, punk and bike messenger collectives to abandon their spaces. The city in 2000 looked a lot different than it had in 1990. But Jacques was to be heard from again, as I discovered on later visits back to San Francisco.

The suitcases of filmic flotsam ended up in 1993 or 1994 in a warehouse loft space at 2430 Third St at the foot of Potrero Hill, by the industrial harbour. Here Jacques and another itinerant film guy, Scott Moffett, who was originally from Shreveport, Louisiana, established the Werepad. They had run into each other in a Kinkos copy shop on Market St, both copying flyers for film shows.

Scott had his own shows over at a bar called The Top on Lower Haight St, and was also involved with a posse of CCAC art school drop-outs who had made a 16mm feature film entitled *A Lovely Sort of Death*. I had been to his Top shows, and had had a memorable previous encounter with him when I had done a film show at The Purple Onion club in North Beach. I showed *The Savage Seven*, and only two people showed up — Scott and his girlfriend. He was always immaculately dressed in freshly-pressed linen suits and the like, and the air of calmness and southern gentility that hung around him belied his obsessions with the most bizarre extremes of trash culture. He and Jacques, with his stream-of-consciousness raps and freely improvised body language, made for a odd couple, but with the Werepad they had found a home. A cinema to live in. Not a permanent space, but rather a stable transitory space.

The place consisted of a main hall that would be used as a party space, a sound studio, a storage area, a cinema and a giant receptacle for the tangible and psychic debris they would drag back to the place. For the Werepad film screenings, they transformed it into a cross between a sixties style cocktail lounge and a light show, the walls and fixed white screens displaying interstellar projections and random hypnotic spirals of color. The diffuse sixties/seventies mash-decor was described once as "Pink Floyd meets Barbarella" and a "chill palace exploding with cosmic-psychedelic *objet d'art*." Viewers sat on overstuffed couches and lounge furniture. Image and sound quality was top

Land of a Thousand Balconies

A typical night at The Werepad.

rate. Scott mixed the martinis and projected the films while Jacques paced nervously, dragging furniture around, etc.

Up along the right side of the hall and to the back, on the second floor level, were living areas and a bathroom, and directly below these, attached to the main auditorium, were smaller rooms: a lounge style bar, kitchen, projection booth, and to the rear another living space and a room with a film editing table. In this vicinity also existed the maze of catacombs that housed the Werepad's Cosmix Hex Film Archive. In this back area were various stairways and cul-de-sacs crammed with movie paper, projectors, film editing mechanisms, screens and other audio visual apparatus that Scott had collected from his various jobs in cinemas and AV rental supply companies. It wasn't a huge space in total, but particularly in the back reaches it was utterly unnavigable. I actually stayed there for a week in the fall of 2000, sleeping in the editing room on a dusty stunt mattress, and never figured out all the twisty passages. As far as I new it could have been endless.

The film archive (16mm and 35mm) grew over the years to include all manner of outré sci-fi, trash, sexploitation, profound European classics, blaxploitation, film noir, etc. It functioned not only as a print source for their screenings and for their shows at other venues around town, but perhaps most importantly it served as a kind of basic spiritual energy core, a psychic power source that pulsed and glowed and radiated back there in the blackness of the back pit. This celluloid was the raw dream material, a plan for living, the *force*. They were always on the hunt for new icons, new acquisitions. And when they got a new film, they possessed not just a movie, but the power and the myth. The Werepad itself was a temple to this hodgepodge of myths, and the films were a way in.

What exactly the Werepad *is* remains open to debate. It isn't a commune or collective in any formal or political sense. And while Scott and Jacques founded the place and are the only two who have stuck it out to this day, many other people have passed through in various spiritual and physical capacities, be they door

Guerilla Cinema In San Francisco

LEFT Jacques Boyreau and Scott Moffett, at the dawn of The Werepad.

BELOW The pop art wall and dancing chicks of The Werepad. Far right is a screen on which *The Green Slime* is playing.

Werepad iconography, which included everything from poster art to comic books to stencillings on the floors. She created the visage of "Leroy", the confidently smiling black man with the large afro who became something of a Buddha and a logo to Werepadians; a beacon of inspiration that summed up where their heads were at in the early period when they were shooting the movie *In*, their "whitesploitation" picture.

Actions committed in the name of the Werepad over the years almost defy categorisation. As film exhibitors, they staged numerous improvisations on the theme of Simulvision, frequently showing two or three films side by side. They even cooked up a definition which appears on the back of one of their programs: "Simulvision, the collision of two or more projectors, the characteristics of narrative psychedelically adulterated, an overwhelming demand upon the viewer's integration skills, a joyride to test one's sensibilities to oblige two contradictory entities at exactly the same time."

Sometimes they take their films on the road. They've done shows at The Andy Warhol Museum in Pittsburgh, among other places.

They put their all into the making of four films: *In*,

men, ticket takers, residents, actors in the films or just some speed freak showing up at two in the morning to paint some weird stage prop.

But in the beginning there were four, the other two being Denise Dolan and Aaron Bass, one of Scott's old crew. Denise couldn't take living in the cold and damp and quit off the bat. Aaron, as Jacques remembers him today, "was a bone collector and acolyte of filth, speed and the avant garde. His drawings were scratchy portraits of his claw, skull and rot piles. Good stuff. But he was a lying alcoholic and we had to kick his ass out and hold his motorcycle hostage until his hippie mom from Bolinas paid his back rent." Others contributed in various ways to the whole amorphous entity that was the Werepad. Vikki Vaden brought cyberspace to the place, and Cornelia Jensen, a superb illustrator, was responsible for much of the early

Planet Manson, *I Do, I Die* and *Candy Von Dewd*. And they have a record label. They have a theremin too, and for a while they were doing something around town called "Rock'n'roll theremin". They have frequent parties, particularly Halloween parties, and sometimes they rent out their space to other groups which helps their fragile economy.

The Werepad has survived, or rather the two Werepadian founders have survived. Survived the occasional psycho-dramas that come with living in something that is (or isn't) a collective, survived the beer-soaked wreckage of a thousand Sunday morning crash and burns… and, neither having cars, they have survived years of long lonely rides on the number twenty-two bus, which ends near the place and is practically the only way to get there. They have survived making movies that drained them financially, movies shown to critics who didn't always embrace or understand them.

They have survived the damp and cold of the place, the tidal wave of high rents that drove similar spaces out of existence at the end of the nineties, and the fire that burned down the Sanford and Son junk shop next door.

I felt the vibes of the place that week I slept back there in the editing room among strips and coils of film. No natural light ever penetrated that den of filmic flim flam. I felt like I was in the hold of a freighter ship; the impenetrable darkness, the musty air, the sounds of things happening that weren't really happening, creakings, lurchings, voices… A trickle of rain water even managed to get down there. The next morning sunlight flooded through the window panels in the roof, and it was a sobering sight. I came to the conclusion that the Werepad should never be seen in broad daylight.

TOP Scott (left) and Jacques.

LEFT Cover of a comic drawn by C X and written by Jacques. Made at the time of their movie *In*.

FEAR & LOATHING & GOOD HASH & DIRTY LAUNDRY IN EUROPE

In the spring of 1992 I accompanied two American colleagues on a low-budget film tour through Europe, they being Marion Eaton, a woman primarily known as an actress in independent and underground films from the sixties and seventies, (*Taboo, Thundercrack!, Sparkles Tavern* etc) and Mike Kuchar, one of America's more visionary underground filmmakers of same period (*Sins Of The Fleshapoids, Tales Of The Bronx, The Craven Sluck* etc). I, in turn, would be presenting films from my own collection with an accent on bizarre educational items and miscellaneous nuggets of trash. These tours were being organised by the intrepid renegade booker, Johannes Schönherr. After starting our tours with a common appearance in his hometown of Nuremberg, we would go our separate ways through Holland, Germany, Austria and England. As to whether the sixty-year-old Ms Eaton could ride out the physical demands of a low-budget whirlwind tour and manage the task of carrying all her prints as well as luggage, I don't recall that anybody gave it a thought. She seemed game.

On April 1, Marion and I met at 6AM at the San Francisco airport and boarded a flight to Frankfurt, change in New York. Playing the role of seasoned traveller, I warned her that if German customs officials

Marion Eaton and George Kuchar in Curt McDowell's *Thundercrack!*

Land of a Thousand Balconies

found the slightest evidence that she intended to earn money over there, she would be in big trouble. I filled her head with so much needless paranoia that she locked herself into the airplane restroom at one point and destroyed various documents before we touched down. It turned out that nobody paid us the slightest bit of attention as we strolled through Frankfurt airport.

We met Johannes and he drove us to Nuremberg in a junk car. We hugged the slow lane as cars hurled past us on the autobahn.

THIS PAGE AND NEXT
Marion Eaton in
Thundercrack!

We joined Mike there in Nuremberg, all three of us ensconced in a cosy little hotel for one week as poorly attended shows took place at a venue called the LGA. A high point was seeing the projectionist passed out dead drunk under the projector on the last night. The three of us got constantly lost walking around Nuremberg. At one point in a fluster I approached several pedestrians and blurted out "excuse me but I don't speak English..." This line became a symbol of the absurdism that dominated the whole experience for all of us. Nightlife consisted of walks over to the LGA building, which had been slated for demolition until it was appropriated for cultural purposes, there to behold hundreds of German youths drinking and talking (and never dancing) in a huge cloud of cigarette smoke.

At the end of the week we went our separate routes; Mike off to Holland where he ran into a train strike, me down to Munich, and Marion on to Berlin where she was met at the Zoo station by a skinny leather-clad punk holding a rose.

The weather in Berlin was cold, rainy, bleak. She was to stay in an East Berlin squatter flat, and that evening was introduced to her fellow residents all gathered in the ruined kitchen... "Fuck you!" blurted out one savage looking possible addict. Marion locked her door that night, thinking she could possibly be murdered, only to discover the next day that all the keys opened all the doors. I later stayed in the same flat. It was being rebuilt and it didn't have any floors.

She took a lot of long walks in Berlin, every day to and from the cinema with said punk and punk's baby. They could have taken the subway but due to punk's refusal to buy a ticket on moral grounds, and Marion's resultant fear of being collared by transit cops as assumed accomplice of said punk — whose appearance she deemed to be an open hassle invitation to coppers — she pretended to like taking ghastly long walks.

After Berlin she went to Copenhagen for some sightseeing. Johannes had arranged for her to stay with Sven Thomson, who for many years ran the Off Off cinema (see: EUROPE IN THE RAW). Sven was a gracious host for just about every underground film-maker who passed through the city in the nineties. And the Off Off was easy to get too, you just went out the main train station's back door onto notorious Istedgade... cut to Marion walking down that frightful junkie-porno street at night, left to the mercy of Johannes' illegible handwriting as the darkness of night fell, she trying to figure out directions. But all went well and Copenhagen was something of a grade-A vacation for her. During her stay, Marion washed her clothes at a laundromat around the corner from the Off Off while a junkie OD'd on the floor. This ranked as her most profound memory of the city, along with the Little Mermaid.

Night train from Copenhagen to Munich. No sleeper car. Long ride through the night with partying teenagers.

She arrived exhausted in Munich the next morning, and was taken directly to the flat of her hosts who were at work. Alone in a strange German apartment, she attempted to take a shower, and accidentally pulled some mysterious switch which she feared was a gas main. In semi-panic she aroused the non-English speaking neighbours in the hallway, producing a chaos of linguistic absurdity... wild facial gesticulations and

Fear & Loathing & Good Hash & Dirty Laundry

bizarre nonsense sign language. Finally her host arrived and the problem was easily solved.

From Munich she travelled to Vienna by train. She stayed in the same flat Mike had inhabited a week earlier, a carton of sour milk left in the refrigerator by him as a calling card and psychic talisman. The shows went well in Vienna, but the next show was a long jump away, in Holland.

She was scheduled out of Vienna on the midnight train. It arrived an hour late, full of Croatians fleeing Yugoslavia and bound for various points in Germany. This was the beginning of the Yugoslavian War. No sleeper car was available, needless to say. Her compartment was crowded with people sleeping, drinking and smoking, others eating bread and salami. She was exhausted but couldn't sleep... no food or water available to buy. Old people, weary and frightened... young children running, jumping and charging about. Marion, heavily burdened with luggage and film prints, had thoughts of defecting from this tour in the long hours of the night.

She changed trains in Munich, although the one she was supposed to have caught had left three hours before. She fell into a long conversation with a twenty-six-year-old Croatian who spoke perfect English. He was trying to talk his parents into resettling with him in Cologne where he had a teaching job. The tragedies of his recent life were quite moving and dramatic.

The Munich train finally pulled into Cologne. Still hungry and sleepless, Marion boarded the train to Utrecht, Holland, and paid the extra fare to sit in first class where two well-dressed German business asked her if she had heard about the earthquake in California. In Utrecht she caught her last train which put her in Groningen two-and-a-half hours late, but amazingly she got to the cinema a half an hour before the show... where she had to stay up for *more* hours since the organisers wanted to show all the films she was packing.

She stayed an extra day in Groningen just to recover, then called up the Rotterdam booker, Marianne, to see if it was OK if she arrived early for that gig. That was fine. She then spent several relaxing days in Rotterdam at Marianne's flat, accompanying her host on nightly rounds of the pubs and coffee shops. This would leave her with fond dreams of cheap Dutch hash once she got back to California.

Meanwhile Mike and I had back-to-back shows at the Husets cinema in Copenhagen. I did the first night, but Mike never showed up for the second night. They went down to the train station to fetch him but he never arrived. He was missing in action in Berlin, and nobody would hear from him for days. Later it was revealed he had taken Marion's plan a step further and after some amount of introspection on the Berlin station platform had simply gone AWOL from the tour and decided to stay in Berlin, where the underground film-maker, Rosa von Praunheim, had provided him with comfortable accommodations. I did his show that night instead, and afterwards ended up being interviewed by the woman journalist who I was to eventually marry, and who had come down to see Mike's program. I've run into Mike over the years since, and I know he takes some credit for this serendipitous confluence of events.

After Copenhagen I travelled to Rotterdam and met up with Johannes and Marion. We had two free days so Johannes suggested we go over to Amsterdam.

Departing Amsterdam's central train station, we put our luggage in the trunk of a cab, hopped in and told the driver we wanted to go to a cheap hotel. "Why didn't you say that in the first place?!" he replied in amazement — and threw us out of the cab. *There weren't any!* It was Queen's Day *and* May Day Weekend and the crush of tourists had virtually doubled the city's population.

In desperation we walked to the flat of somebody we only vaguely knew. Things were too crowded and hectic to stay there and nobody had any ideas. In a fit of stupidity, somebody suggested we just go outside and look for a hotel, so we left our heavier bags and went back out to dig up a hotel room for Marion. We would have been willing to pay upwards of 200 bucks, and we walked in the front doors of some obscenely upscale places, but there was not a room to be had. Apparently the nearest vacant room was in Paris.

We walked all over, even wandering into the red light district. Marion badly needed to wash a load of clothes, and we did finally find a laundromat, but it had

just closed five minutes ago. We walked back to the flat where it was decided that Marion could stay the night there but that Johannes and myself would have to find another solution.

In the meantime our acquaintances were going to a party that night so we went along. Marion went back to the flat early since she had a big London show the next day, and we promised to see her off at the train station. Johannes and I stayed to the end of the party where long discussions transpired in Dutch as to what to do with us. A girl with a flat in an old mansion told us we could sleep in her attic and agreed to meet us there

Marion Eaton in the Scala theatre office, London. She made a personal appearance for a retrospective of her films in May 1992. *Thundercrack!* had played the Scala every month for ten years.

later after she checked out another party. We bundled into a cab which took us over to a strange old Dutch monster mansion where we waited for "the girl", sitting on the steps while people going in and out eyed us suspiciously.

We waited for hours. The sun was starting to come up. Figuring we'd been "had", we decided to walk over to the Red Light district to get a cup of coffee in some imaginary twenty-four hour cheap café of the type they don't at all have in Europe. It was a bad idea if ever there was one since the only thing moving in that part of town at that hour were tanker trucks hosing down the area with disinfectant.

Just as we were stumbling off, she arrived. I opted for the attic bed while Johannes ended up down in hers in a flat two floors below. About three hours later I woke up. I somehow found her flat, snuck in — they were both out cold — and pilfered a few guilders out of Johannes' pocket since I was broke, and dashed outside. I asked the first living person I saw for directions to the train station, and ran along in that direction, dodging under doorways to get in out of the rain.

I met Marion there in the chaos of the station. We had a coffee and checked all the tickets and times and I saw her off on the airport-bound train. She would be presenting *Thundercrack!* that night at London's Scala cinema. The film had been a cult legend for many years in that city and the show would be sold out. After the humility of all these other shows, and travelling, literally, among mobs of refugees, she was finally going to be treated like a real movie star. But that was still a Channel passage away, and at the moment she was packing a knapsack full of damp laundry — having washed her clothes last night at the flat only to discover that the dryer didn't work. I promised to book a room for her so when she got back to Amsterdam in two days she would have a place to lie down in this city of the walking zombies.

Then I went out and waited in line for exactly two hours in the white tourist accommodation building outside the station and did it. I called her in London with the fantastic news and she was *thrilled* to have a room booked. At that very moment somebody was snapping a picture of her.

I met with Johannes later at the monster mansion and we went on to Groningen that day for shows. We didn't see Marion for a couple months until we all met up for a much more relaxed reunion of the survivors of "The Battle of Amsterdam" in her backyard in Mill Valley, California, in the shade of the Redwood trees where all is calm and peaceful and easy. And where the chaos of her European tour, some of it stimulating and some of it torturous, seemed a million miles away.

THE JESUS CAR

From Here to Hell and Almost Back

It was March 19, 1993… I'd just returned to the States after five months in Europe and was passing through New York, on my way back to San Francisco. I was doing a presentation at The Millennium where my German friend, Johannes Schönherr, was the projectionist and janitor. He had helped arrange the show in fact.

We hung out over tacos and beers at The Mission restaurant on the Lower East Side, and after a ridiculous argument as to whether New York or San Francisco had the best Mexican food, we fell into a line of conversation that would have fateful implications for his immediate future.

I knew that Dennis Nyback, who operated The Pike St theatre in Seattle, wanted to take a month off in August, so I suggested to Johannes that he ought to go out there and run the joint for that period of time. Just take over the place, show whatever he wanted. It could be fun, he could have his own movie theatre for a month. He liked the idea and soon after arranged with Nyback to book the place in August. He was also at that point enrolled in the film department of New York University, and even tried to get them finance the project by selling them the idea that this would be his graduate project. They weren't buying.

But the dye had been cast and plans were now being firmed up for shows in Detroit and San Francisco as well. For a couple of months The Mars Bar would be without its best customer.

In July he bought a very used 1972 Dodge Dart for fifty bucks from the underground film-maker and poet, Jeri Cain Rossi, who in turn had bought the junker from the artist, Joe Coleman. The headlights had the face of Jesus painted on them. That was Coleman's work. So, the wreck had a pedigree of sorts and had even appeared in Jeri's film, *Black Hearts Bleed Red*. But could the fuckin' thing *run*?

Nobody thought he'd get out of the city in that car, let alone all the way across the country.

But he did.

Driving almost non-stop, he made it to Detroit. There he did a show at The Bank, an abandoned granite structure that had once been a bank and now sat on a desolate patch of inner-city acreage not far from Tiger stadium. Then, taking the northern route through Butte, Montana and Spokane, Washington, he hit Seattle three days later. He checked in with Dennis and prepared his press attack for what he proposed to pitch as an underground film festival.

His plans were ambitious. He had rented prints from Europe and also planned to stage a week-long Kuchar Brothers retrospective. Mike and George Kuchar and Marion Eaton (star of *Thundercrack!*) had agreed to come up in person from the Bay area. His brave plan was to drive down to San Francisco and bring them up to Seattle in the Jesus car. This was an approximately seventeed hour trip each way! To make matters worse, the car now filled with a cloud of engine exhaust whenever it managed to sputter to a start.

He did get down to San Francisco. There he paid George a visit. George could see the obvious peril of this plan and quickly ordered three cheap plane tickets on Alaskan Airways to get them up to Seattle.

And so they flew up, and Johannes met them back up there. But they still had to get from the Seattle airport into Seattle, and of course that would take place in the Jesus car. George arrived first on a separate flight. He threw his bags in the back and climbed into the front seat as the car roared to life. The fumes were so bad that he kept his head stuck out the window

the whole way into town, and in his nervousness he even managed to fasten the seat belt which had been broken for years. By now the suspension system was shot and the whole production swayed dangerously, not to mention the exhaust pipe which fell off at regular intervals, increasing the decibel level of the experience.

On the way back to the airport to pick up Mike and Marion, the car broke down and they had to take a cab in. The non-existent budget for the festival was already bust and Johannes had to later reclaim the car on foot, hiking for hours through a bleak, industrial landscape by the side of the highway.

The Jesus Car, broken down (again) in Utah.
Photo: Katrin Krahnstöver

As far as living quarters, George immediately went out and got a hotel room, which the thirty-six bucks he eventually received for his appearance could hardly have covered. Mike, Marion and Pam Kray, Johannes' co-organiser, bunked in Nyback's flat. Johannes usually slept on the couch in the cinema after late night drinking sessions in the bars around town.

In addition to the Kuchar retrospective, Johannes premiered the Todd Phillips film, *Hated*, in Seattle, and treated local cineastes to the explicit bestiality film, *Animal Lover*. It's the only print in existence, he bragged to the press. Thank God for that, one writer shot back. He also did a punk sidebar, booking Amos Poe's *Blank Generation* and *Subway Riders*. As noted, some of the prints he had to get from Europe, with predictable high costs. *Blank Generation* had come from Sweden (where much to his shock he discovered the scenes with the Ramones had been cut out) while *Subway Riders* had come from an Austrian distributor who continued to plague the theatre with obnoxious phone calls long after Dennis returned.

With the Pike St experience behind him, it was time to head back down to San Francisco with Pam. There they would play many of the same films at the Klub Komotion. They figured she would take the first shift behind the wheel and pulled into a parking lot and traded places. As soon as she gave it gas the muffler blew off. She got out and fled, eventually driving down in a rented car. Johannes got the Jesus car running again and drove down alone. Twenty hours without a radio down US Route One. He contented himself by listening to the hypnotic roar of the engine as it spewed smoke along the pristine California coastline.

Todd Phillips was in San Francisco at the time, premiering *Hated*, and they got together. Todd took a brief ride in the Jesus Car. He didn't think it would get around the block, let alone back across the country. The cream of the crop of American underground cinema all, at one time or another, rode in the Jesus Car — and they were all petrified by the experience.

After a week of bunking in my flat, situated over a Thai restaurant in the Richmond district, Johannes was joined by his girlfriend from Leipzig who had flown over so that they could drive back to New York together and share the adventure. I remember waving goodbye to them as they pulled out of the parking space in front of my building. I figured they'd be back in a few minutes after the car broke down at the next stop light. It was crammed with film cans, a junk typewriter, clothes, sleeping bags and two New York City phone books that Johannes had pilfered before he'd left. The phone books weighed as much as a full-grown man and further destabilised the car. As he fired it up to a full roar and pulled out, the whole neighbourhood filled with a cloud of blue exhaust smoke.

And they never came back. They were on their way.

The two of them had only just enough money between them to pay tolls and gas, and so they slept in the desert in sleeping bags instead of checking into motels. The front wheels were irreparably out of alignment and he blew four right front tires on the way, refitting them with the cheapest retreads money could buy.

One of the more lasting memories was driving through the entire extent of East St Louis.

Soon after returning to New York, someone stole the battery. Steve Ostringer loaned Johannes another battery to keep it running. Shortly thereafter, Johannes sold the car to a junk yard for thirty-five bucks in New York's worst ghetto, East New York. But first he had to extract Steve's battery and carry it back through the ghetto on public buses to return it to Steve.

A fitting final image of one embattled mobile film festival from the Land Without Grants.

FROM RUSSIA WITH CONFUSION

One of the strangest film related experiences I ever had was a trip to Moscow in the spring of 1992. I was hanging out in Leipzig at the time with Johannes (on the tour mentioned in the last chapter). He was showing me the local attractions, such as that massive stone church, built in the Middle Ages, which was used by Gestapo desperadoes to make a last stand at the end of the war. He was also particularly fond of showing off a giant hole in the earth, dug by workers in the communist period, which had no purpose or reason. He would drag visitors out to this remote site to stand and gaze in rapt silence for several minutes and then announce that it was time to start the two hour bus and tram journey back into the city. Leipzig itself at that time had the appearance of a crumbling ruin covered in grimy black soot. Some of the buildings still bore bullet and shrapnel marks from the war, and many of the advertisements painted on buildings seem to originate from the early part of the century. It was more interesting than any other city I had seen in West Germany. But our idyll was disturbed when we received news that a group of East German film-makers were going to Moscow on a cultural exchange junket and there were two vacant places for us if we wanted. We agreed and I packed up some films. It would last five days and all expenses were covered.

Arriving at the Leipzig airport, we discovered nobody had reserved tickets, so after lots of haggling in German we were flown to Frankfurt and then on to Moscow. We arrived about six that evening, met our guides and were loaded onto a bus which drove us into the city. We arrived somewhere and were herded into a strange restaurant — all of us grimy, exhausted and dishevelled by this point — and were served an elaborate and lavish dinner. It came complete with crystal plates and glassware, selections of caviar and two immaculately costumed waiters ferrying endless plates of food about in an atmosphere of astounding elegance. Then an old man started playing an organ up front, pumping out schlock hits like Volare and The Girl From Ipanema. We looked at each other in bafflement. What the hell? We must have looked like condemned prisoners partaking in a last meal. The Germans couldn't communicate with the Russians and I couldn't communicate with either group, so nobody really knew what was coming next. Somewhere far above our heads all these arrangements had been made. The whole affair had the feel of an elaborate and completely pointless joke, a set-up, a con job. But we ate. The food was real.

Then we were taken to a hotel and given rooms.

The next day the same charter bus picked us up and drove us aimlessly all over Moscow, eventually carting our asses out to an ancient monastery about an hour outside the city. Soon tiring of the ancient splendours there to behold, a few of us bolted across the road to the town's dilapidated movie theatre where we watched a pirated version of a Chuck Norris movie.

Land of a Thousand Balconies

While in Russia I became a big fan of pirated movies. Being poor grade dupe copies, the contrast is very dim and hence the cinema is shrouded in a murky darkness that recalls the ambiance of a porno theatre. In addition to this, all the voices are translated into Russian by one narrator who "plays" all the parts with lazy, faked emotion while the English dialogue mumbles on audibly like a shadow below the surface. When somebody laughs, cries or acts frightened, the narrator attempts to mimic same with a ham-fisted lack of flair

The author in a Moscow sidestreet, May 1992.

and conviction. Watching such pirated copies makes one feel somehow dirty and voyeuristic, like you're watching somebody watching a movie. It's great. You can never get totally absorbed in the movie since you are always keenly aware that you are in a movie theatre watching a movie. Like someone watching a movie of a movie of someone watching a movie. (Get on with it! — Ed)

The bus eventually took us all back to Moscow.
The next day a bunch of us spent hours looking for a bar. It's hell to find anything resembling a tavern in Moscow. We found a small one finally, some blocks out of Red Square on a back street. There were beer cans on the shelf behind the bar. We ordered beers. No beers, indicated the barkeeper, those were just souvenirs. So we ordered glasses of vodka, the only thing one *could* order. We waited as a young Russian couple came in and joined us at our table which was littered with broken glass, cigarette butts and puddles of vodka. At the table across from us a party of Russians were raising drunken hell. A man rose, he jostled with his wife… stumbling about… a masterful leg trip sent the woman flying to the floor while his momentum carried him crashing into our table. The bartender promptly threw his ass out into the street and returned to his post behind the bar. Another woman from their party threw a chunk of debris at him — he ducked to avoid it, continuing to set out glasses for us. We were beginning to doubt this project. Then she rose, made some noble declaration and smashed a vodka bottle over the edge of the table. She sat back down. The bartender emerged to throw her out but she refused to leave. They ended up in deep negotiations, blah blah blah. We eventually tired of this drunken charade, realising we would never get served, and departed the tavern to confront more hours of aimless walking around the city. Thus far we had done nothing in Moscow vaguely related to film.

The day before our departure it was finally time to show some film. This would take place at Moscow University. Wilhelm Hein, the noted German avantgarde curator and film-maker, was in our group, along with his girlfriend. As we left the hotel, he informed us they would meet us later over at the University's theatre as they wanted to dally in the city, and he asked for directions to the theatre. Johannes gave him a street name that even I, despite the fog of multilingual chaos that hung over the entire trip, knew to be wrong. In fact Hein and his girlfriend spent the rest of the day asking Moscow pedestrians directions to this non-existent street. On top of that they had to communicate in gibberish sign language as they knew no Russian. Hein missed my show, which was just as well anyway since my collection of American trash would have rankled this German avant garde purist if only on theoretical grounds. Instead he was out making a fool of himself on the streets of Moscow, wasting the time of innocent pedestrians in his search for a non-existent as well as unpronounceable street. He might as well have been looking for the fountain of youth. Although I have nothing against Wilhelm Hein, I found his predicament to be hilarious. The trip was starting to take a toll on me.

Back at the theatre, I found myself on stage in front

Tales from the Cities

From Russia With Confusion

of 300 Russian film enthusiasts. An Indian fellow had been fetched at the last minute to translate from English to Russian since they had naturally enough assumed all translation would be from German to Russian. The audience laughed a number of times during my introduction. I must be in top form, I figured. (Later I was told that the Indian guy was giving screwy translations of Russian words.)

As the films screened, I sat in the front row and three of us passed the microphone back and forth, giving a rolling translation that periodically bogged down in discussions on word meaning. I showed the audience some Scopitone jukebox films, shorts on vandalism and drunk driving and the 1962 anti-communist cult classic, *Red Nightmare*. They had expected to see personal, profound and artistic works of independent film-making but were happy enough with this on some level, and most of them seemed remarkably hip to the camp elements of the material. After *Red Nightmare* ended, somebody in the back of the balcony stood up and shouted something dramatic in Russian. They later told me he wanted to know why I was picking on the communists.

For our final night in Moscow we were invited to a lavish banquet at the Moscow "House of Cinema", an elitist complex containing four cinemas (one of them gigantic), a cafe and a high-class restaurant where well-dressed eastern European schmuck playboys harassed waitresses and made deals. I was informed that in two weeks Chuck Norris would be invited here for a huge party to celebrate the launch of his films in Russia as legal, copyrighted entities. I was depressed. The pirate versions were infinitely better.

Our send-off supper in this "House of Cinema" restaurant came with all the trimmings the eastern European schmuck playboys usually got. We each had a bottle of wine, vodka, Pepsi and spring water. Vast plates of food circulated the table, giving me pause to wonder yet again who had arranged all this. The alcohol loosened tongues and unleashed torrents of slurred Russian, German and English — a tower of babble buried in a cloud of strong cigarette smoke. And to find ourselves here after wandering the trashed

and mean streets of Moscow for five days! After witnessing the long, omnipresent lines of people standing mute outside every train station or market area, holding up pathetic items for sale; a dead fish here, a tube of toothpaste from the fifties there... to be *here*! Yet any pangs of guilt we might have felt over the inequity of the situation were soon washed away in a rip tide of alcohol.

We ended the night by fleeing out into the streets with some new-found Russian friends in search of some exotic after-hours club on the proverbial unpronounceable street in the non-existent part of town. Needless to say, we never found it...

THE DEADLY CURSE OF THE ONE-ARMED GARDEN GNOME

Report from the First Annual FREAK ZONE Festival in Lille, France

In early May of 1996, "Freak Zone," the first International Trash Film Festival, was held in Lille, France. Lille is a very unchic, working-class city. Tourists usually just pass it by in a blur on their way to glamour capital, Paris, but now for five days it would find itself on the front lines in the holy war against high culture and fine art. And somehow the choice of location seemed right.

Severely jet-lagged foreign participants arrived at the Paris airport from all corners of the globe and were ferried to a cheap hotel in the Montmartre district. Here we would cool our heels until Thursday, May 2, when we would collectively depart for Lille.

Zelimir Zilnik and his beautiful "girl Friday", Sarita, came from Belgrade. Rotund and irrepressible Nakano Takao and his skinny long haired producer, Kanai, came from Tokyo, and the dishevelled, shaven-headed Toby Zoates — who had named himself after the Australian breakfast cereal, "Toby's Oates" — arrived from Sydney after layovers in Bangkok and London. Greg Wild and Jon Moritsugu had come from Vancouver and San Francisco respectively, and I had come from Copenhagen to serve as a jury member and to present three archive programs.

That evening we all left the hotel and walked in a disorganised mob to a cosy French restaurant, Au Virage Lepic, on Rue Lepic.

With some amazement I observed Toby's strolling style which consisted of dazed, unpredictable forays out in front of oncoming traffic. Due to jet lag and his unfamiliarity with right side driving, he had, since arriving in Paris, almost been run over fifty-six times.

The restaurant was packed and smoky. We were finally seated, crowded onto a long table at the back. I sat across from the pallid, ill-looking Zoates near the end of the table next to two respectable French ladies who quickly signalled the waiter for their bill. Our collective assault on the aesthetic experience of our fellow diners continued throughout the night, the charge led by the energetic Greg Wild who appeared to be on speed and who had been talking non-stop in a loud voice on all matter of hair-raising subjects since we'd left the hotel.

To provide counterpoint, Kanai, who was sitting next to him and never uttered a single word the entire week, dozed off dead asleep in his chair for some time. The air was full of indigestible French accents, Nakano's enthusiastic but nearly non-existent "Tarzan English", as he termed it, Toby's broad Australian accent and Greg's loud "American-ese". It was a babble of disoriented and vaguely thrilled people.

The bizarre nature of this event had begun to reveal itself. It was a beggar's banquet of impoverished directors of obscure films who had been plucked from

The Deadly Curse Of The One-armed Garden Gnome

their daily grinds by the well-financed whimsy of organiser, Jean-Jacques Rue. He had flown them to, of all cities, Paris in May, and was now giving them the red carpet film festival treatment — at least as far as we could recognise a red carpet. Heady stuff, this.

Toby in particular, a graduate of the Sydney squatter movement, had never known film festival largesse and at the end of every meal or drinking session he would dig down for a measly handful of coins and pocket lint until somebody told him to knock it off.

Jean-Jacques and his girlfriend were themselves exhausted since the night before Greg Wild had asked for a guided tour of all the Paris gay bars. They were hardly able to hit them all but in any case the great work lasted until sunrise. Greg had no luck himself, but his straight sister/producer/chaperon, Donna, managed to attract some offers from several lesbians, offers which were as enthusiastic as they were unwanted.

After supper, Toby, Greg, Zelimir and some others lingered at the restaurant until the joint was completely empty and the weary, red eyed bartender had to usher them out. From all reports, that liquored-up brainstorming session was the intellectual highlight of the whole festival with many innocent bystanders caught in the mental crossfire. I missed it.

The next day at noon we all gathered at a nearby cafe and waited for assistant director, Laurent Geissmann, to show up before ordering (since otherwise we could never dream to afford it).

Excited talk soon turned to the possible scandals we could provoke and the grand entrances we could make upon our arrival in Lille that afternoon. History was there to be made! Many highly ridiculous and disgusting suggestions were tendered over the inevitable bottles of wine, but finally we decided we wouldn't go to Lille at all since we were already getting free meals and a place to stay right here.

Reality intervened and after lunch cabs ferried us to the Paris North Station where we caught the train to Lille, arriving an uneventful hour later. Disembarking, we were met by a crowd of enthusiastic young girl volunteers Jean-Jacques had recruited to help run the festival. They we resplendent in official Trash Film Festival T-shirts.

But what were they supposed to do, exactly? They met in a mob and conversed in French. They talked, planned, discussed… then they all took off and I never saw any of them again.

The main sponsor of the Trash Festival was Tati, a French discount department store that sold the kind of clothing that any slightly sophisticated Frenchman considered trash, which was why Jean-Jacques had approached them. From an American perspective, Tati could be compared to a Kmart with upscale pretentions.

I would pass the Tati store in Lille on several occasions to see depressed and elderly shoppers pawing through their heaping sidewalk bins of cheap shoes, fake leather purses and plastic flower pots. The bright pink Tati shopping bags, which you could see miles away, were usually clutched in the hands of unhappy and vaguely suicidal looking pedestrians and clashed violently with the bleak, grey weather.

Jean-Jacques had also approached the main French producer of cheap liquor for sponsorship, a company something along the lines of the French Boones Farm Wine. They were not amused and turned him down flat.

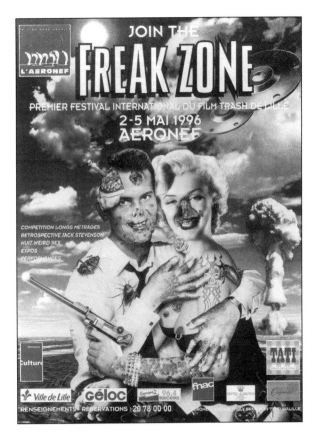

The head executive of Tati, immaculately attired in a three-piece suit, spoke at the opening ceremonies at the L'Aeronef before (reportedly) jetting off to go lay on some Spanish beach.

The three other members of the jury were also introduced at the inauspicious opening ceremonies in the L'Aeronef, an entertainment complex on the upper floors of a huge parking garage. They were all in some

Land of a Thousand Balconies

fashion luminaries of the French underground. There was long-haired and dandified Vuillemin, a famous rude cartoonist. There was the meaty Virginie Despentes, punk authoress in black miniskirt, and there was the stoic Romain Slocombe, an artist who only painted pictures of pretty, smiling Japanese girls wrapped in bandages and bruises. Romain could speak English and some Japanese, so he spent most of the week pinned down as an interpreter. (Virginie Despentes, for her part, would later go on to fame as author of *Baise Moi*, a tale a two female desperadoes who fuck and kill their way across France. She later co-directed the movie version which went on to arouse considerable controversy.)

The invited filmmakers were next up at the podium.

Toby broke out into song on the stage, while Greg proceeded to thank and credit everybody and everything connected with the festival for ten minutes as if he had just won an Oscar. Access up to the stage was afforded by a set of wobbly, portable wooden steps which ensured that practically everybody would trip going up and feel somewhat chastened by the time they reached the microphone. This set a tone of humility and paranoia for the duration of the festival, with everybody casting embarrassed glances back at the steps as they tried to remember what they had planned to say. The rotund, ever enthusiastic Nakano, with flat-top haircut and round spectacles, was last up and did the situation one better by *pretending* to trip.

As Master of Ceremonies, Jean-Jacques had a unique style. Tall, lanky, with long straight hair and thick glasses, he was casually dressed and always spoke away from the mic in mumbling tones until the audience inevitably started yelling for him to speak louder. This gave the start of every show a certain drama,

The rotund and ever enthusiastic, Nakano Takao.

ensured audience participation and shattered any sense of formality or officiousness that might have accidentally crept in.

He gave the appearance of someone who had just wandered in off the street and had no connection whatsoever with the festival. His French translations were reportedly "very creative", and his English was stretched on the rack of a very heavy French accent. The whole festival was, in fact, experienced through the distorting prism of strange, obscure films, rich food, copious amounts of alcohol consumed in the afternoon, and linguistic chaos… "prism" hell! It was like getting hit by a house.

On the second day we were all given an official reception in some kind of ancient Hall of Culture in central Lille.

We four jury members were ensconced in the luxury Carlton Hotel, separate from the film-makers to discourage any form of "bribery", apparently (even though we were all squeezed in together for hours at every sweaty meal and drinking session). I arrived at the reception with Romain. We walked down a series of endless marble hallways as our steps echoed in the sepulchral sanctity.

We were ushered into a select room upstairs which

Tales from the Cities

was dominated by cartoon wall paintings, a long table of fancy drinks and several conversing clusters of leather-clad hipsters and official types in suits.

Toby Zoates, looking particularly pale and unhealthy this morning, sat on a radiator against the wall listlessly holding a cup of some glowing red alcoholic concoction that definitely looked like it should be mixed with something else. At first he found the idea repulsive — drinking something this potent so early — but then he took a liking to the taste and waved off a waiter who had rushed over to finish mixing the drink.

Toby looked supremely out of place, as did all the filmmakers (as did all the jury members). He was dressed in his customary layer of shawls, scarves, patched T-shirts and sweatshirts and a pair of heavy jack boots, a style that harkened back to his roots in the Sydney gay-punk-anarchist-gypsy squatter movement. At one point during the festival, Jean-Jacques had gone to fetch him in a cab and was kept waiting while Toby changed clothes, finally jumping into the cab in an outfit every bit as patched and raggedy as the one he'd just taken off.

The Deputy Minister of Culture, attired in suit and tie, began to speak and welcomed us to Lille. He joked that soon this festival would overshadow boring, dusty Cannes. Then his brow knitted in profound consternation as he spoke of this "trash… sex… freak… festival". He lost his bearings as he tried to think of something witty to say about this thing. He was clearly adrift, even though he spoke the words with force and gusto. Then, for lack of any better idea, he latched on to the movie *Freaks* and began to rhapsodise about its magnificent humanity.

At one point he engaged Romain Slocombe in idle conversation.

"So, what's your specialty?"

"I'm a painter."

"Oh? What do you paint?"

Romain pulled out one of his small pocket sized books of reproductions. The culture guy took it with interest only to quickly hand it back with a nervous chuckle.

Over the next four days, screenings, exhibits and performances of the vilest sort took place at The L'Aeronef from noon until the early morning hours. Toby, Greg and Donna were usually the last to leave after innumerable drinks. In the wee morning hours Toby would end up gathering cans of beer from the film-maker's free commissary upstairs and spiriting them down to pass out to the penniless students in the lounge. He played a combined role of Robin Hood and the Ratso Rizzo who went to the underground party in *Midnight Cowboy*.

Late that Friday night, Greg and Donna decided not to wait for the shuttle van, and, clutching cigarettes and drinks, set out to walk back to their hotel in the rain and darkness. Greg slipped on the wet outdoor metal staircase and tumbled the rest of the way down without getting hurt or barely even noticing.

With Greg confidently leading the way, they cut across a nearby wooded, garbage strewn field in the pitch darkness and began climbing some mysterious steep hill. Once at the top, Greg started down the other side, lost his footing and slipped and rolled in the mud the rest of the way. Back on his feet and full of liquored-up confidence once again, he led Donna across a ditch that turned out to be knee deep in muck and empty beer cans. The two of them, by now soaked in the drizzle and caked in sandy mud, finally walked into the hotel lobby to meet a surprised Jean-Jacques who had just ridden over in the shuttle van.

Here was the grand entrance we had dreamed of!

The film screenings were all well attended, and at most of the shows dialogue was translated into French over headphones. During one film the audience broke into gales of laughter during a serious scene. I was told the two translators had lost their place in the text sheets.

"Shit… where are we? I lost my place!" cried one over everybody's headphones.

"What the hell… can you hear anything on the screen?" replied the other.

On Saturday night my archive show was pushed back half an hour to accommodate some mysterious "transvestite performance" as the program ambiguously announced. The crowd was still filing in and finding their seats when a beautiful skyscraper-tall French transsexual in high heels climbed to the stage — tripping on the wobbly staircase — and began a choreographed striptease to recorded music. For the few people paying attention at this point, it was all quite bewildering. The performance or whatever it was ended quite quickly with the transvestite draped on stage signalling in frustration to the oblivious soundman to cut the music. No luck. He/she then stalked off the stage in exasperation… with the audience, still filing in and taking their seats, none the wiser.

Closing ceremonies were held on Sunday. My three esteemed French colleagues and I met at the fancy Carlton Hotel restaurant and took a table next to an ivory piano player tinkling out classics as waiters hustled over with bottles of wine, plates of hors-d'oeuvres and hideously intricate looking crab salads.

We decided to scribble down our four favourite films on napkins and tally the sum result, thus avoiding

Land of a Thousand Balconies

endless debate — at least to start with. A sound idea since Vuillemin spoke no English and I spoke no French.

In the meantime Jean-Jacques and Laurent were wandering around town looking for something totally useless and repulsive to purchase as a Grand Prize. Eventually they caught up with us at the restaurant and planted a dirt caked garden gnome on the table. The dwarf had an alligator wrapped around its waist in some vaguely sexual configuration. It was indeed hideous trash.

To the glum looks of Jean-Jacques and Laurent, we announced that they had to go out and find another one since we had decided to split the prize. As soon as they left we ordered more wine and yet another round of rich desert. It was suggested that if we kept on debating we could probably get dinner out of this too. When we finally did leave, this once bustling restaurant was empty except for a couple of lingering waiters.

They never did buy a second garden gnome, and the festival was not as rich as these decadent lunches might have suggested. Jean-Jacques in fact at one point complained, however good-naturedly, that Greg was "exploding" his budget with all the beers he was buying.

That evening the awards were given out.

Mod Fuck Explosion by Jon Moritsugu was awarded a special audience prize from a rabble of French punks who had been hanging out. Due to the linguistic chaos, Jon apparently didn't realize that this was just a preliminary prize and he went up to the mic and gave a deeply moving and passionate acceptance speech.

The jury's decision was then announced. The co-winners were *Spiral Zone*, Nakano Takao's supremely politically incorrect Japanese softcore porn kung fu comedy, and *Virgin Beasts*, a twelve-years-in-the-making partially animated afterlife obsession by Toby Zoates which I had voted for despite the fact I couldn't make out a single line of dialogue.

Zelimir, who had entered *Marble Ass*, tried to console Greg, who had come lugging *Highway Of Heartache*. Winning a prize at a "trash" festival, he reasoned, was a dubious honour indeed, and so really everyone won at this festival. Avoiding a prize was as wonderful as winning one!

But Toby and Nakano did get 10,000 French Francs apiece. That wasn't much, but at least it was enough to keep Toby Zoates floating around Europe for some time to come, he having declared his intention to bum around with his films and try to get some shows before returning to Sydney. We could rest assured he would now be plaguing respectable diners and disrupting street traffic across the *entire* continent. His main worry was that his films might get stolen if he ended up living on the streets, since it was hard to zip up two 16mm reels into your coat at night when you went to sleep. He debated leaving them behind and just hitting the road with the one small roll of animation work that he could stick down his pants. (A rumour started circulating that the Australian government had bribed the jury into awarding him the prize to keep him from going back home.)

Anyway, right now, bedecked in shiny black suit, red silk shirt and monstrous tie-clip, he was thrilled.

"This shows Australia and Japan can finally be friends again," he declared up at the mic with his arm around Nakano as they hoisted a giant cardboard cheque.

Then they both repaired back to their seats, leaving the gnome sitting up on stage. I grabbed the fucker and with exaggerated pomp presented it to Toby.

After the ceremony I was conversing with someone outside the theatre when Romain rushed out with a look of hilarious excitement: he had to find some glue, and fast! Toby had accidentally tripped over the gnome and broken its arm off. He was in an agitated state and presently being consoled by onlookers.

Toby Zoates' *Virgin Beasts*. "Grungy survivalist youths meet a death dealing duo at an erotic post-apocalypse party" — say Troma.

We couldn't but help to wonder what kind of evil voodoo curse Toby had unwittingly brought crashing down on the heads of all future winners with his clumsiness… what kind of revenge would this grinning idiot garden gnome seek? It was an act of buffoonery pregnant with all sorts of ominous and ridiculous portents.

The closing dinner that night was a bleary and endless bacchanalia. We all got up at one point and described our most humiliating experiences in film. I

The Deadly Curse Of The One-armed Garden Gnome

boasted about one show I did in Portland at The Blue Gallery that I got eight bucks for — after driving two weeks across the country from Boston. Jon Moritsugu recalled a show he did for three bucks in a bar in front of an audience consisting of two old drunks who never even noticed there was a movie playing. Yeah, but *nobody* came to my show! Who won that contest? I guess we both won.

Zelimir told of the premiere of his film which was held in a huge hall in Belgrade, a privilege automatically afforded to any film produced in Serbia. Thousands were in the audience. On the stage he called for any homosexuals, prostitutes or general deviants to come down front, prompting a human wave surge toward the stage as virtually every single person rushed forward. Ah, among all the failures finally a success story!

Later a jury member stood up with a flourish and grabbed a sword off the wall, preparatory to making some dramatic declaration… only to quietly replace the weapon, quickly chastened by the fact that (1) he couldn't think of anything to say, and (2) was dumbstruck to find that the sword was actually real and could be removed from the wall.

We finally stumbled out of the restaurant in disarray, gathering below on the rain-slick street of a city closed up like a tomb for the night. We exchanged addresses and farewells as Greg futilely tried to talk us all into joining him on an after-hours tour of all the gay bars in Lille.

Postscript

Jean-Jacques did another edition of the festival the following year. That one focused much more on hardcore pornography. He even programmed a bestiality film that year. One of his jury members, a girl with animal rights sympathies, started sobbing during the screening. The police showed up looking for the print after the festival ended, but he had already sent it back. I also heard from somebody that the festival was so expensive that he almost put that giant parking garage out of business. In any case, after that the Freak Zone Festival was finished.

One night some years later Jean-Jacques was passing through Copenhagen, staying with his girlfriend in a cheap hotel next to the train station. I met them in a nearby Pakistani restaurant and over dinner he told me how the festival ceased to exist. Basically the local citizenry simply became appalled by it, something that might have been predicted. And Jean-Jacques himself became a hated man in Lille. Even common folk who never went to the shows, like hotel laundry workers, threatened to go on strike if he came back. The mayor of the city also came in for a lot of grief. The festival left a trail of nasty repercussions that penetrated, in fact, to some level of the French government. A proud achievement. I never saw him again after that night. He owes me some money, too…

OF CELLULOID AND SLIME

Behind the Curtains of the HAMBURG SHORT FILM FESTIVAL

I arrived at the Hamburg train station after a seven hour trip from Denmark and disembarked onto the crowded platform. I was soon met by two girls from the festival, Judith Lewis and Nicole Newman.

Although I was extremely tired, they convinced me to head out with them to the airport where a celebrity welcome was being prepared for Vito Rocco, who was to serve with me on the No-Budget jury. Months before on the phone they had told me they were "trying" to get Vitto to come over from London. I had feigned weak enthusiasm — I had no idea who the fuck he was. From his bio in the catalogue they handed me on the train, I read that he was an oceanographer from Acapulco who got sucked into the motion picture industry and ended up filming underwater fight sequences until his small Mexican studio went bust and he ended up on the streets...

Arriving at the airport, we soon spotted a crowd of festival people that included (1) nurse with wheelchair, (2) tall party girl in scaly green cocktail dress, and (3) a phalanx of shaven headed security goons in head mics and black suits.

We all congregated at the arrival gate. Word soon passed that the plane from London had landed. After a stream of businessmen and tourists lasting twenty minutes, the shrivelled spectre of Vitto Rocco emerged, nestled anaemically in a and wheelchair being pushed by an airline porter. Garbed in white silk suit, prominent neck brace, sunglasses and pointy shoes, Rocco was the essence of effete, exhausted decadence.

Festival minions and confused onlookers darted around the expanding ball of confusion, of which Rocco was the inert nucleus.

Tall, leggy, black-haired Nicole dissolved into the chaos, but not before propping me up with the festival catalogue in an attempt to make contact with the two other jury members who had arrived on the same plane. Actually I had volunteered to do this because I wanted to stay as far away from this Rocco as possible.

Film-makers/jurists Ben Hopkins and Andrew Kötting drifted over to me unnoticed in Rocco's wake, and identified themselves. We killed time... Hopkins puffing furtively on a cigarette. Neither seemed to know exactly who or what Rocco was. Andrew had vague recollections of meeting him a few years ago but couldn't match this prone vision with what he remembered. "I think he's better known in Germany than England," ventured Hopkins as we cooled our heels and waited for someone to tell us what was going on.

Two vintage Mercedes with fender flags aflutter awaited us outside. Eventually the bullshit subsided and Rocco was bundled into the lead car with a driver and two "handlers". Ben, Andrew and I were stuffed into the tiny backseat of the second vehicle with Nicole up front.

Twice on the drive into Hamburg the two cars became stuck side by side in traffic, giving the verbose and beefy Kötting a chance to lean out of the window, over Hopkins, and harass Rocco with a jovial stream of bellicose cockney vulgarities and arcane hand gestures that were all vaguely related to the act of masturbation. The rest of us reacted with frozen/embarrassed/polite smiles. Rocco's imperviously pleasant expression of celebrity certitude glistened bulletproof and inhuman through the reflecting window glass.

The festival entourage, swelled by two or three vans,

Of Celluloid and Slime

Hamburg

spilled out at the Hotel Wedina on Gurlittstrasse (where I could have been sound asleep hours ago), with the increasingly fragile Rocco holding up traffic for a block as he was carefully helped by three festival bodyguards out of the car and into the building. Ben, Andrew and I unfolded out of the backseat and tried to walk again.

That evening, after resting, I dined on a doner kebab and strolled the six or seven blocks over to the Markthalle, a kind of black walled punk concert-hall venue with a big main room, bar, dance floor and irregular ancillary spaces — all of it located on the upper two floors of a long brick building. This was the festival headquarters, and here tonight the jury was to meet the press.

By the time I got there, Rocco was already holding court in the glow of arc lamps with a TV crew encamped around him. I got a beer and took a seat near the door, completely unnoticed. Soon after, I saw the TV crew depart with shit-eating grins all around. Either they got too much or they got too confused...

After the opening ceremonies, a selection of films was shown. I went back to the hotel after that as a party in the bar area raged into the wee hours. Hamburg and Oberhausen were Germany's main short film festivals. From all reports Oberhausen was a deadly dry academic affair. People attending it invariably returned with the same depressed and sombre expressions that you find on the faces of people who have just come back from a funeral. It was not a popular assignment.

Hamburg, in contrast, was run by anarchists.

The next day, Thursday, both the No-Budget and the International juries met at 7PM in the Markthalle to receive instructions. Joining Vito, Andrew and myself on the No-Budget jury — and raising the glamour quotient considerably — was Annabelle Gangneux, who programmed the Super-8 festival in Tours, France, and Margaret von Schiller, who co-programmed the Panorama section of the Berlin festival. We were each given an envelope with 500 deutschmarks for spending money, and the meeting came to a quick close for lack of any intelligent questions.

I didn't see Rocco, but a plainly dressed, sunburned guy who hung quietly at the edges of our group came over after the meeting and stuck out his hand. "Remember me? Rik Bolton?" Indeed, four years ago I had stayed a weekend with Rik and his girlfriend, Liz, in Enschede, Holland where they had arranged a couple of film shows for me. So *this* was the fake/flake celebrity, Vito Rocco! I'd not recognised him in his guise as a the fame hog Rocco, since I'd only managed to catch the glint off his sunglasses which had appeared welded to his head. He was now sunburnt because he'd spent a very sunny morning lying flat out cold in some Hamburg public park.

That evening in the Markthalle we watched the first of two blocks of no-budget short films, each block weighing in at almost two hours running time. Six blocks in total were stretched out over the next three nights. It was an onslaught of Super-8, video, 16mm and 35mm, with the films running a wide range from the divinely inspired to the utterly incomprehensible to the simply appalling. ("Utterly incomprehensible" being my favourite category.) It was hard work at times, especially the long bouts in the Markthalle with those uncomfortable folding chairs. We came to share the kind of exhausted, battle-scarred camaraderie normally only experienced by soldiers in major wars.

I took copious notes and by the end counted seventy-three films, even though the festival catalogue and all other documentation listed only sixty-nine. The International jury was meanwhile watching short films with considerably bigger budgets that were almost exclusively on 35mm.

I, personally, was happy to be a castaway in the low-budget wilderness where one feels like a true explorer and not just a marketing middleman. In the nitrogen gases of the no-budget compost heap was the stuff of life — warped, extreme and highly imperfect

Land of a Thousand Balconies

The No-Budget jury at the Hamburg Shortfilm Festival, 1997. FROM LEFT Margaret, the author, Rik (alias "Vitto Rocco"), Andrew and Annabelle.
Photo: Baernd Fraatz

visions produced by obsessives and delusionals who either don't care or don't know how to polish and structure their stories for the proverbial wider audience. A few years back, I was informed, the No-Budget jury had decided that nothing they saw was good enough to win the prize, and they simply gave the money back to the festival. I hereby publicly damn those faceless predecessors of mine for the arrogant fools they were!

That night after the screenings came another late night party with a DJ and much dancing.

The next afternoon two vans ferried all the festival guests from the hotel down to the harbour for a buffet in one of those long glass ceiling canal boats.

As we walked into the boat we found ourselves ambushed by a luxurious corporate spread that had been underwritten by a cigarette company and a tv station. Two big tables lay heaped with fancy 3-D platters of cascading cold meats and gastronomic creations sculpted in mayonnaise. There were cheeses girded with garlands of grapes, and various rich pates and creamed desserts next to dished assortments of Herring in ten different sauces and tinctures. At the other end of the cabin a cook in dress whites stood ready to carve up a sizzling hunk of high-priced meat.

Our party of fifty was seated as waiters attired in black suits and bow ties hustled about with bottles of wine. Free packets of cigarettes and lighters lay arrayed on the linen-clothed tables.

I still felt somewhat overwhelmed by the long train trip, the excessive drinking of the night before and by the doner kebab I'd eaten before the vans arrived, unaware of the impending dimensions of this buffet which now exerted a Jupiter-like gravity. I was helpless in its grip and submitted to its sensory omnipotence... in other words I dove in.

We shoved off. The boat was soon consumed in tobacco smoke as we began our tour of the industrial

Of Celluloid and Slime

BELOW A scene from *Quel Giorno*, second place No-Budget winner.
Photo: Baernd Fraatz

BOTTOM *Hummeln Im Kopf*

heart of Hamburg's giant port on this grey, rainy afternoon. There under a bridge were stacked suitcases, grand overstuffed chairs and... a cleaning woman sweeping up! That was where Hamburg's "most famous" homeless person lived. And there were the floating dormitories where they kept the immigrants... and there was a floating *prison*...

"All weapons sold by Germany to Turkey — who then use them to slaughter Kurds — are shipped through the port of Hamburg," Nicole patiently narrated to our table where all the No-Budgeteers had gathered, except Margaret who sat at a nearby funloving table. She was becoming popular with a circle of urbane young men, perhaps in part because she had been dancing in her bra at the Markthalle late the night before and word had gotten around.

The richness of the food, drink and tobacco smoke was pushing me to the brink of nausea.

Once docked, we disembarked and scattered in smaller groups. Nicole guided Annabelle and myself back to the main train station by S-bahn (or Underground). Nicole tried to talk us out of buying tickets, counselling us that we could all just run away if transit cops showed up — probably not the kind of advice handlers give to guests at glamour fests like Berlin or Cannes.

That night the No-Budget jurists gathered to watch another four hours of short films. The venue this time being the beautiful art deco Metropolis theatre on Dammtorstrasse. All the Experimental/Avant Garde selections were slotted into this block, and although Andrew and myself rather enjoyed the obscure psychic/electronic journeys, relentless special effects, imponderably abstract lightshows (and comfortable seats), the stuff did not sit at all well with Margaret, who had spent the afternoon drinking champagne with the Norwegian contingent as they travelled from bar to bar.

Following the session at Metropolis, we all went back to the Markthalle where "Die Trash Nite" festivities were about to begin.

Saturday was a period of languid recovery. I had taken to hanging out at the main train station, trying to read the English language newspapers without buying them.

At 6PM we met back at the Markthalle for the final two blocks of No-Budget screenings. As we approached the end, we were hit with two or three particularly atrocious video productions, one of which I refer to in my scribbled notes as

Utterly incomprehensible! video... apparently in Turkish with Iranian voice-over... a shaky travelogue of every unpronounceable Turkish town... endless! Just when you think it ends, long pause and another blast of Turkish horn music strikes up... camera aimed out of car, blurry roadsides, endless last closing shot of sky out dirty windshield... Jesus Christ!

Only the misery of my fellow jurists — at one point Andrew was holding his head in his hands — made me feel better.

Soon after that we ended up in the lonely back room of a cheap Italian restaurant, recommended by Nicole. Here we ate, drank, smoked, pondered over the film entries and kept the polite waiters up far too late. Margaret paid with additional cash she had shaken down the Festival for. We had our verdicts.

We took cabs back to the Markthalle — by now it was about 2:30 in the morning. We were just in time for the second running of the Super-8 projector race. All the seating had been cleared out of the main hall

Land of a Thousand Balconies

and ten projectors had been outfitted with roller skate style wheels. When the starting bell sounded the projectors began to trundle forward along lengths of Super-8 film secured at both ends of the race course and fed through their film path mechanisms. It was a sweaty, boozy, gambling affair with all the atmosphere of an illegal cock fight under the boardwalk. Some projectors advanced steadily in straight lines while others started going sideways and tipping over.

The party went on until daylight, helped along by bottles of vodka that Nicole had talked the bartender into selling her at an unbelievably low price.

We gave Nicole the names of the four films we'd chosen. One of them was a three minute, Super-8 silent entitled *Mullet*. It was a simple yet playful and surefooted parable of a spurned village idiot who wears a fish on his head. Produced by Australian Rick Randall and the Back to Back theatre group, it displayed a vital, collaborative group spirit and managed to turn its low-budget to its advantage. Also it had come at the end of the Experimental/Avant Garde block and had dazzled us with images of actual human beings.

Jack throws fish — a political act!
Photo: Baernd Fraatz

I had been the chief advocate of this film and in return for their acquiescence to a fourth place special mention (dressed up as the bronze prize), my fellow jurors insisted I wear a fish on *my* head. For her part, Nicole volunteered to go down to the harbour that morning and buy a fish at the seafood market. And here I thought she was just making conversation in a forest of empty vodka bottles…

Around 7AM, with the sobering light of day upon us, Annabelle, Rik, Margaret, Andrew and I walked back to the hotel, stopping to drink for another hour at the outdoor table of an all-night bar near the train station. Finally, getting back to the hotel, we found breakfast was out.

For the closing awards ceremony that evening at 8PM, the Markethalle was packed. A bar was set up stage right with lime rickies in mass production. An overstuffed couch and stand-up home organ console were installed to the left, with everything bathed in rosy stage lighting.

The International jury started off with Ben delivering the news from the bar. First prize went to *Flatworld*, a funny, polished and innovative — if perhaps overlong — cartoon by the Englishman, Daniel Greaves. Second prize was given to the Brazilian production, *O Bolo*, by José Roberto Torero, which chronicled a series of everyday moments between an elderly couple with a dry and witty touch. Both films were then screened.

After a short intermission came the awards for the best "three minute quickie", with the primitive yet retardedly seductive *Rebell Für Einen Tag* by Harald Koch being the standout.

The No-Budget awards followed as we piled onto the couch. Vito was resplendent in powder blue leisure suit, matching head bandage, neck brace and fold-up cane. Nicole had brought out the large cod she had bought and it now sat on an upturned metal pan in front of the couch with a rose in its mouth.

Margaret emceed our presentation, and, after a series of obligatory thank you's, she announced *Mullet* as our bronze prize winner. She then publicly nodded to me with profound intent: it was my turn to do something. I had to haul my ass off the couch and do something funny in front of a crowd that was still pretty reserved. For lack of a better idea we'd decided that I'd present the fish back to Nicole, since (1) we all loved her so much in her green vinyl mini-skirt, and (2) she was the one who had bought the goddamn fucking thing in the first place! But surely this had no "grand gesture quality" about it, I thought, as I stood there ready to fizzle out in front of a full house.

The original idea was that I would wear the fish on my head like the fellow did in the film — which we weren't showing. I did actually now put it on my head and capered about briefly to scattered and lukewarm audience reaction that clearly indicated we had reached rock-bottom. I then announced we were presenting the fish back to Nicole, which, if nothing else, was a way out. Nicole started to make her way to the stage as I cradled the slimy monster in my hands. Seized by the moment, I declared that if she didn't come and claim it, I'd have to lob it into the audience. The crowd

instantly came to life... Nicole stopped in her tracks and melted back into the confusion. Rocking the fish back and forth in three theatrical fake heaves, I then let it fly as the audience erupted. Blinded by the stage lights, I couldn't see where it landed. (On some poor girl, apparently.)

With the buzz still resonating throughout the hall, Annabelle's uncertain English struggled for dominance and she announced that the silver prize was going to *Sunset Strip*, by Kayla Parker of Plymouth, England. This three-and-a-half minute piece had impressed everybody at the Metropolis screenings. Comprising 4,000 images, created frame by frame using materials such as bleach, nail varnish, magnolia petals and net stocking, it recorded the impressions of 365 sunsets on a broad and overwhelming 35mm canvas. "I'd had enough of technology for a while" read director Kayla's notes. "For *Sunset Strip* I wanted to make something simple which relied mostly on me and the images I created using film as a physical medium. Direct contact: me, film, light. Definitely no movie cameras... a day-by-day diary of a year's sunsets rendered directly onto a continuous strip of 35mm celluloid."

Andrew announced our second place finish (gold) for *Quel Giorno*, a moving and emotional 35mm treatment of contagious despair on an Italian street corner. Director Francesco Patierno wasn't present so his certificate was given instead to the festival's Italian projectionist and the film was shown.

After *Quel Giorno*, a fellow came up on stage carrying the fish in a blue plastic bag, put it on the floor next to me and told me I owed somebody an apology. I grabbed the mic: "I want to say that I *do* apologise to the person that got hit with the fish, but I don't think there was a soul in the place that didn't mind seeing someone *else* get hit — the public demanded it and I am a man of the people!"

There was a confused murmur from the crowd as I'd blurted out my English too quickly for the mostly German audience to digest... but at least now I realised why I had done it — as a Political Act.

It was becoming clear that what I'd really thrown into the audience was a giant Red Herring (in keeping with the spirit of many of the films they'd thrown at *us*)... something highly theoretical and metaphorical... except to the girl who got hit by it.

Margaret announced our first place prize which went to *Hummeln Im Kopf (Bumblebees In My Head)*, a surreal and visually intoxicating young-girl-in-her-bedroom fantasy. Employing a lush array of visual processes, from hand-painted frames to step printing and animation, the seven minute, 16mm work won both the jury *and* the audience prize — a festival first.

Hummeln Im Kopf was screened and filmmaker Dorothea Donneberg, from Kassel, came on stage to accept the award.

All the festival staff and guests filled the stage to sway and sing along with Vito Rocco's infectious and sloppy celluloid kiss goodbye, *Ciao, Ciao*, as it played on the screen behind us. Andrew dragged the couch to

Members of the jury at the end of festival party.
FROM LEFT Rik, the author, Andrew and Nicole.
Photo: Baernd Fraatz

the edge of the stage with a prone and cane waving Rocco still draped on it. When the song ended he dumped Vito off the couch and into the audience.

The show closed with Kiki and Herb's *Total Eclipse Of The Heart* as people started filing out to the bar. I dragged the fish back to the dressing room where a small crowd gathered in the exhausted glow of rosy anti-climax and farewells. We hoisted Nicole in our arms to careen unsteadily around the room as flash bulbs and beer bottle caps popped.

Later on Nicole told me the girl who got hit with the fish wanted it back in order to fry it up. I handed it over instantly.

My grand political gesture pretty much split the audience: some thought it went too far, while others came up to me later that night in the bar and offered their solemn support and heartfelt encouragement. "I just want to tell you, you did right by throwing the fish," declared one fellow in deadly earnest as he shook my hand.

Some people make great films and some people throw a fish into the audience. I know which side of the fence I was on *that* night (... and *every* night, since I've never had any desire to make a movie).

KOSMORAMA NIGHTS

Heating Up a Movie Theatre in the Cold North

In the fall of 1994, Maren Pust — editor of the venerable Danish film journal, *Kosmorama* — secured permission from the director of the Copenhagen film museum to stage special once-a-month movie screenings in the museum's cinema. Shows could be on any theme she fancied, and she was free to promote the shows with no holds barred. Maren was joined in this endeavour by myself and our friend and steady contributor to the magazine, Kim Foss. The idea was not to just screen films, but stage events. There would be drinks, prizes, special guests and other extras. The sky was the limit, we had lots of ideas and the museum had lots of money. Why not, for example, show *The Seventh Seal* and give away white face powder and plastic scythes? (Actually, *that* we never did. Why do the good ideas always come years later?)

Thus was launched the Kosmorama Night Film series. It would last for two and a half years and throw a jolt into the normally staid and classics oriented programming of the Film Museum. It would also inject a much needed dose of trash'n'sleaze into the broader Copenhagen movie going scene which was heavily art oriented and where a Woody Allen marathon passed as a bold idea.

We had unlimited access to all the prints in the massive, mouldering Danish film archive (housed in the remains of a stone fortress that had been built in 1892). And we had the complicity of the museum brass. They had agreed to pay for door prizes, cases of exotic liquor, beers, snacks, sundry lobby decorations and printed invitations for a mailing list of 500. Not to mention external film rental fees when the gang of three deemed it necessary to go outside their archive for titles. We had it all. And by agreeing to our plan, they found themselves silent partners to a project that could never do anything but lose money. On top of that, the whole thing was a vaguely distasteful descent into "event culture" as Museum boss, Ib Monty, sniffed at the outset.

But the trick, to get people back to the museum cinema in its out-of-the-way location on the island of

Kosmorama Nights

PREVIOUS PAGE Mimi Heinrich in a promotional photo from *Reptilicus*, given to the star on her guest appearance at a Kosmorama Night screening of *Journey to the Seventh Planet*.

BELOW Audience member at the "Elizabeth Taylor Night" about to partake in a hot-dog topped with caviar.

Amager, worked. The old 150-seat house was almost always full, and an assortment of Danish pop culture celebrities, from TV show cooks to rotund lounge singers to famous unclassifiable eccentrics, became regular customers and occasionally active participants.

Although sober screen gems like *Alphaville* and *Let's Get Lost* popped up on occasion, programming quickly gravitated into outré cult, sci-fi and weirdo-horror territory. We screened *The Girl Can't Help It*, *Red Planet Mars* and *Expresso Bongo*. There was a "William Castle Night" with *Homicidal* and *I Saw What You Did*, and a "Seventies Death Sport Night" with *Deathrace 2000* and *Rollerball*.

Low-budget science-fiction was a favourite theme. At one show we paired the 1976 kung fu comic book bash, *Inframan*, with the Danish made poverty row sub-classic, *Journey to the Seventh Planet* from 1961. *Journey* had in fact never been theatrically screened in Denmark (!) and now Danes got a chance to see some of their most beloved stars caught helplessly in the tentacles of a Z-grade outer space picture.

Maren scoured the Copenhagen phone book to she if she could find any of the actors who had played in the picture, and came up with the number of the second female lead, Mimi Heinrich, whom was promptly rung up. Ms Heinrich, who had also been a lead in the better known *Reptilicus*, agreed to appear in person (see: IT CAME FROM BEYOND BELIEF). In her short introduction speech she claimed she'd never even seen the film, and then the Master of Ceremonies shoved a big bunch of flowers in her face. A museum staffer had ferreted out a great photo of her in *Reptilicus*, and that was given out as a door prize along with a toy ray gun. This was aimed and fired at the evil pulsing brains and skull creatures throughout the night. (We gave ray guns out every night, even if we were showing a French New Wave film.) Some kind of glowing green alcoholic concoction was served up at intermission, palmed off as some sort of "space drink". Mimi laughed off my passionate assertions that she was great in the film. She seemed somewhat mortified but over all happy enough. Otto Brandenburg, who crooned the theme song in *Journey*, was wildly cheered at the end when his name appeared on the credits roll: He had recently become something of a folk hero after a recent booze-

fuelled punch-up with the cops.

Elizabeth Taylor's birthday was memorialised with a screening of *X, Y and Zee*. The motor behind this particular show was Denmark's most rabid Elizabeth Taylor fan, a gay guy who successfully pestered shop owners into donating a staggering array of books and artefacts that we gave out as door prizes. It took an hour to give it all away and almost everybody left with an armful of Elizabeth Taylor related memorabilia, even people who had not known what the theme was in advance. He even sent an invitation to Liz herself, but her secretary begged off, citing her recent leg operation. A pølse vogn (fried sausage wagon) was hauled into the museum's cobblestone courtyard to dispense free hot-dogs topped with expensive (donated) caviar to departing patrons who also got a glass of champagne. Hot dogs and caviar were inscribed in legend as Liz's favourite food.

On November 24, 1995, a unique and never-to-be-repeated show was staged on the theme of censorship.

Land of a Thousand Balconies

It had been discovered that through the decades every time a Danish film was censored (before the abolition of censorship in 1969) the offending footage was cut out and sent to the archive at the fortress and randomly spliced onto whatever strip of film had arrived before it by some ultra-diligent employee. There now existed five spools comprising a total of about eighty minutes of nothing but censored out-takes dating back to the silent era. But it was not in any kind of thematic or chronological order, it was just a surreal hodgepodge of whipping scenes from old pirate movies, nude dance numbers, shoot outs, endless cowboy fist fights, jungle adventure snippets proffering naked negro lasses and much more. Racy sexual scenes and animals battling each other to the death were two of the main themes. The celluloid snippets ran anywhere from five seconds to three minutes in length and formed some pretty bizarre juxtapositions. A sexy fireside tango cuts to cowboy on horseback suddenly shot through the neck with an arrow cuts to giant boa constrictor slowly squeezing the life out of a black panther cuts to Indian warriors set aflame and pushed off high cliffs cuts to idyllic nude swim scene cuts to somebody being whipped senseless on a Spanish galleon cuts to an African bull and a lion battling in a closed pen…

Much of the film was on old, combustible nitrate stock. This has a tendency over time to turn into something resembling gun powder, and it can be so unstable that in some places it's illegal to transport it through city streets. It cannot be shown in a theatre unless the projection booth has a direct outside exit. It was legal to show the material at the museum's cinema which had such an exit, but it required the presence of an elderly, specially licensed "master projectionist" to run it. I ventured up into the booth at the end of the night to observe this wizard in action and found him chatting with his pal while they made serious progress on a case of beer. No sweat.

Another instalment was billed "Sex Night" — and idea as unoriginal as it is eternally popular. We screened a beautiful 35mm print of Armando Bo's Argentinean softcore opus, *Fuego*. Lead actress and wife of the director, Isabel Sari, is so "hot" at one point that she has to wallow in a snow bank to cool off. The film was well received but one elitist film buff snob later complained to the museum that they should have showed the original Spanish language version instead of one dubbed in English! I had spent the morning searching the junk shops of Nørrebro in pursuit of a suitable door prize, and found one of those rubber car tire ashtrays. Decades ago some nameless playboy had taped the photo of a naked woman under the glass bottom and screwed it back together, the tape now yellowed and brittle. This sleazy little home-made erotic icon was given out with great pomp and fanfare as the grand prize — and the winner was showered with adulation! There was a certain element of hysteria that was part and parcel of these arrangements.

The final Kosmorama Night took place on May 31, 1996, and was also the last show in the old Film Museum before it moved to its new home in the centre of the city. The Gang of Three decided to close down

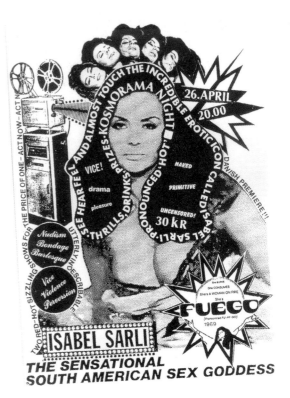

Kosmorama Nights

the series with a double feature of sleazy, indefensible horror films. *The Hypnotic Eye*, from 1959, would warm up the audience for Joel Reed's infamous 1978 S&M sickie, *Blood Sucking Freaks*.

If some of our other choices had caused Museum boss, Ib Monty, pangs of indigestion, this grand finale must have caused him some real nausea, for there on the front page of the Culture section of the largest Danish daily blared the headline: "Violent Porno At The Film Museum". Rather than the attack that it appeared to be, the piece was actually an over enthusiastic plug for the show penned by a local film freak who rejoiced that the Museum was no longer shackled by the binds of staid old French art films.

Despite hot, sunny weather on the day of our sign-off show, about 100 people turned up. The first two door prizes were unceremoniously flung into the audience: a cheap Halloween monster make-up kit purchased in an American supermarket and a bunch of rubber spiders. Another prowl through the junk shops that morning had produced the grand prize — an original and startling pen-and-ink drawing that depicted some kind of African voodoo imagery. This gem cost less than a buck and was ideal to give away in connection with *The Hypnotic Eye* which dealt with hypnosis, mind control and zombification. The drawing was framed and brought to the show with all the other crap.

That night the Master of Ceremonies brandished the picture before the audience and claimed that the lucky winner could use it to hypnotise and manipulate strangers and friends alike... and that furthermore, when hung on the wall, it would hypnotise the winner himself. The audience was lost — things were not getting off to their usual fast start. Quickly a ticket number was called out.

Silence... "I can understand why somebody would hesitate to claim this prize!" he piped up just to fill the awkward space. "It's got a curse on it: check the papers for the terrible things that happened to our last two grand prize winners!"

After two more numbers were called out, a fellow in the second row timidly raised his hand and approached to claim his reward with the most hesitant, wary expression ever to appear on the face of a "winner".

Bloody Marys and pork rinds were served out in the courtyard after *The Hypnotic Eye* ended and the crowd wandered out to enjoy the warmth.

In a fit of apparent masochism, Ib Monty showed up for the start of *Blood Sucking Freaks*, just in time to witness a solid half of the remaining eighty attendees walk out in the course of the first fifteen minutes. They straggled out into the lobby, quite upset and offended, some claiming to be bored, many of them hanging around to help finish off the pot of Bloody Marys and receive psychological counselling from Maren and Jetta, who was our very engaging ticket booth lady.

Of the forty who stayed, half loved the film to an intense and unnatural degree, and I got the clear impression that the other half would have stayed to the end no matter what was playing.

At the end of the night, as a small group of commiserators gathered to clean up the trash in the cinema, we found the voodoo picture. He'd left it behind, tucked next to his seat, and bolted... trying to out run fate.

Frames from *Blood Sucking Freaks*.

COPENHAGEN (IN TWO PARTS)

1. CLUB STRANGE

When I did shows or tours in America, I did so knowing full well I would probably lose money on it all. There's not much public funding for the arts in America, let alone funding for the kind of stuff I had been involved in. The idea of seeking funding would have been absurd in and of itself. I never remotely thought of what I was doing as "art". But once I moved to Denmark in 1993, I saw how different things could be. This same kind of stuff could get masses of funding while being every bit as incomprehensible.

My brief participation with what I dubbed Club Strange was a shining example.

It happened in September of 1995. I was contacted by a guy who lived in Copenhagen, Chris Spacer was the name. He wanted me to show nine hours worth of 16mm film at what sounded like some sort of... multisensory... something. The resourceful young Dane had reached agreement with UFF, a chain of used clothing stores, to sponsor his project. UFF was part of the much larger "Tvind dynasty", a corporate behemoth that had many other sidelines including a ring of folk high schools and clothing shops. They had been previously demonised in the Danish press for cult-like rigidity with which they ran all their operations, to the tune of high profits, and they definitely needed a hipper image. Spacer, who specialised in organising parties and raves, sold them an unusual answer: he would turn their downtown basement thrift shop into a party zone on Saturday nights.

Buyers would be encouraged to come in and browse for used clothes while being blasted out of their wits by sonic-boom rave music and blitzed by banks of strobe lights as smoke machine fog drifted up to their waists.

That was the scene by midnight anyway, on the first and only night in which I participated. Enough audio and effects equipment to outfit a medium-sized stadium rock concert had been installed that afternoon, all of it obtained free under sponsorship arrangements. UFF had chipped in with a sizeable budget covering publicity and various other costs. They paid for great one-sheet posters. "Party shopping in your second-hand shop" and, "Buy first class second-hand clothes and support the third world", ran the tag lines, hinting at the kind of mystical ethics to which they laid claim.

That premiere show into which I had been incorporated kicked off with "event" style hype that included aluminium-foil papered walls, robed figures outside trying to lure in the curious, and radio, TV and print reporters wandering about in a daze trying to figure out what the fuck was going on and what they could possibly write about this.

I was led to the back of the catacombed basement, to a windowless bunker-like room strewn with pillows and cushions. Here I was to show the random assortment of 16mm films that I had lugged over in two bulging suitcases. I set up the projector and started running film. Nobody was there. The crowds would pick up later, they assured me. I pulled up one of the overstuffed couches to sit in and watched the movie. Outside in the main room the show was just starting and it sounded like D-Day.

A pal of mine from Sweden I hadn't seen in many years happened to be in Copenhagen that night and stopped in. He told me it was strange: pushing his way through the crowds and blasting techno music and pulsing strobe lights and smoke to get to the back and find me in an empty room sitting on a couch watching movies. Of the others who later managed to find their

way back there, most just peeked in, bewildered, or wandered in somewhat apprehensively to ask me what I was doing.

The planned twelve show season folded after four shows, leaving a lot of confused people to find other ways to spend their Saturdays, and leaving me with a too small leather jacket that I had taken a hankering to amid all the disorientation, and had gotten for half price.

I did a lot of other shows in Denmark over the years. I did a weekend marathon at Copenhagen's "youth house", an old theatre squatted by anarchist punks, and I did a show at the gigantic Grey Hall in the free state of Christiania, an old military hanger with a capacity of thousands. There I initiated something called a "film drop" which involved the unrolling of a completely trashed 35mm print of The Big Doll House, which was then hoisted way up to the roof in a net. At a specific point the monster mass of celluloid was then dropped onto party goes who dove in and attempted to win a prize by being the first to identify the title by examining frames.

But of all the unlikely places I ever set up a movie projector, nothing was ever quite as absurd as the show at Club Strange.

The NIMB Ballroom.

2. BALLROOM CRASHING

In the early fall of 1995 I was contacted out of the blue by a young employee of the Copenhagen branch of the Ted Bates advertising firm. He and his colleagues were seeking to create some kind of unorthodox entertainment event that could generate publicity for Price Tobacco, a major client of theirs. They were looking to target customers of the Kings cigarette brand which was the popular smoke with existentialists and bohemians, and as the cult thing was catching on in Denmark at the time, they asked me to organise a B-film festival that would appeal to the hipster crowd. The plan was that this would be the first in a series of yearly events: this year it would be cult film, next year square dancing or whatever was underground then.

Broke as usual, I was interested. I weighed the moral ramifications of working for a tobacco company and one second later agreed.

I went over to the Ted Bates building to brainstorm with them and develop the idea. Cloistered in their smoke-filled conference room, we finally settled on the ambitious concept of a fifteen hour movie marathon that would centre on the films of Russ Meyer, who up to that point never had much exposure in Denmark. Now we began to cast about for a suitably atmospheric location.

We thought it would be a cool idea to hold it at the old Saga theatre on Vesterbrogade which currently sat boarded up and plastered with graffiti. In the fifties and sixties it had been one of Copenhagen's bigger show case theatres, premiering everything from Reptilicus to The Green Berets (which drew thousands of young protesters). Exploitation programming later replaced first-run fare, and at some point it degenerated into a hardcore porn theatre, and finally a grungy rock venue. Today it was simply a gigantic abandoned building in one of the cities tougher neighbourhoods...

One day the Bates crew, clad in suits and ties, went over and toured the joint with the owner. It was in an appalling state of wreckage. There was extensive structural damaging, water was leaking from pipes, and the seats were smashed to pieces. In addition to all that, it was inhabited by a militant troop of squatters who were preparing to fight off an imminent police raid. Any involvement with this location would suck the Ted

Bates advertising firm into both an economic and political morass and they quickly crossed the place off our short list. They were still in a state of awe when we met the next afternoon.

Then they hit upon the idea of holding the show at the NIMB Ballroom, located in the famous Tivoli Park. It was an ornate "old world" style ballroom with chambers and lounges and sitting rooms. Normally it was rented out for company bashes and corporate office parties where secretaries and their easily impressed husbands would drink a bit too much and bask in the gilded opulence of eighteenth-century Vienna (or something like that). It had chandeliers and it had plush draperies. In other words it was *perfect*. It was agreed, then, and Ted Bates rented the hall for a weekend.

The NIMB marquee.

I put together the program of films and dealt with the logistics while Ted Bates designed a glossy poster sporting a giant pink bra stretched and waiting to be filled. Classic ad firm approach. The image drew of course on Russ Meyer's contribution to the evening, namely *Motor Psycho*, *Faster, Pussycat! Kill! Kill!* and *Black Snake*. They hired some punk poster plasterers, and soon the image was all over the city. The deal was that Ted Bates would pay all costs and reap a whirlwind of doubtful publicity while I would pocket all the ticket money.

But our timing was cursed: we'd scheduled the show on the same late November weekend that the Danish Prince was getting married to a fetching oriental babe, which guaranteed a dearth of press. On top of it a freak snow storm struck. Despite these travails, the strange film happening or whatever it was came off and attendance was good. Without really trying we had managed to tap into the raincoat crowd, and that night various reticent looking loners mixed with biker types, film freaks, hipsters and Prince Tobacco executives and their mink-stole-draped spouses (who proved the most obnoxious of the lot). They all gathered in the downstairs lobby and then swarmed up the gilded palace staircases.

They crowded into the main room where 35mm projection was set to roll through the night with outré classics like *Driller Killer*, *Wild Harvest*, *The Girl And The Geek* and the aforementioned Meyer films. Meanwhile in the royal sitting room I manned the 16mm projector, screening *Viva Las Vegas*, *Homicidal*, *The Tingler*, *Hell's Angels On Wheels*, *Village Of The Giants* and more.

The first film in the packed main room was *Motor Psycho*, which, with all the scenes of women getting slapped and pulled around by their hair and beaten and raped (off-screen), probably stands as Meyer's most brutal and politically incorrect movie. One had to wonder what the Prince royalty thought of this attempt to burnish their image! Many of them, in any case, remained ensconced in the tapestry-lined main bar, and they were the first to peel off. By the show's end, only a handful of malingerers were left to wander alone and dazed through the various chambers, enjoying a last hour of freedom before being turned out into the brutal, frosty, mid-morning sunlight.

Around 15,000 bucks had been spent in total by Prince for one night of film, and while I only netted 800 from the shindig, it was at least thrilling to sit back and watch this much cash go whizzing over my head. In America this kind of money never flows downhill.

I never heard from the boys at Ted Bates again. I don't know if the square dance ever came off.

UNCENSORED CONFESSIONS OF A FILM COLLECTOR

"Where did you *get* these films?"

That's the one question I have constantly been asked over the course of the last fifteen years as I presented film programs throughout Europe and America.

It's a question with no short, easy answer; a question that stirs a mix of emotions that run the range from shame, guilt and greed to ecstasy, lust and rapture... threatening to unleash a flood of memories and dirty little secrets upon the unsuspecting person in front of me who was just trying to make conversation. So I give some kind of polite answer. It's a question that of course leads straight to the heart of what it means to be a film collector, which I am and which is far more (or less) than someone who just collects films.

It is a question that I am now able to bring some perspective and insight to bear upon thanks to the luxury of a bit of leisurely introspection which the writing process affords. And this is not always polite or dignified stuff.

First I should define what I collect.

I collect 16mm and 35mm film *prints,* the actual celluloid material that runs through a movie projector — the kind of contraption that you probably once saw your teacher fiddling with in grade school. Material that can be scratched, torn and melted and can fall off onto the floor into heaps of tangled coils that can take hours or days to unravel. Material that comes on cores, spools and reels and is shipped in cans and boxes that can be ungodly heavy to lug around. (Old projectionists often develop back problems the same way that truck drivers have their internal organs rattled loose) Material that is so heavy that people often don't even bother to throw it out, leaving it to moulder away in stacks in abandoned buildings, to be found years or decades later by people who think it is worth something. This is one of its dubious attributes which ironically has led to the preservation of a lot of film.

I'm not talking about video, DVD or laser disc which is what the man-in-the-street refers to when he refers to a "film", as in "I own that film."

Not until recently, with the advent of video in the 1980s, could that man-in-the-street "own" a film. Only a company or a film collector could own or possess a film, and the fact that today any schmuck can walk into a gas station and buy "a film" is something that real film collectors look upon with scorn. It also, for different reasons, is a cause of unhappiness for some film makers. "I hate the fact that people can now 'own' my films" said the director, John Waters, some years ago, referring to the fact that they used to only be able to own the fleeting experience of seeing his films. In any case, the video boom begot hordes of video collector nerds that ended up kicking grandma and her old sofa out of the house so they would have more room to store their 7,311 videos.

Stupid *collectors*.

Insufferably purist film collectors (like myself) are

Land of a Thousand Balconies

quick to point out that the schmucks don't own the actual films, only the codes to the films encrypted on a disc or tape, while a film print is the genuine article. It's the actual image that the audience also sees, running at twenty-four frames-per-second through a projector, and the actual sound which you can also see as a wavy line called an optical soundtrack that runs down the side of the film. Moreover, the film collector is going right to the source, not choosing something that somebody else has already chosen for him — which is what videos are, consumer items marketed to the buying public.

Film is a physical, tangible thing. One can with one's own hand repair or damage or paint or edit or scratch or manipulate the material in various inventive and catastrophic ways. Images can be obtained by cutting out single frames of the film and having them blown up, which almost all projectionists do at some point to no great credit to their profession. (Projectionists are a breed apart and deserve their own literary tribute.) These frame-out-takes can be photographically enlarged into works of art that hang on walls and become objects of fetishistic idolatry — far superior to the fuzzy video frame-freezes one so often sees published in books today.

In short, with the proliferation of home viewing technologies, film has become a consumer item, like Chinese take-out food, gasoline and rubbers — while the film *print* has never, at least in the recent past, been a consumer item. The average person does not know what store you go into to buy those because that store does not exist. And all the equipment one needs to work with prints, like splicers, split-reels, rewinds and editing tape, is added effort and expense that the man-in-the-street is hardly willing to suffer. And some of these specialty items are becoming increasingly harder and harder to find. If you were looking for a roll of 16mm sound-censoring tape, forget it. I can tell you there was only one roll of it left in the entire world and I found it a couple of years ago in a dusty corner of a photo shop in San Francisco — and I *stole* it! Sixteen millimetre film is an obsolete and disrespected medium, and these dusty nooks and crannies, these "film corners" hidden in the back of a handful of old photo shops, have the feel of museums about them.

No, celluloid is not a consumer commodity. One doesn't get bored on a Friday night and go out and pick up a pizza and a film *print*. Normal people don't do that, and the man-in-the-street would no doubt stare on in surprise in the face of a film collector's heated exhortations that the video he had tossed into the paper bag with the six-pack was not "the real thing".

What? Come again?

Film collectors possess many of the same qualities/symptoms that are commonly ascribed to other collectors who specialize in stamps, coins, baseballs or antique firearms, for example. They can be as fussy, obsessive, hard to live with and as out of touch with reality. They all have a jealous desire to possess a rare, genuine object in as near perfect condition as possible; an object for which they have a personal passion. They expect these objects, or collections of objects, to gain in value over the years. And, if they can ever bear to part with them, they can eventually be sold to another rabid collector for great amounts of money to pay for that little cottage you and the wife have always wanted (in the process forcing her to apologise for all the years of bitching at having spent all that money on crap and cluttering up the house).

But film collectors are also different from other collectors due to the very nature of what they collect.

The world of film, particularly short films, is a largely unexplored universe. For example, gun collectors know that a 1890 model Winchester exists and what the book value of one in mint condition is, and baseball collectors know there are baseballs signed by the 1969 Mets and what price such an artefact can be expected to fetch at an auction. But, to use a theoretical example, nobody - not even other film collectors — know that there existed a 1953 soap detergent commercial that stars a young Jayne Mansfield. It's a novelty and a rarity, an obscure artefact of star culture that a Mansfield completist would sell his kingdom for. These kind of artefacts function as a sort of spiritual medium to the actor, giving the collector the feeling that he has contact or access to the star (presumably only if they are still alive). I knew a collector who had a number of the five minute TV shows that Les Paul and Mary Ford made back in the mid fifties, and he went down to the music club in New York where an elderly Les Paul plays every week and got him to sign the film cans. This kind of thing is not only done out of love but can increase the value of the item. (There used to be a movie memorabilia shop in San Francisco that served as a kind of sanctuary for a small circle of rabid autograph hounds who would plague any celebrity, star or porn actor who happened to be in town. If you happen to go into the shop while they were there you couldn't get a word in edgeways.)

The world of film is still a largely uncharted sea of product. There are still fantastic discoveries to be made. Every rust-caked film can potentially contains something strange, something of value. This encourages the obscurist tendencies of collectors. They revel in arcania and wallow in secrecy and exclusivity.

But what is this theoretical three minute Jayne Mansfield soap commercial really worth? What is film

Uncensored Confessions Of A Film Collector

really worth?

The material itself is virtually worthless and, in the case of old nitrate film, even dangerous. Nobody in their right mind would bother to steal a print, no pawnbroker would give you a dime for a steamer trunk full of them, and even the most wildly obsessed collectors mercilessly argue the local junk shop proprietor down to a few bucks for those dusty couple of mystery spools sitting on his shelf. I've even known schools and educational institutions to give away their entire film libraries for free to collectors — and even pay for shipping — just so they wouldn't have to throw them in a dumpster.

To quote the classic phrase that rules in the world of film collecting: "It's worth what somebody will pay for it." The world of film collecting tends to be dominated not by a systematic or controlled system of "book value" prices but rather by the mood swings and fits of enthusiasm that take place in the brains of collectors.

In the last few years the on-line auction house, eBay, has destabilized pricing even further, raising the amounts paid for single films to absurd levels and making it possible for film fanatics from Japan and Belgium to square off against each other — as recently happened — and drive up the bidding on an unexceptional 3-minute Scopitone film, Love Me, Please Love Me by Michel Polnareff, to 600 bucks — only shortly after two prints of the same film had been sold for several dollars each. To know that some collectors are scoring jackpots like this gives everybody the hope of making a killing, gives everybody the hope that they too will come in contact with that mythical eccentric Japanese millionaire.

Another difference between film and other collectable items is that film is functional and interactive. You can show a film to a crowd of people and share your passion with them. And if you're smart, you make that a *paying* crowd of people, though that necessitates that you also be daring or indifferent since it may entail copyright violation (more on that later). Film collectors like to show their films, if only to themselves. I once heard about a collector in Seattle who built a tiny five-seat state-of-the-art 70mm theatre in his garage. Anyone who happened to come over would be dragged into the garage to watch his mint Technicolour 70mm print of Star Wars while the concert-sized speakers shook the whole neighbourhood.

But audiences are optional. In fact for a medium that conjures up visions of crowds and noise and laughter, film collecting is a lonely road.

Film collectors are usually intolerably picky when buying or commenting on films. Although I do know a collector who enjoys "red" or "off" prints (the same way album collectors enjoy the rough, unclean sound),

The author posing in the decayed recesses of an Amsterdam cathedral. Props are supplied by the photographer. The overcoat however, is his own, and allows for shoplifting of small rolls of film.

Photo: Jan Willem Steenmeijer

this is extremely rare. Most live in fear that the sky will turn from deep blue to a juicy purplish colour and that the yellows and greens will seep out of the print before their very eyes. Or that tiny vertical scratch lines will appear over a favourite scene despite the care they take with cleaning and projecting the film.

Courage is required since film is such a fragile and transitory medium. Colours fade, the stock crumples and rips in the projector and frames burn up right on the screen as the horrified collector looks on in terror. Projectionists go to the toilet and coils of film fall off the take-up spool and onto the dirty floor. Collectors are paranoid but they have good reason to be since everything is the enemy: the elapse of time which saps the colour dyes, humidity that shrinks the stock, and water that ruins the emulsion as surely as it ruined the

Land of a Thousand Balconies

Wicked Witch of the West. Even the collector himself is the enemy, threading up film incorrectly in a weak moment or losing a print in the post due to shitty handwriting. Suffice it to say, collectors are perfectionists in a medium where perfection is never possible, where the things you value most in the world are sure to be destroyed.

We are perfectionists, and maybe other things as well. I once ordered a print of *Viva Las Vegas* from a seller. He sent me *Blue Hawaii* by mistake. Of course I looked at it — it was in incredibly beautiful condition, the best print I ever saw. Not the tiniest scratch anywhere and the colours were deep and saturated, almost glowing. A wonder to behold. I sent it back and got *Viva Las Vegas* in return which I looked at and found to be in only lesser "very good" condition and I felt crushed and cheated. I wrote letters to the fellow for months afterwards, at first politely asking for and then demanding a better print, a print of the quality of *Blue Hawaii*. I finally sent him a pleasantly worded card informing him that I was travelling and that by happy coincidence I would soon be passing through his small southern town and would stop in and pay him a friendly visit. He took it as a death threat and demanded I cease and desist, which I did after quickly coming to my senses.

The running time of a film is also a factor. Due to the frames and sequences cut out of prints by projectionists, censors and editors for various reasons, no two prints are exactly alike, and collectors will argue that a competitor's print is lacking 5.6 seconds in such and such a scene.

But back to the original question: where does one get these films?

Before eBay opened a Pandora's box of greed, lust and delusion, the main forum for the exchange of prints was *The Big Spool*, a newsprint tabloid whose pages were crammed with tiny hand scrawled ads, shaky drawings of projectors and corny fifties style ad art. The paper was (and is) a free zone for nostalgics of all stripes, a lone prairie where autograph hunters, hero worshippers and print pirates ran amok, a last stand for fans of old Westerns. In addition to its function as a forum for the exchange of prints, it was a haven for crackpot inventors peddling bogus homemade cures guaranteed to miraculously save the damaged films of the world as well as their own bank accounts. Here obsessed collectors searched for treasure or entered into a desperate hunt for that favourite film they planned to take with them to their grave.

In addition to *The Big Spool* and eBay, collectors buy and sell prints through a secretive web of personal contacts. And beyond that there is just endless luck and pure relentless opportunism as prints are found, scrounged, borrowed and never returned… pilfered from attics, projection booths, theatre basements and even abandoned buildings. Films are found in dumpsters and stacked out in back alleys along with busted sofas to be rummaged through by the soon-to-be-disappointed homeless. The rabid collector often finds himself in these kinds of environments. No staircase is too rotten that he won't try to climb it if he thinks there might be a room stacked with prints at the top. The rotten stairway to heaven.

Some years ago, for example, I was visiting a friend of mine in Detroit and was surprised to find his film collection swollen by new acquisitions which chiefly consisted of old refrigerator sales films and advertisements for hi-fi's, ovens, dishwashers and various other consumer products from the fifties and sixties. What the hell? It turned out that he and a couple of dedicated 'junker' pals had just raided the old downtown warehouse of the industrial film company, Jam Handy, which by that point was an abandoned and partially flooded building inhabited by hobos and crack addicts — but which still contained thousands of film prints.

Soon after that construction, workers had boarded up the place and emptied its contents — films, garbage, old needles, splintered furniture — into a giant dumpster,

Uncensored Confessions Of A Film Collector

and it was all hauled off to some garbage pit.

San Francisco, as I discovered when I lived there in the early nineties, had its own army of junkers and scavengers (see: THE NYBACK CHRONICLES).

There was a place in San Francisco that regularly had films for sale, a squalid little store-front down at the foot of Mason St near the intersection of Market, in the heart of the city's rough Tenderloin ghetto. They sold discount pornography along with various and miscellaneous objects they apparently found on the street: a radio, a bottle of shampoo, etc. Sixteen millimetre film spools dumped into a large bin by the window — coils of loose footage spilling out — was also part of the mix, all of it pretty much exclusively gritty amateur hardcore pornography. They also sold old battered 16mm Bell & Howell projectors that were in such filthy condition that I hardly dared to bring the couple I had foolishly purchased into my house.

These films and projectors were the bitter harvest from the old store front porno theatres that populated the Tenderloin back in the seventies... flotsam from another day and age that was still washing up on the shelves of the local gyp joints and flea markets. I say "sell" but I have to say I never saw another customer in the place, just sometimes a couple of transvestite hookers who came in to shoot the shit.

There was another place over in The Mission, a thrift shop crammed floor to ceiling with junk and furniture, that was owned by a Mexican family. The joint was run by an obese old lady with a gammy leg and there were always lots of children running around.

At one point word was going around in the filmmaker and junker community that they were selling film prints.

By the time I got there the stack of prints they had had been sold. There was more in the basement but the old lady had no intention of going down there on her bum leg and told me to come back tomorrow when her son would be working. I came back the next day and he couldn't be bothered to go down there either, but he gave me a flashlight (as none of the lights worked) and let me go down by myself.

The place was a garbage strewn pit, partially flooded and reeking like a swamp. At some point a film lab had gone out of business and tossed its goods (pornographic, again) into a dumpster, and without missing a beat the old lady's virile sons had fished it all out and brought it back to the shop. Now here I was, literally at the bottom of the scavenger food chain, rooting around in the darkness... lifting up watersoaked cardboard boxes whose bottoms immediately fell out to send spools of film rolling into the muck. I fleetingly imagined the indignity that would result should a sudden earthquake send one of these heavy beams crashing down on me, pinning me into all this dirt and all these dirty movies.

I staggered back up with as much film as I could carry, not to mention all the little rolls of film I had hidden in every pocket and undergarment — an act of petty thievery as embarrassing as it was unnecessary since after an apathetic glance he let me have the whole load for twenty bucks.

(Among the films from that heist were several XXX gay porno trailers, including *Get That Sailor* which I later incorporated into a compilation show I presented at the 1995 Rotterdam Film Festival. It turned out to be the surprise hit of the festival with shouts of "get that sailor!" ringing like a battle cry into the air as gangs of inebriated festival goers swayed and lunged down the main promenade.)

One could also buy films from "East Bay Denny" who lived across the Bay in a suburb of Oakland and operated out of his garage. The place was stuffed with prints, everything from cartoons to fifties female pro-wrestling shorts to a dusty old film from the forties that turned out to be about coal miners in Wales getting lung operations. He would shepherd you through the garage and you felt like a kid in a candy shop — film noir over here, biker and blaxploitation features over there and emergency medical films in the corner next to the stack of sex education cautionaries. Denny had a kind of conspiratorial air about him and once asked me if I wanted to buy a 35mm print of *Crocodile Dundee* for $800 in hushed tones that hinted at the probable stolen nature of the goods. It was the last film I wanted.

Denny was a few cuts above the shysters who ran the Tenderloin store fronts, but one was still on a need-to-know basis with him. The world of film collecting is full of Dennys, shady middlemen running garage operations that were, if not criminal in nature, then at least illegitimate. The search for prints brought one in contact with these types, while the very nature of what was being collected ensured that most dealings transpired in a kind of ethical grey zone. The ground rules were clear enough: while it wasn't illegal to own the film material *per se* (as some people think), to screen the films in a public context could entail copyright infringement, and the means by which a film print became available might suggest that an illegal act was somewhere involved. But there were different shades of grey. Disney was famed for crushing anyone who violated its copyrights, while for its part eBay was pressured to ban the sale of 35mm prints after someone posted a print of *Titanic* for sale. On the other hand if you showed *The Estrogen Cycle of a Rat* to a group of friends, you could expect to do so without

interference. But even the most respected film collectors, such as the late author and professor, William K Everson, for example, who never soiled his hands on the mean streets of the Tenderloin, have been visited by the FBI about illegally possessing prints.

On the other hand the world owes a debt of gratitude to film collectors who have obtained, kept and preserved prints of films that the studios cared nothing about and which would have perished if the "private sector" had not played a role. For example, it's a sad fact that after the copyright expires on a film sent abroad, the prints are destroyed in a mechanical guillotine-like device. Thanks to human nature, the masked and muscled operators of these modern day Iron Maidens can be bribed into parting with the prints, and all it takes is the flash of a sweaty C-note by one of the nervous collectors hanging around the loading docks.

But questions of strict legality aside, a pall of dubiousness hangs over most of these people, and my first contact in the world of film collecting, a Vietnam vet named Reggie, was covered with it in spades.

He lived in a small, spartanly furnished two room flat in the working-class Boston neighbourhood of Jamaica Plains. The place had the feel and smell of a 1940s rooming house despite the perfectly scrubbed linoleum floors. The living room/bedroom where he conducted business was furnished with just a cot and a couple of chairs and not much else, not even a TV. Reggie had the nervous energy of a reformed alcoholic or someone who was taking speed to help him get through two full-time jobs. The place was beyond tidy, in fact there was no trace at all of a past or of other interests, no photos, no books… no clues as to what motivated him. He never personally seemed the slightest bit interested in films, and if he had chosen this as a pathway to riches, he had chosen badly.

He never hinted at where he got the films and film equipment that he periodically came in possession of… he would just call me up on the phone out of the blue and tell me to come over because he suddenly had more films.

On one such occasion he told me to bring my film collector pal with me, obviously so that we could bid the prices up against each other. Of course I came alone. He had a pile of films lying in the middle of his floor which included a 16mm print of *Earth vs The Flying Saucers*. I offered him fifty bucks for the lot which he dismissed out of hand, and then he accepted my next offer of eighty bucks. I later sold *Earth vs The Flying Saucers* for 200 bucks alone. (Every collector has cherished stories like this that can warm up a cold night.)

He also had three projectors in his room which upon every visit he ritualistically unpacked and demonstrated and then packed up again. The projectors he wanted too much money for but the films you could get for next to nothing. One of the projectors was a gigantic old Ampro, an ancient and beautiful contraption. According to Reggie the elderly man who had owned it had collapsed while lugging the monster up a staircase, and in the ensuing tumble had been killed.

Reggie with-no-last-name was some kind of psychic and material bridge to that world of elderly men who possessed most of the film prints that existed in the known world, some of them crusty old thieves and con artists, and others kindly movie buffs playing favourite Buster Keaton comedies every night on old projectors in empty houses where children had grown up and left and wives had long ago died. All of them now broke, sick or demented, forced to divest themselves of their cherished films and equipment for a song. Sometimes the old men died first and the wives sold or gave it all away to free up space in the attic…

The film collector's world was a world of these hidden spaces, the cellars and the lofts out in the barn and the dusty attics permeated with the smell of rusty film cans and the vague vinegar scent that old 16mm films give off… the smell that now dominated the pantry of my rent-controlled Cambridge brownstone where I had cleared out the dishes and cans and boxes to store film prints in obsessively systematised order. My own archive of obscure treasures.

While Reggie was my first contact into this spirit world of film collecting, I would occasionally reconnect with it at various points through the years, one glancing encounter occurring after I left America and moved to Denmark in 1993.

Some months after my arrival I went out one day to answer ads placed by parties interested in selling 16mm projectors. I answered seven adds and, with my wife whom I dragged through all this because she could speak better Danish, met almost exactly that number of terminal eccentrics, delusionals and borderline lunatics… bitter old men in wheelchairs living in decaying flats smelling of cat piss, genius experts and wizards of repair that could give a girl the creeps, ultra-specialists whose catacombs were crammed with a million projector parts … and at least one unhinged old couple whose couches were covered in flea-ridden leopard skin and whose windows were painted black. The man had once been "in the industry" (or something), had once had a nice place and things of value and a career and a future, and now all he had was a few projectors, and, as he hinted but never showed me, a cellar full of films. And he and the old lady talked and talked and talked and wanted you and the wife to come over sometime for coffee…

INDEX

3-D Movie 30
13 Ghosts 23
2001: A Space Odyssey 143

A Scanner Darkly 140
Abbott, Bud 69
Abyss, The 105
Adamson, Al 55
Africa Ablaze 41
African Queen, The 47
Agar, John 16, 17
Ain't That Just Like Me
 (Scoptione) 42
Aldrich, Robert 115
Alice in Wonderland 123
All The Boys And Girls
 (Scoptione) 41
Allen, Woody 170
Allin, G G 141
Alo, Vincent 44
Alpert, Herb 44
Alphaville 171
American Look 64
Andersen, Asbjørn 10, 13
Anger, Kenneth 68
Angry Red Planet, The 8, 15
Animal Lover 154
Anka, Paul 42
Arbus, Diane 49
Arkoff, Sam 9, 10, 18, 19
Around the World (Scoptione)
 39

Arrival, The 66
Assembly Line 91
Atomic Submarine 39
Aubret, Isabelle 37

Babb, Kroger 22
Baby Doll 83
Backporch Majority, The 43
Baise Moi 160
Baker, Caroll 83
Baldwin, Craig 129, 130, 144
Ball, Lucille 9
Bang, Poul 10, 13
Barbarella 122
Barenholtz, Ben 49
Barfod, Bang 15
Barfod, Bent
 12, 14, 18, 19, 20
Barfod, Hans 9, 10
Baronessen fra benzintaken
 (Baroness From The Gas
 Station) 9
Bass, Aaron 147
Bates, Ted 175, 176
Batman 40, 116
Battleship Potemkin 94
Beast Of Blood 24
Bee, Molly 40
Bees, The 14
Beggar's Wedding 28
Behrens, Marilise 10
Belfer, Hal 36, 38, 39, 40

Bell, Freddie 42
Ben 24
Benson, Fred 37
Bergman, Ingmar 103, 106
Beruf: Neo-Nazi (Occupation:
 Neo-Nazi) 97
Best Is Yet To Come, The
 (Scoptione) 40
Beuys, Joseph 95
Beyond the Valley of the Dolls
 60, 116, 124, 128
Bicycle Thief, The 103
Big Dipper 140
Big Doll House, The 175
Big Spool, The 180
Bingaman, Fred 46
Black Christmas 58
Black Hearts Bleed Red 153
Black Snake 176
Blake Babies, The 139
Blank Generation 154
Blichmann, Trine 108
Blonde Emanuelle 30
Blood For Dracula 123
Blood Sucking Freaks 173
Blue Hawaii 180
Blue Sunshine 72
Blue Velvet 110
Bo, Armando 172
Bogart, Humphrey 47
Bogus Man, The 129
Bolton, Rik 165, 168
Bonengel, Winfried 97

Land of a Thousand Balconies

Boogeymen, The 140
Boyreau, Jacques 55, 133, 142–144, 146
Bradbury, Ray 15
Brady Bunch, The 56
Brandenburg, Otto 19, 171
Brandt, Carsten 108, 109
Breaking The Waves 57, 99
Breathless 133
Briskin, Irving 36, 42
Browning, Tod 22, 48
Brygger, Mikkel 105
Bubble, The 30
Buchanan, Larry 55
Bucket of Blood, A 112
Burn, Witch, Burn 24
Burnt By The Sun 108
Burton, Tim 55, 119, 121
Butterfly 61
'Bwana Devil 7, 27, 30

Cage, Nicolas 72
Cagney, James 67
Caligula 14, 124
Candy von Dewd 148
Cannibal Girls 24
Capra, Frank 50, 57
Carpenters, The 141
Carr, Vicki 44
Casablanca 47
Cass, Mama 93
Castle Of Blood 24
Castle Of Evil 24
Castle, William 7, 22–24, 26, 171
Cat Women Of The Moon 29
Catena, Gerardo 43
Cave, Nick 72
C'est Si Bon (Scoptione) 41
Chaplin, Charles 87
Chavez, Frederick 83
Che, Cathay 94
Cheater Slicks 140
Chelsea Girls 142
Chien Andalou, Un 130
Christensen, Benjamin 104
Christmas 2025 65
Christmas Carol, A 58
Christmas Evil 60
Ciao, Ciao 169
City of Lost Children 61
Clark, Bob 60

Clark, Petula 42
Cobra Woman 70, 120
Cohn, Roy 43
Coleman, Joe 153
Comin' At Ya! 30
Comstock, Dan 21
Comstock, Daniel F 73
Condors, The 42
Corman, Roger 18
Corpse Grinders, The 24
Corruption 23, 24
Costello, Lou 69
Cramps, The 128
Craven Sluck, The 149
Crawford, Joan 115
Crawl 142
Creature From The Black Lagoon 29
Creeping Terror, The 23
Crocodile Dundee 181
Cromwell, James 65
Crowley, Aleister 101
Cruise, Tom 72
Cult of the Cobra 29
Curse of the Living Corpse 24
Cushing, Peter 23

Dalgaard, Kirsten 106
Dalì, Salvador 17
Damone, Vic 40
Dando, Evan 139
Danforth, Jim 20
Darren, James 40
Date With Death, A 24
Davenport, Glorianna 26
Davis, Amy 133
Davis, Bette 115
Day, Doris 75
de Sica, Vittorio 103
Death Zones 91
Deathrace 2000 171
Deep Throat 100
Deneuve, Catherine 140
Depp, Johnny 55, 119
Dersu Uzala 108
Design for Dreaming 64
Despentes, Virginie 160
Desperate Living 129
Destroy All Monsters 144
Devil's Sleep, The 47
Dial M For Murder 29
Diane Linkletter Story, The 139

Dickies, The 128
Dion 42
Divine 39, 54, 58
Djaevelen gaar forbi (The Devil Walks By) 10
Dolan, Denise 147
Donneberg, Dorothea 169
Douglas, Alan 50
Dr Butcher MD (Medical Deviate) 23
Dracula (play) 22
Dracula, the Dirty Old Man 123
Dragon Zombies Return 79
Dream Child 108
Dreyer, Carl Th 103, 104, 107, 124
Driller Killer, The 176
Drive-In Massacre 24
Duckenfield, William Claude (W C Fields) 97
Due, Jesper 106

E.T. The Extra Terrestrial 30
Earth vs The Flying Saucers 182
Earth vs The Spider 20
Easy Rider 60, 132
Eaton, Marion 149–152, 153, 154
Ebert, Roger 60, 116
Eboli, Thomas 43
Eck, Johnny 52
Eck, Robert 52
Ed Wood 55, 56, 119, 121
Edwards, Theodore 70
Edwards, Wendy 60
Eichelbaum, Stanley 82
El Topo 49, 50
Element of Crime, The 110
Elvis, Der 131, 132, 134
Embalmer, The 24
Esper, Dwain 22, 48, 67, 68, 70
Estrogen Cycle of a Rat, The 87, 181
Evans, Robert 54
Everson, William K 68, 182
Exciters, The 42
Expresso Bongo 171
Eyes of Hell (The Mask) 30

Fame Whore 135

Index

Fast and Filthy Fist 79
Faster, Pussycat! Kill! Kill! 49, 51, 128, 138, 176
Fearless Vampire Killers, The 123
Female Trouble 51, 54, 58, 129, 130
Femininity (Scoptione) 42
Fields, W C 97
Flaming Creatures 120, 126, 127, 129
Flatworld 168
Flesh Eaters, The 24
Flesh For Frankenstein 30, 123
Flesh Gordon 124
Foght, Jørgen 99
Fonda, Jane 122
Fonda, Peter 142
For Time or Eternity 65
For You (Scoptione) 42
Ford, John 67
Ford, Mary 178
Fort Ti 29
Foxy Brown 110
Fraises Musclées, Les (play) 108
Frankenstein Meets The Space Monster 24
Freaks 22, 48, 49, 52, 67, 68, 139, 161
Friday the 13th Part 3 30
Friedman, David F 68
From the Earth to the Moon 27
Frumkes, Roy 141
Fuego 172

Gabor, Zsa Zsa 72
Gad, Urban 105
Gangneux, Annabelle 165, 168, 169
Garland, Judy 115
Garnett, Gale 36, 38, 40
Gary Lewis and The Playboys 42
Gateway To Gaza 8, 9
Geek Maggot Bingo 129
Geissmann, Laurent 159, 162
Gengaeld (Retribution) 9
George, George 127
Get That Sailor 181
Get Yourself A College Girl 42
Ghosts of the Civil Dead 72
Gielgud, John 14

Gimme Shelter 140
Girl And The Geek, The 176
Girl Can't Help It, The 140, 171
Glen or Glenda? 47, 50, 117, 118, 119, 121
Glover, Crispin 61
Godard, Jean-Luc 103
Godzilla 72
Goldfinger (Scoptione) 37
Gordon, Bert I 20
Gordon, J C 44
Gordon, Stuart 18
Gore, Lesley 42
Gorehounds, The 140
Graham, Bill 84
Greaves, Daniel 168
Greco, Juliette 37
Green, Abe 33, 43
Green Berets, The 175
Green Slime, The 143
Green-Eyed Elephant, The 9, 10
Grey, Rudolph 50, 51, 54, 55, 118, 119
Greyson, Mark 10
Grimes, Karolyn 57
Guldbrandsen, Peer 9
Gulf Between, The 73
Gwar 128
Gyldmark, Sven 11
Gypsy Wildcat 70, 120

Haliday, Bryant 47
Halloween 61
Hallyday, Johnny 37, 42
Handy, Jamison 63, 64, 180
Hansen, Klaus 110
Hardy, Françoise 41
Hardy, Oliver 107
Harvey, Cy 47
Hatchet Murders, The (Deep Red) 24
Hated: GG Allin & The Murder Junkies 141, 154
Hatfield, Julia 139
Hayden, Nora 8, 9, 10
Haynes, Todd 133, 139, 141
Heavy Equipment 30
Hein, Wilhelm 156
Heinrich, Mimi 10, 16, 171
Hell's Angels On Wheels 111, 176

Hendrix, Jimi 50
He's Got The Power (Scoptione) 42
Heuermann, Claudia 89
High Boots (Scoptione) 38
High Heeled Sneakers (Scoptione) 42
Highway Of Heartache 94, 162
Hillbillys in a Haunted House 39
Himmelskibet (Sky Ship) 10
Hippy Porn 133
Hitchcock, Alfred 67
Hoberman, J 70, 121, 127
Hold Me While I'm Naked 127
Høm, Jesper 109
Homicidal 24, 171, 176
Homosexuals, The 92
Hondells, The 42
Hong Kong Hodge Podge 87
Hopkins, Ben 164
Hot Cars 39
House of Wax 29, 30
House on Haunted Hill 25
Høyer, Orla 12
Hughes, Howard 82
Hummeln Im Kopf (Bumblebees In My Head) 169
Hussy, Olivia 60
Hypnotic Eye, The 24, 173

I Do, I Die 148
I Drink Your Blood 110
I Saw What You Did 24, 171
If I Had A Hammer (Scoptione) 36, 38
If.... 140
In 147
Incredibly Strange Creatures Who Stopped Living And Became Mixed-Up Zombies 24
Inframan 171
Insight TV 65
It Came From Beyond Space 29
It's A Wonderful Life 50, 57, 58

Jacobs, Ken 126
Jarmusch, Jim 42, 110
Jaws 3 30

Land of a Thousand Balconies

Jazz Singer, The 78
Jensen, Cornelia 147
Jodorowsky, Alexandro 49
Johnny Liar (Scoptione) 40
Jolie Môme (Scoptione) 37
Jolson, Al 78
Jones, January 40
Jorgensen, Christine 47
Journey to the Seventh Planet
 15, 16, 17, 19, 20, 171
J'suis Mordu (Scoptione) 37

Kalmus, Herbert 21, 73
Karen Carpenter Story, The
 139, 141
Katzman, Sam 42
Kaurismäki, Aki 110
Kaye, Irving 33
Keaton, Buster 182
Kelly, Phil 137, 138, 140
Kennedy, Robert 43
Kier, Udo 57, 99, 123
King, Greg 79, 80
King of the Road (Scoptione) 36
King of the Rocketmen 121
Kitt, Eartha 44, 116
Klieler, David 137, 138, 140
Koch, Harald 168
Koed, Kaj 12
Kötting, Andrew
 164, 168, 169
Kray, Pam 154
Kuchar, George 40, 92,
 127, 129, 153
Kuchar, Mike 40, 92, 122,
 127, 129, 149–154
Kurosawa, Akira 108

Lagrimas Negras 97
Land Of 1000 Dances
 (Scoptione) 38, 42
Landau, Martin 55
Lansing, Joi 39, 40, 41
Lansky, Meyer 43
Last House On The Left, The
 141
Last Year at Marienbad 137
Laurel, Stan 107
LaVey, Anton 48
Lawrence, Delphi 9

Leconte, Patrice 108, 109
Lennon, John 49
Let's Get Lost 171
Leuthesser, Fred 44
Lewis, Gary 43
Lewis, Jerry 69
Lewis, Judith 164
Little Miss Go Go (Scoptione)
 38
Logan, Josh 83
Lonely Lady 61
*Looking Ahead Through Rohm
 And Haas Plexiglas* 63
Loren, Sophia 83
Lorre, Peter 47
Love Me, Please Love Me
 (Scoptione) 42, 179
Love Slaves of the Amazon 121
Lovely Sort of Death, A 145
Lynch, David 61, 67, 116
Lynn, Roberta 42

Macabre 23, 24, 26
Madison, Holler 10
Maggart, Brandon 60
Malnik, Alvin I 33, 34, 43
Malnik, Irving 42
Maltin, Leonard 61
Man from O.R.G.Y., The 15
Man Hole 30
Maniac 70
Manlove, Dudley 71
Mansfield, Jayne 72, 178
Marble Ass 162
Marco Polo 14
*Marijuana: Weed with Roots in
 Hell* 68
Mark Of The Devil 24
Markowitz, M L 80
Martin, Dean 139
Martindale, Wink 64
Mask, The 23, 30
Mathis, Johnny 42
Maze, The 29
McCormick, Maureen 56, 92
McDowell, Malcolm 140
McKelvey, George 45
McLean, Dan 78, 79, 81
McNair, Barbara 40
Meatrack, The 56
Medved, Harry 51, 119
Medved, Michael 51, 119

Meet A Body (play) 22
Mejding, Bent 10
Mekas, Jonas 122, 127
Melchior, Ib 8, 11, 13,
 15, 16, 19, 20
Meredyth, Douglas 65
Meyer, Russ 41, 49, 51,
 116, 128, 129, 175, 176
Midnight Cowboy 161
Mighty Mississippi, The
 (Scoptione) 43
Mikhalkov, Nikita 108
Millar, Gavin 108
Miller, Jody 36, 39, 40
Miller, Roger 36, 42
Miracle on 34th Street 58
Mirren, Helen 14
Missile to the Moon 121
Mixed Blood 129
Mod Fuck Explosion 134, 162
Moffett, Scott 145, 146
Mommie Dearest 115
Monch, Peter 16, 18
Monkees, The 14, 40
Monsieur Hire 108
Monsour, George 137
Montez, Maria
 70, 75, 119, 120, 121
Monty, Ib 170, 173
Moore, Rudy Ray 83
Morgan, Jane 38, 40, 41
Moritsugu, Jon 60, 128,
 130, 131–135,
 158, 162, 163
Morrissey, Paul 123, 129
Morton, Jim 51, 84
Motor Psycho 176
Moving Targets 140
Mr Sardonicus 26
Mr Touchdown (Scoptione) 41
Mullet 168
Murray, Bill 55
Murray, K Gordon 61
My Degeneration 132, 133
My Father's Call Girl 49, 52
My Teenage Fallout Queen
 (Scopitone) 45
Myra Breckinridge 121
*Mystery Of The Wax Museum,
 The* 29

Narcotic 22, 68

Index

New Horizons 63
Newman, Nicole 164, 167, 168, 169
Nicholson, Jack 106
Nicholson, James 9, 18
Nielsen, Asta 105, 110
Nielsen, Børge 110
Night Has A 1,000 Eyes, The (Scoptione) 36
Night Of Bloody Horror 24
Night of the Living Dead 49, 54, 55, 112, 142, 144
Nightmare On Elm Street, A: Freddy's Dead 30
No Exit (play) 7
Norman, Ruth 66
Norris, Chuck 155, 157
Nyback, Dennis 56, 85–94, 111, 153, 154

O Bolo 168
Oboler, Arch 7
O'Brien, David 70
Olsen, Fleming John 10, 11, 13
Olsen, Mette 107
On The Bowery 94
On The Street Where You Live (Scoptione) 37
One Has My Name, The Other Has My Heart (Scoptione) 38, 39
One I Love Belongs To Somebody Else, The (Scoptione) 41
Operation Camel (See also *Gateway To Gaza*) 9
Osco, Phil 124
Ostringer, Steve 154
O'Toole, Peter 14
Ottosen, Carl 10, 11, 16
Outlaw, The 82

Paisan 103
Palmer, Lilly 10
Paradisio 30
Parker, Kayla 169
Passer, Dirch 9, 12, 14, 16
Patierno, Francesco 169
Paul, Les 178
Peary, Danny 119

People Next Door, The 143
Peppermint Twist (Scoptione) 42
Petersen, Kjeld 14
Phillips, Todd 154
Pin Down Girls 47
Pink Flamingos 50, 58, 129, 133
Pink, Phillip 17
Pink, Sidney 7–20, 48, 56
Piranha Brothers, The 139
Plague of the Zombies 24
Plan 9 From Outer Space 51, 71, 118, 119
Planet Manson 148
Player, The 68
Playgirls and The Bellboy, The 30
Poe, Amos 154
Polanski, Roman 60, 106, 123, 140
Polnareff, Michel 42, 179
Porky's 58
Presley, Elvis 143
Price, Vincent 26, 72
Procul Harum 42
Psyrcle, The 42
Purple Monster Strikes, The 121
Purple Oblivion 143
Pussycat A Go Go (Scoptione) 38
Pust, Maren 170, 171, 173

Quadrophenia 134
Queen of Outer Space, The 72
Queen Of The House (Scoptione) 36, 39
Queers, The 139, 141
Quel Giorno 169

Race Is On, The (Scoptione) 40
Race With The Devil 142
Railsback, Steve 72
Rains, Claude 47
Ramones, The 128, 154
Randall, Frankie 40
Randall, Rick 168
Rasputin the Mad Monk 24
Rats Are Coming, The Werewolves Are Here, The 24

Rebell Für Einen Tag 168
Red Nightmare 157
Red Planet Mars 171
Reed, Joel 173
Reefer Madness 68, 70
Refn, Helge 106
Refn, Peter 105, 106
Reinhardt, Max 105
Renaud, Louis Miehe 16
Reptilicus 9, 10–16, 19, 48, 56, 171, 175
Repulsion 140
Resnais, Alain 103
Reynold, Debbir 38
Reynolds, Debbie 36
Riley, Billy Lee 42
Robe, The 73
Robinson, Edward G 88
Robot Monster 29, 121
Robot vs The Aztec Mummy, The 24
Rocco, Vito (Rik Bolton) 164, 165, 168, 169
Rock Around The Clock 42
Rocky Horror Picture Show, The 50, 56, 57, 83, 99, 121
Roffman, Jullian 23
Rohauer, Raymond 49, 67–68
Rohde, Bent 106
Rollerball 171
Rome, Open City 103
Romero, George A 49
Rosemary's Baby 60
Rosen, Anton 105, 106
Rossellini, Roberto 103
Rossi, Jeri Cain 153
Rozier, Elizabeth 85–87, 94
Rue, Jean-Jacques 159, 162, 163
Russell, Andy 40
Russell, Jane 82
Rydell, Bobby 42

Sabbath in Paradise 89
Safety or Slaughter? 112
Sammy and Rosie Get Laid 110
Sandberg, Henrik 8, 9
Santa Claus 61
Santa Claus Conquers the Martians 61
Sargeant, Jack 129

Land of a Thousand Balconies

Sari, Isabel 172
Satana, Tura 49
Satre, Jean Paul 7
Satuloff, Bob 93
Savage Seven, The 145
Schönherr, Johannes 88–93, 149–156
Schwartz, Barry 25
Schwarzenegger, Arnold 72
Scola, Ettore 110
Scorpio Rising 137
Screen Tests 120
Scumrock 135
Sea Cruise (Scoptione) 38
Sedaka, Neil 42
Sesock, Dennis 83
Seven Brides For Seven Brothers 43
Seventh Seal, The 170
Sextette 83
Shakin' All Over (Scoptione) 42
Shanty Tramp 110
Sheik, The 67
Shining, The 112
Showgirls 124
Si Mon Amour (Scoptione) 37
Signal 30 112
Silencer, The (Scoptione) 41
Silent Night, Deadly Night 60, 61
Sinatra, Nancy 42
Sinclair, Phil 83
Singles 87
Sinister Menace 68
Sins Of The Fleshapoids 40, 149, 121, 122
Sixth Street Love 52
Skaarup, Victor 11
Skotak, Robert 15
Sleazy Rider 60, 132
Slocombe, Romain 160, 161
Smith, Jack 70, 71, 120, 121, 126, 127
Smyrner, Ann 10
Soldater kammerater serien 9
Son of Sinbad 23, 29
Sonny, Dan 68
Sontag, Susan 40, 113, 115, 117, 119, 122, 124, 127
Spacer, Chris 174
Sparkles Tavern 149
Spectres of the Spectrum 130
Spiral Zone 162

Splendour 110
Sprogøe, Ove 9, 16, 20
Star Pimp 142
Star Trek 66
Star Wars 30, 75, 179
Starr, Kay 37, 38, 40
Steckler, Ray Dennis 25
Steeple Snakes, The 144
Steiger, Aaron A 33, 34, 36, 42, 44
Sten Møller, Henrik 106
Stevens, April 44
Stewardesses, The 30
Stewart, Doug 86
Stewart, Jimmy 57, 79
Stracher, Joseph 43
Strait Jacket 24
Street Of Lost Hope 94
Street Trash 112
Stripped to Kill 79
Subway Riders 154
Sudan 70
Sunset Strip 169

Taboo 149
Takao, Nakano 158, 160, 162
Talbot, Dan 49
Tales Of The Bronx 149
Tammy And The Doctor 142
Taormino, Howard 84
Tarantino, Quentin 67
Taylor, Elizabeth 171
Taylor, Vince 42
Tell Him (Scoptione) 42
Terminal USA 130, 133
Terror in the Haunted House 24
Terror in Toyland (Christmas Evil) 60
Theodore, Donna 42
They Eat Scum 129
Thomas, Mike 79, 80, 82, 83, 84
Thomson, Sven 150
Three Men And A Baby 76
Thrill Killers, The 24
Thundercrack! 91, 149, 152, 153
Thyssen, Gretta 16
Tingler, The 24, 25, 26, 176
Titanic 72, 181
Todd, Mike 21

Toffler, Alan 62
Toksvig, Claus 10
Tom Thumb 23
Tønsberg, Marianne 108
Topless A Go Go (Scoptione) 41
Torero, José Roberto 168
Torture Garden, The 24
Total Eclipse Of The Heart 169
Touch of Magic, A 64
Touchdown Girls (Scoptione) 41
Trash 129
Tribulation 99 129
Trip, The 110, 139, 142
Truffaut, Francois 103
Turner, Ike 42
Turner, Lana 83
Turner, Ted 49
Turner, Tina 42
Tweedlee Dee (Scoptione) 42
Twelve Commandments, The 73
Twenty Flight Rock (Scoptione) 42
Twilight Zone, The 46
Twist And Shout (Scoptione) 37

Ultraman 144
Undertaker and His Pals, The 24
Up A Lazy River (Scoptione) 38

Vaden, Vikki 147
Vadim, Roger 122
Vampire's Coffin, The 24
Varda, Agnes 109
Vartan, Sylvie 42
Vee, Bobby 36, 42, 44
Vega, Suzanne 88
Vegas in Space 121
Verne, Jules 32
Vertigo 75
Vester Vow Vow (At the North Sea) 106
Vidal, Gore 121
Village Of The Giants 176
Virgin Beasts 162
Viva Las Vegas 111, 112, 143, 176, 180
von Schiller, Margaret 165, 167, 168
von Trier, Lars 99, 104, 110
von Westernhagen, Esther 105

Index

Walker Brothers, The 42
Wallace, Mike 92
War Of The Gargantuas 144
Wargasm 129
Warhol, Andy 52, 120, 123, 127, 147
Warren, George 84
Waters, John 39, 49–51, 54, 57, 58, 119, 128–130, 132, 136, 139
Watson, Emily 57, 99
Watusi A Go-Go (Scoptione) 42
Web of Love, The (Scoptione) 39
Webster, Nicholas 61
Weinrich, Bent 106
Weiss, Gordon 47
We'll Sing In The Sunshine (Scoptione) 36
Welles, Orson 62, 67
Wenders, Wim 110
Werby, Willy 48
West, Mae 83
What Ever Happened to Baby Jane? 115
Wheel Of Fortune (Scoptione) 37, 39
When The Screaming Stops 24
Where Do You Go To Go Away? (Scoptione) 38, 39
White Savage 70, 120
Whiter Shade Of Pale, A (Scoptione) 42
Whittaker, Wetzel 65
Whitten, Danny 42
Whole Lotta Twistin' (Scoptione) 42
Wild Angels 138–140, 142
Wild At Heart 61
Wild, Greg 94, 158–161, 163
Wild Harvest 176
Wild in the Streets 56, 94
Wilke, Birthe 11, 12, 14
Williamson, Fred 72
Wilson, Dooley 47
Wiltrup, Aage 9, 18
Wittenstein, Alyce 90
Wizard of Oz, The 75, 115
Wolsgaard, Torben 107
Wood Jr, Ed 7, 47, 50, 51, 54–57, 117–119, 129

Written on the Wind 75

X, Y and Zee 171

Year 1999 AD 64
Year Of The Horse 42
Yellow Haired Woman (Scoptione) 40
You Better Watch Out (Christmas Evil) 60
Young, Barry 38
Young, Neil 42

Zadora, Pia 61
Zedd, Nick 128, 129
Zilnik, Zelimir 158, 159, 162, 163
Zip Code Rapists, The 142, 144
Zoates, Toby 158, 161, 162
Zorn, John 89

If you have enjoyed *Land of a Thousand Balconies*, you will dig *Trashfilm Roadshows* — more insider accounts from the world of cult movies

> "Vastly enjoyable... For those with a taste for subversive fare, Trashfilm Roadshows is a trip well worth taking"
>
> *Film Review*

TRASHFILM ROADSHOWS

Off the Beaten Track with Subversive Movies

by Johannes Schönherr

For Johannes Schönherr, no place has proven too distant nor too strange that he cannot screen or hunt down obscure underground trash movies. From the bowels of New York's Lower East Side, ruins in Detroit and punk clubs in San Francisco, to Moscow on a fake visa and North Korea, Schönherr is a cinéaste on a mission.

Trashfilm Roadshows tells of the trials and tribulations met by Schönherr on the road, including intrepid first-hand accounts of

- A Richard Kern show brought to a (perfect) halt by violent leftists
- A strange invitation to Russia for the screening of anti-Communist propaganda
- A trip across America in a dodgy vehicle loaded with reels of film
- Wild cinematic discoveries at New York's cheapest film-to-video transfer shop
- Running a no-budget rathouse of a cinema
- Nick Zedd being attacked by feminists in Nuremberg, Germany

Trashfilm Roadshows also contains the author's eyewitness account of GG Allin's last gig; advice on disposing of a stash of Heroin unearthed while renovating a movie theatre; and of being branded an 'imperialist spy' in North Korea.

Available Now ISBN 1-900486-19-9 Pages 176pp Price UK £14.99 US $19.95

If ordering in the UK add £1.80 p&p/Europe add £3/Payment via credit card, UK bankable cheque or POs
Residents in the US & Canada call Consortium toll free on 1-800-283-3572

www.headpress.com

Catch *Slimetime*, another top film book from the publishers of *Land of a Thousand Balconies* and *Trashfilm Roadshows*

"Some of the best bizarre film commentary going... with sharp, no-nonsense verdicts"

The Village Voice

SLIMETIME

A Guide To Sleazy, Mindless Movies

by Steven Puchalski

Seriously warped movies from around the world! Sci-fi, schlock, women-in-prison, Japanese monsters, biker gangs, brazen gals, mindless men, kung fu mischief, bad music, flower power, and puppet people!

Courtesy of savvy, in-depth reviews, **Slimetime** wallows in those films which the world has deemed it best to forget — everything from cheesy no-budget exploitation to the embarrassing efforts of major studios.

Many of the motion pictures in **Slimetime** have never seen a major release, some were big hits, others have simply 'vanished'. To compliment the wealth of reviews are detailed essays on specific sleaze genres such as Biker, Blaxploitation and Drug movies.

This fully updated & revised edition contains a hundred new reviews, many new illustrations and a report on a rare live appearance by Hunter S Thompson.

Available Now ISBN **1-900486-21-0** Pages **376pp** Price UK **£15.95** US **$24.95**

If ordering in the UK add £1.80 p&p / Europe add £3 / Payment via credit card, UK bankable cheque or POs
Residents in the US & Canada call Consortium toll free on 1-800-283-3572

www.headpress.com

keep up to date and order online at

www.headpress.com

or send a large SAE (or two IRCs) for our catalogue

Headpress / Critical Vision
PO Box 26
Manchester
M26 1JD
Great Britain